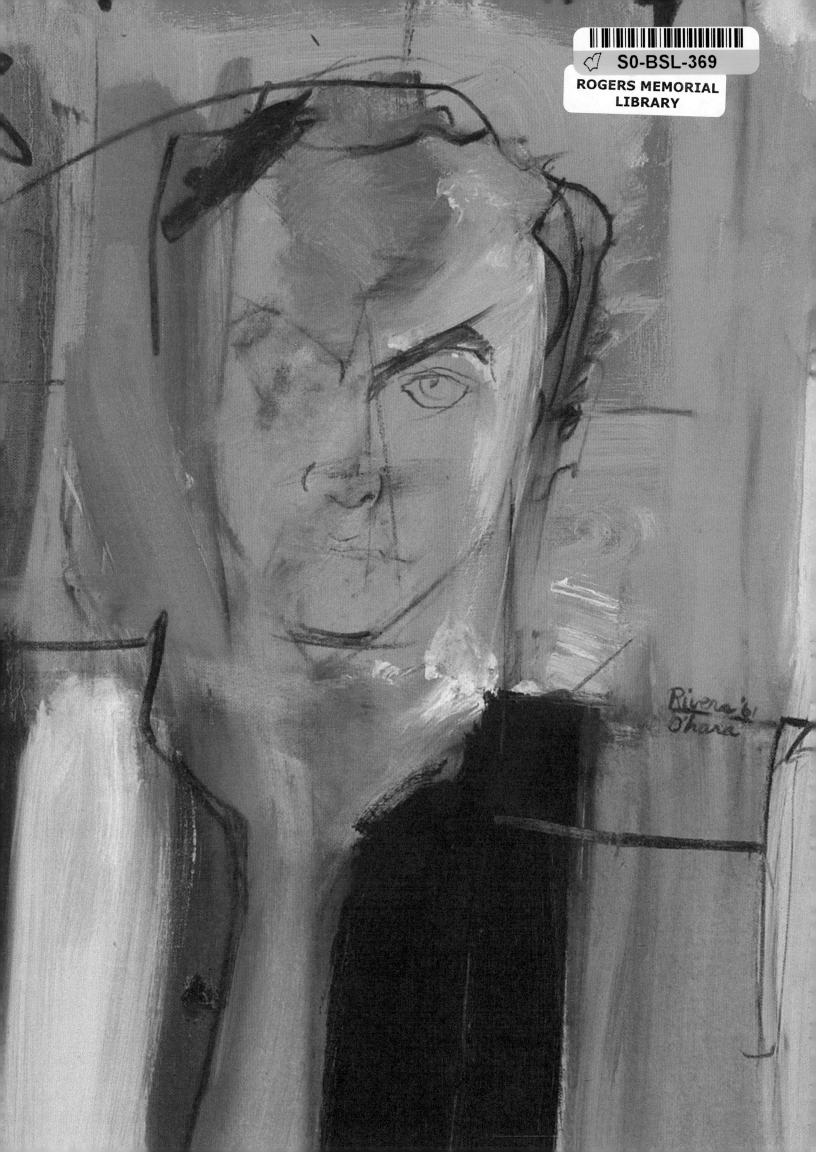

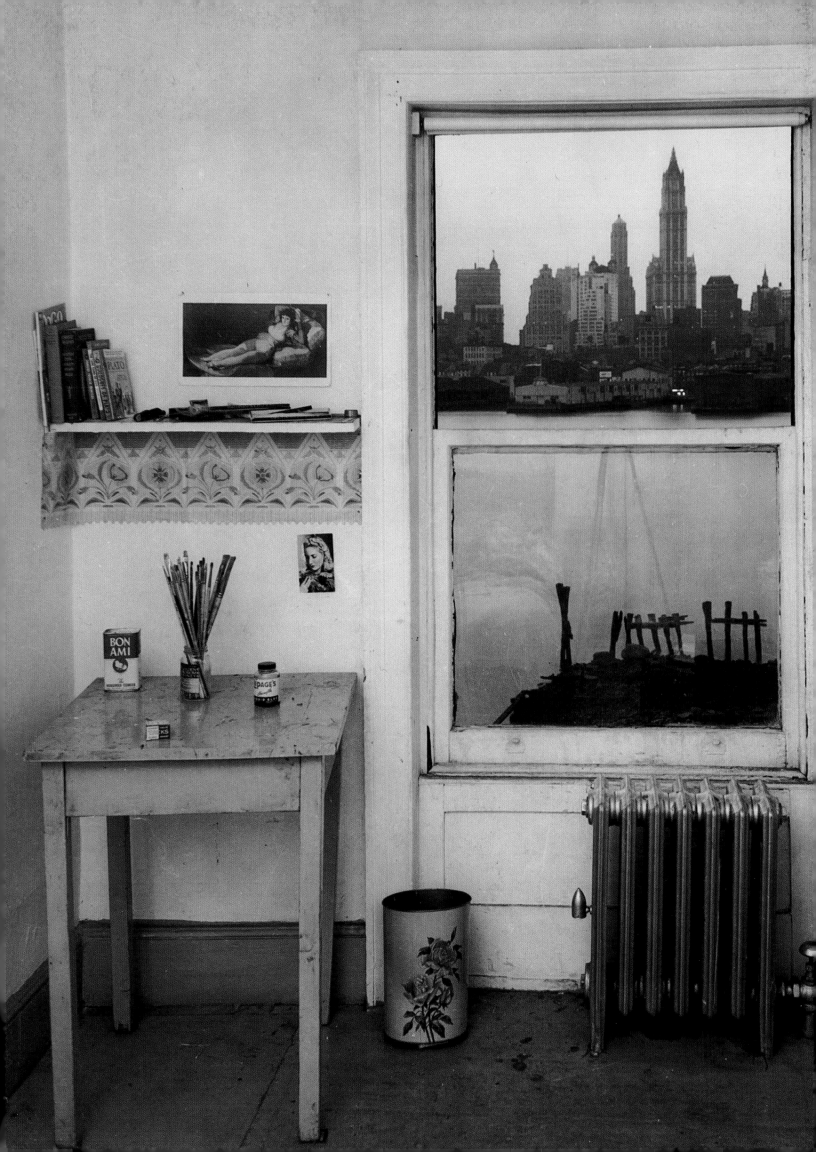

New York School Painters & Poets
Neon in Daylight

Jenni Quilter

EDITOR
Allison Power

ADVISORY EDITORS
Bill Berkson & Larry Fagin

FOREWORDS BY
Bill Berkson & Carter Ratcliff

RIZZOLI
NEW YORK

New York · Paris · London · Milan

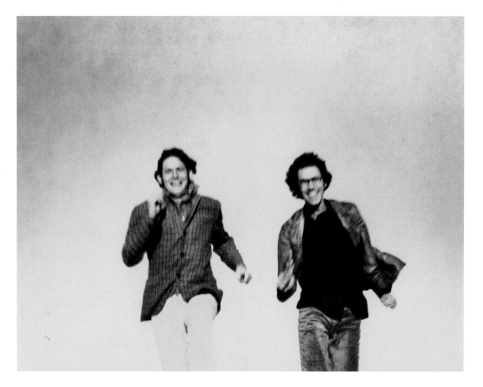

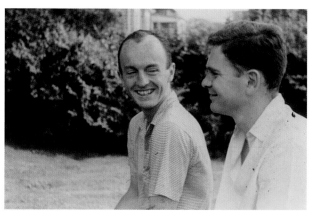

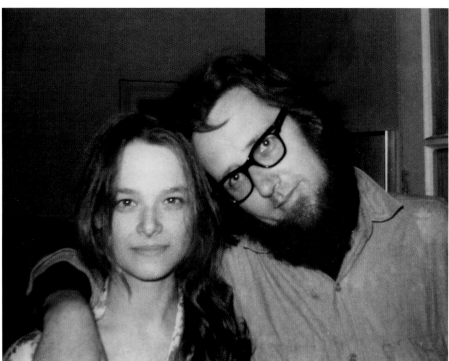

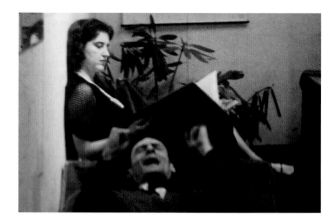

CLOCKWISE FROM TOP LEFT
Bill Berkson and Joe Brainard, West Hampton, ca. 1968.

Frank O'Hara and James Schuyler in the Porter's backyard, Southampton, New York, ca. 1960.

Kenneth Koch, Water Mill, New York, 1958.

Jane Freilicher and Larry Rivers in still from *Mounting Tension*, 1950.

Fairfield Porter paints John Ashbery's portrait, Big Spruce Head Island, Maine, 1970.

Anne Waldman and Ted Berrigan, 1968.

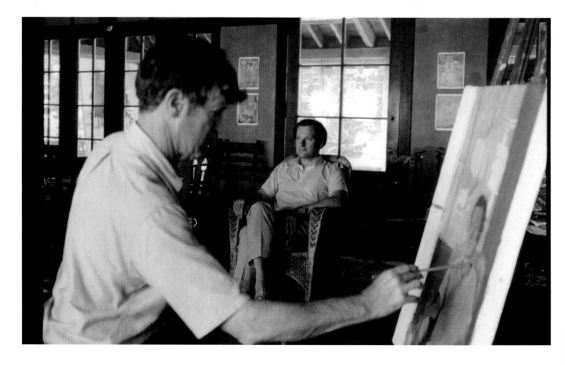

CONTENTS

Daylight

And when I thought,
"Our love might end"
the sun
went right on shining

James Schuyler

Joan Mitchell, drawing to James
Schuyler's poem "Daylight," ca. 1975.

7

MODUS VIVENDI

by Carter Ratcliff

For decades, art and poetry have inhabited separate planets. But there was a time, beginning in the early 1950s and lasting into the '70s, when poets and painters lived in the same world—or, rather, shared a stretch of Manhattan that reached from the Lower East Side to Chelsea. The painters attended poetry readings. The poets visited the artists' studios and wrote about the paintings they saw not only in verse but in the pages of *ARTnews*. From the intertwined lives of that time and place emerged the astonishing array of verbal-visual hybrids celebrated in *The New York School Painters & Poets: Neon in Daylight*.

Among the poets were John Ashbery, Frank O'Hara, Kenneth Koch, Barbara Guest, and James Schuyler—founders of the so-called New York School of poetry. Older but too vigorously engaged to be called elder statesmen were the poet and dance critic Edwin Denby and the photographer/film maker Rudy Burckhardt. The painters included Willem de Kooning and other inventors of Abstract Expressionism—Franz Kline, Philip Guston, Robert Motherwell—and such second-generation acolytes as Al Leslie, Michael Goldberg, and Grace Hartigan. Of course no trend goes unbucked, and by the end of the 1950s, abstraction's domain had undergone a friendly invasion by a disparate band of figurative painters, most notably Jasper Johns, Robert Rauschenberg, Alex Katz, Fairfield Porter, Jane Freilicher, and Larry Rivers. In *Stones*, begun in 1957, O'Hara and Rivers worked in quick alternation on single surfaces—in this case, a suite of lithographic stones, which they attacked with a still palpable urgency.

As the 1960s got under way, the scene became a magnet for the most adventurous and soon to be most accomplished younger poets of the era— Ted Berrigan, Anne Waldman, Ron Padgett, Larry Fagin, Bill Berkson, and others. From Andy Warhol's Factory came the poet and photographer Gerard Malanga, and Warhol himself became involved, as George Schneeman, Donna Dennis, Joe Brainard, and Trevor Winkfield joined the fluid ranks of the artists. On occasion, Allen Ginsberg, Jack Kerouac, and Gregory Corso would appear, forging a fugitive link to the writers of the Beat Generation.

As Willem de Kooning's *Gotham News*, 1955, reminds us, Manhattan is a place of sharp shadows and sooty grays. Sailing in from the North Atlantic, the light is silvery and harsh, and it flickers at a grand scale. There is nothing harsh about the politesse that gives O'Hara's poems their astonishing responsiveness and yet his tone is sometimes so refined that it cannot prevent itself from acquiring, on occasion, an ironic edge. And one hears an urban toughness in the slangy lingo recruited for poetry by New Yorkers as disparate as Ashbery and Waldman, Berrigan and Schuyler. Shifting tones and modes of speech with ease, the New York poets showed an originality equal to that of the painters who were solidifying New York's claim to have replaced Paris as the capital of Western art.

In the usual way of things, poets compete with poets, painters with painters. But when a poet and a painter collaborate, the game changes. Stimulated by the differences between their mediums, they hope to be surprised and often are. Surprises build on surprises, as the boundaries between sensibilities blur. In this willingness to abandon a measure of hard-won individuality, I glimpse an unusual degree of trust. The collaborations reproduced in this book are alive with generosity and off-the-cuff verve. Yet some have a deliberate, almost ceremonial quality, as if the poets and painters meant them as memorials to a scene that, even as it blazed with fresh energy, could feel itself burning out.

While it lasted, downtown Manhattan's fizzy mix of talent and ambition produced not only single works on paper and canvas but also portfolios and books, films and theatrical productions. Sometimes collaboration stalled and went nowhere. More often it led to unexpected harmonies. Always, the inhabitants of this endlessly improvised environment were exemplary to one another. Across mediums and generations, the poets admired the painters' capacity for large gesture and risk. The painters admired the poets' knack for the subtly modulated insight.

Although de Kooning, Ashbery, and a few others represented here are well-known figures, widely recognized for their achievements in their respective mediums, the manner of their recognition has removed them from the world where they flourished. Giving us for the first time a full picture of the scene these artists and writers shared, this book illuminates the unities and tensions, the playfulness and glamour and startling authenticity of their collaborations. Here we not only see evidence of a modus operandi. We also feel the exuberance of a certain modus vivendi, a way of life I am tempted to call pastoral—not in the traditional style, of course, but in the community it created and in the pleasure it generated with such intensity.

FOREWORD
Bill Berkson

Compare and contrast:

An artist is someone who makes art too. He didn't invent it. How it started—"the hell with it." It is obvious that has no progress. The idea of space is given to him to change if he can. The subject matter in the abstract is space. He fills it with an attitude. The attitude never comes from himself alone.
—Willem de Kooning, "A Desperate View," 1949

As the poem is being written, air comes in, and light, the form is loosened here and there, remarks join the perhaps too consistently felt images. . . . All these things help the poem to mean only what it itself means, become its own poem, so to speak . . .
—Frank O'Hara, "Design Etc.," 1952

Both quotations come from texts prepared, by painter and poet respectively, for group sessions held during the formative years of the Artists' Club, that floating hotbed of avant-gardism where, starting in the late 1940s, adventurous New York painters and sculptors spent long hours arguing among themselves and otherwise listening to poets, critics, philosophers, social theorists, and psychologists air their own views on tangential matters. In terms of poetry, O'Hara advances the technical aspect of what in the previous sentence he called "a clearheaded, poetry-respecting objectivity," which assumes, just as de Kooning does about painting, that a poet is someone who writes poetry, "too." The attitude is that each art stakes out a particular area whose limits, once marked, demand immediate testing.

As I stood on a New York street corner last winter, thinking about the probable contents of Jenni Quilter's book on the interactions of poets and painters in New York, it dawned on me how there are those poets who have been turned around by the explosive changes in visual art since the early twentieth century, and there are those others who haven't caught the drift, whether because of geography or disposition or both. The difference may be that those who have been so affected feel themselves analogously capable as any action painter or installation artist of putting together in their poems whatever diverse materials come their way, without compunction. A poet who has recognized modern art and poetry as ever-expanding fields where there is always more to be done and what is done is often cobbled together in unlikely ways will be inspired to follow suit. Such a poet is inclined to write works of a kind never conceived before—assembling, fitting, or joining, for instance, with the continually fresh insight

that everything one wants in the work will go there: it all fits, or will if one just pays everything the right sort of attention. If surface energy is the one attribute shared across the board in the art and poetry of the New York School, it is probably this ongoing sense of recombinant impulse and reckless assemblage that keeps the surface lively, bubbling, or, as sometimes happens, flailing. Collaborating open-mindedly with whatever materials appear near to hand for one's own poems clears the way for working similarly with others— so that the poem written by two or more poets at a time and/or the poem-painting or comic or "work" with images and words daubed helter-skelter is an available, more sociable next step. Many New York poets show this capability, and the poems they write together, as well as the works they do with painters, show it, too.

An instance that might serve as a parable for the sort of wholesome interdisciplinarity under discussion here is the story Elaine de Kooning liked to tell of her husband Willem de Kooning's visit to Buckminster Fuller's class at Black Mountain College:

One day, [Buckminster Fuller] held up two jagged, irregular lumps of metal. "If these are put together a certain way, they will form a perfect cube," Bucky explained. The two lumps were passed back and forth between the students for an hour and a half with much discussion of how and why they didn't fit. Then Bill wandered into the room. Bucky had a special regard for the intuitive approach of artists. "Let's see what someone from another discipline can do," Bucky said to the class and explained the problem to Bill, handing him the two lumps. Bill hefted them and studied each one separately and then snapped them together, forming the perfect cube on the first try.
—Elaine de Kooning, *The Spirit of Abstract Expressionism: Selected Writings* (New York: George Braziller, 1994), pp. 210–11.

Then, too, a cross-country telephone conversation late one night in the early 1980s with Ted Berrigan produced the following volley:

BB: When Poetry . . .
TB: . . . meets Painting . . .
BB: . . . one begins to wonder . . .
TB and BB (in unison): . . . about Art!
 (Much laughter.)

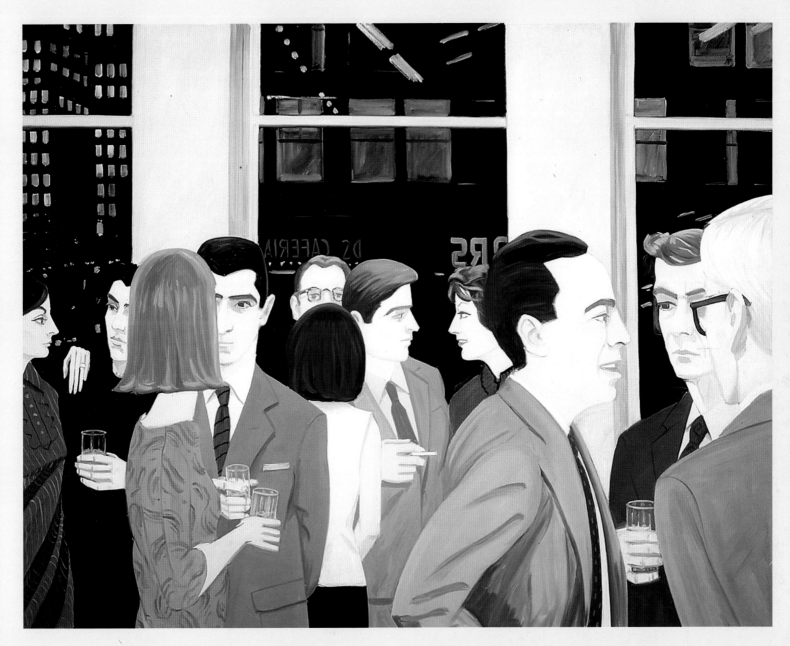

Alex Katz, *The Cocktail Party*, 1965.

Such wonder of the kind Ted and I then had in mind is of course indeterminate, none of the three key terms ever staying still long enough for any definition to stick.

In Kenneth Koch's workshop sessions at the New School for Social Research beginning in the late 1950s, Kenneth was fond of quoting Paul Valéry to the effect that a poem is written by someone other than the poet and addressed to someone other than the reader. Otherness, Kenneth made clear, was not just some Parisian poet's ornamental mystique but a welcome intimation of the impersonality factor that regularly keeps, or should keep, the call letters of creation duly scrambled. Accordingly, it was logical for Kenneth then to suggest that students write poems together. The benefits of mystery and surprise being foremost, it remains to discover what lies in wait out there, in the collaborative crosscurrents—whether it be what William Burroughs called the Third Mind, or "the polyphonic style" John Ashbery observed in some New York poets of his own age and younger, or, as Ron Padgett says a little further along in these pages, "a larger version of [one's] self that might be accessible . . . in the process of writing."

In collaborative works by poets and painters together, does the verbal support the visual, or does the eye go first and most hungrily to the words that are in or of the image? And on which side does the debt weigh heavier: do the painters repay the poets' attentions with rapt musings over the poems in books their images adorn? O'Hara's early poem "Memorial Day 1950" begins, "Picasso made me tough and quick, and the world," but in a letter to a young poet written a dozen years later O'Hara insists on a different sort of primacy, proclaiming poetry as "the highest art, everything else, however gratifying, moving and grand, is less demanding, more indulgent, more casual, more gratuitous, more instantly apprehensible, which I assume is not exactly what we're after." Be that as it may, it is thanks to the examples they set for one another that these poets and painters alike tend to work free of false assumptions. Neither the "finish, platitude, and trivial anecdote" that Thomas Crow sees as traditionally defining academic art nor any other brand of dullness finds credit here.

Of the first- and second-generation New York School artists, Philip Guston, Willem de Kooning, Robert Motherwell, Joan Mitchell, Alex Katz, and Jane Freilicher were known as great, intense readers of contemporary poetry. Jasper Johns's attentiveness to particular poems by Hart Crane, O'Hara, Samuel Beckett, and Ted Berrigan manifests itself explicitly in some of his most poignant works. Of the younger artists associated with the second-generation poets, Joe Brainard is now understood to have been as brilliant and subtle a writer as he was a draftsman, collagist, and painter; Trevor Winkfield is an accomplished art critic, translator, and editor of the legendary literary magazine *Juillard*; and George Schneeman originally aspired to be a writer while studying Ezra Pound and Dante in college. For the rest, just about any artist or writer, if asked, would probably say that music has had the greatest outside influence on his or her work, while also expressing the overriding feeling that analogies between all the arts seem endless, but that art's relevance to other instances of human behavior is crucial. A painter may invite a poet to pose for many reasons, but normally one of them will be that the poet is good company and the conversation, when permitted between brushstrokes, will help the portrait turn out well. That poet in turn is capable of seeing something extra about the likeness, identifying it as a shared vision of a beautiful life.

As for the span of generations involved, for those who are still at it, the differences in birth dates

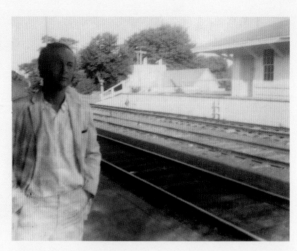

LEFT
Frank O'Hara, LIRR train station, Southampton, New York, 1964.

OPPOSITE
Jane Freilicher, *Parts of a World*, 1987.

have long since ceased to matter. A few years ago, after a reading Amiri Baraka gave in San Francisco, I went backstage to say hello to this man whom, when we first met around 1961, although he was only four years older, I looked up to as an already accomplished poet, editor of *Yugen* and coeditor of *The Floating Bear*. Bringing me into focus some fifty years later, Amiri blurted out, "When I knew you, you were just a kid!" "I know," I blurted back, "isn't it funny? Now we're the same age!" For the poets of my age and inclination who began or came to live as New Yorkers, talk of the New York School was only part of the larger excitement generated by "the New American Poetry" in its various designations, geographical and other. If the terms "Black Mountain," "San Francisco," "New York," "Beat," etc., meant anything it was only that within each could be found the very broadest lineaments of fleetingly collective attitude and certainly nothing that amounted to a shared style. As Harold Rosenberg said of the action painters, "What they think in common is represented only by what they do separately." What was great for those of us who caught the fervor of the poetry—and the arts in general—appearing mostly in subterranean places in the 1950s and early '60s was that each of us could make of it all, as de Kooning would say, "a little culture for [oneself]—like yogurt" without obligation to any master, locale, or group. "The hell with it"—no one knows for certain when poetry or painting began or whether originally both were parts of some elaborate dance event. The bonus in all the hyperactivity that has followed—paintings, poems and their hybrid spin-offs that continue to proliferate as we speak—is the radiance of what Edwin Denby called "a civilized habit," one that has in it, as Edwin also said (about dance), "a bit of insanity . . . that does everybody a great deal of good."

Flying Point Beach, Water Mill, New York, 1959. Apropos of "this leaving out business," Jasper Johns is incorrectly labeled as Robert Fizdale.

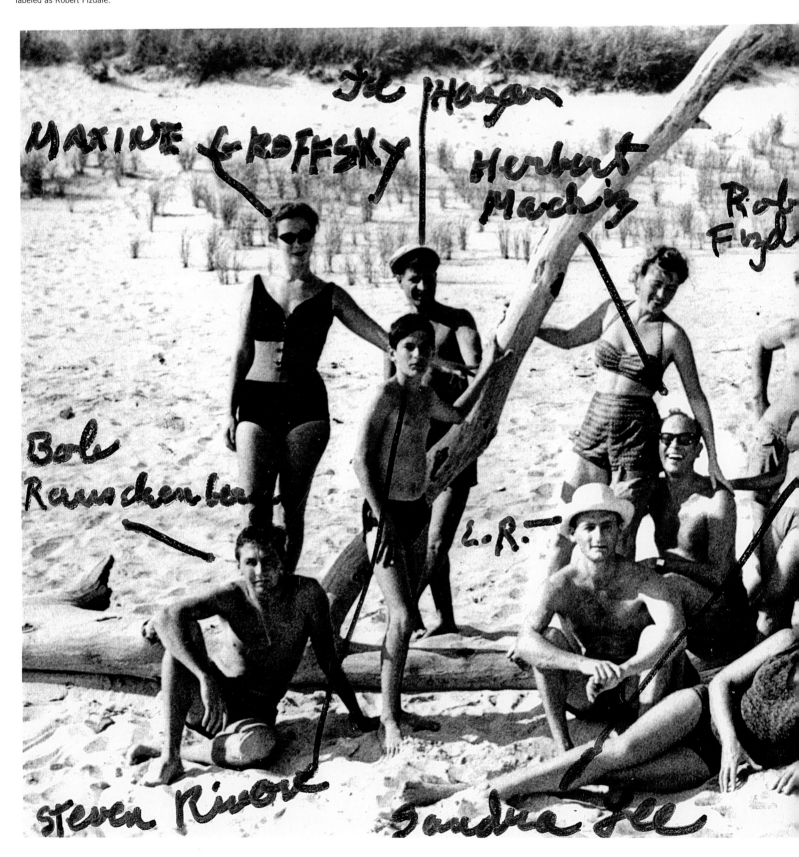

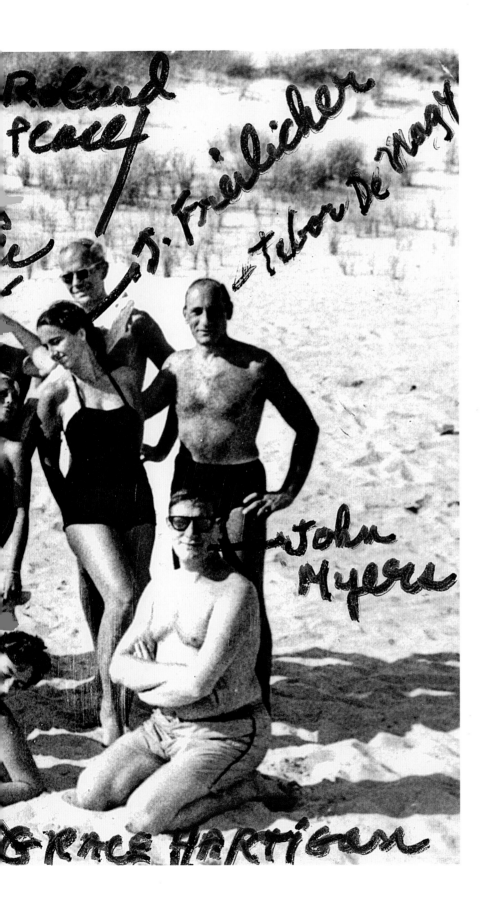

Roland Pease
J. Freilicher
Tibor De Nagy
John Myers
Grace Hartigan

THIS LEAVING OUT BUSINESS

Introduction

Today, the name "New York School" has largely fallen out of circulation. This is for a number of reasons. For one, it's been applied and reapplied throughout the decades to different generations of artists and poets. Originally coined in the late 1940s to refer to a number of visual artists who are now commonly identified as Abstract Expressionists, the name was then extended a decade or so later to include a second generation of younger painters in New York, along with their poet friends. For a time in the late 1950s, it looked like there might be a New York School of photography, and decades later, one of music too—though both these notions ebbed fairly quickly. Today, the context in which the phrase is most well-known today is literary; from the end of the 1960s onward, the phrase was generally used in relation to poetry, and one could be a first-, second-, or arguably a third-generation New York School poet.[1] These days, many younger readers of the New York School poets are only dimly aware that it was once an art term, and it is also possible to imagine that in fifty years' time, the name might have fallen out of use in the poetry world as well. As a name, its forms of approximation has always been provisional. It's not that these poets won't be read or these artists appreciated, but that they may well be encountered in different company.

The name was never particularly popular. Of the sixty or so artists and writers who were supposedly members of the New York School, very few—perhaps two or three—have publicly embraced their "enrollment." At best, it was a convenient way to identify a number of interconnected social circles in the avant-garde art world that were particularly active in the 1950s and '60s. Try to treat the name as anything more than an anticipation of what others might find amusing, and you're likely to end up with a framework far too heavy-handed for the art itself.

But it's also the case that many members of the New York School collaborated with each other,

producing films, dance and music performances, and plays; publishing books; writing together; and creating and curating conjunctions of text and image. The traces of their shared looking are collected here. And common threads do appear. There is a delicacy to their collective skepticism, a kind of tonal wrinkling of the nose that recurs over and over again in letters and emails and the stories people like to tell. You can hear it in Ron Padgett's letter to James Schuyler in 1968. At the time, Padgett and David Shapiro were editing *An Anthology of New York Poets* and were seeking Schuyler's contribution. Padgett wrote:

> *When I described the project as a collection of "New York" poets, I too shuddered. I don't even know what New York is, let alone a New York poet. I guess the nearest thing to a New York poet is García Lorca—he lives just down the hall with Señora Lorca and the 12 little Lorcas. Anyway, I don't even remotely consider myself a New York Anything, I just happen to be here right now. Also, I can't recall having written a single poem that has any connection, other than coincidental, with New York. In fact, I'm getting pretty tired of typing the words "New York." So quell your fears about the anthology's having some grotesque slant . . .*

You can hear Padgett's voice here: his casualness, the directness of his sentences, the flourishing of his verbs ("shudder" and "quell"—how ironic they are). There is an offhand exactness, a willingness for each sentence to contain a minimum of insistence so that when depth comes, it comes swiftly, like a karate chop meant to disarm rather than bruise.

I recognize Padgett's tone, not so much from time I've spent with him but from hours talking with Bill Berkson and Larry Fagin, both New York School poets and both advisory editors for this book. I've passed enough mornings and afternoons and evenings with each man in turn to feel like I'm being ineffective,

if not downright wasteful with their time and mine—but it's this inefficiency, in a way, that has taught me more about the New York School than anything else. Over the years, I've grown better at sensing each man's reaction, their horror at certain phrases of mine and guarded appreciation of others. They are generous with their praise of me as a human being, and picky about my writing. They despair at the current state of the art and poetry worlds. They are relentless, curious, always interested in making distinctions that accumulate rather than simplify. They have a higher standard of exactitude than nearly anyone I know, but their precision is not cautious. I can sense the same blend of caution and delight, the same wry delicacy in other members of the New York School—in Jane Freilicher, Clark Coolidge, John Ashbery, Trevor Winkfield, and Charles North.

Of course, my articulation of this sensibility has something to do with my own reflective surfaces. But it also strikes me that this is nothing new when it comes to the New York School. Its arrangements are strikingly familial. There is a real difference between the anodyne hierarchy of a formal family tree, its blunt lines of marriage and birth, and what a family gathering actually feels like: stories that never became public record, odd distinctions within a generation, unexpected closenesses, and irrational distances. Every family member has his or her own version of events. The same goes for the New York School. What amounts to gossip—who was sleeping together, who had fallen out, whose work was secretly (or not so secretly) disliked, who had settled for an incomprehensible form of domesticity—has indirectly influenced the scale of much of the work collected in this book. And accordingly, there are unexplained emphases, stories that have come to take a disproportionate place over others. The artist Nell Blaine, for instance, was a formidable force in the downtown painting world in the 1940s and '50s, introducing many of the poets and artists included

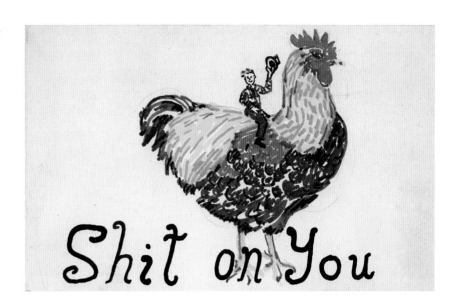

George Schneeman with Ron Padgett,
Shit on You, mid-1970s.

here to each other. Arnold Weinstein called her loft the "Big Bang" of the New York School, "the place where everybody met." But she is barely present in this book. A bout with polio in Greece in 1959 meant that for much of her later life, she was confined to her apartment on the Upper West Side. There is also Kenward Elmslie, whose work as a librettist, poet, and later, as publisher of *Z Magazine* and *Z Press* is extensive, and who collaborated just as much with Joe Brainard as Padgett and Ted Berrigan did. And yet his presence is too slight here, as are Barbara Guest's and Alfred Leslie's. There is no pressing reason why these writers and artists are not emphasized more in the stories that members of the New York School like to tell about each other—only that they aren't. My own writing here cannot help but duplicate, sometimes unknowingly, these strange historical sleights of hand.

I've come to see that a New York School sensibility frequently relies upon a shared sense of discretion—on what Ashbery, in his poem "The Skaters," calls "This leaving out business." On it, he says, "hinges the very importance of what's novel / Or autocratic or dense or silly." This is the case in these artists' and poets' solo work, but it is an especially powerful element in their collaborations. For instance, in conversation with Padgett, George Schneeman observed that most of his collaborations "invent a sort of utopia in the form of a visual field filled with pleasure, quickness, and wit." He continued: "Even the gaps and spaces between the words and images tend to be witty." In much of the work included in this book, it's about that gap, that sense of space. We can see something has been excised, withheld. Often it's indicated by an in-joke or a sotto voce aside. There's a running joke in *The Coronation Murder Mystery* (a play collaboratively written by Frank O'Hara, Kenneth Koch, and Ashbery for Schuyler's birthday in 1956) about a Bessarabian poet (who "paints gravel poems") that the Tibor de Nagy Gallery director John Bernard Myers wants to publish. It's funny because even if no

one knows where Bessarabia is, no one's surprised that this poet has fetched up in New York or that Myers wants to publish him. Bessarabia—its geography, customs, history—might be arcane, but it's dealt with in B-movie detail; esoterica treated as exotica. The comic tension comes from seeing both categories of knowledge at once, in understanding how beautifully useless Bessarabia as a piece of knowledge might actually be. This wit keeps us off-balance. It keeps us doubting. In his 1968 lecture "The Invisible Avant-Garde," Ashbery suggested that an element of doubt was what kept avant-garde art avant-garde: "Most reckless things are beautiful in some way, and recklessness is what makes experimental art beautiful, just as religions are beautiful because of the strong possibility that they are founded on nothing." Much of the art in this book still feels avant-garde, as well as comfortable with its mortality. Exemplary in this regard is *Shit on You*, a collaboration between Padgett and Schneeman, which features a small man riding a rooster (or a normal-size man riding a giant rooster) and the titular phrase printed in neat cursive beneath. Is this a threat or cheerful sally? The piece clearly risks being dismissed as scatological absurdity. And that risk is part of the point. This art keeps the horizon of possibility wide open. It reflects a shared sensibility that is resolutely ephemeral. Artists and writers wrote doggerel together over kitchen tables, made one-of-a-kind books for friends, put plays on during the holidays. These art objects were considered more creative by-product than principal event, a consequence of fun with friends. Frequently, they seem slight, even silly, but that does not mean they lack meaning or force. One of the pleasures in editing this book has been acquainting myself with this kind of responsiveness—quick to understand, to respond, to let things be—which is more rare than it should be today.

I've come to think of collaboration as a burr of sorts (which I frequently imagine as a Trevor Winkfield drawing), snagging and hooking parts of a culture it

never directly fixed upon. I began this book with the notion that collaboration ought to be defined by a material object like a book, painting, or film, and balked at the idea that collaboration could be defined so generally as to become a synonym for influence. And yet it's the case that (especially in the 1960s) collaboration became so much a part of the milieu that to deny its pervasive character—its atmospherics—seems somewhat churlish. I'm still reluctant to let go of my original impulse. I don't want to expand the definition of collaboration to be synonymous with influence or culture or art itself (if art implies connectivity, a transactional impulse). I don't really want to believe that we're collaborating right now, on the page, with me offering up these words and you making of them what you will; it feels like a form of unwarranted inflation. And yet the book clearly implies this. Included here are memoirs, letters, photos, poems, and paintings, many of which are not explicitly collaborative. Perhaps the only way to account for this discrepancy is to point out that for all the talk of a social milieu or scene in the chapters to follow, the force behind much of the work in this book is the result of individual friendships. Frank & Larry. John & Jane. Ron & Joe. These friendships are complicated, and, of course, private. But they have exerted a real influence in terms of an artwork's implied audience—especially when these artists and writers were young, starting out, and mostly writing and painting just for each other. In 1959, O'Hara announced in his mock manifesto "Personism": "The poem is at last between two persons instead of two pages." It's that sense of address—of an epistolary "Dear" other—that might help suggest the lingering particularity of the New York School, its holding together, despite it all.[2]

But the most persistent element in this "leaving out business" is the city—that is, New York itself. Very few of the poets included in this book refer directly to Manhattan. Only a few artists painted it.

Many spent significant amounts of time away from the city, and some settled elsewhere permanently. "I just happen to be here right now," Padgett wrote to Schuyler. Not even live—just "be." And yet Padgett still lives in the East Village today, with his wife, Pat. No matter the difficulty of living here, it is hard to imagine another city where, accidentally falling in step with a stranger on the street, you can be so oblivious to their presence and also willing, in a heartbeat, to respond to their question or ask your own. New York allows anonymity and encourages presence. This place, to steal Edwin Denby's term, offers a "climate" in which to write—and like most atmospheres, we tend to look through it, rather than at it. This climate is quite different than what visitors might imagine. At the edges of the day, when there are fewer people on the street than usual, you can sense a geniality to the city, along with a kind of relaxation. "There is light in there, and mystery and food," Ashbery wrote in his poem "Just Walking Around," and though he was not writing about New York, this phrase often comes to mind when I am just walking around. You can see this in the straightforward photography of Rudy Burckhardt, in his shots down the avenues: one taken in 1948, and another later, in 1970 (the front cover to this volume). You can sense the air—hotter than it should be—and anticipate the strange ease of movement, how possible it is to swiftly slip from view. "People of the world—Relax!" Joe Brainard wrote in 1975. And New York, unexpectedly, allows that to happen, even as one is moving briskly through it.

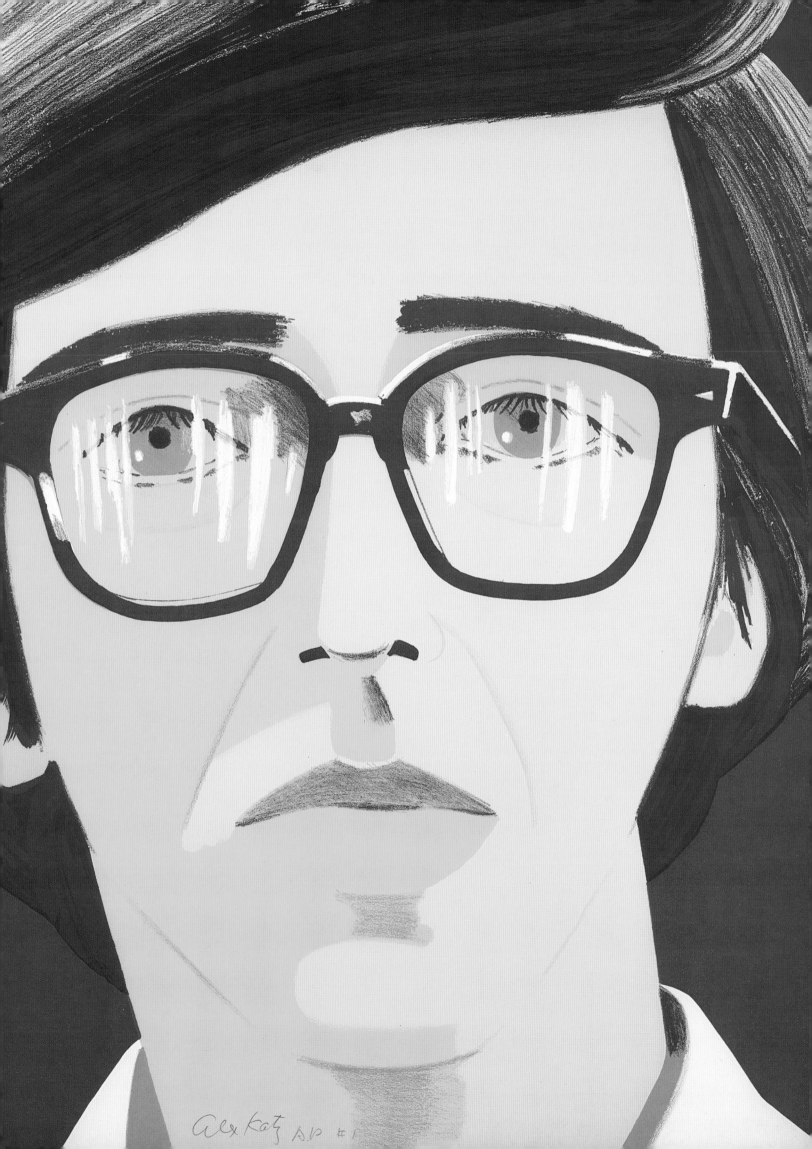

George Schneeman, Ron Padgett, and
Tom Veitch, *Star Gut*, 1968.

CLOCKWISE FROM TOP LEFT
The first Earth Day, Central Park,
New York City, 1970.

Joe Brainard, Anne Waldman, and
Kenward Elmslie, 1969.

Lewis Warsh and Bernadette Mayer,
1976.

Ted Berrigan and Bill Berkson,
at a poker game at George and Katie
Schneeman's apartment, 1967.

Kenward Elmslie, en route to
New England with John Ashbery
(not pictured), 1969.

Peter Schjeldahl and Ron Padgett with
set by Red Grooms, ca. 1967.

Pat Padgett and Joe Brainard, 1969.

FOLLOWING PAGES
Rudy Burckhardt, *A View from Astoria,
Queens*, 1940.

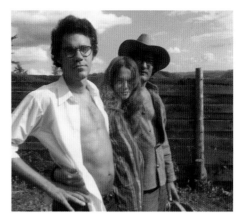

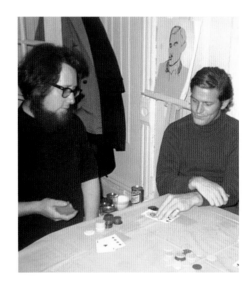

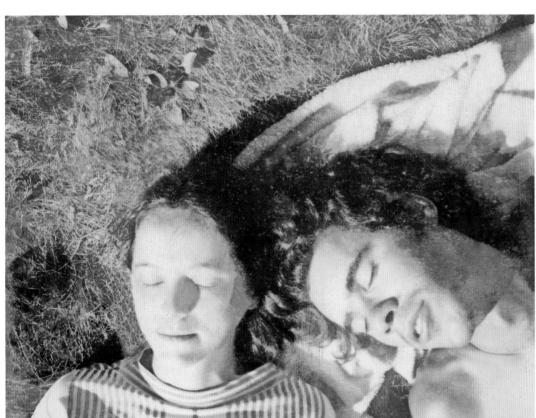

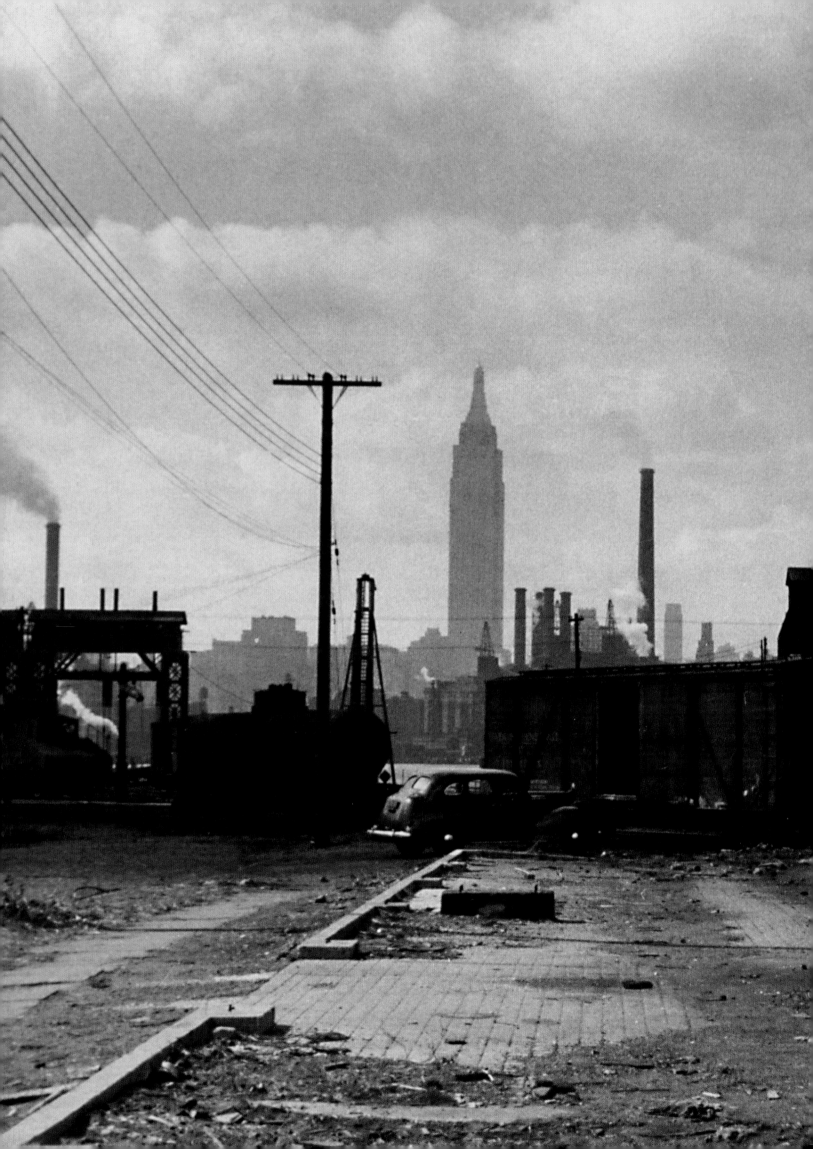

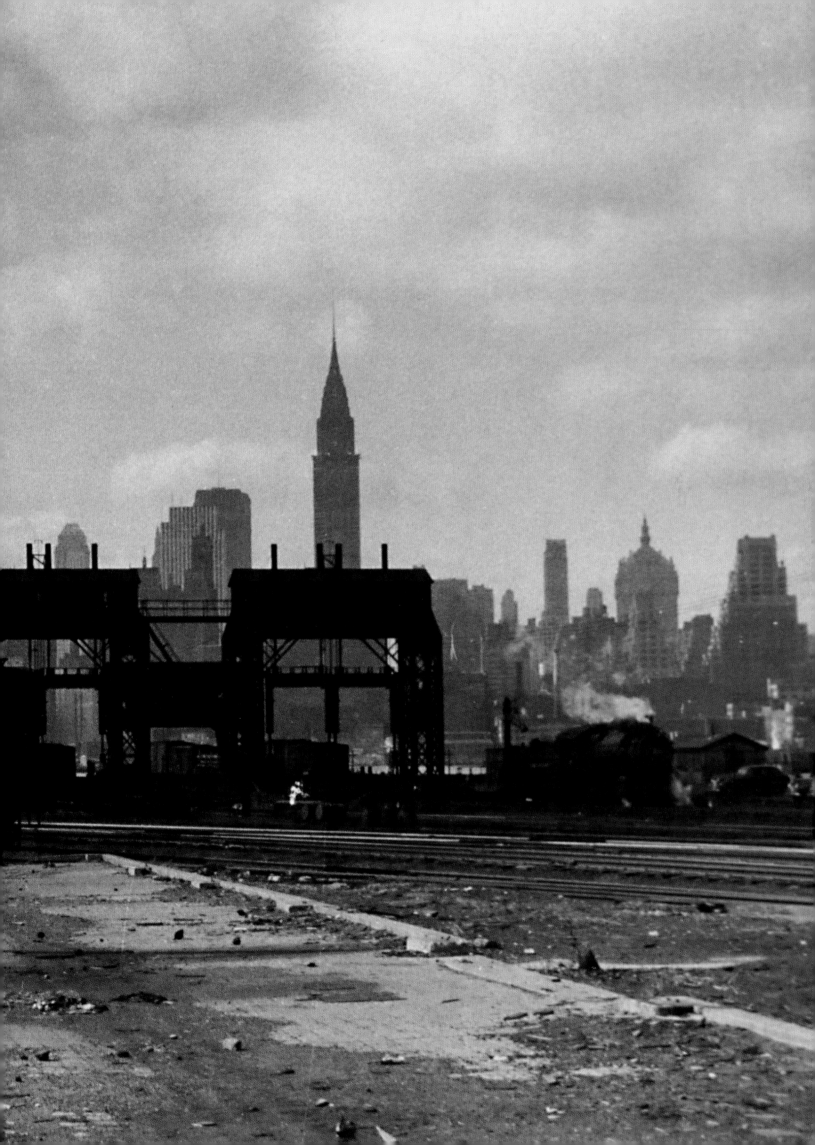

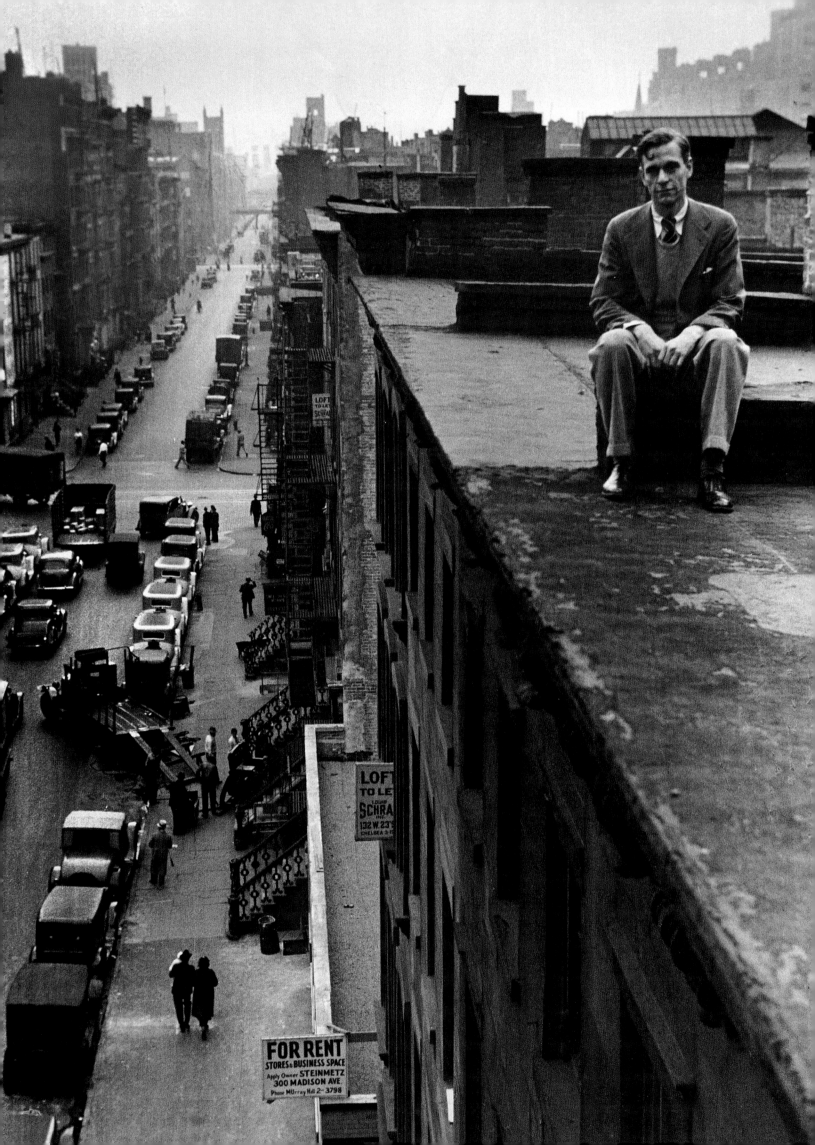

In Public, In Private

1935–1948

PREVIOUS PAGES
Rudy Burckhardt, *Edwin Denby on
21st Street, New York*, 1937.

BELOW
Rudy Burckhardt, *Willem de Kooning,
22nd Street*, 1938.

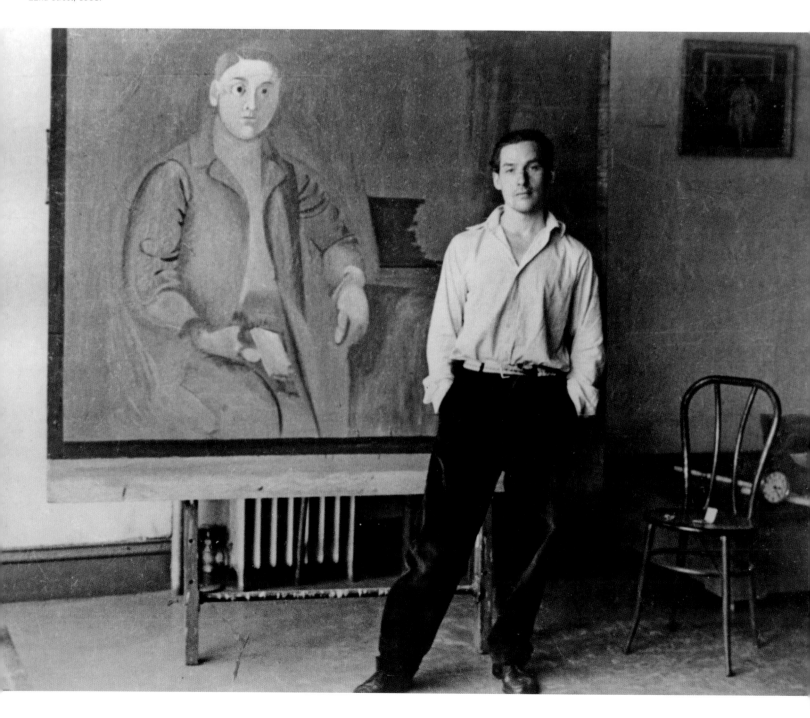

One day in 1935, a black-and-white kitten called Marilee wandered through the window of painter Willem de Kooning's loft and out onto the fire escape, where his neighbors, Rudy Burckhardt and Edwin Denby, discovered her. When de Kooning came looking for the cat, the three men struck up a conversation.

They turned out to have a lot in common. They had all left the old world for the new: Burckhardt and Denby had recently arrived in New York from Europe, and de Kooning had grown up in Holland, immigrating to the United States in 1926. For the better part of a decade, he had worked as a house painter and muralist in New Jersey, but now he was living in Manhattan and already part of the downtown painting scene, close to John Graham and Stuart Davis and inseparable from Arshile Gorky. Denby was born in China; his grandfather was minister to China, and his father a businessman there. He was educated in the United States before moving to Germany in the 1920s, where he worked with figures in the avant-garde including Bertolt Brecht, Lotte Lenya, and Kurt Weill, adapting librettos, writing poetry and stories, choreographing dance, and specializing in *Grotesktanz* ("eccentric dancing"). In 1934, passing through Basel, Switzerland, a friend recommended that Denby look up Burckhardt, a mutual acquaintance who did passport photography. It was a chance encounter that changed both their lives. Burckhardt was twenty years old, a reluctant medical student, and a keen amateur photographer, while Denby, thirty-one years old, was a seasoned dancer who had smoked opium with Jean Cocteau and undergone psychoanalysis. To Burckhardt, Denby "was just what I was waiting for without knowing it." When Denby decided to move to New York in 1935, partly because his satirical dancing was considered politically suspect in Germany, Burckhardt followed him, financed by an inheritance of $20,000. The two of them found a cold-water loft at 145 West 21st Street. Many artists lived close by, including the painter Nell Blaine (who would be an important connection between Denby, Burckhardt, and de Kooning, and younger painters and poets in the 1950s). Fairfield Porter had a studio on the same block.

In New York, Denby continued to work on librettos and theatrical adaptations with people like Orson Welles, Paul Bowles, Aaron Copland, and Virgil Thomson (whom he had met in Europe in 1930). Denby began to write dance reviews for the magazine *Modern Music* in 1936 (and later, when the war broke out, for the *New York Herald Tribune*). He sometimes attended the ballet in these years with Elaine Fried, a young artist and model, who had begun to date de Kooning. Denby encouraged her to write her own reviews. The personal and the professional overlapped

Nell Blaine at her studio on 21st Street, New York City, 1942–43.

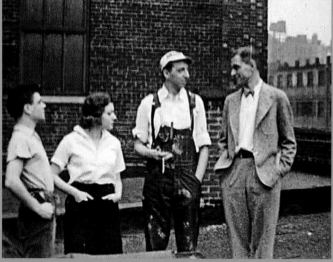

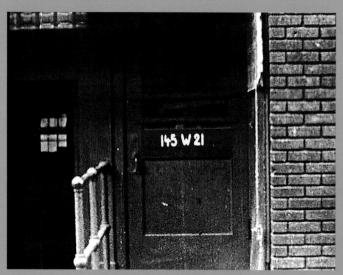

LEFT
Rudy Burckhardt, stills from
145 West 21, 1936.

OPPOSITE
Rudy Burckhardt, self-portrait,
New York City, 1937.

casually. Sometimes there were parties uptown to attend, in "Fifth Avenue millionaires' houses," Burckhardt recalled, where they were "served by butlers who had to show us which glass to use for red wine and which for white. I was Edwin's Little Swiss Friend, and didn't say much, but looked and listened." His self-effacement here is typical.

In his first years in the city, Burckhardt felt overwhelmed by Manhattan's scale, and couldn't photograph it, turning instead to film; his first, *145 West 21* (1936), included cameo appearances by Bowles, Copland, John LaTouche, Thomson, and Denby. (Characteristically enough, the film is a gentle caper: fixing a young couple's skylight, two workmen can't resist stealing four dollars, overlooking the twenty-dollar note kept in exactly the same place. It ends happily enough; the men get a great dinner, and the couple isn't cleaned out.) A year or two later, Burckhardt began to photograph the city, wandering the avenues and parks, focusing on the dancelike movements of pedestrians, the absent-minded looks of people speaking on public telephones, neon signs in Time Square, and distant figures walking among the trees in Central Park at dusk. This kind of looking might be quiet, but it was distinct. It aimed for simplicity. Any drama was unhurried. You can sense these qualities in his well-known photographic portrait of Denby sitting on the rooftop of their building, with his polite expression, and how Burckhardt keeps his distance. Denby described Burckhardt's gaze as an "instantaneous eye. He doesn't . . . exploit the city for places where the situation will be right. If something should happen, that's right by chance."

That phrase "right by chance" is a particularly resonant one for the time. There was a felicity in seemingly random meetings, in the fortuitousness of the city itself, which Cyril Connolly described in *Horizon* magazine in 1947 as "continuously insolent and alive, a place where one can buy a book or meet a friend at any hour of the day or night." Denby and

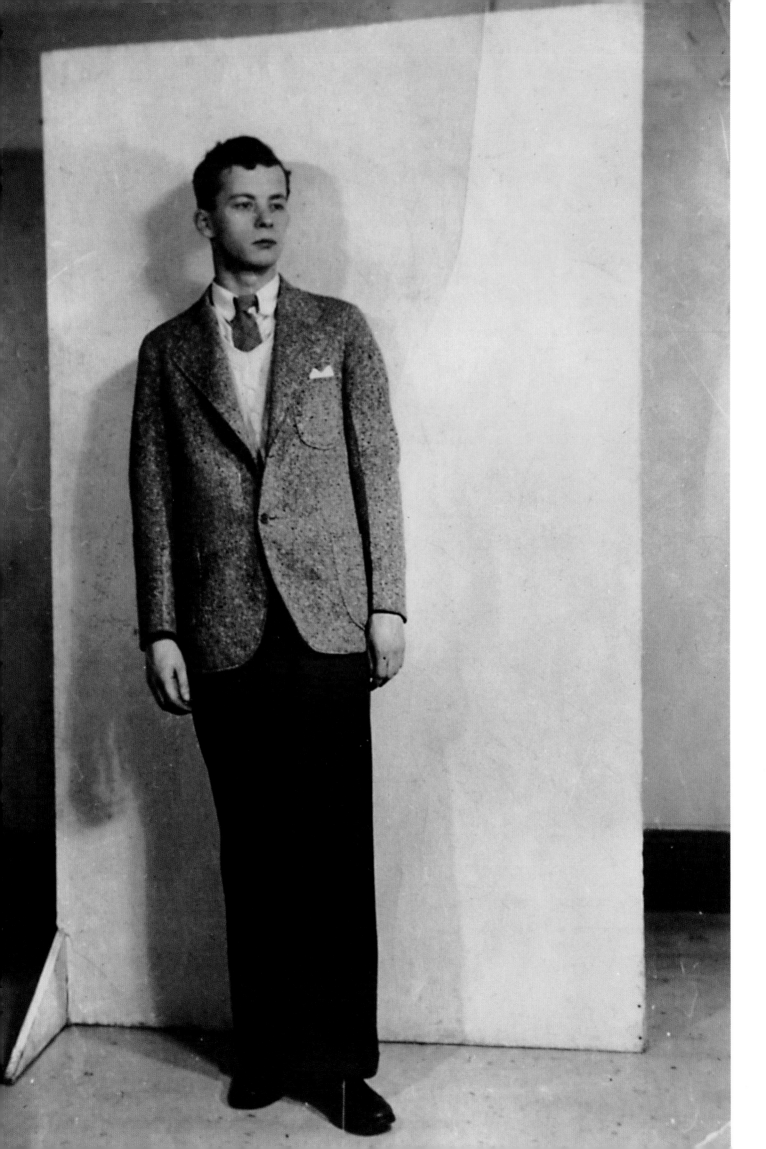

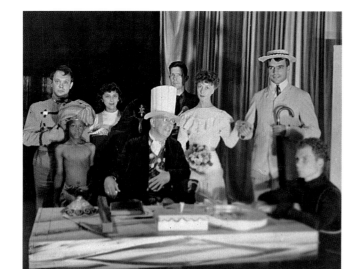

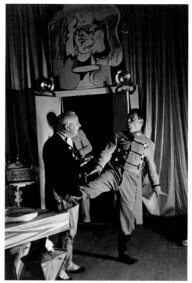

The performance of Eric Satie's *The Ruse of Medusa* at Black Mountain College, 1948. Set designed by Willem de Kooning and Elaine de Kooning. Left to right: Issac Rosenfeld as Polycarp, Alvin Charles Few (little boy) as the page, Buckminster Fuller as Baron Medusa, John Cage, Elaine de Kooning as Frisette, Wiliam Shrauger as Astolfo, and Merce Cunningham as Jonas.

De Kooning's painting of a woman's head is above the door. Buckminster Fuller (left); Merce Cunningham (right).

Horse Eats Hat, by Edwin Denby and Orson Welles, 1948. Adapted from *An Italian Straw Hat*, Eugène Labiche, 1851.

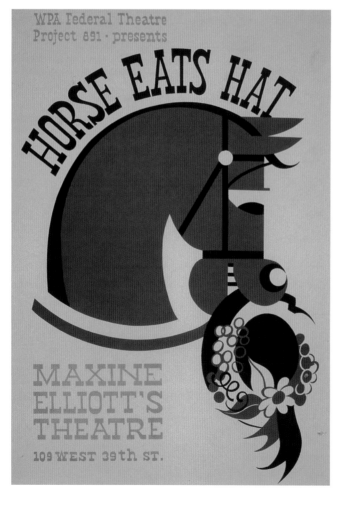

Burckhardt would often wake in the afternoon, and work into the evening, breaking to meet for a late dinner or a performance or a party, sometimes staying up till dawn. No one really had cash, but they helped each other scrape by. As Burckhardt remembered, he and Denby occasionally lent de Kooning money, or bought a painting. For his part, de Kooning worried what would happen to "those kids" when their money ran out. (It took almost a decade for this to happen— and much later, those small de Kooning paintings bought by Burckhardt paid for his "divorce, a house in Maine, and a co-op loft on 29th Street.")

These were the days, Denby wrote, when "everybody drank coffee and nobody had shows." There was an easy willingness to help out. Film, theater, and dance are innately collaborative, and it was entirely unsurprising that one would participate in an art form other than one's own, even if just to ham it up, as Denby did, playing the rear legs of the horse in the play *Horse Eats Hat* (1936), which he co-wrote with Orson Welles, and for which the incidental music by Bowles was orchestrated by Thomson. Social networks in art, dance, theater, writing, and music, each one intricate as a miniature, overlapped in labyrinthine ways. There were concerts to attend by then-obscure composers like John Cage, and dance performances by Merce Cunningham. Decades later, de Kooning commented to an interviewer, "Through them [Denby and Burckhardt] I got interested in things. I didn't work with them but they introduced me to other kinds of life—dancing, theater, and things like that." (It's quite possible that Denby introduced the de Koonings to Cunningham and Cage—and in 1948, the de Koonings would collaborate on a performance of Erik Satie's *The Ruse of the Medusa* with Cage and Cunningham at Black Mountain College.)

These forms of introduction had aesthetic consequences. In the studio, Denby and de Kooning would stand in front of the mirror, equally fascinated by the musculature of the human body. They were

both drawn to shoulders; Denby even wrote a poem called "The Shoulder." At the time, de Kooning was painting the male figure over and over again. It's been said that these portraits depict alienated, Depression-era Everymen, but their posture and musculature are often those of a dancer's, erect and contained; the profile of the painting *Seated Man* (c. 1938), for instance, is clearly Denby's.[1] And just as de Kooning's seated men were strangely resolute, preoccupied with their own thoughts, Burckhardt's photographs of everyday New Yorkers were hardly Depression-era figures. Rather, these people seem quick, determined, preoccupied with getting from *A* to *B*. Burckhardt's photographs were, in Phillip Lopate's words, "more playful and tender, less melodramatic, more true to the spirit of the everyday" than the prevailing trend of socially conscious photojournalism. There is a cheerfulness to them that has never quite dissipated.

"We were happy," Denby later recalled, "to be in a city the beauty of which was unknown, uncozy, and not small scale." Manhattan felt inexhaustibly fascinating. The three men all "talked a great deal" about the "difference of instinctive scale in signs, painted color, clothes, gestures, everyday expressions between Europe and America," exploring the streets together, often at night. Elaine de Kooning (she married Willem in 1943) later remembered their walks as full of quick exchanges: "Bill would constantly be pointing out things he thought were 'terrific': a big gasoline stain on the side walk would be a 'terrific shape,' or a billboard would have 'terrific colors,' or graffiti on a wall would be a 'terrific drawing.' He made the word 'terrific' variable in its meanings, and we all caught the nuances." These nuances could be straight and simple. Denby, in his poem "The Silence at Night," wrote about "The sidewalk cracks, gumspots, the water, the bits of refuse, / They reach out and bloom under arclight, neonlight." Burckhardt photographed very similar stretches of pavement.

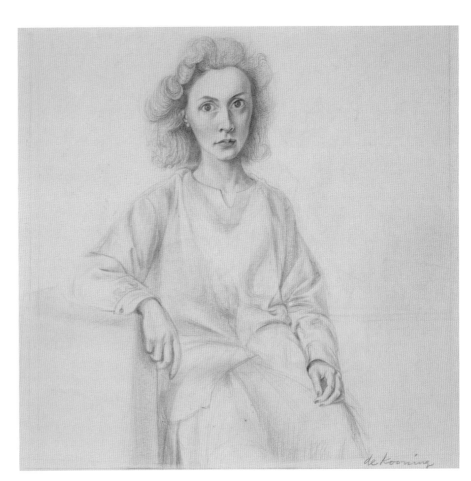

Willem de Kooning, *Portrait of Elaine de Kooning*, 1940–41.

TOP
Willem de Kooning, New York City, 1937.

BOTTOM
Elaine and Willem de Kooning in his studio with a working version of *Seated Man (Clown)*, 1940–41.

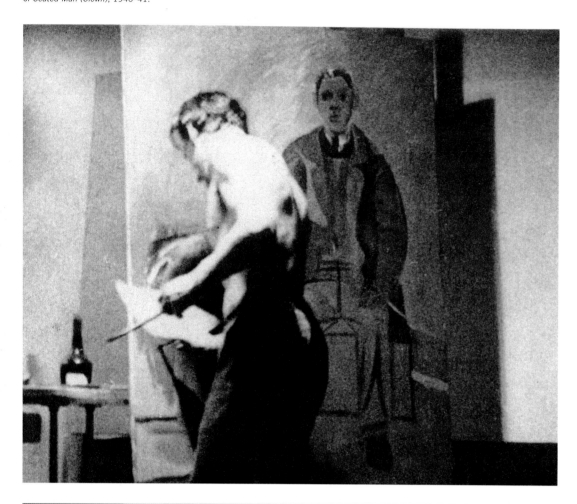

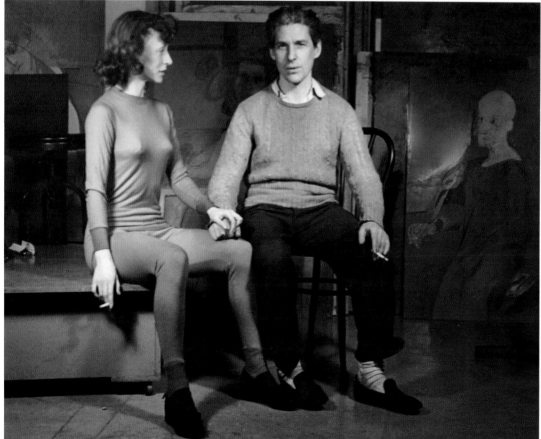

I'm struggling, Bill would say when asked about how his painting was going. He sometimes walked through the city all night. Depressed without a steady girl, he told us how, when you have a girl over, you drink and smoke and talk half the night away and next day, you are confronted with cigarette butts with lipstick on them all over the place, you're hung over and have lost a day for work. It's enough to make you want to be queer, he told Edwin. Two weeks later, he fell wildly in love with Elaine. She didn't treat him too well at first. She would go to bed with him, but he had to take her home to Brooklyn at two or three in the morning, an hour subway ride each way, so after a while, they got married.

—Rudy Burckhardt, from *Mobile Homes*, 1979

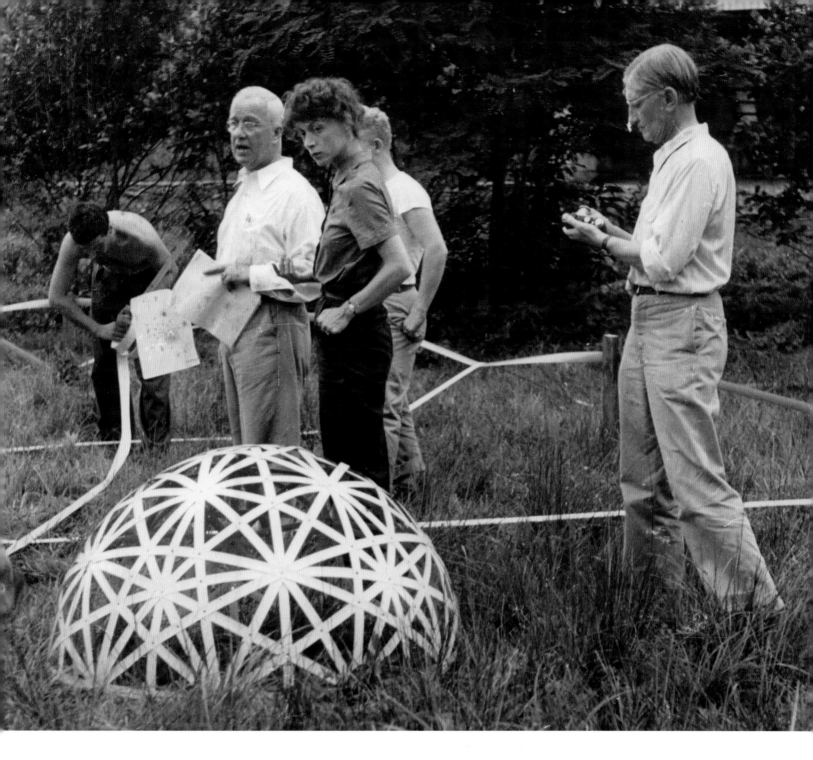

Buckminster Fuller, Elaine de Kooning, and Josef Albers by the Supine Dome during Fuller's class at Black Mountain College, North Carolina, summer 1948.

The Ruse of Medusa, *a light little play by Satie that had been produced only once in Paris, was translated by the poet and ceramist M.C. Richards for John, who wanted it done at Black Mountain with Bucky Fuller playing the part of the Baron Medusa and me as the Baron's daughter . . .*

Since nobody else seemed interested, I designed the sets and costumes—if design *is the word,* allocate *might be a better one. Bill transformed a huge stodgy desk and two nondescript columns into magnificent pink and grey marble with a technique he had learned at a decorator's shop in Holland when he was sixteen years old. The list of props—telephone, candelabrum, feather pen, inkwell, magnifying glass, thermometer, and Bucky's top hat—was turned over to students who were told they had a whole month to come up with things that were suitably oversized and flamboyant. Mary Outten, a pretty girl who was a wizard with a sewing machine, made a marvelous white Victorian dress for me out of gauze we bought in town for sixty cents a yard. And she sewed stripes of grey satin ribbon to Bucky's khaki work pants for a comical effect of elegance.*

John Cage played the Satie score, and Merce created wonderful little entr'acte dances for his role,

a "costly mechanical monkey." Everything went flawlessly the night of the performance. The participants all felt it was a sparkling event and that was that. There were no photographs to speak of and no recordings. The sets and costumes were saved for a while and then vanished. I wore the lovely dress the following year in a movie called The Dogwood Maiden *by Rudy Burckhardt (who also appeared at Black Mountain that summer to show his extraordinary city movies), and then the dress vanished too.*

While I spent too much time in student activities, Bill had also become deeply involved with his students. Too involved, Albers thought. He said to Bill at the end of the summer, "You had ten students. Six of them are leaving the college to go to New York City this September. Do you know anything about it?" "Sure," said Bill. "I told them if they wanted to be artists, they should quit school and come to New York and get a studio and start painting." Albers seemed not to take this amiss. When he was appointed chairman of the art department at Yale two years later, Bill was the first artist he hired to teach there.

—Elaine de Kooning, from "de Kooning Memories," 1983

Willem de Kooning, *Portrait of Rudy Burckhardt*, 1937.

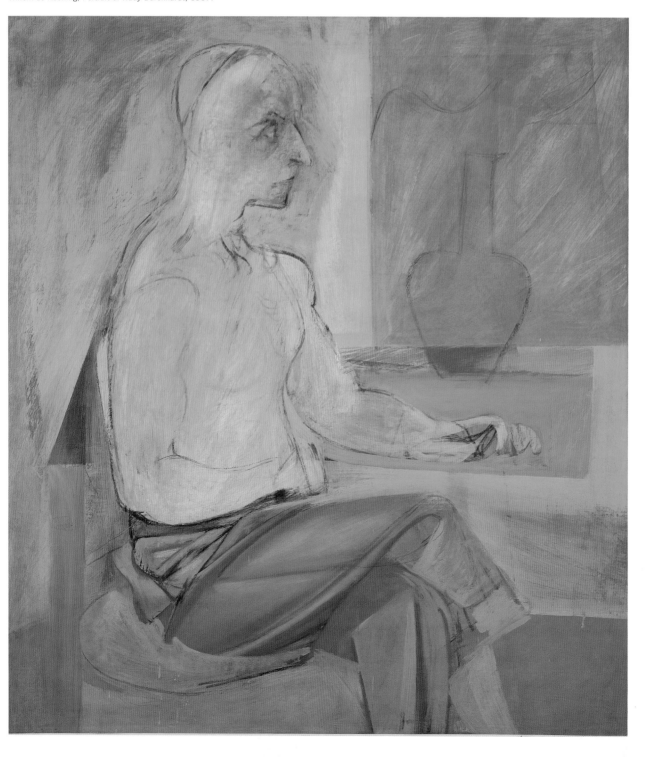

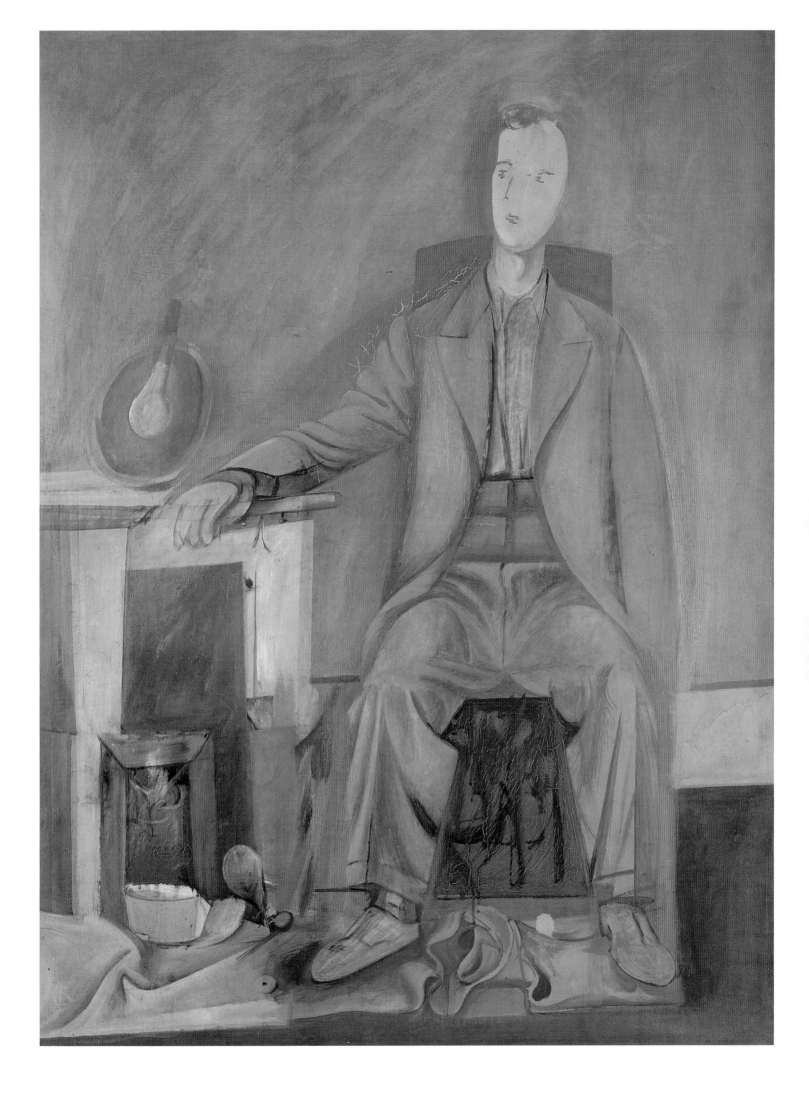

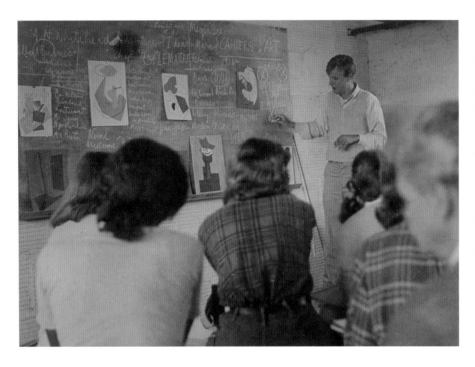

Robert Motherwell teaching at
Black Mountain College, ca. 1945.

In the 1930s, the three men were living in a country in which, a presidential commission report concluded, "the fine arts of painting and sculpture, in their non-commercial, non-industrial forms, do not exist" for the "overwhelming majority" of American people. This state of affairs was changing, but it was changing slowly. There were important initiatives—in particular, the Federal Art Project, which began, in 1935, to provide a living wage to artists. Members of the Works Progress Administration (WPA) would gather together on Friday afternoons to cash their weekly checks and meet at the Artists' Union, and then later move to Stewart's Cafeteria at 23rd Street and Seventh Avenue, often talking until late. (De Kooning was a member from 1935 to 1936, working in part on a mural project at the French Line pier on the Hudson River in collaboration with the French painter Fernand Léger.) The WPA fostered an increasing sense of camaraderie and collective purpose within the art world, particularly when it came to abstraction in art, but in the 1930s, modernism's momentum seemed largely European; the avant-garde in cities like Paris and Berlin seemed that much more established, its faith in experimentation in art, literature, philosophy, music, and psychology a given rather than a matter of constant questioning.

In 1936, *Life* magazine profiled the exhibition *Fantastic Art, Dada and Surrealism*, which had opened at the Museum of Modern Art, printing color reproductions of works by Dalí, Oppenheimer, Magritte, Ernst, and de Chirico. The poet John Ashbery, then a nine-year-old living in Rochester, New York, pored over the magazine, declaring himself "a Surrealist at that moment." He would later distance himself from such a claim—as would others. Nonetheless, the broader point remained; you need not replicate the finer points of Surrealism in order to revel in the sense of *la grande permission*, in a devotion to risk. One could upend the world by recording strange slips of mind and tongue.[2] The outbreak of war necessitated the arrival of key figures in New York from Europe's avant-garde, and

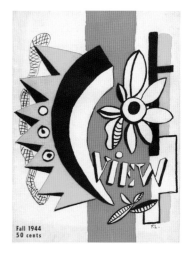

with them came a clearer sense of what a more publicly visible avant-garde might look like. In that political climate, as Denby put it, "the paranoia of surrealism looked parlor-sized or arch," but the Surrealists also brought with them manifestos, magazines, fame, the support of wealthy collectors like Peggy Guggenheim, and very significantly for later members of the New York School, aesthetic (and collaborative) parlor games like *cadavre exquis*. Magazines published in the United States like *View*, *VVV*, and *Tigers Eye* presented a rich mélange of European art and writing. In 1944 John Bernard Myers—who would become the director of the Tibor de Nagy Gallery—moved from Buffalo to New York City to be the managing editor of Charles Henri Ford and Parker Tyler's *View* magazine. As Douglas Crase has pointed out, the contents of *View* in particular offered a veritable reading list for the later New York School, or in Crase's terms, a "mimetic soup" from which its members might "fashion its DNA." One issue, he noted, contained the following: "In addition to Lautréamont, *Hebdomeros* and Duchamp, there were reviews of jazz and John Cage, a poem by Ford about Billie Holiday, an essay on Florine Stettheimer, reproductions of work by de Chirico, Hélion, Léger and Cornell, translations of Henri Michaux and Raymond Roussel."

To the art critic and painter Robert Motherwell, it was clear that American artists, if they were to become more than provincial shadows of their European counterparts, needed to find a "creative principle" they could make their own.[3] He wasn't alone. A lot of the talk in the downtown painting world was a search for some underlying principle, an animating force. From the mid-1940s onwards, several names were floated to account for this sense that there was a group of painters and sculptors working in New York whose work overlapped in significant and new ways: the options included "abstract expressionism," "abstract-symbolist," "intra-subjectivist," "direct art," and "self-evident art." As Jed Perl has pointed out, this

search was conducted with a "a brusque kind of dialectical thinking." Nowhere was this more evident than at the Artists' Club. Begun in 1948 (or 1949, depending on who you talked to), the Club, as it was simply known, was inspired by the social clubs of Greeks and Italians along Eighth Street, and was intended to be a place for artists to gather and discuss art, an alternative to the Waldorf Cafeteria (the successor to Stewart's), whose owners had begun to discourage artists from lingering for hours over a single cup of coffee. Its members set up a weekly schedule of lectures, panel discussions, and parties. The panel discussions were frequently about the relationship between various art forms, between painting and poetry, art and architecture, or the painter as editor. It was generally expected the artists would be well-read in areas other than visual art; whatever principle they might settle upon would likely have implications beyond their own art form. During Friday's panel discussions in particular, the atmosphere was slightly chaotic; as the sculptor Philip Pavia (one of the Club's founders) recalled, "the arguments went in a seesaw pattern; encountering of personalities, feuding of personalities; play down ideas, play up ideas; wronging down the cause and righting up the effect." This passion contained a lot of old-fashioned romanticism. Despite their intellectual iconoclasm, the figure of the artist remained particularly idealized; the artist was the outsider, the visionary, willing to forgo middle-class pleasures.

In 1949 in two lectures, and later in an essay, Motherwell first used the phrase "New York School" (or almost interchangeably, the "School of New York"). As he put it, the school was "a collection of extreme individuals" whose work was "'abstract,' but not necessarily 'nonobjective.'" "The process of painting," he wrote, "is conceived of as an adventure. . . . Fidelity to what occurs between oneself and the canvas, no matter how unexpected, becomes central." Motherwell considered his name for the group to be neutral, the

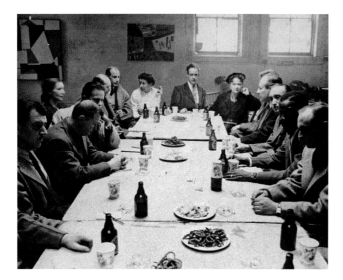 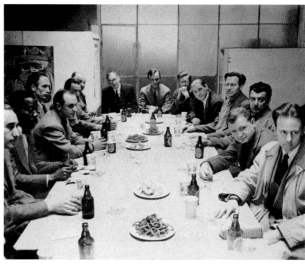

ABOVE LEFT
Artists' sessions at Studio 35, April 1950. Left to right: Seymour Lipton, Norman Lewis, Jimmy Ernst, Peter Grippe, Adolph Gottlieb, Hans Hofmann, Alfred H. Barr, Jr., Robert Motherwell, Richard Lippold, Willem de Kooning, Ibram Lassaw, James Brooks, Ad Reinhardt, and Richard Pousette-Dart.

ABOVE RIGHT
Artists' sessions at Studio 35, April 1950. Left to right: Brooks, Reinhardt, Pousette-Dart, Louise Bourgeois, Herbert Ferber, Bradley Walker Tomlin, Janice Biala, Robert Goodnough, Hedda Sterne, David Hare (partly hidden), Barnett Newman, Lipton, Lewis, and Ernst.

OPPOSITE
Willem de Kooning, *Zurich*, 1947.

least offensive rather than the most suitable; better the city these artists shared with millions than an –*ism*. But "New York School" wasn't a name received with much enthusiasm.[4] Very simply, the artists involved resented being spoken for; Motherwell's attempt to account for the similarities that united them felt like a gross generalization. It was noted (rather darkly) that he was behaving like a critic, rather than a painter.

Motherwell named de Kooning as one of the school's members (along with Jackson Pollock, Mark Rothko, and Hans Hofmann).[5] It wasn't a surprise; de Kooning was very active in the early days of the Club, and took the time to meet and talk with the younger painters. "During the war years," Mark Stevens has noted, "de Kooning became an essential figure in New York's art world, no longer an outsider or dabbler but a kind of founding father for many other artists." He was admired for his "seriousness" of purpose and his determination to work slowly, to endlessly revise; Denby recalled that de Kooning would look at a picture "sharply, like a choreographer at a talented dancer, and say bitterly, 'Too easy.'" His work ethic became a touchstone.

It is easy to overlook the scale of an observation like this. Burckhardt and Denby had lived in the city for thirteen years before de Kooning's first solo exhibition in 1948. De Kooning, at that point, was forty-seven years old, had lived below or barely above the poverty line for decades—as had many downtown painters—and any sense of financial success was still in the distance. But his show at the Charles Egan Gallery was a success, not because of sales, but because virtually everyone in Manhattan's avant-garde saw it and recognized the audacity and quality of paintings like *Zurich* (1947). In these black-and-white enamel paintings, you could sense the city itself, how it was growing up "wildly" (to use Burckhardt's word). De Kooning's sense of dynamism matched the city's casual contrasts and incidental movements—as Cyril Connolly put it, "the reelings-home down the black

steam-splitting canyons, the Christmas trees lit up beside the liquorice ribbons of cars on Park Avenue." The shapes in *Dark Pond* (1948) echoed the bulky outlines of shop signs, also photographed by Burckhardt, their curves resembling but never quite resolving themselves into letters of the alphabet. Both Burckhardt and de Kooning were fascinated by the twitching neon of the city at dusk.

Asked by Alfred H. Barr, Jr., what they should name themselves at a round-table discussion in 1950, de Kooning replied, "It is disastrous to name ourselves." He, along with others, distrusted any view of the world that had, in Denby's words, a "single center of action." He was all for camaraderie and an active life of the mind, but he also saw how Motherwell's "creative principle" might promote a certain rigidity of thinking. De Kooning once complained to Burckhardt about dogmatism in the Federal Art Project, saying (in his thick Dutch accent), "Vell, these people. They like a cup of coffee in the morning. So they say, 'The people want coffee in the morning.'" De Kooning admired the descriptive, but not the prescriptive; everybody might drink coffee, but nobody *should*. Denby was also not interested in defining the moment as a series of strategies. In his essay "The Thirties" (written in 1957), Denby noted the "cliché about downtown painting in the Depression—the accepted idea that everybody had doubts and imitated Picasso and talked politics." But he politely declined to offer another cliché in its place. Rather, he described the climate of those days in beautifully pellucid sentences that read like lines of poetry: "Later, I saw in some Greek temples contradictory forces operating publicly at full speed." Denby's sense of restraint signaled a question about what needed to be clarified. What contradictory forces? And how are they public?

For many of the poets and artists who came to be associated with the New York School later on, there was a horror of the gauche statement, the necessity to explain a joke or a thought that one simply

The Silence at Night
(The designs on the sidewalk Bill pointed out)
Edwin Denby, 1948

The sidewalk cracks, gumspots, the water, the bits of refuse,
They reach out and bloom under arclight, neonlight —
Luck has uncovered this bloom as a by-produce
Having flowered too out behind the frightful stars of night.
And these cerise and lilac strewn fancies, open to bums
Who lie poisoned in vast delivery portals,
These pictures, sat on by the cats that watch the slums,
Are a bouquet luck has dropped here suitable to mortals.
So honey, it's lucky how we keep throwing away
Honey, it's lucky how it's no use anyway
Oh honey, it's lucky no one knows the way
Listen chum, if there's that much luck then it don't pay.
The echoes of a voice in the dark of a street
Roar when the pumping heart, bop, stops for a beat.

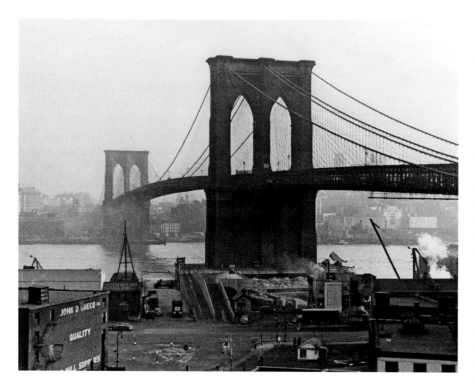

Photograph by Rudy Burckhardt from
In Public, In Private, by Edwin Denby,
1948.

accompanied by the resonant perceptions of his friends; yet as Padgett later noted, "the scant critical response ranged from lukewarm to mixed to thoroughly negative." Denby's poetry was not "aggressively modernist or 'experimental.'" The difficulty of it, Padgett suggested, lay in its "shifting tones," and these tones were easily overlooked by people with history on their minds. Denby's sensibility, like Burckhardt's, was a quiet one, preoccupied with what he saw rather than who was seeing him. De Kooning's work, in contrast, anticipated a viewer's gaze, called for his or her attention. It's a distinction that may seem slight, but it is significant. Burckhardt's photos and Denby's poems often seem mild next to the strong contrasts in de Kooning's paintings and his emphatic brushwork. They knew your gaze would skip on, and they were fine about it.

In the coming years, as New York became the center of the art world and de Kooning became one of the most famous American painters of the twentieth century, Denby's and Burckhardt's work did not travel easily beyond their circles of friendship and acquaintance. Denby was known mostly for his dance criticism rather than his poetry, and Burckhardt, as Ashbery noted in the 1980s, was "unsung for so long that he is practically a subterranean monument." The three men's friendship would become a footnote in most monographs about de Kooning. In the long run too, the name for Motherwell's "creative principle" that won out, which was used to account for an abstract painterly fidelity to process, was Abstract Expressionism. Regardless of whether it was a more suitable phrase than "New York School," it made its way into overseas catalogs and newspapers, into feature articles in *Life* magazine and educational curricula.

Of course, names fall in and out of favor, and artists' careers rise and fall. (There is also some romanticism to being a "subterranean monument.")

ought to get. When it came to writing about art, there was a certain exhilaration to be had from considering the careful tension between what could be said and what couldn't, by calculating a golden mean of indeterminacy that fluctuated year by year, exhibition by exhibition. This exhilaration was a private affair, and like a particular sound frequency, it did not register well with those who had an ear for posterity, or for those who were only interested in the margins insofar as they suggested a center.

The same year that de Kooning exhibited at the Egan Gallery, Denby published his first collection of poetry, *In Public, In Private* (1948). The book included a frontispiece by de Kooning, and photographs by Burckhardt were interspersed throughout. It was an elegant summation of Denby's art to date,

Frontispiece by Willem de Kooning
for *In Public, In Private*, by Edwin
Denby, 1948.

But what is clear in hindsight is that "New York School" implied something that "Abstract Expressionism" did not, no matter Motherwell's own description—at least, if we think about what de Kooning, Denby, and Burckhardt's friendship became to others, how it conveyed a shared sense of discretion. There is a great deal of implication in the title *In Public, In Private*. Denby saw the slow press of history and what it might do to one's art. It's well established that what one names as private can, in turn, invite a public; a sense of exclusivity has long been vital to the avant-garde. Yet part of the negotiation of any artist is in fighting for some part of his or her work to remain private; the generative power of a creative impulse can easily be overexposed. The trick was preserving the neat equality of that comma in Denby's title—*In Public, In Private*—even when in public. As Denby suggested in the last sentence of his essay "The Thirties," "private life goes on regardless." The quieter, more modest components of an avant-garde, which were just as important as manifestos, statements, and exhibitions—namely, casual sociabilities with one's art, the intermingling of aesthetic sensibility, the landmarks in a friendship rather than a career—these were the important things to people who would later love Denby's and Burckhardt's work, and who were willing to understand de Kooning's painting in terms other than the heroics of the canvas and his brushwork, who would read and reread his deceptively quiet and simple statements about painting and art. To the younger poets and artists moving to Manhattan in the late 1940s, who had heard about the Club, who understood that, for the first time, there was an American avant-garde tradition to inherit or repudiate, the sideways grace that Burckhardt, de Kooning, and Denby often showed in their work and living, was, to them, something quite special.[6]

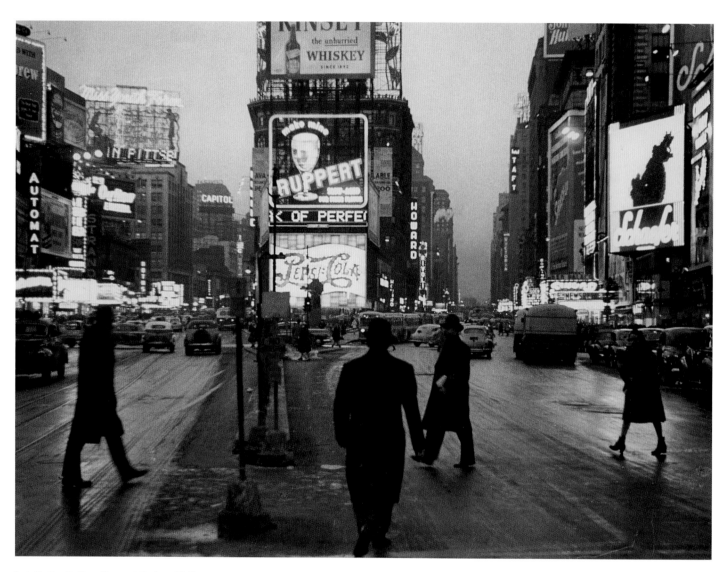

Rudy Burkhardt, *Times Square at Dusk*, ca. 1947.

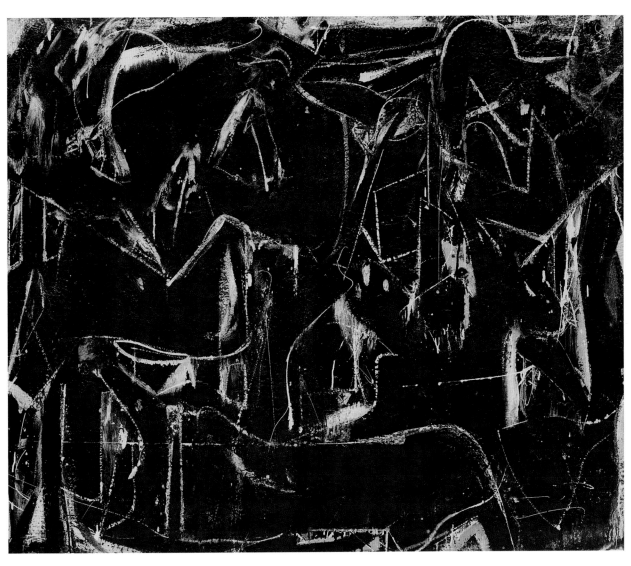

Willem de Kooning, *Dark Pond*, 1948.

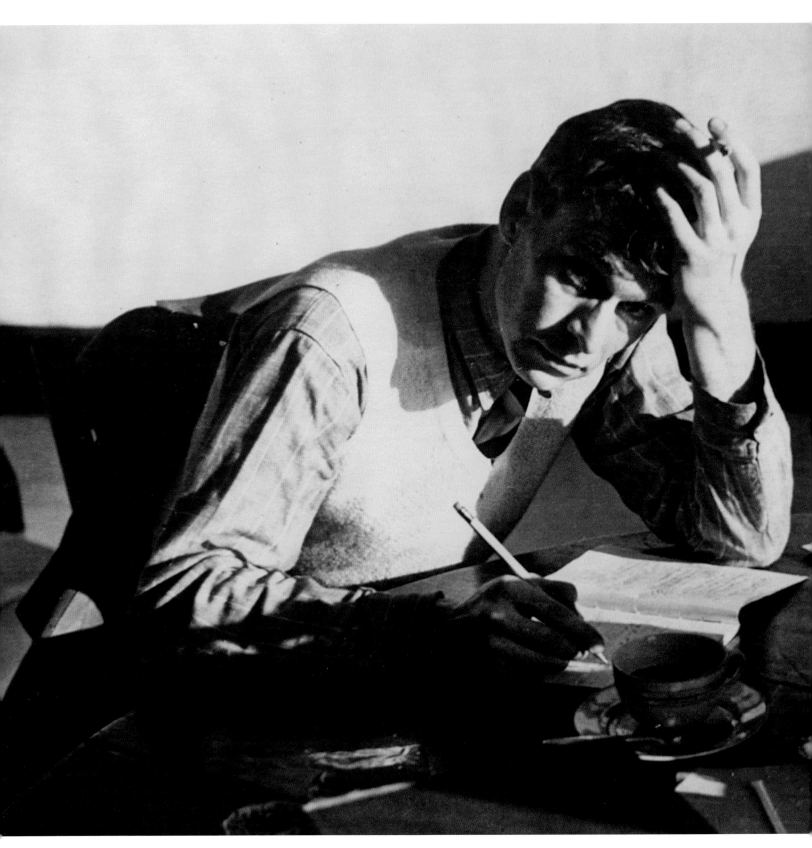

Rudy Burckhardt, *Edwin Denby*, 1937.

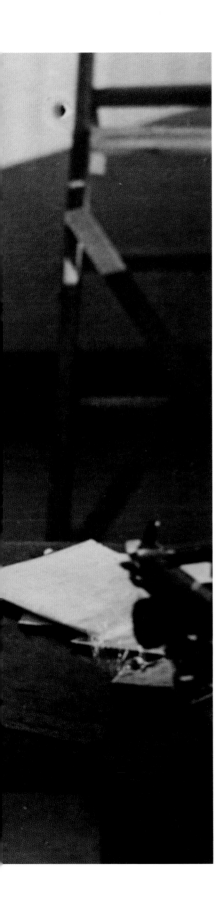

THE THIRTIES

Edwin Denby
From *The '30s: Painting in New York*, 1957

Pat Pasloff asked me to write something for the show about
New York painting in the thirties, how it seemed at the time.
The part I knew, I saw as a neighbor. I met Willem de Kooning
on the fire escape, because a black kitten lost in the rain
cried at my fire door, and after the rain it turned out
to be his kitten. He was painting on a dark eight-foot high
picture that had sweeps of black across it and a big look.
That was early in '36. Soon Rudy Burckhardt and I kept
meeting Bill at midnight at the local Stewart's, and having a
coffee together. Friends of his often showed up, and when
the cafeteria closed we would go to Bill's loft in the next
street and talk some more and make coffee. I remember people
talking intently and listening intently and then everybody
burst out laughing and started off intent on another tack.
Seeing the pictures more or less every day, they slowly became
beautiful, and then they stayed beautiful. I didn't think of
them as painting of the New York School, I thought of them as
Bill's pictures.
 These early ones are easy to get into now from the
later point of view of the New York School. At the time, from
the point of view of the School of Paris, they were impenetra-
ble. The resemblances to Picasso and Miro were misleading,
because where they led one to expect seduction and climax,
one saw instead a vibration. To start from Mondrian might
have helped. One could not get into the picture by way of
any detail, one had to get into it all at once, so to speak.
It often took me several months to be able to.
 I remember walking at night in Chelsea with Bill during
the depression, and his pointing out to me on the pavement
the dispersed compositions—spots and cracks and bits of
wrappers and reflections of neon light—neon signs were few
then—and I remember the scale in the compositions was too

CONTINUED

big for me to see it. Luckily I could imagine it. At the
time Rudy Burckhardt was taking photographs of New York that
keep open the moment its transient buildings spread their un-
known and unequalled harmonies of scale. I could watch that
scale like a magnanimous motion on these undistorted photo-
graphs; but in everyday looking about, it kept spreading beyond
the field of sight. At the time we all talked a great deal
about scale in New York, and about the difference of instinc-
tive scale in signs, painted color, clothes, gestures, everyday
expressions between Europe and America. We were
happy to be in a city the beauty of which was unknown, uncozy,
and not small-scale.

 While we were talking twenty years ago, I remembered
someone saying, "Bill, you haven't said a word for half an
hour." "Yes," he answered, his voice rising like a New Yorker's
to falsetto with surprise, "I was just noticing that, too."
He was likely to join in the talk by vehemently embracing a
suggestion or vehemently rejecting it. Right off he imagined
what it would be like to act on it and go on acting on it.
He didn't, like a wit, imitate the appearance of acting on it;
he committed himself full force to what he was imagining.
As he went on, characteristic situations in his life or those
of friends came back to him as vividly as if they had just
happened. He invented others. Objections he accepted, or cir-
cumvented, or shouted his opposition to. He kept heading for
the image in which a spontaneous action had the force of the
general ideas involved. And there he found the energy of con-
tradictory actions. The laugh wasn't ridiculousness, but the
fun of being committed to the contrary. He was just as inter-
ested in the contrary energy. Self protection bored him. In the
talk then about painting, no doctrine of style was settled at
Bill's. He belligerently brought out the mysterious paradoxes
left over. In any style he kept watching the action of the
visual paradoxes of painting—the opposition of interchangeable
centers, or a volume continued as a space, a value balancing a
color. He seemed to consider in them a craft by which the pic-
ture seen as an image unpredictably came loose, moved forward,
and spread. On the other hand, his working idea at the time
was to master the plainest problems of painting. I often heard
him say that he was beating his brains out about connecting a
figure and a background. The basic connection he meant seemed
to me a motion from inside them that they interchanged and
that continued throughout. He insisted on it during those
years stroke by stroke and gained a virtuoso's eye and hand.
But he wanted everything in the picture out of equilibrium
except spontaneously all of it. That to him was one objective
professional standard. That was form the way the standard
masterpieces had form—a miraculous force and weight
of presence moving from all over the canvas at once.

 Later, I saw in some Greek temples contradictory forces
operating publicly at full speed. Reading the *Iliad*, the poem at
the height of reason presented the irrational and subjective,
self-contradictory sweep of action under inspiration. I had
missed the point in the talks on 22nd Street. The question Bill
was keeping open with an enduring impatience had been that
of professional responsibility toward the force of inspiration.

That force or scale is there every day here where everybody is. Whose responsibility is it, if not your own? What he said, was "All an artist has left to work with is his self-consciousness."

From such a point of view the Marxist talk of the thirties was one-track. The generous feeling in it was stopped by a rigid perspective, a single center of action, and by jokes with only one side to them. If one overlooked that, what was interesting was the peremptoriness and paranoia of Marxism as a ferment or method of rhetoric. But artists who looked at painting were used to a brilliance in such a method on the part of the Paris surrealists and to a surrealist humor that the political talk did not have. Politically everybody downtown was anti-fascist, and the talk went on peacefully. Then when friends who had fought in Spain returned, their silence made an impression so direct that the subject was dropped. Against everybody's intention it had become shameless.

In the presence of New York at the end of the thirties, the paranoia of surrealism looked parlor-sized or arch. But during the war Bill told me he had been walking uptown one afternoon and at the corner of 53rd and Seventh he had noticed a man across the street who was making peculiar gestures in front of his face. It was Breton and he was fighting off a butterfly. A butterfly had attacked the Parisian poet in the middle of New York. So hospitable nature is to a man of genius.

Talking to Bill and to Rudy for many years, I found I did not see with a painter's eye. For me the after-image (as Elaine de Kooning has called it) became one of the ways people behave together, that is, a moral image. The beauty Bill's depression pictures have kept reminds me of the beauty that instinctive behavior in a complex situation can have—mutual actions one has noticed that do not make one ashamed of one's self, or others, or of one's surroundings either. I am assuming that one knows what it is to be ashamed. The joke of art in this sense is a magnanimity more steady than one notices in everyday life, and no better justified. Bill's early pictures resemble the later ones in that the expression of character the picture has seems to me of the same kind in early and later ones, though the scope of it and the performance in the later ones becomes prodigious.

The general look of painting today strikes me as seductive. It makes the miles of New York galleries as luxurious to wander through as a slave market. Room after room, native or imported, the young prosperity pictures lift their intelligent eyes to the buyer and tempt him with an independent personality. The honest critics, as they pass close to a particularly lush one, give it a tweak in the soft spots. The picture pinches them in return. At the end of a day's work, a critic's after-images are black-and-blue. It takes more character to be serious now.

Twenty years ago Bill's great friend was Gorky. I knew they talked together about painting more than anyone else. But when other people were at Bill's, Gorky said so little that he was often forgotten. At one party the talk turned to the condition of the painter in America, the bitterness and unfairness of his poverty and disregard. People had a great deal to say on

CONTINUED

the subject, and they said it, but the talk ended in a gloomy silence. In the pause, Gorky's deep voice came from under a table. "Nineteen miserable years have I lived in America." Everybody burst out laughing. There was no whine left. Gorky had not spoken of justice, but of fate, and everybody laughed open hearted.

At a WPA art occasion, I heard that LaGuardia had made a liberal speech about art and society. After the applause, Gorky who was on the reception committee stepped forward unexpectedly and began. "Your Honor, you know about government, and I know about art." Short LaGuardia looked at tall Gorky, who was earnestly contradicting him in a few sentences. I imagine he saw Gorky's seedy sport-clothes and the exhilarating nobility of his point of view and valued them. Maybe he felt like laughing happily the way we did. The last time I saw Gorky, not long after the war, he was sitting with Bill and Elaine in the diner that used to be at Sixth Avenue across from 8th Street, and I went in and joined them for a coffee. I told them I had just read in a paper that when the war was over there were 175 million more people in the world than before it began. He looked at me with those magnificent eyes of his and said quietly, "That is the most terrible thing I have heard." The beauty of Gorky's painting I understood only last year.

I began this train of thought wondering at the cliché about downtown painting in the depression—the accepted idea that everybody had doubts and imitated Picasso and talked politics. None of these features seemed to me remarkable at the time, and they don't now. Downtown everybody loved Picasso then, and why not. But what they painted made no sense as an imitation of him. For myself, something in his steady wide light reminded me then of the light in the streets and lofts we lived in. At that time Tchelitchev was the uptown master, and he had a flickering light. The current painters seem for their part to tend toward a flickering light. The difference strikes me between downtown then and now is that then everybody drank coffee and nobody had shows. Private life goes on regardless.

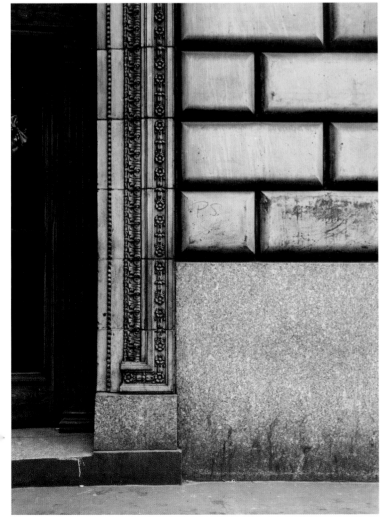

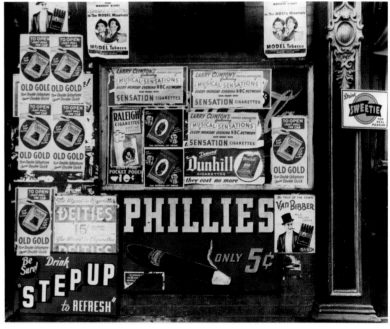

CLOCKWISE FROM TOP
Rudy Burckhardt, *Circles, New York*, 1934.

Rudy Burckhardt, *Smoke More, New York*, 1939.

Rudy Burckhardt, *No Encroachment, New York*, 1938/39.

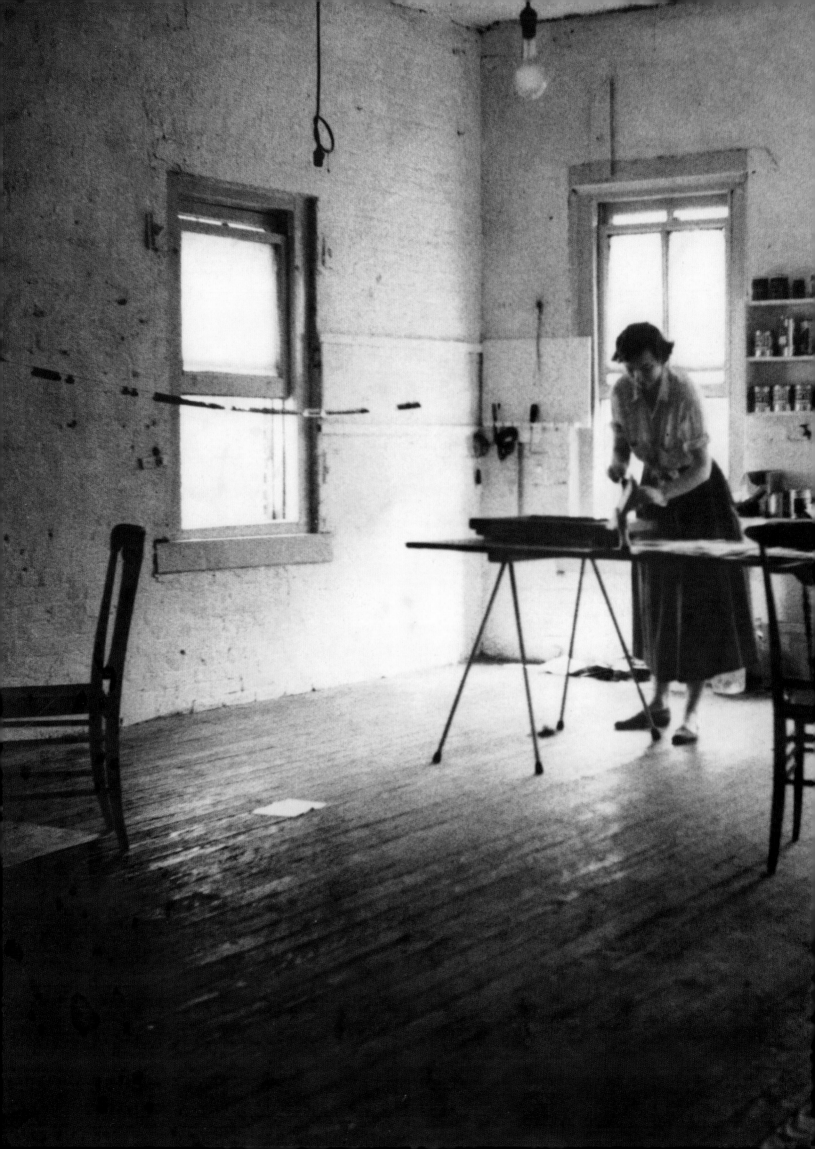

Modernism in the Lyrical Laconic

1948–1955

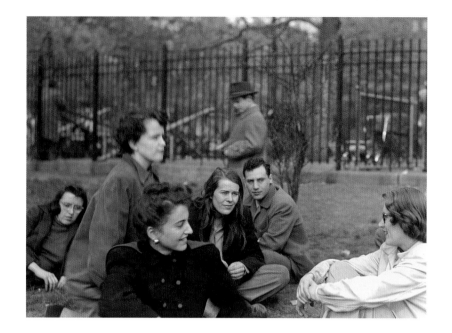

PREVIOUS PAGES
Grace Hartigan working on silk-screen prints for *Folder 1*, 1953. These were Hartigan's first prints of this type. Founded by Daisy Aldan, *Folder* was designed as a series of loose-leaf pages and prints and placed together in a folder (hence the magazine's name).

RIGHT
Jane Freilicher (foreground left), Nell Blaine (foreground right), Al Kresch (back center), and others, Washington Square Park, 1948–49.

BELOW
Left to right: Kenneth Koch, Larry Rivers, John Ashbery, Jane Freilicher, person unknown, and Nell Blaine. East Hampton, New York, 1951.

Rudy Burckhardt, *Hans Hofmann*, New York, 1948.

In 1948, the same year that Denby's *In Public, In Private* was published and de Kooning had his first solo exhibition, a young poet named Kenneth Koch graduated from Harvard University and moved to New York, taking an apartment on Third Avenue at 16th Street. By chance, his upstairs neighbor was the painter Jane Freilicher, who had grown up in Brooklyn, married young (to a jazz musician called Jack Freilicher), and who, at the time, was teaching art to middle school students to make ends meet. She was exceedingly quick-witted. "Jane is filled with excitement and one hundred percent ironic," Koch wrote in his poem "A Time Zone," almost fifty years later: "The conversation is joy is speed is infinite gin and tonic / It is modernism in the lyrical laconic."

Downtown was newly awash with younger artists and writers who passionately wanted to talk it all out. Freilicher introduced Koch to a circle of young painters, including Nell Blaine, Grace Hartigan, Alfred Leslie, and the irrepressible Larry Rivers, who was a "sometimes visitor" (in Koch's words) to her apartment. Rivers had grown up in the Bronx, but had been drifting steadily southward, away from his own early marriage (to Augusta Berger), working as a jazz saxophonist in the evenings and painting during the day. (He first picked up a pencil, watching Freilicher at work in Maine one summer in 1945.) Both he and Freilicher, along with many others, had studied or were studying under the German émigré painter Hans Hofmann; his influence as a teacher was such that one moved to Manhattan to enroll in his school, Blaine recalled, "as a pilgrim comes to Mecca."[1] The influence of Blaine herself was not inconsiderable; slightly older than the others, she was, to Freilicher, "our Joan of Arc," willing, as Rivers said, to tell "us what Art was all about, impressionist art and expressionist art and Giotto art." Her loft, across the street from de Kooning, Burckhardt, and Denby's building, was the location of many parties. The artist

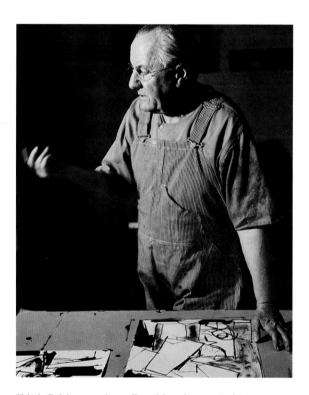

Edith Schloss—whom Burckhardt married in 1947—described Blaine as "always first on a new kick. Although she and Bob [Bass, a musician] had very little money, friends and friends of friends, even complete strangers were welcome to eat, to listen to music, to stay as long as they pleased at the loft, overnight too. Sessions lasted for days until a group of people drifted apart from exhaustion." "I am inspired by these painters," Koch wrote in rhyming couplets: "They make me want to paint myself on an amateur basis / Without losing my poetic status." He kept a close friend of his, a young poet called John Ashbery, then in his final year at Harvard, apprised of events.

When Ashbery graduated in the summer of 1949, he too moved to New York and sublet Koch's apartment while Koch was visiting his parents in Cincinnati. Freilicher let Ashbery into the building.

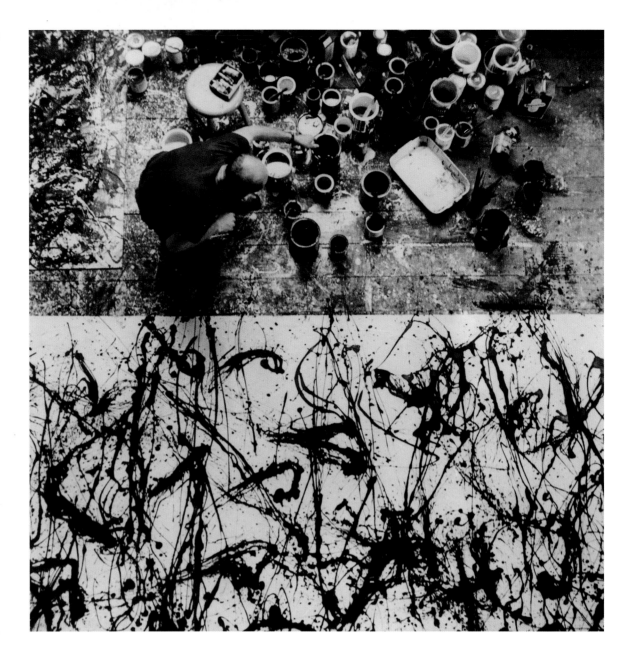

Immediately the two were, as Koch put it, "afloat with ironies jokes sensitivities perceptions and sweet swift sophistications." It was quite natural that Freilicher would bring her new friend along to the first day of shooting on a small film she had agreed to appear in—*Mounting Tension* (1950), directed by Rudy Burckhardt.

Mounting Tension stars Freilicher, Ashbery, Rivers, and Ann Aikman. The film is a lark—a comic, improvisatory enterprise, instinctively tongue in cheek in its representation of the creative act. It opens with Rivers in his studio, painting, then putting down the brush to pick up his saxophone to play a tune for a moment or two before picking up the brush again. Rivers is clearly an equal-arts opportunist; he raises his eyes and thanks heaven for his creative genius. When a young girl (Aikman) wanders into his studio, Rivers embarks on a comically transparent seduction routine, showing her a number of nude paintings and clearly expecting that Aikman will disrobe, transported by the spirit of modern art. He also gives her a book entitled *Modern Art*—which Aikman, having escaped Rivers's clutches, then takes to her

boyfriend, a baseball jock played by Ashbery.[2] (In this way, the virus of art is passed on, a by-product of sexual intrigue.) Rivers, frustrated by his inability to get laid, ends up on the couch of Madame Frauhauf, a psychoanalyst, played by a swaggering Freilicher. She "adjusts him," through a talking cure, then sheer quackery, and finally, by seducing him. The film ends cheerfully, in Central Park, with Ashbery painting Freilicher on the bank, and Aikman rowing while Rivers plays his saxophone: romantic harmony as a means of artistic production. The film's Parnassian vision is underscored by the senselessness of this turn of events; these characters have literally wandered into each other's lives off the streets of Manhattan, in much the same way as the actors did.

In *Mounting Tension*, everyone was, to a degree, playing ham versions of themselves: Freilicher had a passion for psychoanalysis, Rivers's nudes were actually his paintings (revealing the considerable influence of Bonnard), and Freilicher and Rivers were having an affair. It also seems ironically apropos, given Ashbery's later career as an art writer, that one of our first images of him as part of the New York School is

OPPOSITE
Rudy Burckhardt, *Jackson Pollock,
Springs, New York*, 1950.

BELOW
Cedar Street Tavern, 1959.

RIGHT
Rudy Burckhardt, stills from *Mounting
Tension*, 1950.

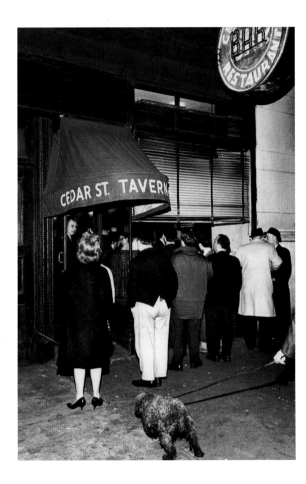

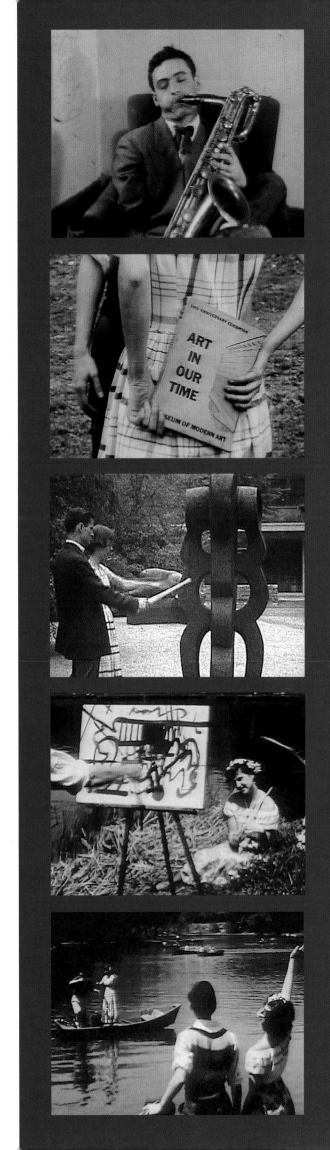

of a young man being schooled in modern art
somewhat reluctantly; he and Aikman wander
through the sculpture garden of the Museum of
Modern Art, Ashbery gesturing at pieces by Calder
and Maillol with his baseball bat, much to the
alarm of the security guards. Though silly, *Mounting
Tension* is also exceedingly quick, both delighting
in and mocking Baudelaire's maxim that "the arts
aspire, if not to complement one another, at least to
lend one another new energies." It's this offhand
quickness, this casual joy, which is clearly present in
much of the collaborative work that was to follow.

Ashbery's and Koch's arrivals in New York
coincided with, in Ashbery's words, "the cresting of
the 'heroic' period of Abstract Expressionism, as it
was later to be known." In 1949, *Life* magazine asked
if Jackson Pollock was "the greatest living painter in
the United States." The fact that the question had
been asked at all indicated a growing awareness—if
not approval—of American avant-garde art. For
decades, downtown painters had worked in isolation
and penury, but the tenor of their days appeared to be
shifting. Galleries exhibiting modern abstract art were

"Why, my dear, haven't you heard? I have a gallery of the liveliest, more original, and above all youngest, painters in America and for every painter there's a poet. You know we've discovered something called 'the Figure' that's exciting us enormously this season."
—John Bernard Myers in the play *Kenneth Koch: A Tragedy* by Frank O'Hara and Larry Rivers, 1954.

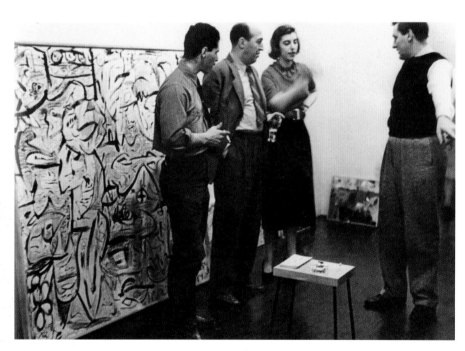

ABOVE
Alfred Leslie, Clement Greenberg, Helen Frankenthaler, and John Bernard Myers hanging first Frankenthaler exhibition at the Tibor de Nagy Gallery, November 1951.

OPPOSITE
John Bernard Myers and Tibor de Nagy, inaugural show at the Tibor de Nagy Gallery, 1950.

increasing in number, as were prices. Museums were showing interest. Younger painters, including Freilicher and her peers, paid close attention to the older painters' work (particularly Pollock's and de Kooning's). They drank alongside painters like Franz Kline, de Kooning, and Philip Guston at the Cedar Tavern near the corner of University Place and Eighth Street, already legendary for its boozing, brawling, and impassioned discussions about art, and they attended parties, lectures, and panel discussions at the Club on Eighth Street, increasingly participating in the panels (with titles like "Image in Poetry and Painting" or "The Figure in Painting") themselves. The older painters' support was prized; according to O'Hara, Rivers's career highlight was de Kooning's comment that Rivers's paintings were "like pressing your face into wet grass." At the same time, O'Hara noted, the older painters' influence was to be "avoided rather self-consciously rather than exploited. If you live in the

studio next to Brancusi, you try to think about Poussin." In her diary, Grace Hartigan described meeting with Alfred Leslie for "coffee and a brief honest talk. The same old thing—subject material, expressionism, the 'look,' etc." That this was the "same old thing" by 1952 says a lot about the speed with which ideas about art were being absorbed and challenged. Of Expressionism, Hartigan continued, "I'm going to grapple with the monster, use it, drain it, eat it and eventually I KNOW I'll throw it away."

The monster could be tamed more easily with like-minded friends, and increasingly, with the support of critics, collectors, curators, and gallery owners. In December 1950, the Hungarian émigré Tibor de Nagy and Buffalo native John Bernard Myers opened the Tibor de Nagy Gallery at 206 East 53rd Street.[3] The two men were taking the bold but financially risky step of representing mostly young, unknown painters, inheritors rather than initiators of Abstract Expressionism. The art critic Clement Greenberg advised de Nagy and Myers on whom to represent, recommending a number of artists—Hartigan, Rivers, Leslie, and Robert Goodnough—that he had recently selected for the Talent 1950 show at the Kootz Gallery. Soon after, Helen Frankenthaler, Freilicher, and Harry Jackson joined the gallery, followed by Fairfield Porter and Nell Blaine.

Myers, whom James Merrill described as an "ageless, hulking Irishman with the self-image of a pixie," had a talent for publicity and a passion for cultivating an aesthetic milieu. He was delighted to meet his painters' poet friends, and in turn, to introduce them to others. (It was through Myers, for instance, that O'Hara and Ashbery would meet the then-aspiring novelist James Schuyler.) Through openings, parties, readings, studio visits, and a multitude of other social occasions, a flourishing set of associations between the writers and artists attached to the Tibor de Nagy Gallery began to develop. The painters Joan Mitchell and Michael Goldberg were drawn in to what Blaine

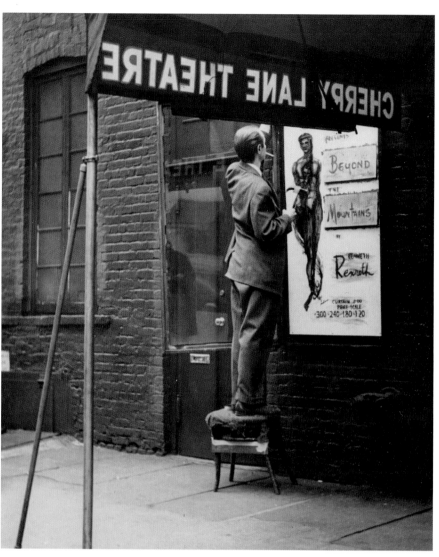

CLOCKWISE FROM TOP LEFT
John Cage, 1957.

Julian Beck in front of Cherry Lane
Theatre, New York City, ca. 1952.

Joan Mitchell and Michael Goldberg,
ca. 1950

Judith Malina and Paul Goodman at
San Remo, New York City, 1956.

Frank O'Hara, 1953.

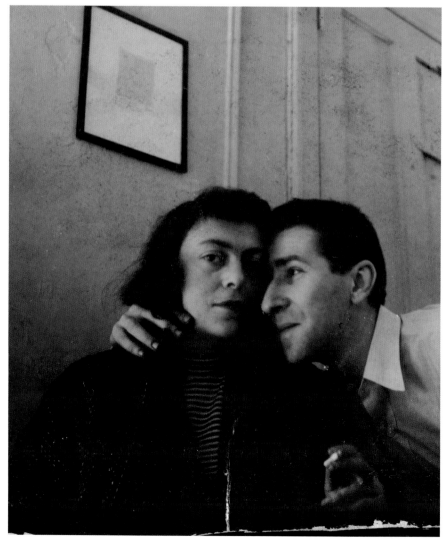

called a "roving pack." As Freilicher recalled, "Everyone felt this kind of energy . . . The new art of younger people was being done here . . . The action was here. One knew all these people. It was a kind of community."

Of these early years in New York, Ashbery later noted that the "one thing lacking . . . was the arrival of Frank O'Hara [in 1951] to kind of cobble everything together and tell us what we and they were doing." The two poets had met at Harvard in the fall of 1949 (Ashbery wrote to Koch, "I think we have a new contender") and after a year in Ann Arbor, Michigan, doing graduate work, O'Hara moved to the city. He was immediately beloved; everyone wanted, as Ted Berrigan later put it, to be "perfectly Frank." O'Hara saw New York, as Schuyler did, as a "painters' world; writers and musicians are in the boat, but they don't steer."[4] He obtained a job at the membership desk at the Museum of Modern Art, and quickly developed close friendships with many painters, young and old. There was, as de Kooning recalled, a "good-omen feeling about him." To Rivers, he was a "professional fan. . . . He talked a lot of artists into thinking that they were terrific. . . . He had you on his mind. And if 20 percent of it was horseshit, so what? With most people 90 percent of it is horseshit . . ." Denby described him as "everybody's catalyst." Together, Denby and O'Hara attended many ballet performances (they were both fans of Balanchine). O'Hara also involved himself in the Club, putting together and participating in a number of panel discussions. He became a ubiquitous presence so quickly that on May 2, 1952, Pavia noted, no panel was organized and so O'Hara simply filled in. He was swiftly becoming the "central switchboard" of the New York art scene.

The Club was only one of a number of art scenes in Manhattan.[5] As Ashbery put it, there were "other things to attend to: concerts of John Cage's music, Merce Cunningham's dances, the Living Theatre, but also talking and going to movies and getting ripped and hanging out and then discussing it

all over the phone." Their love affair with the cinema was consummated on all fronts as frequently as possible, and passionately expressed in O'Hara's poem "To the Film Industry in Crisis," in which he praised "the Tarzans, each and every one of you (I cannot bring myself to prefer / Johnny Weissmuller to Lex Barker, I cannot!)" And there was always gossip—who were sleeping together, who were no longer sleeping together, and who were about to sleep together. (As Koch recalled in his poem "Fate," on his return home from a Fulbright fellowship in Aix-en-Provence in 1951, his friends didn't want to hear about Europe, but were "much more / Interested in gossip . . .")

These writers and artists were mostly in their early twenties, and the city seemed wide open to them, a world away from the small towns that they had grown up in. At the time, the United States, deep in the Korean War and in the grip of McCarthyism, was a socially oppressive place, and New York City was an enclave for an artist inclined toward recklessness. Ashbery experienced writer's block from the summer of 1950 to the end of 1951, telling an interviewer later

Postcard for a panel at the Club, 1952. These postcards announcing the Friday night panels at the Club were mailed out the day before. Philip Pavia recalled "a hilarious poets' panel consisted of: five poems against MoMA; three poems against critics; one poem against intellectuals."

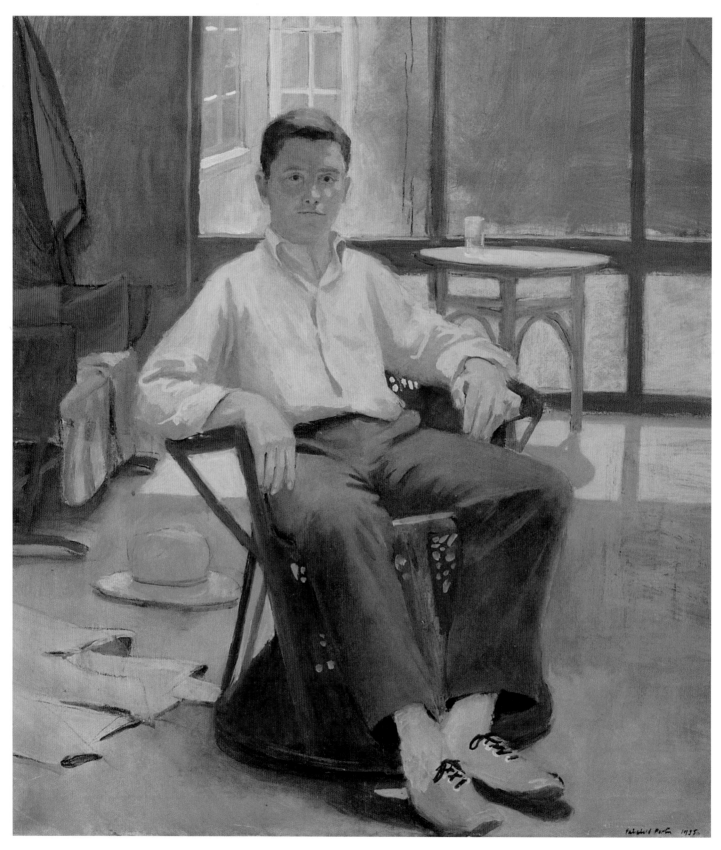

Fairfield Porter, *Portrait of James Schuyler*, 1955.

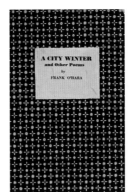

The absorption of this rich mélange of influence was marked by a quick wit; an arch look and a droll comment could help subvert the possibility of pretension in any avant-garde, and these artists and writers perfected the art of laconic observation, collecting each other's *bon mots* and passing them on. Ashbery noted that he and O'Hara both "felt that art is already serious enough; there is no point in making it seem even more serious by taking it too seriously." It was in this capacity that Freilicher was sovereign, famous for her witticisms and adored by the poets, who reviewed her work and wrote plays and poems about her (including "Looking Forward to Seeing Jane Real Soon," "Presenting Jane," "Chez Jane," "Jane Awake," "Jane Bathing," and "Jane at Twelve"—all by O'Hara). An appreciation of Freilicher's cleverness was a mark of distinction; recalling Schuyler's arrival, Koch wrote, "Schuyler had passed one test for being a poet of the New York School by almost instantly going crazy for Jane Freilicher and all her works."[6] People were swiftly drawn in; reading one of Barbara Guest's poems in *Partisan Review*, Freilicher and Ashbery recognized her approach as startlingly like their own, and Freilicher contacted the magazine for Guest's address.

Myers always had an eye for collaborative artistic ventures: in addition to being the managing editor of *View* magazine, he had also been the co-founder of the Tibor de Nagy Marionette Company. On opening the gallery, he immediately set about publishing limited-edition books in which he paired poets he knew with artists he represented. In the first ten years of the gallery's operations, under the imprimatur of Tibor de Nagy Editions, Myers published O'Hara with Rivers, and later, O'Hara with Hartigan; Chester Kallman with René Bouché; Koch with Blaine; Ashbery with Freilicher; Guest with Goodnough; and Kenward Elmslie with Ron Gorchov.[7] This kind of publishing project would have seemed a particularly natural idea to a nascent avant-garde; as

that "it was a terribly depressing period both in the world and in my life. I had no income or prospects. The Korean War was on and I was afraid I might be drafted . . ." On New Year's Day in 1952, O'Hara and Ashbery attended a performance of John Cage's *Music of Changes*, performed by David Tudor. The performance "was a series of dissonant chords, mostly loud, with irregular rhythm. It went on for over an hour and seemed infinitely extendable" but it "profoundly refreshed" Ashbery, who began writing again.

SEMI-COLON

Edited by John Bernard Myers
Published by the Tibor De Nagy Gallery
24 East 67th Street
$1.00 for 6 copies • 20¢ per copy Vol. II., No. 1 Ms. should be accompanied by stamped self-addressed envelope.

POEM	COLLECTED POEMS
Sky	
woof woof!	
harp	**BUFFALO DAYS** I was asleep when you waked up the buffalo.
sky	
woof woof!	**THE ORANGE WIVES**
harp	A mountain of funny foam went past.
sky	**GREAT HUMAN VOICES**
woof woof!	
harp	The starlit voices drip.
sky	**COLORFUL HOUR**
woof woof!	
harp	A few green pencils in a born pocket.
sky	**EXPRESSION**
woof woof!	
harp	New little tray.
sky	**SLEEP**
woof woof!	
harp	The bantam hen frayed its passage through the soft clouds.
sky	**A MINERAL WICK**
woof woof!	
harp	Town sofa.
sky	**SOMEWHERE**
woof woof!	
harp	Between islands and envy.
sky	**CECELIA**
woof woof!	
harp	Look, a cat.
sky	**THE SILVER WORLD**
woof woof!	
harp	Expands.
sky	**JEWELRY SEVENTHS**
woof woof!	
harp	Minor wonders.
sky	**AN ESKIMO COCA COLA**
woof woof!	
harp	Three-fifths.
	THE EXCEPTION PROVES THE RULE
sky	Eight-fifths.
woof woof!	Nine-fifths.
harp	Three-fifths. Six-fifths.

Kenneth Koch and Frank O'Hara

ABOVE
Semi-Colon 2, no. 1, 1956.

Semi-Colon was a periodical broadside edited by John Bernard Myers from 1953 to 1956 and published by the Tibor de Nagy Gallery. This issue was devoted to Frank O'Hara and Kenneth Koch, both separately and together.

RIGHT
Page from the manuscript of the novel *Nest of Ninnies* by John Ashbery and James Schuyler, begun on a summer car ride home from Southampton in 1952 and published in 1969.

Rivers later commented, "There was a glorious halo around the idea of each inspiring the other . . . I saw a book where Picasso did something with Eluard and other books with other 'greats' who had gotten together." Rivers is referring here to the tradition of the European *livre d'artiste*, fine-press limited-edition books that gave the impression of a collaborative effect by pairing image and text, regardless of the working methods used. This was also the tradition the de Nagy editions followed. These chapbooks made a case for shared set of sensibilities between artists and poets— as Freilicher would later put it, "a sympathetic vibration." Self-consciously beautiful objects, typeset by hand and printed on fine paper, these books are quite different from the rougher mimeo aesthetic that was to follow a decade later.[8] For Ashbery, Koch, Guest, Schuyler, and O'Hara, all in their mid- to late

twenties, these books were their first published collections of poetry, and a critical landmark in their careers.

Quite naturally, the poets and some of the artists, including Rivers and Freilicher (though not together) began to write collaborative poetry.[9] They often used particular forms like acrostics or sestinas) and deployed found language from newspapers and magazines.[10] "Worried," Myers wrote, "that I would not somehow be in the very center of this literary gold mine, I decided to publish . . . *Semi-Colon*," a pamphlet of new writing that was sold at the gallery, the Club, and the Cedar Tavern. One issue consisted exclusively of collaborative poetry by Koch and O'Hara— including the delightful "Sky / woof woof! / harp" that "is repeated ten times," as Koch recalled in "A Time Zone," and was "composed in a moment / On the sidewalk," on the way to lunch.

The most extensive instance of this collaborative writing was the novel *A Nest of Ninnies*, begun by Ashbery and Schuyler (writing in alternate sentences) in a summer car ride home from Southampton in 1952. The book is a parody of suburban life that implicitly satirizes the modernist notion of creative exile. Line by line—speech by speech—Ashbery and Schuyler document the minutiae of middle-class travel aspirations of characters who meet over cocktails and at dinner parties in Kelton, New York, Florida (a trial holiday), and then in France and Italy. The characters' conversations never turn to contemporary events, politics, art, or writing. Rather, the main thematic vehicle for satire in *A Nest* is taste, and the novel's humor comes from "tasteful" habits, such as the peppering of one's speech with French phrases. Ashbery and Schuyler had both grown up with these habits; as Schuyler later wrote to Clark Coolidge, "I, like John A., am indelibly stamped by the outer suburbs. Certain things about his mother and her house, and my mother and *her* house are strangely (?)

*I was in the Cedar Tavern last night and Bill de Kooning
was there, so I asked him if he'd seen your poem about
his picture. He said, "Yeah, is that right?" He said,
"Yeah, but how can you be sure it's about my picture, is it
just about a picture?" I quoted you, "I have my beautiful
de Kooning / to aspire to. I think it has an orange /
bed in it . . . " He said, "It's a couch. But then it really is
my picture, that's wonderful." Then he told me how he
had always been interested in mattresses because they
were pulled together at certain points and puffed out at
others, "like the earth." No wonder that "bed" is more
than the ear can hold! (This last is me, not Bill.) Anyway,
he seemed very pleased. He, as well as the other painters
and sculptors, have read and claimed to feel like
acclaiming our Semi-Colon but I really don't know what
to think about anyone's liking it, it's more like a
flat surface than anything else in literature so far. I love
it, of course; do you?*
—Kenneth Koch, from letter to Frank O'Hara, March 22, 1956

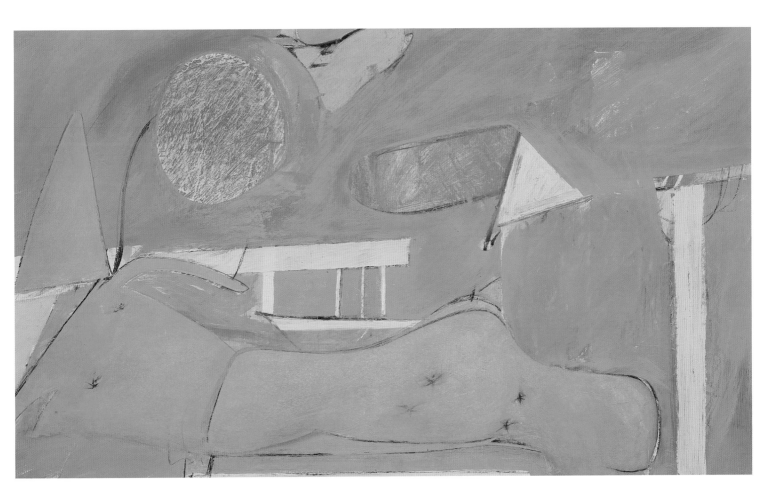

Willem de Kooning, *Summer Couch*, 1943.

*Well, I have my beautiful de Kooning
to aspire to. I think it has an orange
bed in it, more than the ear can hold.*
—Frank O'Hara, from his poem "Radio"

Grace Hartigan, 1952 or 1953.

alike—as a glance in their respective china cupboards would plainly show." Their parody in *A Nest* clearly indicated some distance from the outer suburbs had been achieved—though Ashbery and Schuyler (and the others) shared with their characters a passion for all things Continental. It might simply be that they preferred Proust and Pasternak, rather than, say, André Gide or Leo Tolstoy.

In 1953, Myers and Herbert Machiz formed the Artists' Theatre to put on plays written by "his" poets, and with sets by "his" artists. In the first year of the theater, Myers restaged O'Hara's *Try! Try!* (with a set by Rivers), and staged *Presenting Jane* by James Schuyler (with sets by Elaine de Kooning and film by John LaTouche), *Red Riding Hood* by Koch (with a set by Hartigan), *The Heroes* by Ashbery (with a set by Nell Blaine), *The Lady's Choice* by Barbara Guest (with a set by Jane Freilicher), and *The Bait* by James Merrill (with a set by Albert Kresch). The stagings were, according to many, a mixed success. As O'Hara later told an interviewer, "John . . . when he was producing us, he would look at the audience and say, 'Well, Harold Rosenberg is here; Tom Hess is here, Mark Rothko just came in. It *must* be a hit. Only it'd be a one-night hit."[11]

It was only a matter of time before the writing of these plays also became collaborative. Rivers and O'Hara, for instance, wrote *Kenneth Koch: A Tragedy*, which parodied the art world, including characters like Franz Kline, de Kooning (with a strong Dutch accent), the voice of Mark Rothko's mother, and an appearance by Jackson Pollock (as a bull). These collaborative plays were more anarchic creations, written for one-night performances, for birthdays and parties in lofts. And just as with *Mounting Tension* and *A Nest of Ninnies*— which opens with one character telling another, "I dislike being fifty miles from a great city," precisely where Ashbery and Schuyler were—these plays tended to reflect intensely on the absurdity of themselves as art objects. *The Coronation Murder Mystery*, written for Schuyler's birthday in 1956 by O'Hara, Koch, and

Ashbery and performed at Mike Goldberg's loft, has, as its opening scene, Goldberg's studio on 10th Street itself. The stage directions note, "*Jimmy Schuyler is visiting Mike and looking at his paintings when a pretty girl bursts in.*" (As in *Mounting Tension*, the action begins with a *puella ex machina*.) The lines between the stage and the audience were deliberately blurred; at the play's performance, Schuyler sat in the audience, watching Ashbery play him. Freilicher sat nearby, but was still in the script, interjecting skeptical asides. O'Hara was The Body, ostensibly the source of the murder mystery, but also refusing to play dead.

It is a particularly delicate dance that these plays, poems, and books weave, a gavotte of affectionate mockery. To be refigured in an art form not one's own was the highest of compliments. In her diary, Hartigan wrote regularly of the blessings of her friendship with O'Hara, who dedicated numerous poems to her— including "For Grace, After a Party," "Christmas Card to Grace Hartigan," and "Portrait of Grace." On receiving the last of these in 1952, Hartigan wrote that the poem "makes me feel as though I exist now. I get so confused about myself, as though only the paintings are real. This poem makes me have an existence." In 1954, for her painting *Masquerade*, she posed her friends in fancy dress, had Walt Silver photograph them, and then painted the photo; returning the favor, she was fashioning a theater of their friendship.[12]

During these years, Rivers and O'Hara were also particularly close. In 1953, Rivers, along with his two sons, Joseph and Steven, and mother-in-law, Berdie Berger, had moved out to Southampton, near Fairfield and Anne Porter's home, and O'Hara often caught the train out on the weekends to visit. Rivers's star was rising in the art world. In 1953, he painted the work that defined his early career, *George Washington Crossing the Delaware*, and his deliberate attention to the human figure made him notorious in a downtown scene dominated by Abstract Expressionism. "I wanted to do something the New York world would consider

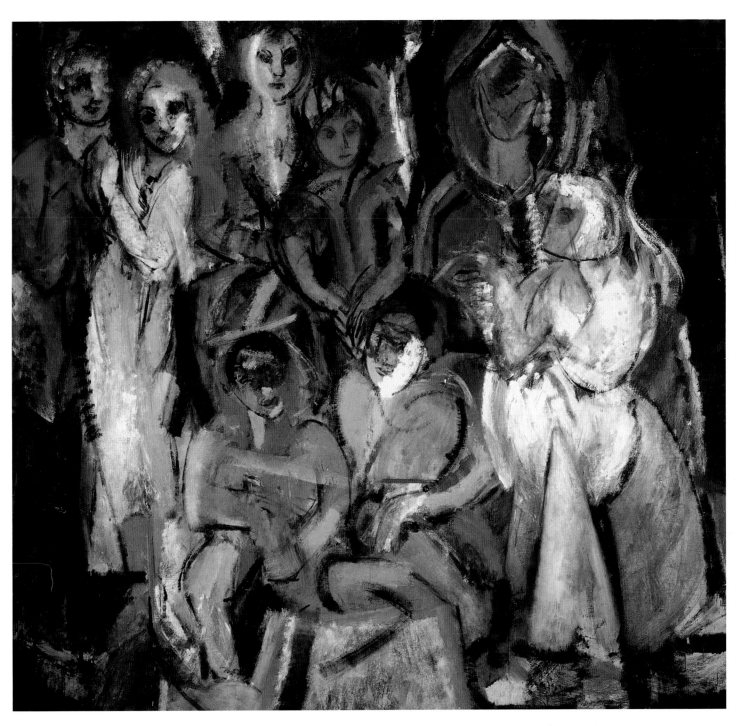

Grace Hartigan, *Masquerade*, 1954.

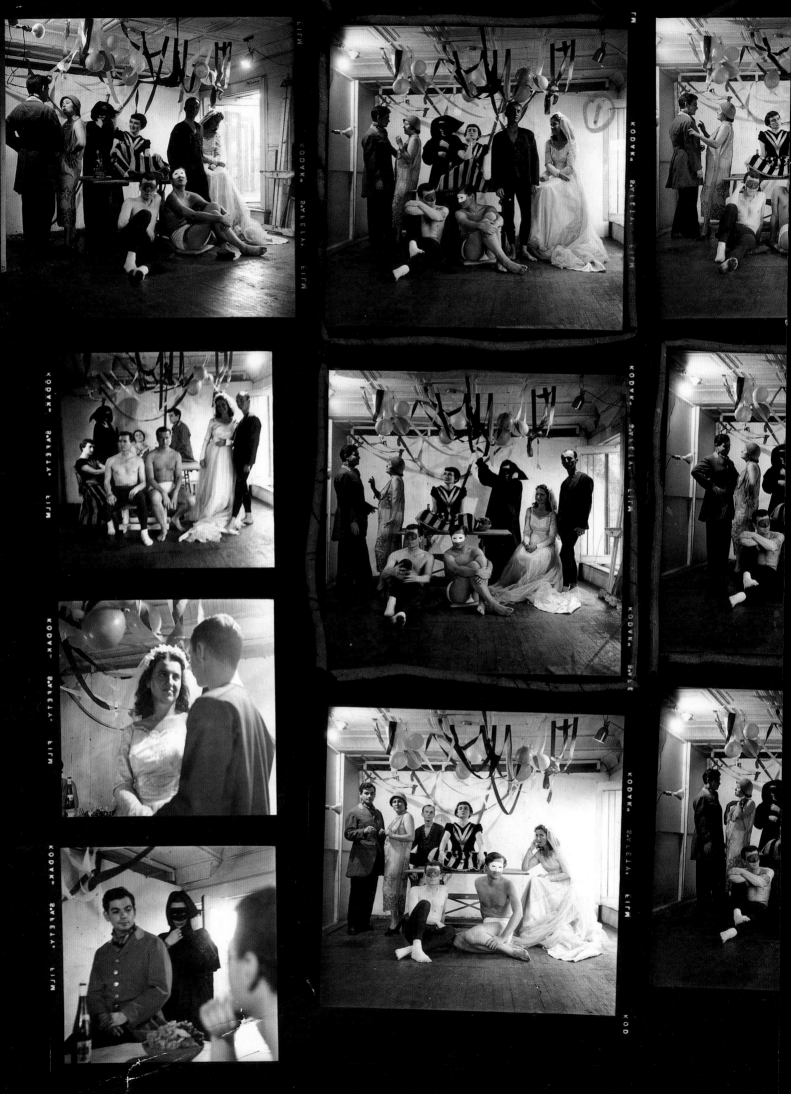

**From *The Journals of
Grace Hartigan*, 1951–1955**

June 20
*In the Ludlow Market Thursday I came upon piles of
old clothes and costumes, and I bought some that excite
me—a long black hooded coat, harlequin shirt and
blouse, a red hunter's coat, a beaded twenties dress.
Since then I can think of nothing but a large painting
called "Masquerade," for which I want all the Folder
people and Jane, Frank & John Ashbery to pose.
I think of them in various attitudes around a table,
a feeling of strangeness, madness.*

June 24
*My tableaux has been posed and photographed, and I
have an almost 7 foot square canvas tacked on the wall.
I intend to begin to-day drawing in charcoal. I want to
work this picture in a lot of detail if I can, simplifying
toward the end. I also hope its look will not cause
people to say "Bechmann" (sic) as they seem to be
saying recently. I hope it is only the surface similarity
of drawing in black line. Certainly there are many
artists I would prefer being compared to.*

*I pray that someday my painting will lose that look
known as "expressionism."*

June 28
*One day drawing in charcoal, another day in flat
washes of oil & turp.*

So far it shows less than nothing, inept and amateur.

*I am a mass of bruises from falling into a brook while
picking tiger lilies.*

*My pictures may be called expressionistic in those
times when the formal values are overcome by
"expressive" ones—personal and emotional. To keep
this from happening requires intense self discipline—
which I am incapable of at times.*

*It seems the only way I can have the architecture I
want in a picture is to maintain some attitude towards
cubism and to almost* deliberately construct the
picture in planes. *Remember this while working on
Masquerade....*

Worked all to-day, more openly and loose.

*My last two paintings (Nude with Blue Stole and Peonies
& Baby's Breath) are very unsatisfactory to me—they
were self-indulgently painted, and I can learn nothing
from them.*

June 29
*All day on Masq. Some flashes of what it might be,
then muddles. I thought of ochres, blues and blacks.*

July 15
*Work on Masq for some days, then away to Lavallette
[New Jersey] with the family & Jeff. Spent the time in
bed with an attack of virus.*

*Now I am faced with Masq. again, I seem to have no
sense of it, or myself, or art or life or anything.*

July 17
At last it's beginning to come.

*Don't force a complete articulation of the facial features.
They should be explicit only when the inevitability of
the form demands it.*

July 20
*Three days obsessed with this picture, close to it, then
loosing it—I've given up everything on the way, all the
early stages of skill and brilliant color. Now its almost
gone, just big wiped muddy areas, I've lost all the magic.*

July 21
*Ferocious work yesterday and today on Masquerade.
I think it's finished but for ending touches.*

*I don't know what to think—it shows my study of
cubism certainly.*

*Surely no other picture has cost me so much as this
one, I am weak and spent.*

Contact sheets of images used to develop Hartigan's painting *Masquerade*,
1954. The verso of the contact sheet notes the identities of the sitters:
"Richard Miller (riding coat), Floariano Jecchi (black mask), Daisy Aldan
(striped dress), Olga Petroff (cloche hat), Jane Freilicher (bridal gown),
Frank O'Hara (jacket and tights), John Ashbery (white mask), Grace Hartigan
(black cloak)."

disgusting, dead, and absurd," he later wrote. Rivers was interested in antiheroics, in anticlimax—but, of course, all of this was presented on what was a fairly sizeable canvas, as was his mock-monumental portrait, *O'Hara Nude with Boots* (1954). In these years, Rivers and O'Hara worked frequently alongside each other (O'Hara wrote parts of his long poem "Second Avenue" in Rivers's studio), and casually collaborated on poetry, plays, and later, pseudo-manifestos and lithographs. Their letters are filled with the joys of proposal: new intimacies (they were lovers), reading series, and different kinds of collaboration. One autumn night in 1953, O'Hara wrote to Rivers, "Perhaps you would like to see the print of my hand, so that you may have a better idea of the coolness of our communication and the hot thoughts of the roses." He then drew his hand.

Yet these kinds of connection were never about the reducibility of one art form to another.[12] Very few of these writers and artists were interested in a kind of illustrative ekphrasis—namely, that a poem might "describe" a painting, or a painting "illustrate" a poem at the level of a clearly identifiable shared subject. O'Hara's poem "Why I Am Not a Painter" is not "about" Mike Goldberg's painting *Sardines*, to which it refers. Rather, O'Hara is interested in a similarity of approach; both men finish pieces of art that do not describe their subject. (Of course, the discrepancy between the title and poem enacts the final turn of the screw: this poem is also a poem that is not about its subject.) This kind of approach grew out of a respect for the fundamental particularity of each other's art form. One can be a friend, with certain aesthetic tastes in common, but painting and writing are two different languages, and to collaborate was to carry out a conversation with no intention of translating the meaning of one art form into another. A distinction between forms had to be preserved and respected; without this distinction, any emotion would be flattened, turned into an archetypal paste of creativity that connected artworks by

Thomas B. Hess, editor of *ARTnews* in his office, New York City, 1961.

Jane Freilicher, *Untitled (Still Life with Copy of ARTnews)*, ca. 1963.

equalizing them. (Fairfield Porter pointed this out in a letter to the *Partisan Review*, in which he lambasted an article by Wyndham Lewis on Pablo Picasso. He observed that Lewis "looks at paintings through the spectacles of words, and without these spectacles would be blind. He does not know the difference between the pictures and his talk about them.")

Knowing the difference—and respecting it—led to a particular kind of looking. In a speech at Juilliard in 1956, Denby advised dance students not to look at the world in a "professional" fashion, attentive only to their chosen art form, but rather in a "more general way." His thinking was a gentle parry against a certain academicism or philosophizing. There is a plainness to Denby's prose that could undercut high-minded cant about modern art. Whatever you observed should not bend to fit your own language; rather, your own language had to bend, and in that bending, exhibit a kind of stress or fracture, a surrealism of the everyday. The younger poets found Denby's approach an attractive one—and their habits of "general looking," which they cultivated in their prose, may have been one reason why so many were hired by Thomas B. Hess as writers for *ARTnews* magazine: Guest in 1952, O'Hara in 1953, Schuyler in 1955, and Ashbery in 1957. (Elaine de Kooning and Porter had already begun writing for the magazine in the late 1940s.) Appointed as executive editor in 1950, Hess was passionate about poetry and knew (in Ashbery's words) that poets would make "sensitive, unbiased and articulate observers of art," and also that the poets were broke.[13] His editorial eye could be beautifully pragmatic. In 1950, he initiated the influential series "Paints a Picture," in which a photographer and a writer documented the process of an artist. Burckhardt was often the photographer employed; one of his first assignments was to photograph Pollock working in his studio on Long Island. (The shoot ended up being posed: Pollock couldn't work on cue.) Over the years, many New York School artists were profiled in the "Paints a Picture" series by their friends: Rivers by Porter, Porter by O'Hara, Freilicher by Porter, and Alex Katz by Schuyler. These articles indirectly and casually demonstrated how a group of writers and artists could be engaged in the shared endeavor of making art. We can read, for instance, about Porter watching Freilicher painting the poet, playwright, and librettist Arnold Weinstein in 1955. Alongside Porter's words, we have Burckhardt's photographs of the process—the painting, as it changes, and Freilicher smiling, standing at her painting table, dipping her brush in paint and watched, for a moment, by Weinstein.

Though Koch's "A Time Zone" was written forty years later, the poem clearly conveys the sense of a gathering excitement in these years, an awareness of how simultaneous things might be:

> *De Kooning's landscapey woman is full of*
> *double-exposure perfections*
> *Bob Goodnough is making some small flat red*
> *corrections*
> *Jane is concentrating she's frowning she has a look*
> *of happy distress*
> *She's painting her own portrait in a long-sleeved*
> *dark pink dress*
> *I'm excited I'm writing at my typewriter it doesn't*
> *make too much sense*

Of course, each approached their task with as light a heart as possible. You can sense their bright excitement in the photographs taken by Walt Silver in 1953 of a reading to celebrate Daisy Aldan's magazine *Folder*. These artists and poets were making their way in the New York art world, and somehow, making something—a sociability, sensibility, whatever it was—*together*.[14] As Koch later recalled, "We inspired each other, we envied each other, we emulated each other . . . we were almost entirely dependent on each other for support. Each had to be better than the others but if one flopped we all did."

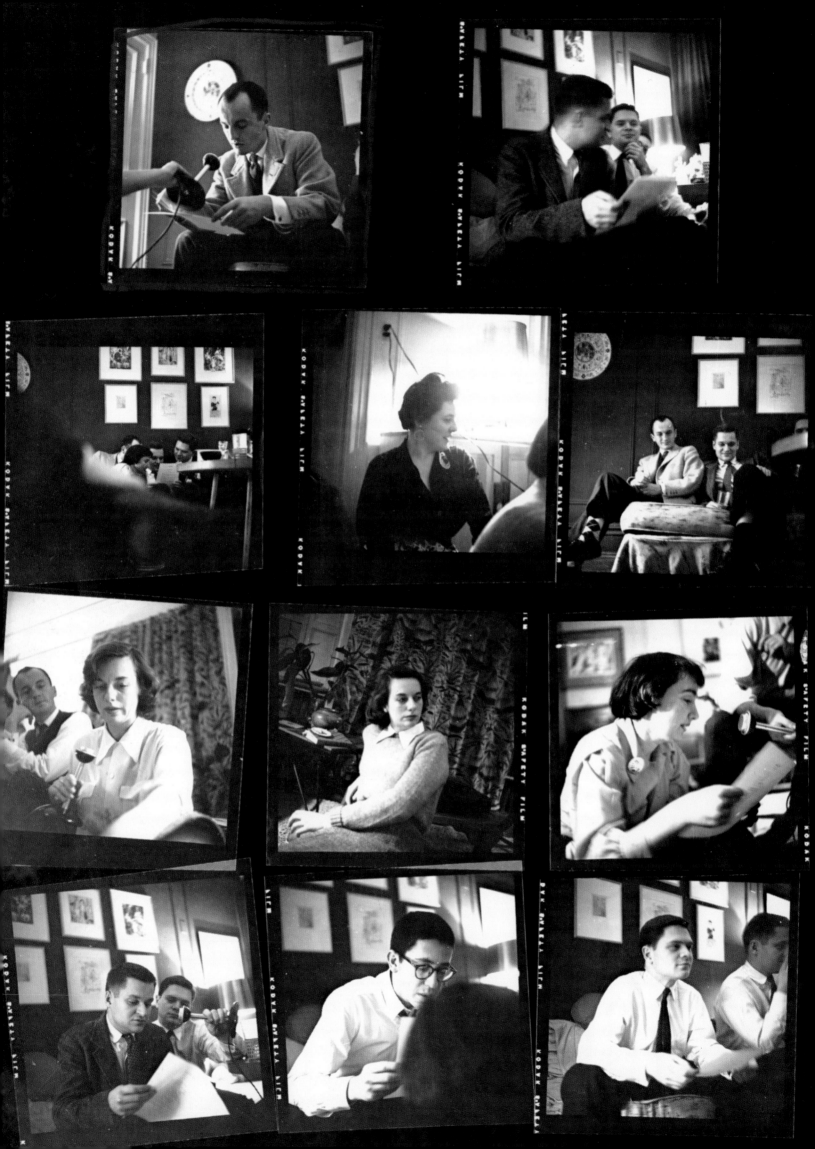

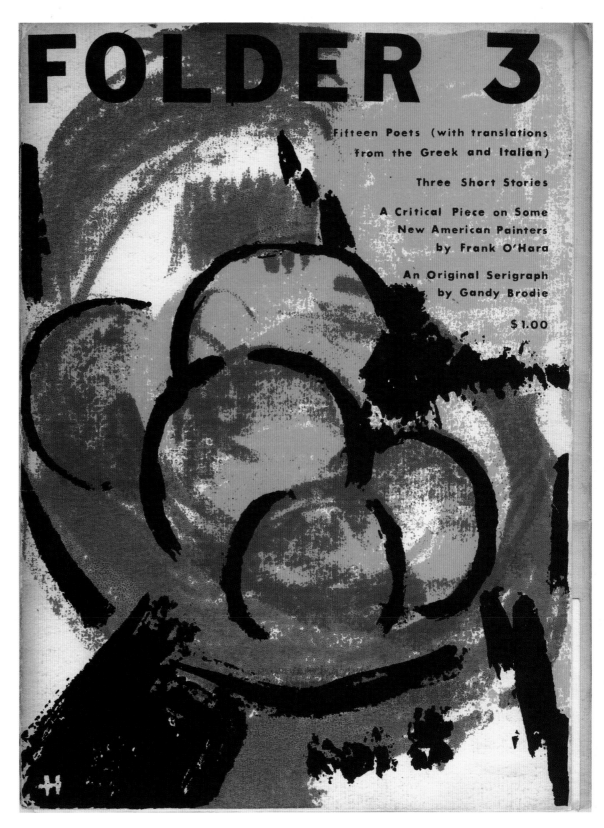

FOLDER 3

Fifteen Poets (with translations from the Greek and Italian)

Three Short Stories

A Critical Piece on Some New American Painters by Frank O'Hara

An Original Serigraph by Gandy Brodie

$1.00

Cover of *Folder 3* (1954–55).

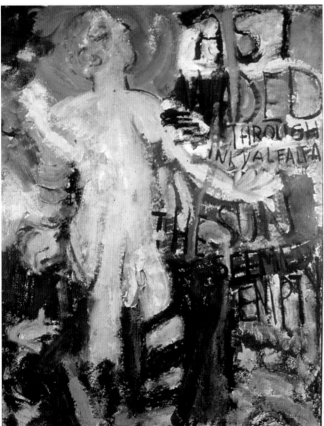

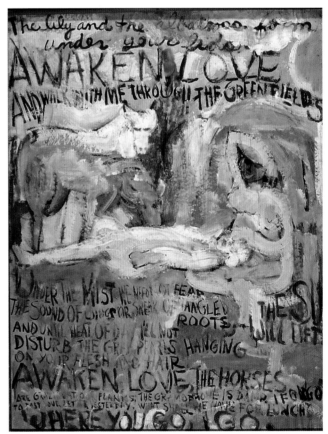

Grace Hartigan's *Oranges*, 1952, are based on the prose poems "Twelve Pastorals" by Frank O'Hara. Shown here are ten of the original twelve paintings, originally exhibited at the Tibor de Nagy Gallery in the spring of 1953. O'Hara's set of poems were published as a chapbook for the occasion of the exhibition, and Hartigan hand-painted the covers for twenty-six of the hundred copies. The cover design for these books—a painting of oranges—was, in turn, used for the cover of Daisy Aldan's *Folder* magazine. The collaborative ricochet effect continued; three years later, O'Hara wrote a poem called "Oranges" (see page 75), which references the painting by Mike Goldberg entitled *Sardines* (see page 74).

ABOVE (CLOCKWISE FROM TOP LEFT)
Grace Hartigan, *Oranges No. 4*, 1952.
Grace Hartigan, *Oranges No. 8*, 1952.
Grace Hartigan, *Oranges No. 9*, 1952.
Grace Hartigan, *Oranges No. 11*, 1952.

OPPOSITE
Grace Hartigan, *Oranges No. 7*, 1952.

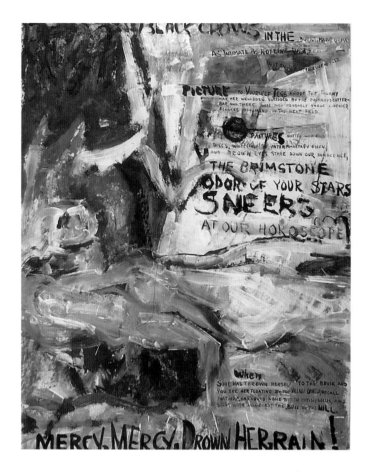

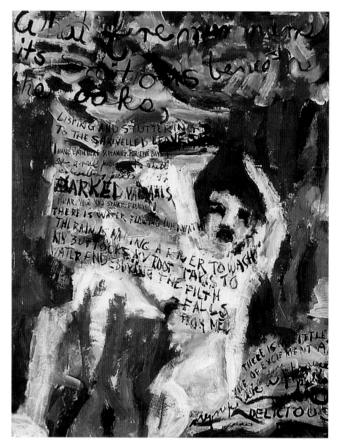

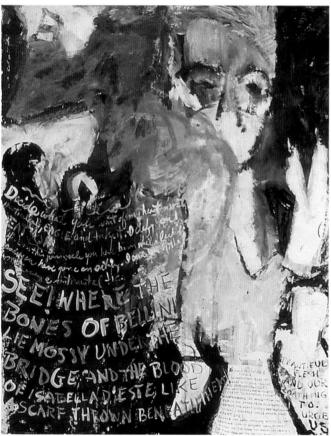

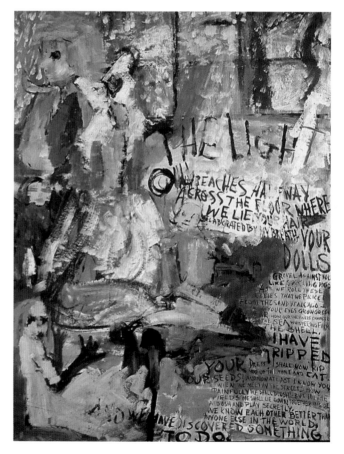

ABOVE (CLOCKWISE FROM TOP LEFT)
Grace Hartigan, *Oranges No. 1*, 1952.
Grace Hartigan, *Oranges No. 3*, 1952.
Grace Hartigan, *Oranges No. 6*, 1952.
Grace Hartigan, *Oranges No. 5*, 1952.

OPPOSITE
Grace Hartigan, *Oranges No. 12*, 1952.

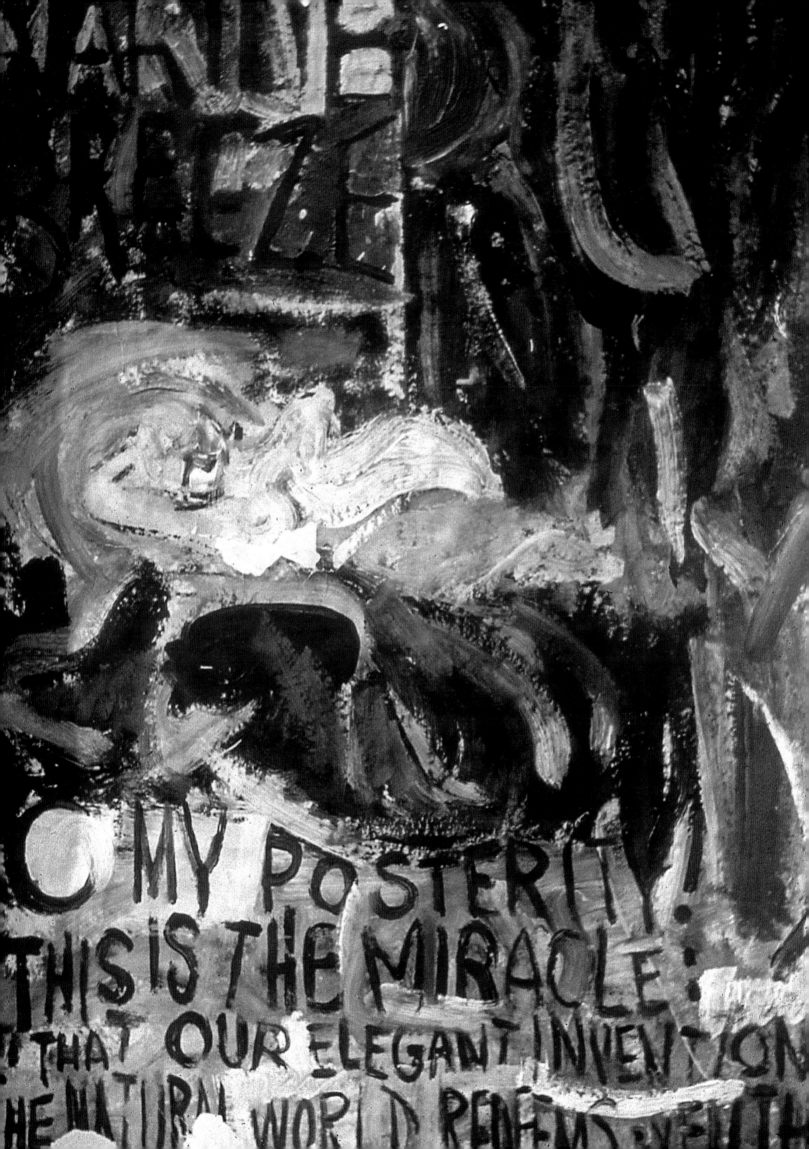

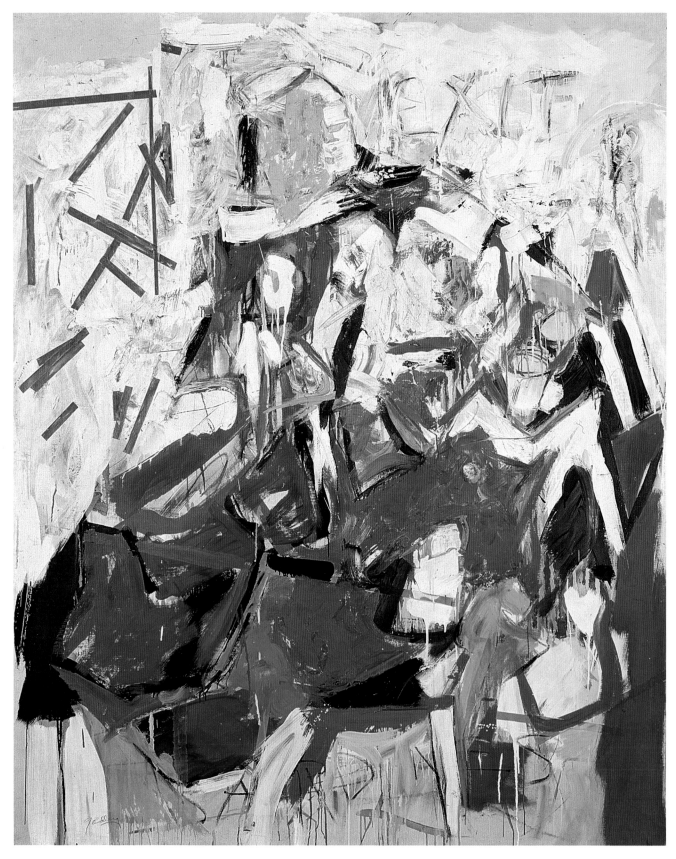

Mike Goldberg, *Sardines*, 1955.

Why I Am Not a Painter
Frank O'Hara, 1956

I am not a painter, I am a poet.
Why? I think I would rather be
a painter, but I am not. Well,

for instance, Mike Goldberg
is starting a painting. I drop in.
"Sit down and have a drink" he
says. I drink; we drink. I look
up. "You have SARDINES in it."
"Yes, it needed something there."
"Oh." I go and the days go by
and I drop in again. The painting
is going on, and I go, and the days
go by. I drop in. The painting is
finished. "Where's SARDINES?"
All that's left is just
letters, "It was too much," Mike says.

But me? One day I am thinking of
a color: orange. I write a line
about orange. Pretty soon it is a
whole page of words, not lines.
Then another page. There should be
so much more, not of orange, of
words, of how terrible orange is
and life. Days go by. It is even in
prose, I am a real poet. My poem
is finished and I haven't mentioned
orange yet. It's twelve poems, I call
it ORANGES. And one day in a gallery
I see Mike's painting, called SARDINES.

LARRY RIVERS: A MEMOIR

Frank O'Hara
From the exhibition catalog *Larry Rivers*, 1965

I first met Larry Rivers in 1950. When I first started coming down to New York from Harvard for weekends Larry was in Europe and friends had said we would like each other. Finally, at for me a very literary cocktail party at John Ashbery's, we did meet, and we did like each other: I thought he was crazy and he thought I was even crazier. I was very shy, which he thought was intelligence; he was garrulous, which I assumed was brilliance—and on such misinterpretations, thank heavens, many a friendship is based. On the other hand, perhaps it was not a misinterpretation: certain of my literary "heroes" of the *Partisan Review* variety present at that party paled in significance when I met Larry, and through these years have remained pale while Larry has been something of a hero to me, which would seem to make me intelligent and Larry brilliant. Who knows?

The milieu of those days, and its funny to think of them in such a way since they are so recent, seems odd now. We were all in our early twenties. John Ashbery, Barbara Guest, Kenneth Koch and I, being poets, divided our time between the literary bar, the San Remo, and the artists' bar, the Cedar Tavern. In the San Remo we argued and gossiped: in the Cedar we often wrote poems while listening to the painters argue and gossip. So far as I know nobody painted in the San Remo while they listened to the writers argue. An interesting sidelight to these social activities was that for most of us non-academic and indeed non-literary poets in the sense of the American scene at the time, the painters were the only generous audience for our poetry, and most of us read first publicly in art galleries or at The Club. The literary establishment cared about as much for our work as the Frick cared for Pollock and de Kooning, not that we cared any more for establishments than they did, all of the disinterested parties being honorable men.

Then there was great respect for anyone who did anything marvelous: when Larry introduced me to de Kooning I nearly got sick, as I almost did when I met Auden; if Jackson Pollock tore the door off the men's room in the Cedar it was something he just did and was interesting, not an annoyance. You couldn't see into it anyway, and besides there was then a sense of genius. Or what Kline used to call "the dream." Newman was at that time considered a temporarily silent oracle, being ill, Ad Reinhardt the most shrewd critic of the emergent "art world," Meyer Schapiro a god and Alfred Barr right up there alongside him but more distant, Holger Cahill another god but one who had abdicated to become more interested in "the thing we're doing," Clement Greenberg the discoverer, Harold Rosenberg the analyzer, and so on and so on. Tom Hess had written the important book. Elaine de Kooning was the White Goddess: she knew everything, told little of it though she talked a lot, and we all adored (and adore) her. She is graceful.

CONTINUED

Larry Rivers and Frank O'Hara outside
Lincoln Center, New York City, 1965.

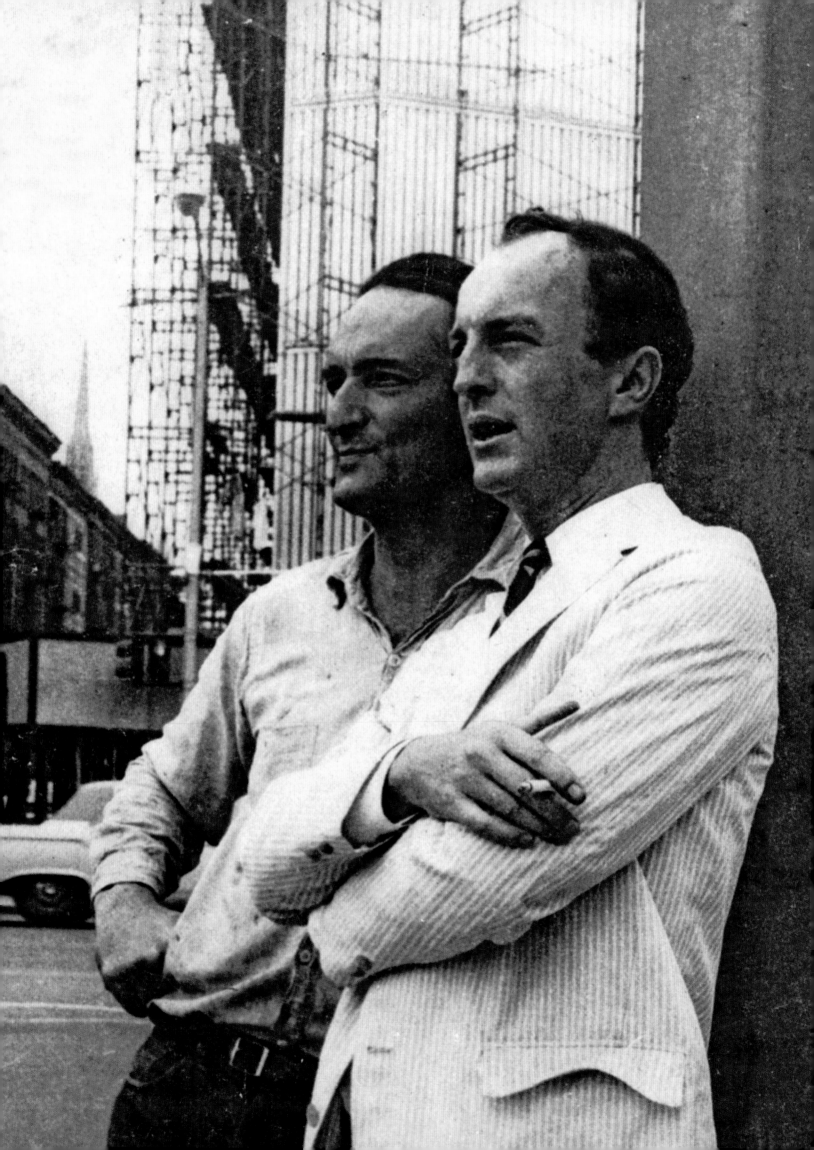

Into this scene Larry came rather like a demented tele-
phone. Nobody knew whether they wanted it in the library, the
kitchen or the toilet, but it was electric. Nor did he. The
single most important event in his artistic career was when de
Kooning said his painting was like pressing your face into wet
grass. From the whole jazz scene, which had gradually dimin-
ished to a mere recreation, Larry had emerged into the world of
art with the sanction of one of his own gods, and indeed the
only living one.

It is interesting to think of 1950–52, and the styles of
a whole group of young artists whom I knew rather intimately.
It was a liberal education on top of an academic one. Larry was
chiefly involved with Bonnard and Renoir at first, later Manet
and Soutine; Joan Mitchell—Duchamp; Mike Goldberg—Cézanne-Vil-
lon—de Kooning; Helen Frankenthaler—Pollock-Miró; Al Leslie—
Motherwell; De Niro—Matisse; Nell Blaine—Helion; Hartigan—
Pollock-Guston; Harry Jackson—a lot of Matisse with a little
German Expressionism; Jane Freilicher—a more subtle combination
of Soutine with some Monticelli and Moreau appearing through the
paint. The impact of THE NEW AMERICAN PAINTING on this group was
being avoided rather self-consciously rather than exploited. If
you live in the studio next to Brancusi, you try to think about
Poussin. If you drink with Kline you tend to do your black-and-
whites in pencil on paper. The artists I knew at that time knew
perfectly well who was Great and they weren't going to begin to
imitate their works, only their spirit. When someone did a false
Clyfford Still or Rothko, it was talked about for weeks. They
hadn't read Sartre's *Being and Nothingness* for nothing.

Larry was especially interested in the vast range of pos-
sibilities of art. Perhaps because of his experience as a jazz
musician, where everything can become fixed so quickly in style,
become "the sound," he has moved restlessly from phase to phase.
Larry always wanted to see something when he painted, unlike the
then-prevalent conceptualized approach. No matter what stylis-
tic period he was in, the friends he spent most time with were
invariably subjects in some sense, more or less recognizable,
and of course his two sons and his mother-in-law who lived with
him were the most frequent subjects (he was separated from his
wife, Augusta). His mother-in-law, Mrs. Bertha Burger, was the
most frequent subject. She was called Berdie by everyone, a
woman of infinite patience and sweetness, who held together a
Bohemian household of such staggering complexity it would have
driven a less great woman mad. She had a natural grace of tem-
perament which overcame all obstacles and irritations. (During
her fatal illness she confessed to me that she had once actually
disliked two of Larry's friends because they had been "mean" to
her grandsons, and this apologetically!) She appears in every
period: an early Soutinesque painting with a cat; at an Impres-
sionistic breakfast table; in the semi-abstract paintings of
her seated in a wicker chair; as the double nude, very realis-
tic, now in the collection of the Whitney Museum; in the later
The Athlete's Dream, which she especially enjoyed because I posed
with her and it made her less self-conscious if she was in a
painting with a friend; she is also all the figures in the Muse-
um of Modern Art's great painting *The Pool*. Her gentle interest-
edness extended beyond her own family to everyone who frequented
the house, in a completely incurious way. Surrounded by painters

Larry Rivers, *Portrait of Frank O'Hara*,
ca. 1955.

Larry Rivers, *O'Hara Nude with Boots*, 1954. On January 19, 1954, Frank O'Hara reported on the painting's progress in a letter to Jane Freilicher: "I am posing for Larry avec la nudité in great big boots for a canvas to be called 'The Truth about Christine' and the drawings are going along with wonderful candor and verve; he'll also stay at my place while in town ... "

and poets suddenly in mid-life, she had an admirable directness with esthetic decisions: "it must be very good work, he's such a wonderful person." Considering the polemics of the time, this was not only a relaxing attitude, it was an adorable one. For many of us her death was as much the personal end of a period as Pollock's death was that of a public one.

I mention these details of Rivers' life because, in the sense that Picasso meant it, his work is very much a diary of his experience. He is inspired directly by visual stimulation and his work is ambitious to save these experiences. Where much of the art of our time has been involved with direct conceptual or ethical considerations, Rivers has chosen to mirror his preoccupations and enthusiasms in an unprogrammatic way. As an example, I think that he personally was very awed by Rothko and that this reveals itself in the seated figures of 1953-54; at the same time I know that a rereading of *War and Peace*, and his idea of Tolstoy's life, prompted him to commence work on *Washington Crossing the Delaware*, a non-historical, non-philosophical work, the impulse for which I at first thought was hopelessly corny until I saw the painting finished. Rivers veers sharply, as if totally dependent on life impulses, until one observes an obsessively willful insistence on precisely what he is interested in. This goes for the father of our country as well as for the later Camel and Tareyton packs. Who, he seems to be saying, says they're corny? This is the opposite of pop art. He is never naïve and never oversophisticated.

Less known than his jazz interests are Larry's literary ones. He has kept, sporadically, a fairly voluminous and definitely scandalous journal, has written some good poems of a diaristic (boosted by Surrealism) nature, and collaborated with several poets (including myself) who have posed for him, mainly I think to keep them quiet while posing and to relax himself when not painting or sculpting. The literary side of his activity has resulted mainly in the poem-paintings with Kenneth Koch, a series of lithographs [*Stones*] with me, and our great collaborative play *Kenneth Koch, A Tragedy*, which cannot be printed because it is so filled with 50s art gossip that everyone would sue us. This latter work kept me amused enough to continue to pose for the big nude which took so many months to finish. That is one of Larry's strategies to keep you coming back to his studio, or was when he couldn't afford a professional model. The separation of the arts, in the "pure" sense, has never interested him. As early as 1952, when John Myers and Herbert Machiz were producing the New York Artists' Theatre, Larry did a set for a play of mine, *Try! Try!* At the first run-through I real-

CONTINUED

ized it was all wrong and withdrew it. He, however, insisted that if he had done the work for the set I should be willing to rewrite to my own satisfaction, and so I rewrote the play for Anne Meacham, J.D. Cannon, Louis Edmonds and Larry's set, and that is the version printed by Grove Press. Few people are so generous toward the work of others.

As I said earlier, Larry is restless, impulsive and compulsive. He loves to work. I remember a typical moment in the late '50s when both Joan Mitchell and I were visiting the Hamptons and we were all lying on the beach, a state of relaxation Larry can never tolerate for long. Joan was wearing a particularly attractive boating hat and Larry insisted that they go back to his studio so he could make a drawing of her. It is a beautiful drawing, an interesting moment in their lives, and Joan was not only pleased to be drawn, she was relieved because she is terribly vulnerable to sunburn. As Kenneth Koch once said of him, "Larry has a floating subconscious—he's all intuition and no sense."

That's an interesting observation about the person, but actually Larry Rivers brings such a barrage of technical gifts to each intuitive occasion that the moment is totally transformed. Many of these gifts were acquired in the same manner as his talents in music and literature, through practice. Having been hired by Herbie Fields' band in his teens he became adept at the saxophone, meeting a group of poets who interested him he absorbed, pro or con, lots of ideas about style in poetry, and attending classes at Hans Hofmann's school plunged him into activities which were to make him one of the best draftsmen in contemporary art and one of the most subtle and particular colorists. This has been accomplished through work rather than intellection. And here an analogy to jazz can be justified: his hundreds of drawings are each like a separate performance, with its own occasion and subject, and what has been "learned" from the performance is not just the technical facility of the classical pianists' octaves or the studies in a *Grande Chaumière* class, but ability to deal with the increased skills that deepening of subject matter and the risks of anxiety-dictated variety demand for clear expression. When Rivers draws a nose, it is my nose, your nose, his nose, Gogol's nose, and the nose from a drawing instruction manual, and it is the result of highly conscious skill.

There is a little bit of Hemingway in his attitude toward ability, toward what you do to a canvas or an armature. His early painting, *The Burial*, is really, in a less arrogant manner than Hemingway's, "getting into the ring" with Courbet (*The Funeral at Ornans*), just as his nude portrait of me started in his mind from envy of the then newly acquired Géricault slave with the rope at the Metropolitan Museum, the portrait *Augusta* from a Delacroix; and even this year he is still fighting it out, this time with David's *Napoleon*. As with his friends, as with cigarette and cigar boxes, maps, and animals, he is always engaged in an esthetic athleticism which sharpens the eye, hand and arm in order to beat the bugaboos of banality and boredom, deliberately invited into the painting and then triumphed over.

What his work has always had to say to me, I guess, is to be more keenly interested while I'm still alive. And perhaps this is the most important thing art can say.

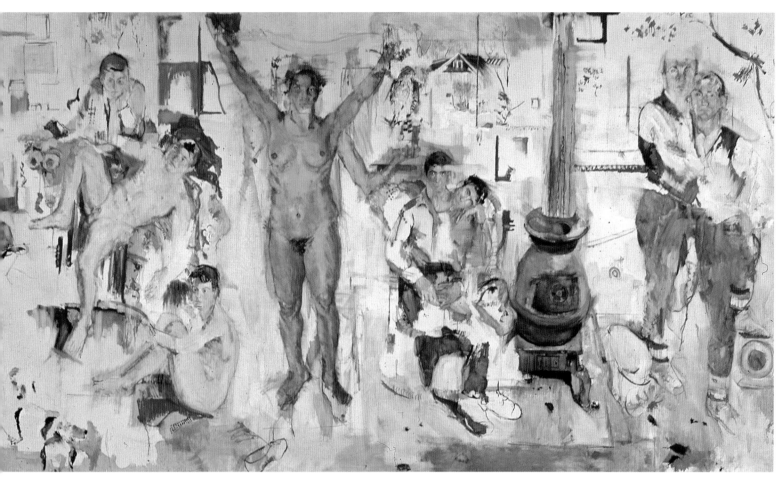

Larry Rivers, *The Studio*, 1956.

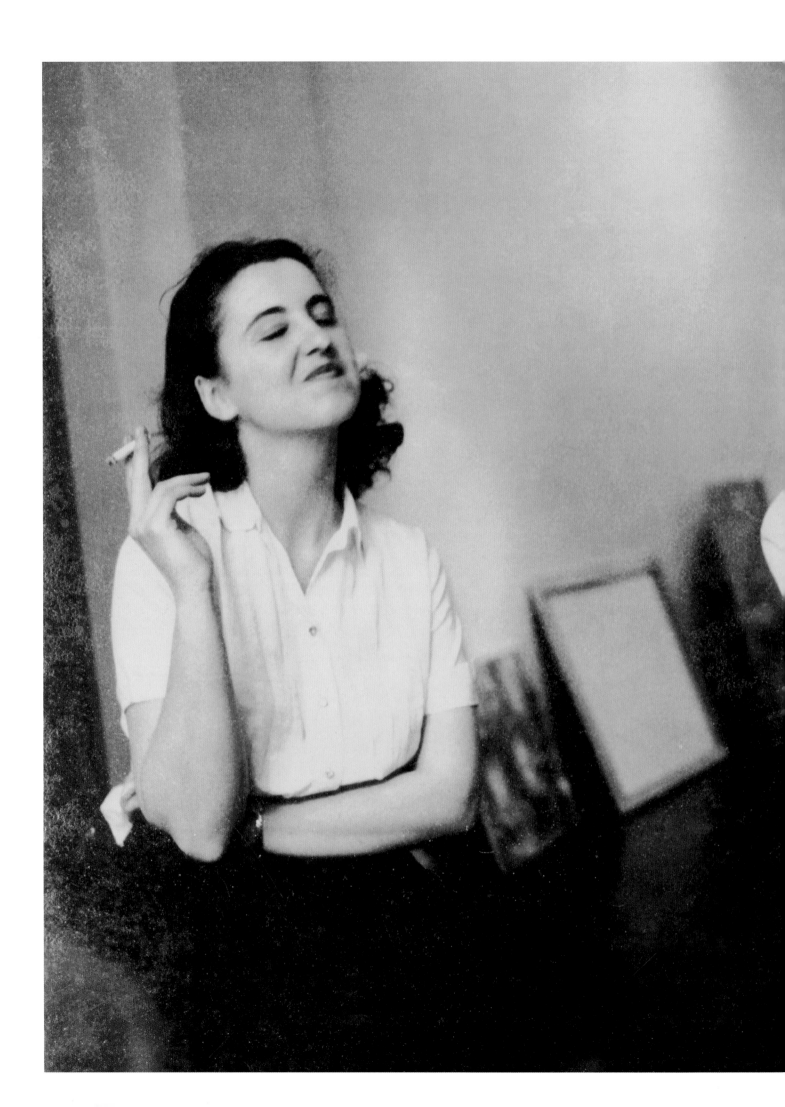

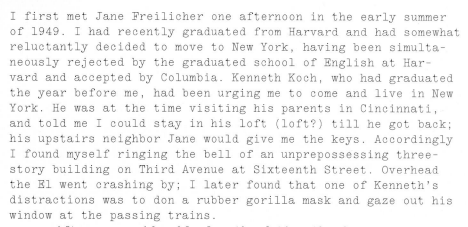

JANE FREILICHER

John Ashbery
From *Jane Freilicher: Paintings 1953–85*, 1986

I first met Jane Freilicher one afternoon in the early summer of 1949. I had recently graduated from Harvard and had somewhat reluctantly decided to move to New York, having been simultaneously rejected by the graduated school of English at Harvard and accepted by Columbia. Kenneth Koch, who had graduated the year before me, had been urging me to come and live in New York. He was at the time visiting his parents in Cincinnati, and told me I could stay in his loft (loft?) till he got back; his upstairs neighbor Jane would give me the keys. Accordingly I found myself ringing the bell of an unprepossessing three-story building on Third Avenue at Sixteenth Street. Overhead the El went crashing by; I later found that one of Kenneth's distractions was to don a rubber gorilla mask and gaze out his window at the passing trains.

After a considerable length of time the door was opened by a pretty and somewhat preoccupied dark-haired girl, who showed me to Kenneth's quarters on the second floor. I remembered that Kenneth had said that Jane was the wittiest person he had ever met, and found this odd; she seemed to serious to be clever, though of course one needn't preclude the other. I don't remember anything else about our first meeting; perhaps it was the same day or a few days later that Jane invited me in to her apartment on the floor above and I noticed a few small paintings laying around. "Noticed" is perhaps too strong of a word; I was only marginally aware of them, though I found that they did stick in my memory. As I recall, they were landscapes with occasional figures in them; their mood was slightly Expressionist, there were areas filled with somewhat arbitrary geometrical patterns. Probably she told me she had done them while studying with Hans Hofmann, but it wouldn't have mattered since I hadn't heard of him or any other member of the New York School at that time. My course in twentieth-century art at Harvard had stopped with Max Ernst. (For academic purposes it was OK to be a Surrealist as long as the period of Surrealism could be seen as being in the past, and things haven't changed much since.)

Despite or because of our common trait of shyness, Jane and I soon became friends, and I met other friends of hers and Kenneth's, most of whom turned out to be painters and to have had some connection with Hofmann. (This is not the place to wonder why the poets Koch, O'Hara, Schuyler, Guest and myself gravitated toward painters: probably it was merely because the particular painters we knew happened to be more fun than the poets, though I don't think there were very many poets in those days.) There was Nell Blaine, whom the others seemed in awe of and who differed from them in championing a kind of geometric abstraction inflected by Léger and Hélion. There were Larry Rivers, Robert de Niro and Al Kresch, who painted in a loose figurative style that echoed Bonnard and Matisse but with an edge of frenzy or anxiety that meant New York; I found their work particularly exciting. And there was Jane, whose paintings of the time I still don't remember very clearly beyond the fact that they

CONTINUED

Jane Freilicher and John Ashbery
at the Tibor de Nagy Gallery, New
York City, 1952.

seemed to accommodate both geometry and Expressionist surges, and they struck me at first as tentative, a quality I have since come to admire and consider one of her strengths, having concluded that most good things are tentative, or should be if they aren't.

At any rate, Jane's work was shortly to change drastically, as were mine and that of the other people I knew. I hadn't realized it, but my arrival in New York coincided with the cresting of the "heroic" period of Abstract Expressionism, as it was later to be known, and somehow we all seemed to benefit from this strong moment even if we paid little attention to it and seemed to be going our separate ways. We were in awe of de Kooning, Pollock, Rothko and Motherwell and not too sure of exactly what they were doing. But there were other things to attend to: concerts of John Cage's music, Merce Cunningham's dances, the Living Theatre but also talking and going to movies and getting ripped and hanging out and then discussing it all over the phone: I could see all of this entering into Jane's work and Larry's and my own. And then there were the big shows at the Museum of Modern Art, whose permanent collection alone was stimulation enough for one's everyday needs. I had come down from Cambridge to catch the historic Bonnard show in the spring of 1948, unaware of how it was already affecting a generation of young painters who would be my friends, especially Larry Rivers, who turned from playing jazz to painting at that moment of his life. And soon there would be equally breathtaking shows of Munch, Soutine, Vuillard and Matisse, in each of whom—regardless of the differences that separate them—one finds a visceral sensual message sharpened by a shrill music or perfume emanating from the paint that seemed to affect my painter friends like catnip. Soutine, in particular, who seems to have gone back to being a secondary modern master after the heady revelation of his Museum of Modern Art show in 1950, but whose time will undoubtedly come again, was full of possibilities both for painters and poets. The fact that the sky could come crashing joyously into the grass, that trees could dance upside down and houses roll over like cats eager to have their tummies scratched was something I hadn't realized before, and I began pushing my poems around and standing words on end. It seemed to fire Jane with a new earthy reverence toward the classic painting she had admired from a distance, perhaps, before. Thus she repainted Watteau's "Le Mezzetin" with an angry, loaded brush, obliterating the musician's features and squishing the grove behind him into a foaming whirlpool, yet the result is noble, joyful, generous: qualities that subsist today in her painting, though the context is calmer now than it was then. The one thing lacking our privileged little world (privileged because it was a kind of balcony overlooking the interestingly chaotic events happening in the bigger world outside) was the arrival of Frank O'Hara to kind of cobble everything together and tell us what we and they were doing. This happened in 1951, but before that Jane had gone out to visit him in Ann Arbor and painted a memorable portrait of him, in which Abstract Expressionism certainly inspired the wild brushwork rolling around like so many loose cannon, but which never loses sight of the fact that it is a portrait, and an eerily exact one at that.

After the early period of absorbing influences from the art and other things going on around one comes a period

of consolidation when one locks the door in order to sort out what one has and to make of it what one can. It's not a question—at least I hope it isn't—of shutting oneself off from further influences: these do arrive, and sometimes, although rarely, can outweigh the earlier ones. It's rather a question of conserving and using what one has acquired. The period of Analytical Cubism and its successor Synthetic Cubism is a neat model for this process, and there will always be those who prefer the crude energy of the early phase to the more sedate and reflective realizations of the latter. Although I have a slight preference for the latter, I know that I would hate to be deprived of either. I feel that my own progress as a writer began with my half-consciously imitating the work that struck me when I was young and new: later on came a doubting phase in which I was examining things and taking them apart without being able to put them back together to my liking. I am still trying to do that; meanwhile, the steps I've outlined recur in a different order over a long period or within a short one. This far longer time is that of being on one's own, of having "graduated," and having to live with the pleasures and perils of independence.

In the case of Jane Freilicher one can see similar patterns. After the rough ecstasy of the Watteau copy or a frenetic Japanese landscape she once did from a postcard came a phase in the mid-1950s when she seemed to be wryly coping what she saw, as though inviting the spectator to share her discovery of how impossible it is really to get anything down, get anything right: examples might be the painting done after a photograph by Nadar of a Second Empire *horizontale* (vertical for the purposes of the photograph) with sausage curls; or a still life whose main subject is a folded Persian rug precisely delineated with no attempt to hide the fact of the hard work involved. Her realism is far from the "magic" kind that tries to conceal the effort behind its making and pretends to have sprung full-blown onto the canvas. Such miracles are after all minor. Both suave *facture* and heavily worked-over passages clash profitably here, as they do in life, and they continue to do so in her painting, though more subtly today than then. That is what I meant by "tentative". Nothing is ever taken for granted; the paintings do not look as if they look themselves for granted, and they remind us that we shouldn't take ourselves for granted either. Each is like a separate and valuable life coming into being.

I was an amateur painter long enough to realize that the main temptation when painting from a model is to generalize. No one is ever going to believe the color of that apple, one says to oneself, therefore I'll make it more the color that apples "really" are. The model isn't looking like herself today—we'll have to do something about that. Or another person is seated on the grass in such a way that you would swear that the tree branch fifty feet behind him coming out of his ear. So lesser artists correct nature in a misguided attempt at heightened realism, forgetting that the real is not only what one sees not also a result of how one sees it—inattentively, inaccurately perhaps, but nevertheless that is how it is coming through to us, and to deny this is to kill the life of the picture. It seems that Jane's long career has been one attempt to correct this misguided, even blasphemous, state of affairs; to let things, finally, be.

CONTINUED

One of my favorite pictures from this period of slightly rumpled realism—which, in my opinion, though perhaps not in hers, reflects a quiet reaction against Expressionism. Impressionism and Realism all at once—a kind of "OK, but let's see what else there is" attitude—is a still life I own, of a metal kitchen table that she once used as a palette. It was perhaps done in a tiny cold-water flat in the East Village that was her studio in the mid-1950s. The walls were (and are in the picture) an unglamorous off-white, and there was little that was eye-catching in the apartment beyond some Persian print bedspreads, potted plants and cut flowers, which suffice to animate the pictures of that period with luscious but low-keyed arabesques that wouldn't be out of place in Matisse's Nice-hotel-room paintings of the 1920s. (One of her most beautiful works and one of the most magical paintings I know is a picture of a vase of iris on a windowsill at night, with the fuming smokestacks of a Con Ed plant in the background, proving that *luxe*, *calme* and *volupté* are where you find them.) Perhaps I chose the painting-table still life because of my own fondness for a polyphony of clashing styles, from highbred to demotic, in a given poem, musical composition (the "post-modern eclecticism"—unfortunate term—of David del Tredici and Robin Holloway, for instance or picture. "The Painting Table" is a congeries of conflicting pictorial grammars. There is a gold paint can rendered with a mellow realism that suggests Dutch still-life painting, but in the background there is a reddish coffee can (Savarin?) that is crudely scumbled in, whose rim is an arbitrarily squeezed ellipse—one understands that this wasn't the shape of the can, but that the painter decided on a whim rim is an arbitrarily squeezed ellipse—one understands that this wasn't the shape of the can, but that the painter decided on a whim that it would be this way for the purposes of the picture. Other objects on the table are painted with varying degrees of realism, some of them—the flattened tubes of paint and the blobs of pigment—hardly realistic at all. There is even a kind of humor in the way the pigment is painted. What better way than to just squeeze it out of the tube onto the flat surface of the canvas, the was it is in fact lying on the surface of the table, reality "standing in" for itself? But she doesn't leave it entirely at that; there are placed where she paints the image of the pigment too, so that one cant be exactly sure where reality leaves off and illusion begins. The tabletop slants up, the way tabletops are known to do in art since Cézanne—but this seems not the result of any Expressionist urge to set things on edge but rather an acknowledgement that things sometimes look this way in the twentieth century, just as the gold tin can is allowed to have its way and be classical, since that is apparently what it wants. The tall, narrow blue can of turpentine accommodates itself politely to this exaggerated perspective, but the other objects aren't sure they want to go along, and take all kinds of positions in connivance with and against each other. The surrounding room is barely indicated except for the white wall and a partly open window giving on flat blackness. (Is it that these objects have come to life at night, like toys in some *boutique fantasque*?) The result is a little anthology of ways of seeing, feeling, and painting, with no suggestion that any one way is better than another. What is better than anything is the renewed realization that all kinds of things can and must exist side by side at any given moment, and that that is what life and creating are all about.

Jane Freilicher, *John Ashbery*, ca. 1954.

One would expect that a painter who could give the assorted objects found on a tabletop at a given moment their due would not go out of her way to arrange things so as to make some point, and one would be right. It's always possible to tell whether a still life has been posed, even those that are meant to look chaotic and arbitrary, just as one can tell a *plein-air* landscape from one composed in the studio. The artist of the world can be divided into two groups: those who organize and premeditate, and those who accept the tentative, the whatever-happens-along. And though neither method is inherently superior, and one must always proceed by cases, I probably prefer more works of art that fall in the latter category. Not surprisingly, Jane Freilicher has never gone very far from home ("Wherever that may be," as Elizabeth Bishop reminds us) in search of things to paint. During the past twenty years she has divided the year between New York and a summer home in Water Mill, Long Island, and most of her paintings have been of views from her studio windows in both places, or of still lifes, self-portraits or portraits of friends. In 1975, as one of a group of artists commissioned by the Department of the Interior to paint the American scene for a show commemorating the Bicentennial, she was offered a trip to any American site she wished to paint, but settled for the landscape outside her window – a suitably American decision in the circumstances, for hasn't our popular music told us that "That bird with feathers of blue/ Is waiting for you/ Back in your own backyard"? Not that there is anything rigid or doctrinaire, either, in her choice. As must be obvious by now, such qualities are entirely absent from her work, but neither is there any implication that her surroundings are a bill of goods that has been paid for and must therefore make its presence known on canvas: she is capable of including a cat copied from Gainsborough in an otherwise straight-forward inventory of the studio's contents on a particular day—a shaggy bouquet of flowers with window, landscape and sky.

She has become one of those artists like Chardin, Cézanne or Giacometti who, unlike Delacroix or Gauguin, find everything that they need close at hand, and for whom the excitement of their craft comes not from the exotic costumes that reality wears in different parts of the world, but in the slight disparities in the sibylline replies uttered by a fixed set of referents: the cat, the blue pitcher, the zinnias, the jumble of rooftops or stretch of grass beyond the window. Yet how enormously, disconcertingly varied these answers can be. And how confusingly different replies to the same question ("What do I see?") would be if one lost sight of the fact that each is a major piece in the puzzle, that the only single answer is the accumulation of all of them, with provision made for those still to come. We should never lose sight of what Robert Graves, in his most famous line of poetry, tells us: "There is one story and one story only." But it is even more important to remember that it is minute variations in the telling that make this situation bearable and finally infinitely rich, richer than the anxious inventions of Scheherazade. Luckily we have artist of Jane Freilicher's stature to remind us.

PRECEEDING PAGES
Jane Freilicher, *The Painting Table*,
1954.

BELOW
Rudy Burckhardt, *Rooftops and
Water Towers II*, 1947.

Jane Freilicher, *Early New York Evening*, 1954.

Daily life is wonderfully full of things to see. Not only people's movements, but the objects around them, the shape of the rooms they live in, the ornaments architects make around windows and doors, the peculiar ways buildings end in the air, the water tanks, the fantastic differences in their street facades on the first floor. A French composer who was here said to me, "I had expected the streets of New York to be monotonous, after looking at a map of all of those rectangles; but now that I see the differences in height between buildings, I find I have never seen streets so diverse from another." But if you start looking at New York architecture, you will notice not only the sometimes extraordinary delicacy of the window framings, but also the standpipes, the grandiose plaques of granite and marble on ground floors of office buildings, the plaques of granite and marble on ground floors of office buildings, the windowless side walls, the careful, though senseless, marble ornaments. And then the masses, the way the office and factory buildings pile up together in perspective. And under them the drive of traffic, those brilliantly colored trucks with their fanciful lettering, the violent paint on cars, signs, houses as well as lips. Sunsets turn the red-painted houses in the cross streets to the flush of live rose petals. And the summer sky of New York for that matter is as magnificent as the sky of Venice. Do you see all this? Do you see what a forty- or sixty-story building looks like from straight below? And do you see how it comes up from the sidewalk as if it intended to go up no more than five stories? Do you see the bluish haze on the city as if you were in a forest? As for myself, I wouldn't have seen such things if I hadn't seen them first in the photographs of Rudolf Burckhardt. But after seeing them in his photographs, I went out to look if it were true. And it was. . . . Go and see them. There is no point in living here if you don't see the city you are living in. And after you have seen Manhattan, you can discover other grandeurs out in Queens, in Brooklyn, and in those stinking marshes of Jersey.

—Edwin Denby, from "Dancers, Buildings, and People in the Streets" (an essay prepared as a lecture to dance students at Juilliard but never delivered), 1954

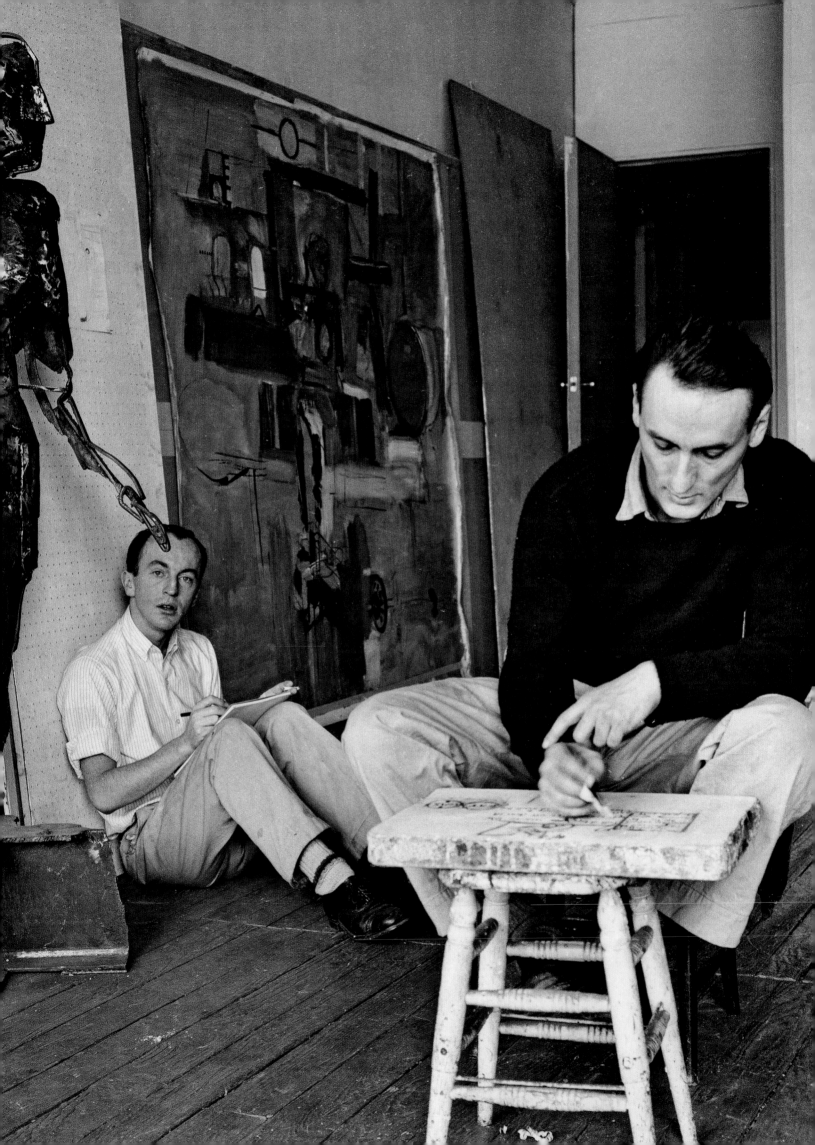

Go on Your Nerve

1955–1962

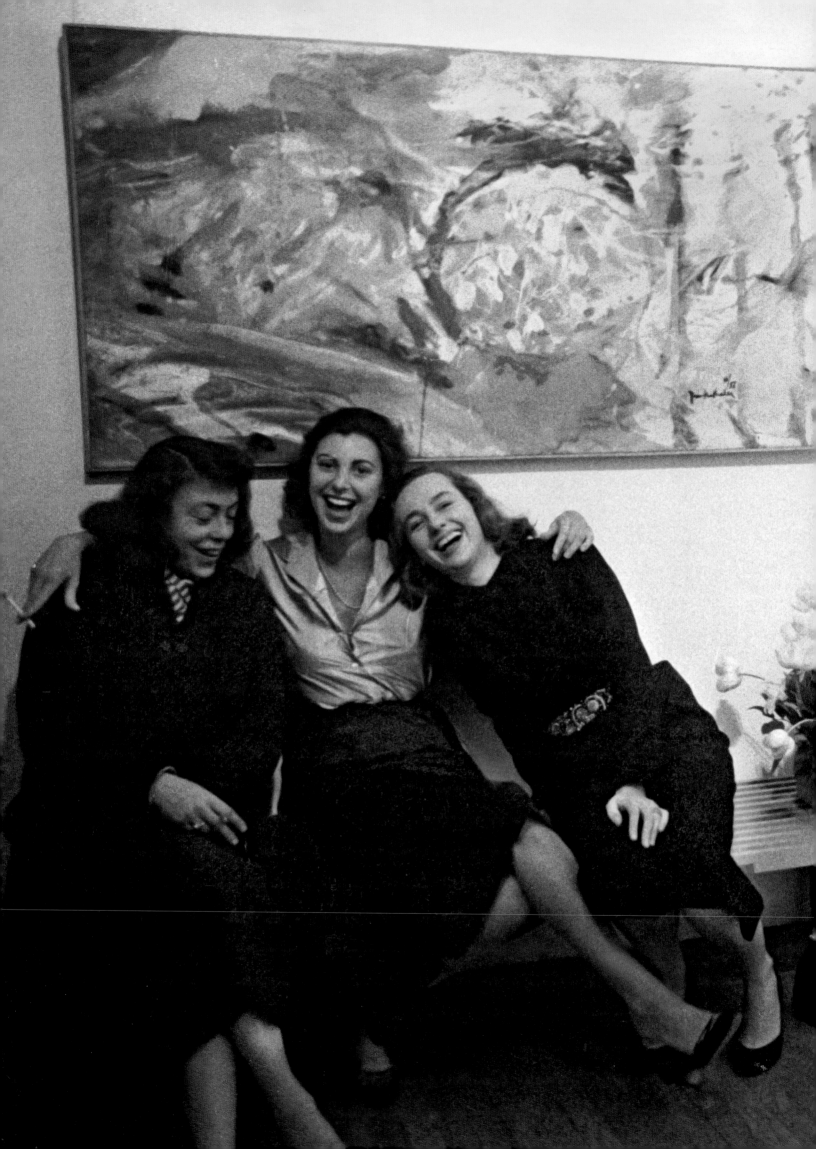

PREVIOUS PAGES
Larry Rivers and Frank O'Hara
working on *Stones*, 1958.

OPPOSITE
Joan Mitchell, Grace Hartigan, and
Helen Frankenthaler at an opening
of an exhibition of Frankenthaler's
paintings at Tibor de Nagy Gallery,
New York City, 1957.

I n the early and mid-1950s, Frank O'Hara shared an apartment with Hal Fondren on 49th Street that was so flooded by sunlight that sleeping during the day was impossible. Its view included the United Nations building, then being built only a block away.

In that part of town, the light feels strangely brighter, breezier than the rest of Manhattan, partly a result of the large green-glassed building and the fresh closeness of the East River. You can sense this in O'Hara's poetry written at the time; for instance, in "A Step Away from Them." "It's my lunch hour," the poem begins, "so I go / for a walk . . ." O'Hara records the various people on the street in midtown Manhattan, his lunch, his thoughts of others. "It is 12:40 of a Thursday," he notes, and everything seems right without trying to be so. "Neon in daylight is a / great pleasure," he observes, "as Edwin Denby would / write . . ." This kind of light offered clarity without contrast—and this white coolness also made its way into much of the poetry and art made during these years: into, for instance, the slightly overexposed young girl dancing her way through Bryant Park in Rudy Burckhardt and Joseph Cornell's film *Nymphlight* (1957) or Larry Rivers's use of white-yellow in paintings like *The Studio* (1956).

This light also came with music: as O'Hara put it in "A Step Away from Them," "everything honks" at the same moment. In those years, John Cage was teaching a course in experimental composition at the New School for Social Research, extending and explaining his aleatory games of chance in composition (one exercise consisted of listening to a pin drop) as well as writing music for Merce Cunningham's choreography. Cage was, as Morton Feldman later noted, one of the first to demonstrate how a composer might work with sound, rather than music. In 1960, he appeared on the popular television show *I've Got a Secret*. His "secret" was his instruments: a water pitcher, iron pipe, goose call, bottle of wine, electric mixer, whistle, watering can, ice cubes, two

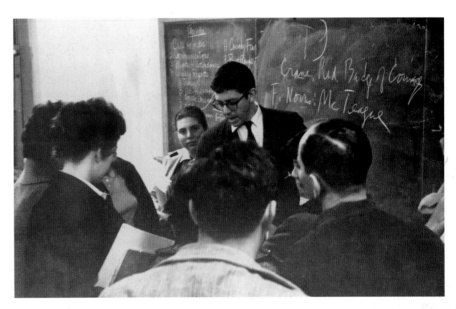

Kenneth Koch in an unidentified classroom, 1960s. Koch taught at Rutgers, Brooklyn College, Columbia University, and the New School where he also directed the poetry workshop program.

cymbals, mechanical fish, quail call, rubber duck, tape recorder, vase of roses, seltzer siphon, five radios, bathtub, and grand piano. The host warned Cage that the audience might laugh. "I consider laughter preferable to tears," Cage replied.

This light touch was prized in more than one kind of music: in the 1950s, New York was also an epicenter for the development of cool jazz, hard bop, and modal jazz. The musicians' sense of improvisatory play influenced many of the poets—including Clark Coolidge, then nineteen years old, who lived in the West Village for a year, from 1958 into 1959 (having dropped out of Brown). During this stint in the city, Coolidge met virtually no one from the circles he would later move in, but he spent his days and nights playing the drums and listening to jazz, nursing one beer through an evening at the Five Spot, Half Note, or Village Vanguard, listening to Thelonious Monk, John Coltrane, or Ornette Coleman. His later experiments with language would be strongly influenced by the musicians' approach to sense-making. At the time, jazz was strongly associated in the poetry world with the

In 1955, Joseph Cornell, the self-taught artist who lived in quasi-seclusion in Queens, famous among the avant-garde in New York for the surrealist tableaux he created inside boxes, rang Burckhardt and asked if he wanted to make a film together. Over the next two years, Cornell and Burckhardt shot the footage that would become *Nymphlight* (1957), *A Fable for Fountains* (1957), *Mozart on Mulberry Street* (1956) and *A Legend for Fountains* (1957, 1965).

ABOVE
Rudy Burckhardt and Joseph Cornell, still from *Nymphlight*, 1957.

OPPOSITE
Rudy Burckhardt and Joseph Cornell, stills from *What Mozart Saw on Mulberry Street*, 1956.

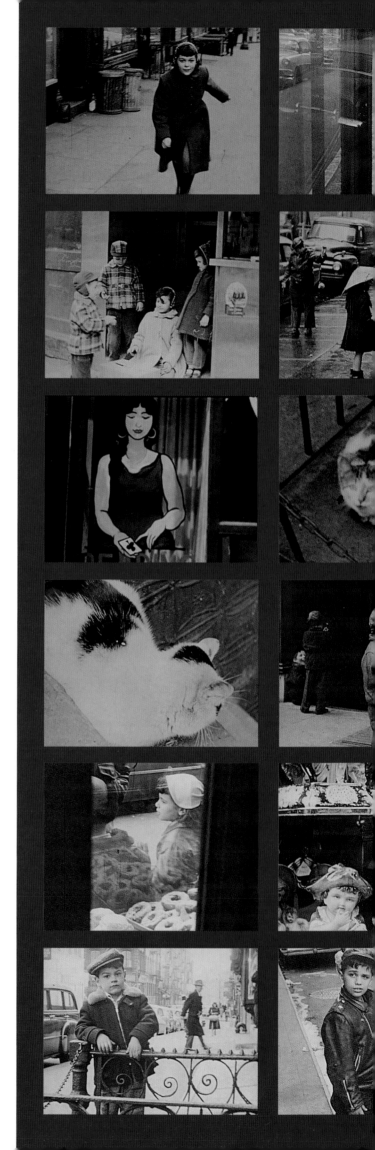

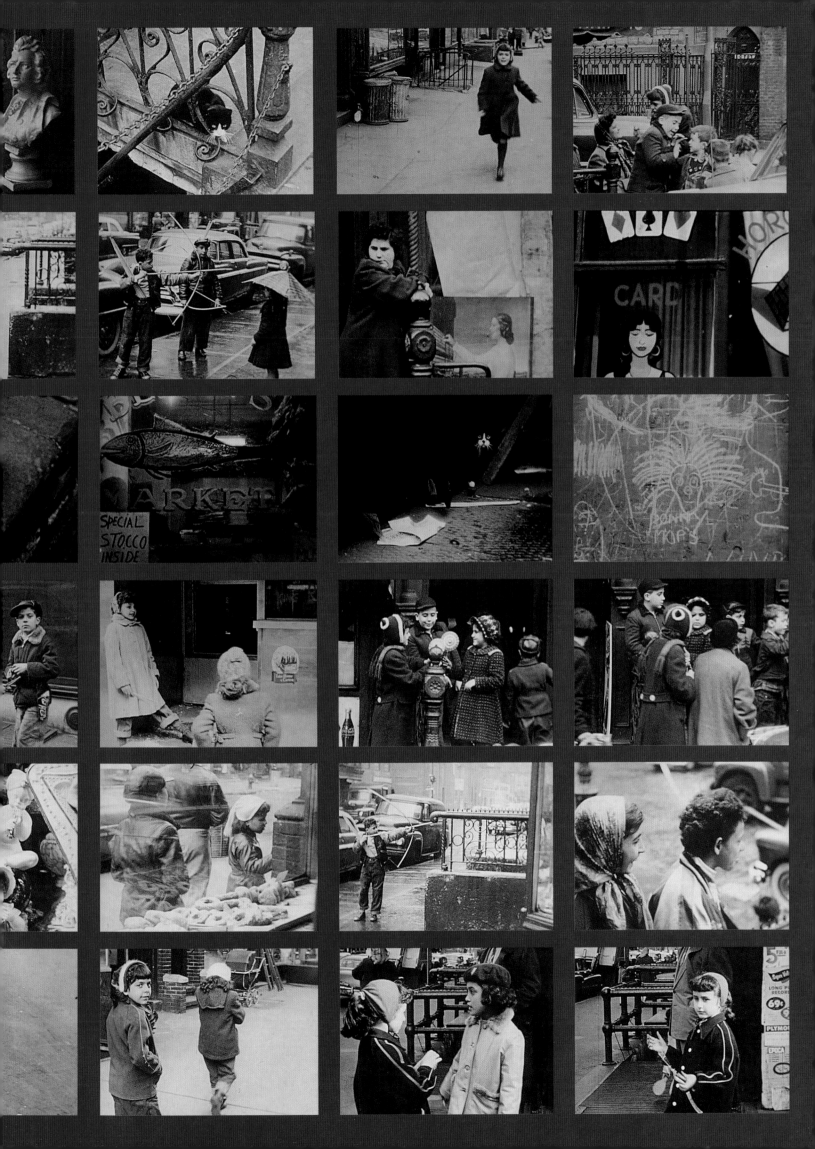

Larry Rivers, *Washington Crossing the Delaware*, 1953.

Beats: Jack Kerouac, for instance, would often read accompanied by David Amram on the piano or bongos. This sense of cool was read by some as overdetermined.[1] Kenneth Koch, for instance, satirized the impulse by reading the telephone book out loud at the Five Spot one evening, accompanied by Rivers on sax (who had organized a performance series there). Billie Holiday was allegedly in the room. "Man," she told Koch afterward, "your poetry is weird."

To Alex Katz, a young painter who had graduated from Cooper Union in 1949, jazz during this decade was becoming "more intellectual and cerebral and closed." He preferred to go dancing uptown at the Palladium to Afro-Cuban music. He and Burckhardt met each other at the Club, and shortly afterward, they decided to go dancing. Burckhardt arrived with a friend—an "elderly gentleman in a suit," as Katz later recalled, who didn't dance but was particularly curious about the differences between Afro-Cuban rhythms, between the merengue and the cha-cha. This was Edwin Denby.

Denby's curiosity, Katz later remarked, indicated a kind of classicism, a curiosity that was, "in a sense, big and impersonal rather than something constrained and linear." Denby's sense of tradition extended itself into the world rather than retreating from it. You could see it in the snappy, looping grace of his walk, which was frequently captured in Burckhardt's films. "Edwin was like my graduate school," Katz later noted. Katz began to make sculptures of his new poet friends, developing the technique of the cutout (which he also used to create the set for Koch's play *George Washington Crossing the Delaware* [1962]). That same year, an exhibition of these stand-alone figures at the Tanager Gallery drew, as O'Hara wrote to Vincent Warren, "lots of favorable comment": "Edwin [Denby] went into the office to make a phone call and when he hung up he addressed a remark to my cut-out, which was right near the door with its back to him, and then wondered why I hadn't answered."

Katz's poise had to do with an urbanity present in much of the art at this time—a kind of New York cool. Koch's poem "Fresh Air," written in 1956, is precisely that—a blast of fresh air down the avenues:

> Blue air, fresh air, come in, I welcome you, you are
> an art student,
> Take off your cap and gown and sit down on
> the chair.
> Together we shall paint the poets—but no, air!
> perhaps you should go to them, quickly,
> Give them a little inspiration, they need it, perhaps
> they are out of breath,
> Give them a little inhuman company before they
> freeze the English language to death!

Worried that some parts were too loud, too boisterous, Koch showed the poem to Ashbery, who replied with encouragement, "The louder the better, says this reader."

Koch wasn't the only one calling for a new kind of sensibility. In 1953, Rivers and Frank O'Hara began writing the mock manifesto "How to Proceed in the Arts: A Detailed Study of the Creative Act" (see pages 120–123), which was mostly advice for the younger artist, and which included witticisms like "Don't just paint. Be a successful all-round man like Baudelaire," or "When involved with abstractions, refrain, as much as possible, from personal symbolism, unless your point is gossip. Everyone knows size counts." A sense of disobedience quite naturally marked them out as inheritors of a tradition. "We all know Expressionism has moved to the suburbs," O'Hara and Rivers announced. "If you are interested in schools, choose a school that is interested in you. Piero della Francesca agrees with us when he says, 'Schools are for fools.'" (As O'Hara observed of their advice in a letter to Rivers, "in our own discursive way we are getting to be the moralists of our time, since we are always trying to tell people how to act.")

In 1959, Alex Katz found that one of his paintings wasn't working out. Figures weren't connecting to the background in a satisfactory way, and it did not appear that they would. But Katz liked the figures, so he cut them out and pinned them to the wall. Some time later he mounted them on plywood and gave them bases. Soon he was painting directly on metal and cutting out the image with a power saw. Freestanding figures were being envisioned from the outset. The cutout had been invented. These works occupy our space like sculptures, but their physicality is compressed into planes, as with paintings. So they are neither paintings nor sculptures. The word "effigy" hovers around them.

— Carter Ratcliff, from "Alex Katz's Cutouts," 2003

Alex Katz at the Martha Jackson show of his cutouts for Kenneth Koch's play, *George Washington Crossing the Delaware*. Photograph by Rudy Burckhardt, 1961.

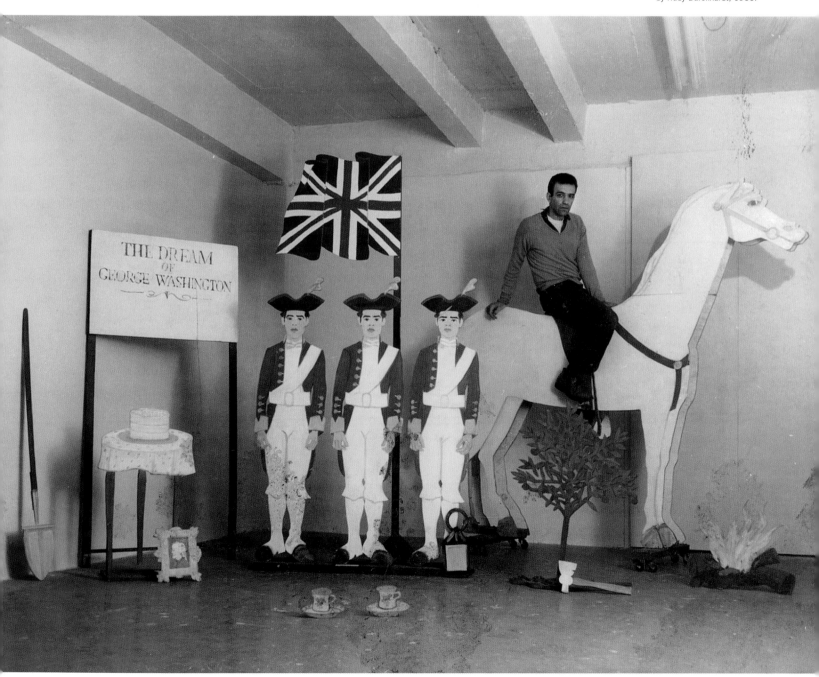

BEAN SOUP - .35
w/ ORDER - .25

BEEF GOULASH 1.25
LAMB SHANK 1.00
HAWAIIAN HAM STEAK 1.35

LIMA BEANS BOIL POTS
SALAD HOME FRYS

Balla

The poets were all, in some fashion or another, on their way—going, as O'Hara would put it, "on your nerve." Returning from a road trip to Mexico with Jane Freilicher, Joe Hazan, Grace Hartigan, and Walt Silver in 1954, John Ashbery was informed that he had been awarded a Fulbright to study in France. He departed for Montpelier that September, and moved to Paris in the new year—where he lived for the next decade, making a living as an art critic for the *International Herald Tribune* and a translator of French detective novels. O'Hara, having started out at the membership desk at the Museum of Modern Art, began to make inroads into the curatorial department, working as an assistant in the International Program and helping prepare overseas exhibitions like *The New American Painting*. In 1959, Koch was appointed as associate professor of English and Comparative Literature at Columbia University.

And the painters were also making their own way. "Youth wants to burn the museums," O'Hara and Rivers announced in "How to Proceed in the Arts." "We are in them—now what?" Earlier that year, MoMA had purchased Rivers's painting *George Washington Crossing the Delaware* for $2,500. It was not the museum's first acquisition from this generation of younger painters; in 1953, Alfred J. Barr had lifted Hartigan's painting *Persian Jacket* right off the wall at the Tibor de Nagy Gallery and taken it with him in a cab back to MoMA. To the younger painters, purchases like these felt like lightning strikes. All of a sudden, the gods of modern art might descend and anoint you as collectible. But for Hartigan, these moments seemed too far and few between. In the previous two and a half years, she had sold only one painting, and although she was selected for the *Twelve Americans* show at MoMA in 1956, the only woman so chosen, her diary indicates that she felt this was an exception rather than any epochal shift. The poets also considered their gains reasonably tenuous. In 1961, Ashbery would mournfully note in a letter to Harry Mathews that "life is beginning [to] resemble a game of Monopoly when everybody else is building hotels on Park Place and you have only three houses on Baltic Avenue." The Guggenheim Foundation had just turned him down—for the sixth time.

Nonetheless, as these young poets and artists moved into their thirties, there was, increasingly, the

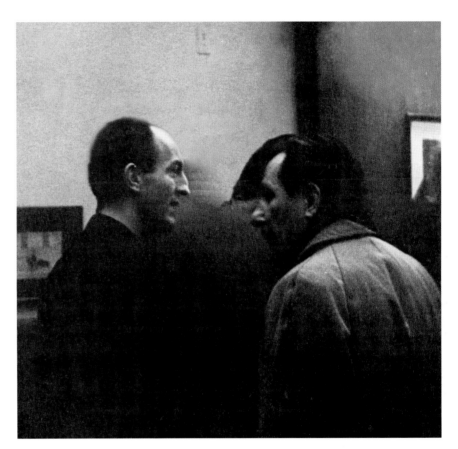

accumulated weight of a shared life together. O'Hara described this well in "Poem Read at Joan Mitchell's." All he wanted, he wrote, was more: "more / more drives to Bear Mountain and searches for hamburgers, more evenings / avoiding the latest Japanese movie and watching Helen Vinson / and Warner Baxter in *Vogues of 1938* instead . . ." (The wish was possibly elegiac; the shadow corollary of "more," of course, was "enough.") He added:

> *This poem goes on too long because our friendship has been long, long*
> *for this life and these times, long as art is long and un-*
> *interruptible,*
> *and I would make it as long as I hope our friendship lasts if I could*
> *make poems that long*

O'Hara had long been writing poems about his friends; in 1951, he had taken to heart Paul Goodman's argument (published that year in *The Kenyon Review*) that poetry ought to "bathe in the everyday," and that

Frank O'Hara and Franz Kline, Cedar Tavern, New York City, 1959.

"Occasional Poetry," said Goethe, "is the highest kind— for it gives the most real and detailed subject-matter, it is closest in its effect on the audience, and it poses the enormous problem of being plausible to the actuality and yet creatively imagining something, finding something unlooked for. . . . An aim, one might almost say the chief aim, of integrated art is to heighten the everyday; to bathe the world in such a light of imagination and criticism that the persons who are living in it without meaning or feeling suddenly find that it is meaningful and exciting to live in it."

—Paul Goodman, from "Advance-Guard Writing, 1900–1950"

this everyday involved the "physical reestablishment of community" for the avant-garde. In order to solve "crises of alienation," Goodman wrote, the artist needed to take "the initiative precisely by putting his arms around them [other artists] and drawing them together. In literary terms this means: *to write for them about them personally*" (emphasis Goodman's). At the time, O'Hara had praised Goodman's essay to others for its prescience; to Freilicher, he wrote, "It is really lucid about what's bothering us both besides sex, and it is so heartening to know that someone understands these things . . . just knowing that he is in the same city may give me the power to hurt myself into poetry." In Goodman's lines, O'Hara recognized an imperative to make art for and about one's friends.[2] Poetry could be occasional, a gift, a recognition of social pleasures. "Poem Read at Joan Mitchell's," for instance, was written for the occasion of Jane Freilicher and Joe Hazan's wedding, in 1956.

O'Hara's tendency to name his friends in his poetry only grew more pronounced as the 1950s progressed. It became a conscious aesthetic, one that he enacted in his poetry and wrote about in his prose— in particular, his mock manifesto, "Personism," which was written in about an hour on September 3, 1959, and which retains the sharp edge of something written in a rush, more like improvisatory jazz than the Rachmaninoff he was listening to. In it, he offered advice on writing, "at the risk of sounding like the poor wealthy man's Allen Ginsberg." "Personism," he wrote, is "a movement which I recently founded and which nobody knows about." It is opposed to any kind of abstract removal, any grand philosophizing. Rather, he wrote, any sense of abstraction should only arise from "the minute particulars where decision is necessary." These details of one's existence, described in poems, do "not have to do with personality or intimacy." Personism was not a form of biographical unburdening. However, O'Hara suggested, it did have to do with a sense of address and audience: "one of its minimal

aspects is to address itself to one person (other than the poet himself), thus evoking overtones of love without destroying love's life-giving vulgarity, and sustaining the poet's feelings towards the poem while preventing love from distracting him into feeling about the person."

The emotional precision of this complicated sentence is strangely exhilarating. Affection could act as a kind of creative catalyst, but it shouldn't be a smooth trade. Your love (for anyone and anything) could—and should—direct the focus of your own art without collapsing into sentimentality. Quite possibly, the reader would only dimly sense the exact source of that feeling, but the feeling must be there. O'Hara's affection here was like a skipping stone, his time with one person leading him to thoughts of another: intimacy widening, but not losing focus. O'Hara's clarity about the sociability of his art is particularly important for an understanding of New York School collaborations. He confirmed what might be at stake; that is, our sense of what an audience *is* in turn changes our understanding of what art *does*. "The poem is at last between two persons instead of two pages," O'Hara wrote. He intended the manifesto lightly, and it would be a mistake to push the connection between this piece of writing and his collaborations and poetry too far. But collaboration was (and is), of course, a curiously literal expression of his sentiment. To artists and poets without an established reputation, a sense of direct address created companionship in the moment of composition. The tone was distinct, intimate, even if the connections seemed elliptical or fragmentary.[3]

You can see this associative give-and-take very clearly in *Stones*, a collaborative set of twelve lithographs made by O'Hara and Rivers over a two-year period, from 1957 to 1959 (see pages 143–149). It was the first time (in this social circle) that an artist and a poet collaborated simultaneously, sitting side by side, working on the same surface together; in this case, O'Hara and Rivers took turns writing and drawing

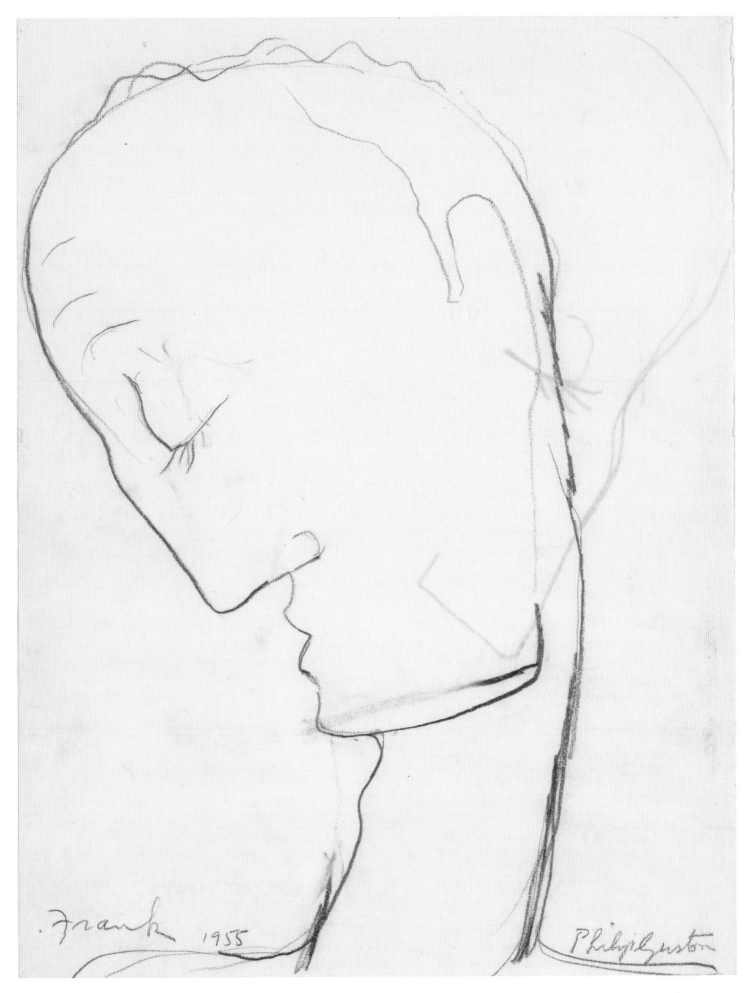

Phillip Guston, *Frank*, 1955.

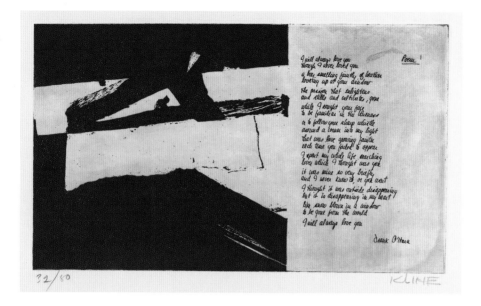

Franz Kline with "Poem" by Frank O'Hara, from *21 Etchings and Poems*, a limited edition set of collaborative prints conceived by Peter Grippe in 1951 at the graphic workshop Atelier 17. The etching project—which paired twenty-one artists with poets—was completed in 1960.

respectively with a crayon on the stone tablet. Writing about the process, Rivers was firm about what distinguished the collaboration: "This Siberian lady [Tatyana Grosman, the publisher of Universal Limited Art Editions (ULAE)] didn't just find some painter and some poet who would work together. She asked two men who really knew each other's work and life backwards which means to include all the absurdity and civilization a lively mind sees in friendship and art." For Rivers, it was the quality of the friendship that indicated the value of collaborative art, the emotional and intellectual reference each person would bring to the composition. Quite simply, the accumulation of time spent with a friend—the discussions about art, the dancing and parties, the movies seen and theater productions attended, visits to the opera and summer vacations, the money lent, witnessing of heartbreak, gossip, encouragement, slow fade and sudden infatuation—these experiences might be the shared ground from which an imagined world could be created. The depth of friendship had direct bearing on the quality of collaborative art that might be made.

For O'Hara, this depth also came from a kind of compression. These years were extraordinarily prolific ones for him. Consider, for instance, his date book for the second week of July, 1959. On Monday, he had lunch with the painter Norman Bluhm (with whom he would complete a series of collaborative poem paintings the following year). On Tuesday, he lunched with Le Roi Jones and wrote "Personal Poem." (While writing the poem, he later recalled that he realized "that if I wanted to I could use the telephone instead of writing the poem, and so Personism was born.") The same day, O'Hara had an unscheduled drink with the artist Jasper Johns, who asked him to recommend some writers to read. He dashed off a reading list that day (see pages 133–134). (The list is remarkable for its range; he encouraged Johns to read not only James Schuyler, Koch, and Ashbery, but also Michael McClure, John Wieners,

Gary Snyder, Philip Whalen, Gregory Corso, Charles Olson, and Jack Kerouac.) The next day, he wrote the well-known poem "All That Gas." On Thursday, he had drinks with Larry Rivers. On Friday, Billie Holiday died, which he wrote about that same day in his much-anthologized poem "The Day Lady Died." This was also the year that O'Hara published the first monograph on Jackson Pollock and the Tibor de Nagy Gallery mounted what *ARTnews* described as an "homage" to O'Hara, exhibiting Hartigan's *Oranges* and Rivers and O'Hara's *Stones*, as well as portraits of O'Hara by each artist. The extent of O'Hara's contribution to the art and poetry worlds was becoming increasingly clear.

By the late 1950s, O'Hara had grown a little apart from Freilicher, whose life had entered into a new kind of domesticity (her daughter, Elizabeth, was born in 1956). He had also fought, to some degree, with Schuyler, and their friendship had cooled. In 1960, Hartigan would dramatically break off all contact with O'Hara (following the advice of her therapist) and move to Baltimore. But there were other friendships: O'Hara grew close to Patsy Southgate (who was then married to Mike Goldberg), and to Bill Berkson, a young poet who had returned to New York from Brown University in 1959.

Berkson met O'Hara through the literature course he was taking with Koch at the New School. In this class, the sense that the arts were assuredly commingling in New York was made very clear. As Berkson later recalled, Koch would "make an analogy between some moment in a poem and the sensibilities of New York painting—the amplitude of a de Kooning, Larry Rivers's zippy, prodigiously distracted wit, or Jane Freilicher's way of imagining with her paint how the vase of jonquils felt to be on the windowsill in that day's light." Berkson became an assistant at *ARTnews*, and frequently joined O'Hara on sorties through the city, visiting Philip Guston in his studio one day, attending the ballet with O'Hara and Denby the next.

Song Heard Around St. Bridget's
Bill Berkson & Frank O'Hara, 1960

When you're in love the whole world's Polish
and your heart's in a gold stripped frame
you only eat cabbage and yogurt
and when you sign you don't sign your own name

If it's *above* you want and you know it
and the parting you want's in your hair
the yogurt gets creamy and seamy
and the poles that you climb aren't there

To think, poor St. Bridget, that you never got to see an
Ingmar Bergman movie
because you were forbidden our modern times
but you're not as old as all that, you're not a mummy
you saw the Armory Show and Louis Jouvet
and Mary of Scotland and ANCHORS AWEIGH

and we're sure
that you've caught up with La Vie et Esprit poetically pure
and are indeed quite contemporary and just as extraordinary
as ice cubes and STONES and dinosaur bones and manure

When you're in love the whole world's a steeple
and the moss is peculiarly green
you may not be liked or like people
but you know your love's on your team

When you're shaving your face is a snow bank
and your eyes are particularly blue
and your feelings may be fading and go blank
but the soap is happy "It's you!"

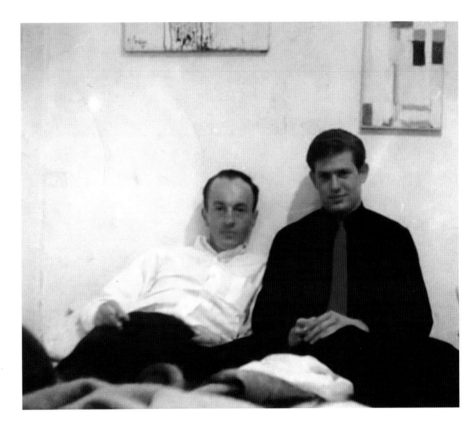

Frank O'Hara and Bill Berkson at
O'Hara's apartment on 441 East
9th Street, New York City, 1961.

TOP
Jane Wilson, Hal Fondren, Jane
Freilicher, Arnold Weinstein, Frank
O'Hara, Elaine de Kooning, Naomi
Newman, New York City, 1956.

BOTTOM
Gerard Malanga, LeRoi Jones,
David Shapiro, Bill Berkson,
Frank Lima, and Frank O'Hara
at Wagner College, 1962.

Everybody, he commented, was "keeping New York time." His appointment calendar for just one week in 1961 gives a good sense of the city's double time:

> Going to see a new French movie (Zazie dans le métro by Louis Malle), the New York City Ballet at City Center, an evening at my place with Frank [O'Hara], Joe LeSueur and Norman and Carey Bluhm to watch a Busby Berkeley musical on TV, a raft of lunches, two big midtown art parties (Earl and Camilla McGrath and Fay and Kermit Lansner), a Saturday date at the Tropical Gardens, and Mingus at the Jazz Gallery after. Madeleine Renaud was appearing in Beckett's Happy Days at the Cherry Lane. Nureyev and Fonteyn rocked the Met. At a benefit for Leroi Jones at the Living Theater (money for legal fees to clear The Floating Bear of obscenity charges), Frank and Morton Feldman played four-hand piano. Frank complained afterward of the difficulty of matching the lightness of touch that Feldman's pieces required and that Feldman's own large fingers could muster.

That past winter alone, shows in Manhattan were hung and dismantled of work by Freilicher, Michael Goldberg, Norman Bluhm, Helen Frankenthaler, and Katz. There was a benefit sale of paintings for Nell Blaine, who had contracted polio in Greece; the show at the Poindexter Gallery included work by Elaine de Kooning, Joan Mitchell, Hans Hofmann, Ad Reinhardt, Guston, Robert Motherwell, Hartigan, Rivers, Frankenthaler, Robert De Niro, Sr., and Pollock. John F. Kennedy had been elected president, ushering in what felt like a new era of openness and support for the arts, including the "avant-garde." (Jackie Kennedy even paid a visit to the Tibor de Nagy Gallery, looking to purchase art for the White House. She selected a collage by Robert Goodnough.)

All in all, there was increasing recognition of O'Hara and his friends as a distinct group, as a coterie with public dimensions. In 1959, the collector B. H. Friedman published the book School of New York: Some Younger Artists, which took Motherwell's phrase, coined a decade before, and applied it to younger painters and writers.[4] "An exchange between the various arts is developing in this generation," Friedman wrote in his introduction, which "can only be beneficial to everyone involved."[5] This translated into an assured self-confidence, a kind of sass. Consider the following excerpt from "A Hearsay Panel," published in ARTnews in 1959, which O'Hara, Goldberg, Elaine de Kooning, Bluhm, and Mitchell collaboratively wrote. It was purportedly a transcript of comments made at an evening's discussion at the Artists' Club:

> Joan: We'll open with a question. Is style hearsay?
>
> Frank: Well, Pavia says, nowadays everyone talks about you behind your back in front of your face.
>
> Elaine: Yes. Philip Guston told Andrew Wyeth that Louis B. Mayer told John Huston: Well, if you don't like it here, go back to Greenwich Village and starve on a hundred dollars a week.
>
> Norman: Frank says: Style at its lowest ebb is method. Style at its highest ebb is personality.
>
> Mike: Norman is worried because lately he finds himself being polite to everyone. He meets someone and he says How do you do? I'm very happy to meet you when he's not happy at all.
>
> Elaine: At openings, Norman says, the greeting of people has nothing to do with the greeting of people. Norman also thinks the Whitney Museum looks like a drugstore.
>
> Norman: The feat that someone is liable to know something around here touches me.
>
> Frank: Harold Rosenberg says that artists read paintings and look at books.
>
> Norman: Would the noisy Black Mountain Boys stop picking the change off the bar.? We will buy you your beers anyway. . . .

There is a real confidence here that others would consider this kind of repartee funny; to publish dialogue like this in a magazine was quite different from performing it in a loft for a friend's birthday. Just as with The Coronation Murder Mystery, the key formulation was that everyone is always quoting someone else: Pavia says, Philip Guston told, Frank says, Norman says, Rosenberg says . . . In a sense, this displacement is an echo of "Personism"—that is, it is a slippery triangulation of authority by aestheticizing gossip. Gossip was the thing that made the private public. But if one were in the know, it also marked exclusivity, indicating an obscure privacy in the midst of a public event.

When O'Hara had lunch with LeRoi Jones—his lunch date in "Personism"—gossip would've definitely been on the menu. At this time, Jones saw the downtown poetry scene as "very political, and very much he-said and she-said, and rumors of this and rumors of that, and a coup in the East and a coup in the West." He and O'Hara, he said, were "allies," but the coups he described had to do with the perceived

Winter 1961 $1.00

LOCUS SOLUS
I

Summer 1961 $1

LOCUS SOLUS
II

A Special Issue of Collaborations
by

The Car
Jane Freilicher and Kenneth Koch, 1961

Choke: I am a bloke. My name is choke.
Wheel: I am a wheel, central feel of the automobile.
Gear: I am a gear. You all fear me.
Tires: I am the tires, a raspberry is filled with sins.
Window: I am a window. I know everything.
Windshield Wiper: I am a wiper of window that shieldwiper.
Crank: I am a crank.
Crankcase: I am a crankcase.
Nurse: Bottoms up.
Transmission: I am the transmission, ever close to you.
Trunk: I am a trunk, full of personality.
Dashboard: I am my setting sun, a dashboard.
Clutch: I clutch. We like each other.
Brake: Brake, brake, brake.
Shift: Shifty me you like to see.
Roof: I am roof, the winter's tooth.
Throttle: They call me throttle. Relax everybody.
Backseat: I am the backseat. Climb up and down.
Petroleum: I am petroleum, love's dream.
Doctor: Where the hell is that nurse?
Nurse: I am in the glove compartment.
Glove Compartment: I am the glove compartment, your love
department.

aesthetic differences between various groupings of poets. These groupings were hinted at in Donald Allen's anthology *The New American Poetry*, which, along with *Evergreen Review*, was about to bring before a much larger public the work of post–World War II anti-academic and anti-formalist poets.[6] Allen grouped the poets by geographic locale—separating the Beats from the Black Mountain poets and those in New York. Whether these groupings really mattered entirely depended on with whom you spoke, but there were moments of high melodrama, such as O'Hara's reading with Corso at the Living Theatre in 1959, which O'Hara described with glee in a long letter to Ashbery in France. Kerouac, heckling O'Hara from the audience, accused him of ruining American poetry. O'Hara replied, "That's more than you ever did for it." From the stage, Gregory Corso shouted out to de Kooning, "Now wasn't that beautiful, de Kooning? Aren't you going to give me a painting? Goldberg and Rivers did." De Kooning replied, "I'll give you a reproduction."[7]

It wasn't until three years later, in 1962, that the phrase "New York School of Poetry" was first floated as a group name for O'Hara, Ashbery, Barbara Guest, Schuyler, and Koch (along with Kenward Elmslie and Berkson). John Bernard Myers coined the term for *Nomad* magazine, writing that that he had begun to use it in conversation four or five years prior. (It is unclear if he did.) Myers was careful to note the poets' diffidence about the term. They didn't, he wrote, have "much in common, and if they did it would be quite certain one or more would instantly resign from 'The School.'" Nonetheless, he continued, they did have an association with New York City, had all been published by the Tibor de Nagy Gallery, and had an eye for art and art reviewing, and an interest in collaborating or at least "hanging around Larry Rivers" (a rather loaded comment, given his feelings about Rivers and O'Hara's relationship). The poets, he also noted, had been educated at Harvard or thereabouts, disliked literary pretentiousness, and liked the same people (the de

Koonings, Denby, Burckhardt, and Katz). They were "passionate about the New York City Ballet and the movies." All of this was certainly the case. And Myers's motivation in using the name was understandable; the name "New York School" had proven effective in promoting the postwar artists to audiences, and he reasoned the same tactic would help raise these poets' profile. Yet, in hindsight, what seems just as important in identifying a general manifestation was the poets' publication of the literary magazine *Locus Solus*. From 1961 to 1962, Ashbery, Schuyler, and Koch edited five issues (in rotation), and their selections offer one of the best definitions of the New York School as a thriving social circle: the first issue included Koch, Guest, Schuyler, Ashbery, O'Hara, and Mathews, but also Denby, Anne and Fairfield Porter, and Burckhardt. Harry Mathews, a writer and expatriate American living in Paris, published the magazine.[8]

The second issue of *Locus Solus*, edited by Koch, was devoted to collaboration. It was remarkable for its broad historical view; as Koch wrote in a letter to Mathews, "I have been doing research on the subject (collaboration). It's quite immense. Japanese do it. Indians do it. Surrealists do it." He began the issue with Chinese and Japanese poetry from the eighth to the fifteenth centuries, included a few examples of troubadour poetry, moved on to English collaborations (for instance, Shakespeare and John Fletcher, or Samuel Taylor Coleridge and Robert Southey) and then to Surrealist work, poetry by hoax modernist Ern Malley, cut-ups and collaborations by the Beats (William Burroughs and Corso reassembled Rimbaud's texts), and finally, work by the "New York School" and associates (including a chapter from *A Nest of Ninnies*). Koch, in this fashion, constructed a lineage for his and his friends' collaborations. It was one of the first times a New York School "member" had consciously reflected on the collaborative process and what possibilities it offered to the artist: "Collaboration," Koch wrote, "gives objective form to a usually concealed subjective phenomenon and

SALUTE

BY JAMES SCHUYLER PRINTS BY GRACE HARTIGAN

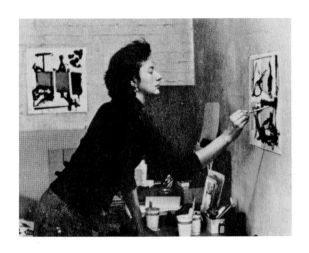

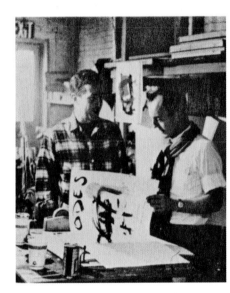

TIBER PRESS offers, in limited edition,
a set of four volumes of poetry by JOHN ASHBERY,
KENNETH KOCH, FRANK O'HARA, and JAMES SCHUYLER
illustrated with original silk screen prints by
JOAN MITCHELL, ALFRED LESLIE, MICHAEL GOLDBERG,
and GRACE HARTIGAN

CIAMPINO · ENVOI

Flying from Greece to see Moscow's dancing girl
I look down on Alba Longa, see Jacob's house
And the Pope's, and already the airplane's curls
Show St. Peter's, and the Appian tombs' remorse;
But Jacob, a two year old American
Is running in the garden in August delight;
'Forum not a park, Forum a woods,' he opines
In November quiet there on days less bright;
Now in New York Jacob wants to have my cat
He goes to school, he behaves aggressively
He is three and a half, age makes us do that
And fifty years hence will he love Rome in place of me?
For with regret I leave the lovely world men made
Despite their bad character, their art is mild

34

ROMAN FORUM

Spread from *Mediterranean Cities*, 1956. Poems by Edwin Denby, photos by Rudy Burckhardt.

therefore it jars the mind into strange new positions." The methodical way in which he charted these positions (complete with his extensive endnotes to each poem) is, in hindsight, fairly extraordinary.

There were other publications that also suggested these collaborative New York School groupings. In 1960, the Tiber Press (separate from the Tibor de Nagy Gallery) published a set of four limited-edition books: *The Poems* by Ashbery, with prints by Mitchell; *Permanently* by Koch, with prints by Al Leslie; *Odes* by O'Hara, with prints by Goldberg; and *Salute* by Schuyler, with prints by Hartigan.[9] These were large books, deliberately monumental, with silk-screen prints whose colors in the serigraph process burst across the page. Fairfield Porter reviewed them in *The Evergreen Review*, observing that these books "are the first [book-form] American example of extensive collaboration between poets and painters that I know of." In turn, Porter's review was the first example of a critic writing about these painters and poets together. His comments were revealing. Porter compared the Tiber books unfavorably to *Mediterranean Cities*, a collaborative book by Denby and Burckhardt, which had been published by Wittenborn and Company in 1961 and which seemed, to Porter, "a more organic collaboration." The book was a result of Burckhardt and Denby's travels through Europe in 1955 and 1956 (sometimes together, and sometimes separately).[10] In contrast, Porter thought there wasn't enough responsiveness in the Tiber books; the poets weren't necessarily responding to the artists, and the artists felt no close connection to the verse. Porter's review was a characteristically lucid and severe assessment of his milieu's potential—and this lucidity is particularly interesting given his deepening friendship and relationship with Schuyler at this time. "The artists have more in common than the poets," Porter wrote, and "the poets differ more than they resemble each other." His characterization of each poet's verse was extremely apt. Of Schuyler, he wrote, "He tends towards a deceptively simple Chinese visibility, like

transparent windows on a complex view." Ashbery's language, on the other hand, was "opaque; you cannot see through it any more than you can look through a fresco." Porter was one of the few critics to focus on articulating these poets' differences, rather than their supposed similarities.

In these years, Ashbery and Schuyler were continuing their own trans-Atlantic collaboration, attempting to finish *A Nest of Ninnies*. Because of the distance, they tried to write in sections rather than alternate sentences, but as Ashbery wrote to Schuyler, that method lacked "the nubbly, handwoven texture that we can probably only get by pitting our respective 'wits' against each other, which I think is the principal thing to be said in favor of the book." Not incidentally, much of the novel is in dialogue—which is entirely in keeping with the prominence of conversation in New York School collaborations. The comic intensity of Schuyler and Ashbery's collaboration came from characters' splitting of cultural hairs. Announcing their decision to open a 'notions' shop, for instance, two characters airily discussed their stock:

> "Well," Victor said, "you see, we're trying not to specialize—like French copper-bottomed pots, for instance. On the other hand, we are trying to play down Japan a little."
>
> "And what's more," Alice boomed with unexpected gusto, "we feel it's time the Western Hemisphere had its day in court. Besides Guatemalan rebozos, we're getting some Eskimo walrus-tooth accessories and some Navajo turquoise and silver jewelry that's not the usual junk."

The humor of *A Nest* was so particular that Ashbery and Schuyler applied the novel's title to all kinds of behavior; one could do a little Ninnying, one could be "very *Nest*." Certain characters were modeled on friends, and chapters, as they were completed, were

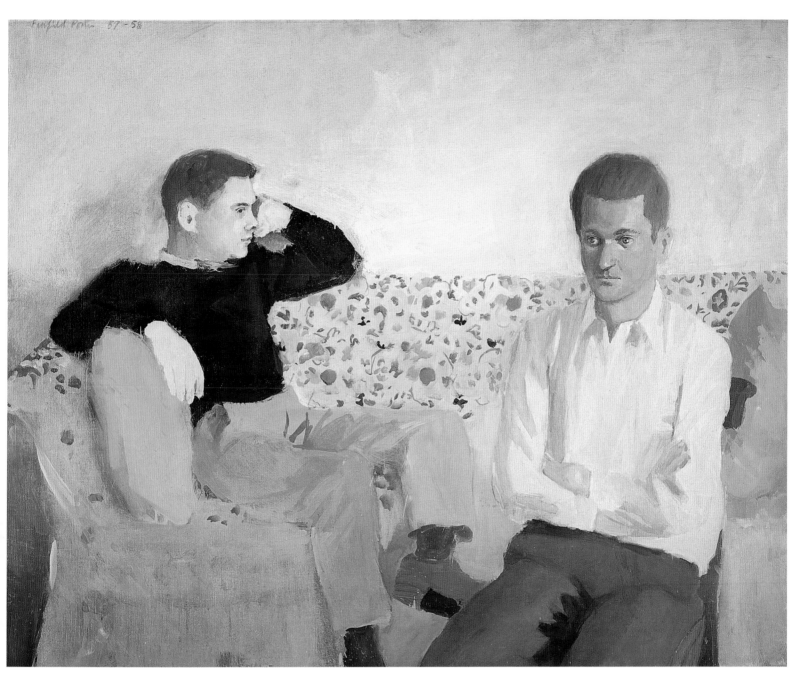

Fairfield Porter, *Jimmy and John*, 1957–58.

passed on from one person to another. When Maxine Groffsky, the editor of *The Paris Review* (and partner of Mathews) decided to serialize the novel, Mathews wrote to Ashbery that "Maxine almost mailed it [a chapter] to the printers without showing it to me, but I made such a fuss she went off to rescue it from her 'out' basket in the middle of the night. As I wiped away my happy tears, I realized that I had at last learned what it's like to travel with me." (In *A Nest*, Paul Lambert, a race-car driver, is obviously modeled on Mathews, and enters the narrative with flair: "the door burst open. A dark heavyset man of thirty-eight with busy but receding hair and wearing a black suit and raincoat advanced into the room. 'Well, Victor,' he said, or rather, roared, 'at last we meet!'") Accordingly, *A Nest*

became a cult classic within their circle before it was even close to being finished. When it was finally published in 1969, and Freilicher read the novel from cover to cover, she wrote to Schuyler in thanks, commenting, "I feel I have sat for quite a few life studies in it, especially Fabia Bridgewater." Freilicher continued, "But I guess that's what accounts for its profound universality. Gosh you boys are clever! A gold-mine of silliness, that's what it is." *A Nest* demonstrates, to quote Norman quoting Frank, just how much "style at its highest ebb is personality," and how the reverse might also be true. Consequently, a taste for "Ninnying about" could be just as much an indicator of a shared sensibility as the term "New York School" would ever be.

Eventually, Larry and I were featured players, running mates actually, in Kenneth Koch's play The Election, *which ran as an after-hours show at the Living Theater during Election Week 1960. Larry was LBJ and I was John F. Kennedy. Since Kenneth's script took off on Jack Gelber's play about addicts waiting for dope— the candidates were likewise strung out, needy for the vote—my part consisted mainly of laying around front stage in a withdrawal stupor while Larry/Lyndon speechified on the shortfalls of democracy. Before he became president, Kennedy's distinctive intonation wasn't so familiar to us; Kenneth knew he had gone to Harvard so he wanted my jivey entrance line delivered with a WASP-ish Ivy Leaguer's lockjaw drawl: "Oh mahn, ah'm wiggin'!" The improbability of following Kenneth's direction without appearing entirely off the mark got a laugh every time.*
—Bill Berkson, "A New York Beginner," 2003

LEFT
Kenward Elmlsie as Henry Cabot Lodge, Gary Goodrow as Dwight David Eisenhower, Larry Rivers as Lyndon Baines Johnson, and on the floor, Bill Berkson as John Fitzgerald Kennedy, in Kenneth Koch's play The Election, November 8 (election night), 1960.

BELOW
Amiri Baraka reads for a *Kulchur* magazine benefit at the Living Theater, New York City, 1961.

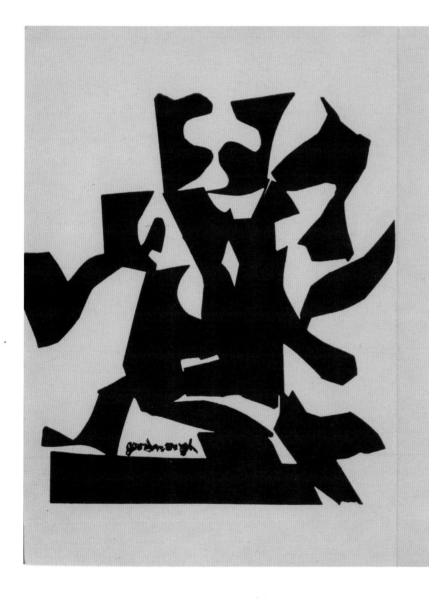

the location of things by bar bara guest col lage by robert goodnough tibor de nagy editions new york city 1960

TOP
Barbara Guest, Water Mill,
New York, 1962.

BOTTOM
The Location of Things, 1960.
Poems by Barbara Guest,
frontispiece by Robert Goodnough.
Published by Tibor de Nagy Gallery.

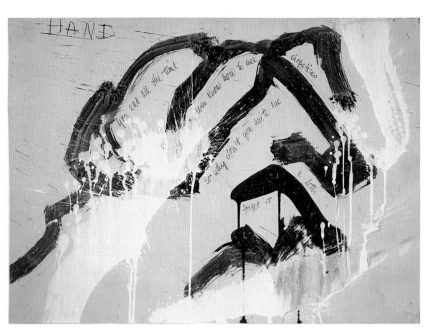

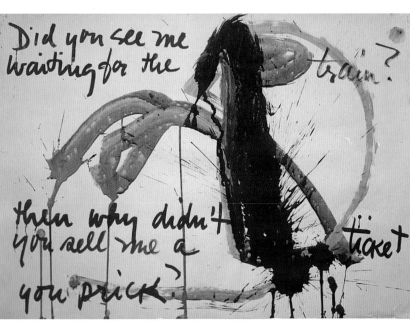

It was a Sunday, a dismal day in October, 1960. Frank O'Hara was supposed to come over to my studio and see what I was up to, and then we were going back to my house for lunch. Cary and I lived on 17th Street then, next door to Anton Dvorák, and Frank often came over to our house for lunch on Sundays.

My studio at the time was the top floor of the old Tiffany Glass building, 333 Park Avenue South. My landlord had found all these sheets of paper in the basement and had given them to me, and I had stapled a lot of them to the walls of my studio. Frank and I were sitting around in the studio, talking, and I believe Prokofiev's "Piano Sonata for Left Hand" was on the radio. We were talking about music. We both liked a lot of the same things, especially late nineteenth and early twentieth-century piano music and opera. Frank played piano beautifully, and I told him that when I was a child I had to play the cello. I only lasted a year, because I was so bad that they finally took the cello away from me. Frank and I often went to the opera together, along with Tom Hess, who was then the editor of ARTnews. His family had box seats. Of course, Frank liked lots of kinds of music, and so we also used to go to the Five Spot and other jazz clubs together.

At any rate, I was talking about the Prokofiev. I don't remember what I said, but to illustrate my point I took a brush and went up to the paper and made a gesture. And just like that, Frank got up and wrote something, "Bust," or something like that. He was open and quick, and we were talking, and what we did was part of our conversation. Right away, we decided to do some more. I drew a hand; he wrote something. We worked separately and together. The spontaneity of Frank and I doing twenty-six things at once meant that we would have different connections with different poem paintings. Each one was different. Frank would write something on a sheet of paper while I was in another part of the studio, making a gesture on the paper. It was all instantaneous, like a conversation between friends. You know, going back and forth. Quick and playful. There were no big thoughts, no idea that anyone would be interested in it or that it would ever be shown or published. We were just having fun on what had started out as a dismal Sunday afternoon. And what happened was an interlocking energy of words and art, but to be honeset, I think Frank's words are more creative and that my work is just the illustrative factor. . . .

—Norman Bluhm, from "Twenty-Six Things at Once: An Interview with Norman Bluhm," by John Yau and Jonathan Gams, 1996/ 97.

TOP LEFT
Norman Bluhm and Frank O'Hara, *Hand*, 1960.

BOTTOM LEFT
Norman Bluhm and Frank O'Hara, *Did You See Me?*, 1960.

OPPOSITE
Norman Bluhm and Frank O'Hara, *Meet Me in the Park*, 1960.

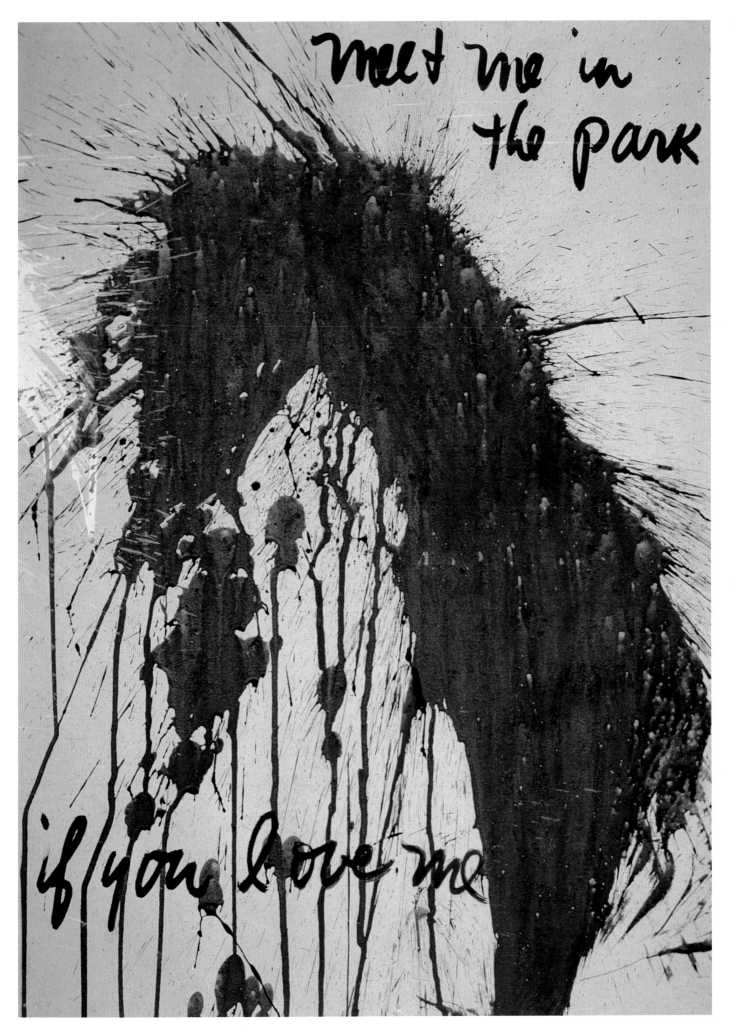

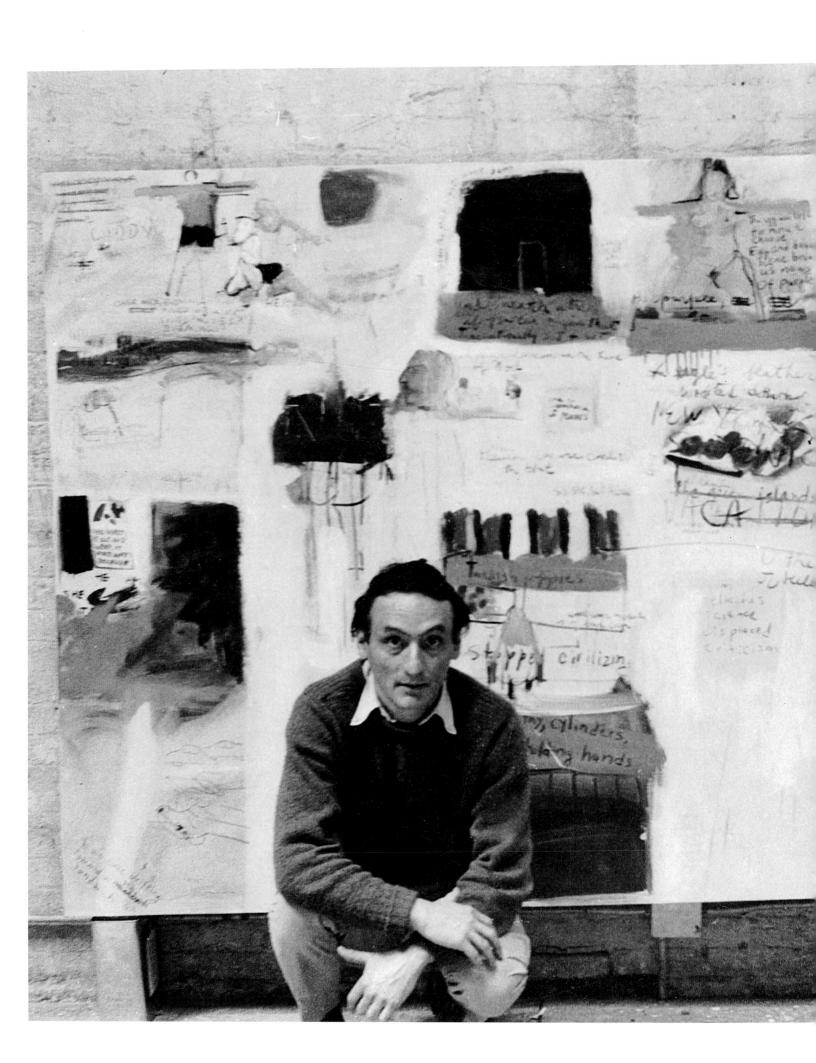

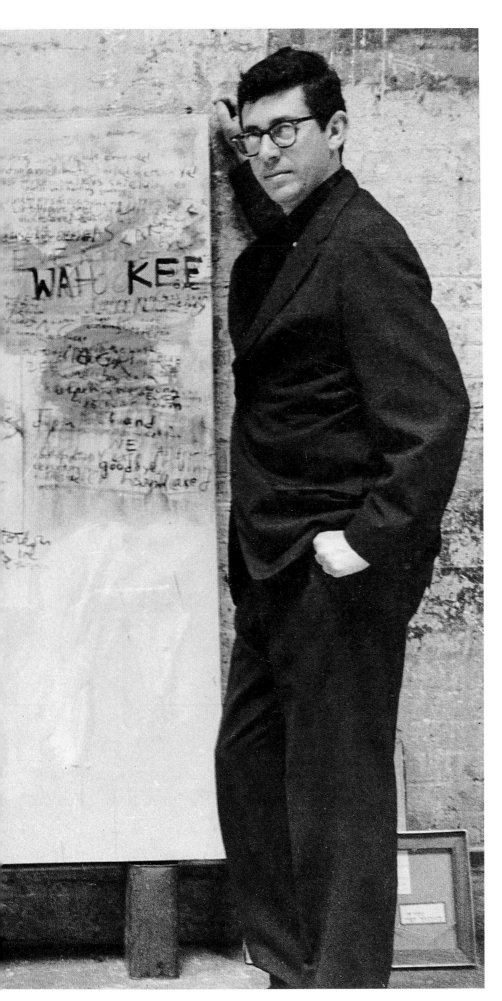

If the conceit beneath the "Stones" with Frank O'Hara was "Anything is possible if we turn to it" or "You name it we do it" with "Post Cards" and "New York 1950–60" with Kenneth it was "If we do it, anything is possible, and its name is marvelous." In the traditional sense our artistic personalities were not always comfortably compatible. The sentimentality surrounding an object or a fact of a situation can be a point at which I might feel ready to begin something using it in my own way. He is quite a McCarthy. Instead of communists he finds sentimentality everywhere and it governs to a great degree his choice of ideas, words, organization and so forth. It is his strength and leads him to little-nibbled pastures. From the inside looking out our "N.Y. 1950–1960" seems like a busy field on which there are, according to where you may look, combinations of mutual self-absorption, his openness to my color, my off the cuff responses to his sudden rain of words, ideas of space, uncritical and disgusting delight in our past, and if it is good, a constant reminder that everything, everything, even the nausea associated with being dumped by someone, is of some use. It was like a colorfully decorated gossip column where the content is so obscure you are forced to look for something else to distract yourself. What it was for us was chunks of the canvas devoted to mutually experienced parties, neighborhoods, resorts, houses, studios, people and restaurants. The purple that had Frank O'Hara's profile in it became a five cent postage stamp with a Kochian remark nearby. And so forth and so on until the canvas is covered and each of us becomes worried about his end of the affair . . . And so we say goodbye to the natives standing on the shore knowing we won't be remembered for what we tried but what we did.

—Larry Rivers, from "Life Among the Stones," 1963

Larry Rivers and Kenneth Koch with their collaborative work *New York, 1950–1960*, ca. 1961.

HOW TO PROCEED IN THE ARTS

Frank O'Hara and Larry Rivers, 1952 / 1961

I. A DETAILED STUDY OF THE CREATIVE ACT

1. Empty yourself of everything.
2. Think of faraway things.
3. It is 12:00. Pick up the adult and throw it out of bed. Work should be done at your leisure, you know, only when there is nothing else to do. If anyone is in bed with you, they should be told to leave. You cannot work with someone there.
4. If you're the type of person who thinks in words—paint!
5. Think of a big color—who cares if people call you Rothko. Release your childhood. Release it.
6. Do you hear them say painting is action? We say painting is the timid appraisal of yourself by lions.
7. They say your walls should look no different than your work, but that is only a feeble prediction of the future. We know the ego is the true maker of history, and if it isn't, it should be no concern of yours.
8. They say painting is action. We say remember your enemies and nurse the smallest insult. Introduce yourself as Delacroix. When you leave, give them your wet crayons. Be ready to admit that jealousy moves you more than art. They say action is painting. Well, it isn't and we all know Expressionism has moved to the suburbs.
9. If you are interested in schools, choose a school that is interested in you. Piero della Francesca agrees with us when he says, "Schools are for fools." We are too embarrassed to decide on the proper approach. However, this much we have observed: good or bad schools are insurance companies. Enter their offices and you are certain of a position. No matter how we despise them, the Pre-Raphaelites are here to stay.
10. Don't just paint. Be a successful all-around man like Baudelaire.
11. Remember to despise your teachers, or for that matter anyone who tells you anything straight from the shoulder. This is very important. For instance, by now you should have decided we are a complete waste of time, Easterners, Communists, and Jews. This will help you with your life, and we say "life before art." All other positions have drowned in the boring swamp of dedication. No one paints because they choose to.
12. If there is no older painter you admire, paint twice as much yourself and soon you will be him.
13. Youth wants to burn the museums. We are in them—now what? Better destroy the odors of the zoo. How can we paint the elephants and hippopotamuses? Embrace the Bourgeoisie. One hundred years of grinding our teeth have made us tired. How are we to fill the large empty canvas at the end of the large empty loft? You do have a loft, don't you, man?

CONTINUED

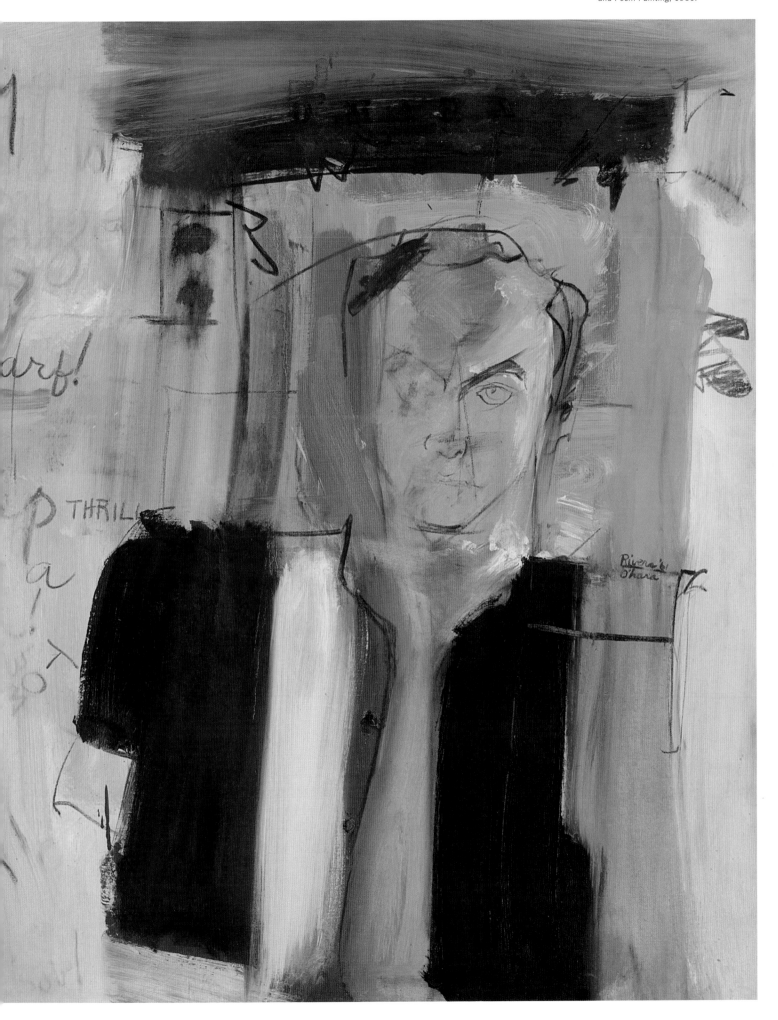

Larry Rivers and Frank O'Hara, *Portrait and Poem Painting*, 1961.

14. Is it the beauty of the ugly that haunts the young paint-
 er? Does formality encompass the roaring citadels of the
 imagination? Aren't we sick of sincerity? We tell you,
 stitch and draw—fornicate and hate it. We're telling you
 to begin. Begin! Begin anywhere. Perhaps somewhere in the
 throat of your loud asshole of a mother? O.K.? How about
 some red-orange globs mashed into your teacher's daily and
 unbearable condescension. Try something that pricks the air
 out of a few popular semantic balloons; groping, essence,
 pure painting, flat, catalyst, crumb, and how do you feel
 about titles like "Innscape," "Norway Nights and Suburbs,"
 "No. 188, 1959," "Hey Mama Baby," "Mondula," or "Still Life
 with Nose"? Even if it is a small painting, say six feet by
 nine feet, it is a start. If it is only as big as a postage
 stamp, call it a collage—but begin.
15. In attempting a black painting, know that truth is beauty,
 but shit is shit.
16. In attempting a figure painting, consider that no amount
 of distortion will make a painting seem more relaxed. Oth-
 ers must be convinced before we even recognize ourselves.
 At the beginning, identity is a dream. At the end, it is a
 nightmare.
17. Don't be nervous. All we painters hate women; unless we
 hate men.
18. Hate animals. Painting is through with them.
19. When involved with abstractions, refrain, as much as possi-
 ble, from personal symbolism, unless your point is gossip.
 . . . Everyone knows size counts.
20. When asked about the old masters, be sure to include your
 theories of culture change, and how the existence of a
 work of art is only a small part of man's imagination. The
 Greeks colored their statues, the Spaniards slaughtered
 their bulls, the Germans invented Hasenpfeffer. We dream,
 and act impatient hoping for fame without labor, admiration
 without a contract, sex *with* an erection. The Nigerians are
 terrible Negro haters.

II. WORKING ON THE PICTURE
The Creative Act As It Should Flow Along

1. You now have a picture. The loft is quiet. You've been
 tired of reality for months—that is, reality as far a
 painting goes. The New York School is a fact. Maybe this
 painting will begin a school in another city. Have you
 started—now a lot of completely UNRELATED green—yes,
 that's it. We must make sure no one accuses you of that
 easy one-to-one relationship with the objects and artifacts
 of the culture. You are culture changing, and changing
 culture—so you see the intoxicating mastery of the situa-
 tion. In a certain way, you are precisely that Renaissance
 painter whom you least admire. You are, after all, modern
 enough for this, aren't you? Don't be sentimental. Either
 go on with your painting or leave it alone. It is too late
 to make a collage out of it. Don't be ashamed if you have
 no more ideas; it just means the painting is over.

CONTINUED

2.	Colors appear. The sounds of everyday life, like tomato being sliced, move into the large area of the white cloth. Remember, no cameras are recording. The choice you make stands before the tribunals of the city. Either it affects man or infects him. Why are you working? No one cares. No one will. But Michelangelo has just turned over in his grave. His head is furrowed and you, like those dopey Florentines, accuse him of being homosexual. He begins to turn back, but not before you find yourself at his toes, begging for the cheese in between.

3.	At this point go out and have a hot pastrami sandwich with a side order of beans and a bottle of beer. Grope the waitress, or, if you are so inclined, the waiter. Now return to your canvas—refreshed and invigorated.

4.	Michelangelo??? Who likes cheese anyway? Call a friend on the phone. Never pick up your phone until four rings have passed. Speak heavily about your latest failure. (Oh, by the way is this depressing you? Well, each generation has its problems.) Act as if there is continuity in your work, but if there isn't it is because that position is truly greater. Point out your relationship to Picasso who paints a Cubist painting in the morning, after lunch makes a Da Vinci drawing and before cocktails a *Sturm und Drang* canvas out of the Bone Surreal Oeuvre. His ego is the pint of continuity.

5.	Do you feel that you are busy enough? Truly busy. If you have had time to think, this will not be a good painting. Try reversing all the relationships. This will tend to make holes where there were hills. At least that will be amusing, and amusement *is* the dawn of Genius.

6.	If it is the middle of the day, however, discard the use of umber as a substitute for Prussian blue. Imitation is the initial affirmation of a loving soul, and wasn't James Joyce indebted to Ibsen, and didn't we know it from his words "at it again, eh Ib."

7.	Later on, imitate yourself. After all, who do you love best? Don't be afraid of getting stuck in a style. The very word style has a certain snob value, and we must remember whom we artists are dealing with.

8.	Refine your experience. Now try to recall the last idea that interested you. Love produces nothing but pain, and tends to dissipate your more important feelings. Work out of a green paint can. Publicly admit democracy. Privately steal everyone's robes.

9.	If you are afraid you have a tour de force on your hands, be careful not to lean over backwards. It is sometimes better to appear strong than not to be strong. However, don't forget the heart either. . . . Perhaps we mislead you. . . . Forget the heart. To be serious means to include all. If you can't bear this you have a chance of becoming a painter.

10.	Whatever happens, don't enjoy yourself. If you do, all that has been wisely put here has been an absolute waste. The very nature of art, as opposed to life, is that in the former (art), one has to be a veritable mask of suffering, while in the latter (life), only white teeth must pervade the entire scene. We *cry* in art. We *sing* with life.

FAIRFIELD PORTER TO JAMES SCHUYLER

ca. 1961

Dear Jimmy:

It is raining, it is cold, the light does not inspire me to paint, I cannot write anything, and I find that what I want to do, even without any assurance that you will find it entertaining, is to write to you. Perhaps in this way can find out something for myself. It seems to me that I am getting less and less to depend on any specific audience but I still have to go through the form of addressing myself to one. Yesterday I painted something in the south meadow that is no good, that is all scraped off, strawberries. Which are very thick there.

I suppose it is dull of me, but the parts I like in Proust are the somewhat aphoristic parts (is this an example of "measuring the immeasurable"?) like that in Elstir's paintings there was a metamorphosis of things represented analogous to metaphor "and that if God the Father had created things by naming them, it was by taking away their names or giving them other names that Elstir created them anew. The names which denote things correspond to an intellectual nation alien to our true impressions."

Also, "every big thing which we have begun by fearing, because we knew it to be incompatible with smaller things to which we clung . . . does not so much deprive us as it detaches us from them." And "to strip our pleasures of imagination is to reduce them to their own dimensions, that is to say nothing." And "so long as you distract your mind from its dream, it will not know them for what they are; you will always be being taken in the appearance of things."

Sometimes Bill de Kooning makes metaphors of say a woman with a building, but this, in so far as I can name the metaphor that he is using, is literary, and it would be to me more interesting to make a metaphor in a painting that cannot be named as a thing, but only described in its colors and shape, if you describe it in words. "Realistic" painting does this better than abstract painting, except some of Joan Mitchell's landscapes, because abstract painting is usually in so far as it is abstract, extremely matter-of-fact. Please do not think that I am rating paintings, I am only writing of what interests me for myself to do, right now. If I do it I may cease to want to do it, and want to do something I cannot now foresee. I would like to write using words as their meanings change, so much that they can mean something that the first meaning could not include. I suppose I like to write sestinas because they provide me with an excuse to do this. I would like to do it without being bound by sestinas, but I don't know how.

I am glad I did not send you the analysis of your, Frank's, John's and Kenneth's poetry: it would have annoyed you because it was of necessity comparative. Of yours I think that what is good, as well as an accuracy of word—"Words present to

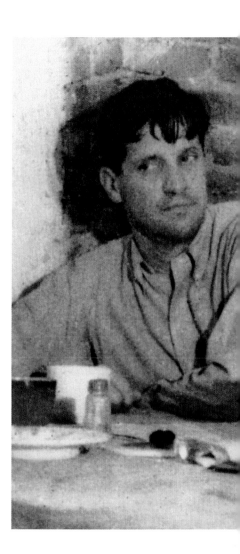

us little pictures of thing[s] lucid and normal, like the pictures that are hung on the walls of schoolrooms to give children an illustration of what is meant by a carpenter's branch, a bird, an anthill" is an accuracy of sentiment; and that when you are not good, it is because you censor your emotions, in the interest of Verlainian purity of lyrical integrity; that when you are not good, you are being influenced by your Christian Science background, and that when your emotion is most accurate you do not censor your emotions, but that the emotion is that of that wild party of high school, full of drinking and fucking.

In the middle of the last paragraph, I went down to the fire, paced up and down, went to the kitchen for some rum, and had a conversation with Anne about this very thing. The odd thing is that I like talking to you only for what you (I hope) will say to me, that talking to you is an attempt on my part to make you talk, so I can listen, whereas I like to *talk* to Frank, who talks a lot, but to whom I prefer to talk over listening to him.

Katy yesterday on the way back from the south meadow picked daisies with stems only an inch long, and some hawkweed, and anything else, and I only knew about it on seeing a low glass dish on the table paved with these flowers, like a hat, or a glass paper-weight, all of which she did herself, with no thought of any audience, with no thought of hiding it from me, what she was doing, nor of later presenting it as a surprise. "Elle est dans le vrai," n'est-ce pas.

I noticed downstairs in the kitchen that I had not yet mailed a letter I wrote yesterday, answering your practical letter, so you can know from this, that this letter follows that one.

I dislike, I am bored by, theological talk, such as Harold Rosenberg indulges in, (or Paul Mattick, but better) and P. R. I like specific and immediate stuff such as I get from you. If I become "theological" it is from being upset. Perhaps that is why I dislike it.

I hope you have not been put off by my upsetness.

Fairfield

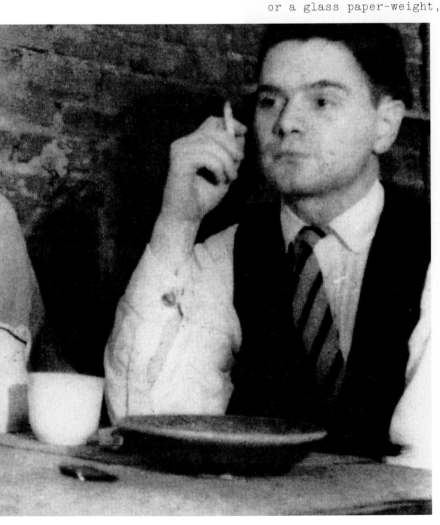

Fairfield Porter and James Schuyler, 1955.

CRONE RHAPSODY

John Ashbery & Kenneth Koch, 1961

"Pin the tail on the donkey," gurgled Julia Ward Howe. A larch shaded the bathtub. From the scabiosa on
the desk

The maple gladioli watched Emily Post playing *May I?* in the persimmon bathtub with the fan.

"Nasturtiums can be eaten like horseshoes," murmured the pumpkin, "but on Hallowe'en when Cécile
Chaminade's *Rhapsody* roars in the beeches and a bathtub chair

Holds Nazimova, a lilac palm plays mumbledy-peg with an orange bathtub filing cabinet,

And Queen Marie of Roumania remembers the Norway maple." Pitching pennies from the cantaloupe bathtub, I
remembered the poppy and the typewriter,

The mangrove and the larkspur bathtub. I saw a banana Carrie Nation ducking for apples in the lamp.

Oak dominoes filled the bathtub with a jonquil. A crabapple rolled slowly toward the Edith Wharton lamp,

Crying, "Elm shuffleboard! Let the bathtub of apricots and periwinkles give May Robson a desk!"

"Heavy, heavy hangs over thy head," chanted the black raspberry. A zinnia dropped from the plane tree into a
rotting bathtub. Dame Myra Hess slumped over the typewriter

And wrote, "Dear Madame de Farge: A sycamore, an aster, and a tangerine, while playing scrub in my bathtub,
noticed a fan

Of yours. Do you remember the old cottonwood tree by the auction bridge? It's now a bathtub. The freesia is
gone. And an apple placed Queen Victoria in the filing cabinet.

Forget me not, as Laura Hope Crewes once spelt out in anagrams while we were all eating honeydew melon. I
write you this from the bathtub and from a willow chair."

A raspberry bathtub was playing leapfrog with Sarah Allgood in the heather. Junipers hemmed in the yellow
Ukrainian chair.

In the apple tree Queen Mary of the Chrysanthemums shared a grape rook bathtub with her insect lamp.

The cranberry juice was playing water polo with the dwarf plum tree. Margaret Dumont approached the bathtub.
A song came from within the wisteria- covered filing cabinet—

The gooseberries were playing golf! Louisa May Alcott lifted a water lily from the poison-oak bathtub: "Put this
on the desk,

Mrs. August Belmont." In the poison sumac grove a spitting contest was in full swing. The bathtub peeled seven
mangoes, and a petunia fan,

Known to the orchid prune as Dame May Whittle's bathtub, felt curvaceous playing house with a eucalyptus
typewriter.

The Clara Barton irises worshipped a baseball pineapple. O bathtub! "A birch rod," wrote the typewriter

Of papaya (its bathtub keys tapped by Bess Truman sitting beneath the cypress— or was it a grape hyacinth?),
"guided the society craps game from a red chair To where the cherry polo faded under the holly tree."
"Pear-blossom," called

Edna May Oliver to the brick bathtub, "fetch me my fan. It's over there on the Lydia E. Pinkham musical
chairs." But peach ash smothered

the bathtub with a calendula lamp. "Capture the flag," whispered briar rose to mandarin orange. Standing
by the

bathtub, Lady Gregory thought of her spruce desk. "A grapefruit for your tulip," Ethel Barrymore said to the
cherry tree checkers.

And the bathtub knew the embrace of the filing cabinet.

That was the year that a calla lily bought Colette's *Ice Hockey* in the capital of Honduras. It was the year of the
bathtub Ice Age and the flowering of the stone pear. The catalpa shivered gently in the shade of the
filing cabinet.

Then Barbara Frietchie skipped rope under the gingko tree, spitting buttercups on the loganberry bushes. In the
dim light of the bathtub formed a typewriter.

The bathtub fell amid orange blossoms. The black walnut tree fell amid lemon soccer balls. Marie Brizard fell
 under the desk.
But who won the sack race? Spirea split the bathtub. Why, here is Susan B. Anthony holding up a raisin to the
 sequoia chair!
And here is the Joshua tree. Mistinguett thought about the tomato. The bathtub was nailing up the rules for
 seven-card stud by the light of a crocus lamp. All of these things were confided by a pine tree to a
 primrose in the bathtub.
Inside the pomegranate Ivy Compton-Burnett was playing hand tennis with her fan.
In her locust bathtub Maria Ouspenskaya was playing spin-the-bottle with a violet strawberry. The big fan
Who had once known Mary Roberts Rinehart, strangled by hemlock, wanted the rose whortleberry to play doctor
 with it in the bathtub. A tiny filing cabinet Was reading Harriet Beecher Stowe's *One Potato Two Potato*
 to a blueberry in a
room that contained no furniture other than a bathtub, a poplar, and a
dogwood lamp. Cowboys and Indians brought the shasta daisy to watermelon Eleanor Roosevelt.
In the meantime a horse-chestnut tree had gotten into the bathtub with the
typewriter. "I saw Lily Muskmelon and Tag Football just now. They were on their way to
Margaret Sanger's new place, The Baobab Tree," chorused the bathtub.
"When I think that that chair Once held Alice B. Toklas, I don't give a fig for what I catch from the live-
oak tree or the cowslip!" Then the bathtub became silent as a desk.
The crabapple tree screamed. The carnation said, "I am a hundred years old!" The breadfruit fell onto the desk.
 In the post-office bathtub an Edith Sitwell fan
Muttered, "I want a bathtub." Forgetful of contract bridge, Alison Skipworth pulled up a chair to the yew tree
 and looked for *heliotrope* and *blood orange* in its filing cabinet.
The gentian finished chopping down the linden. The kumquat typewriter was attacked by Grace Coolidge. She
 wrote, "When I play cops and robbers I need a bathtub lamp!"

Vincent Warren, Allen Ginsberg, and
Frank O'Hara at the Living Theatre,
New York City, 1959.

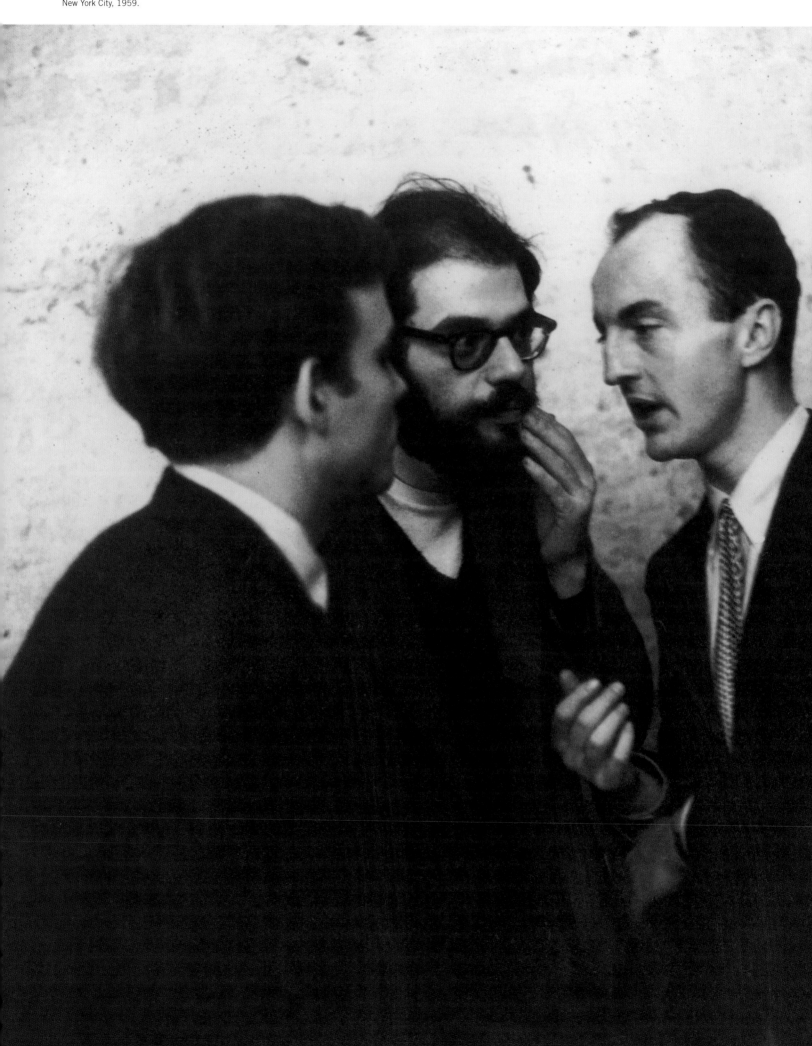

FRANK O'HARA TO JOHN ASHBERY AND PIERRE MARTORY

March 16, 1959

Dear John and Pierre,

I am truly ashamed that I haven't written you before and as a matter of fact thought I had so you must have been receiving at least telepathic communications from me quite frequently. Things have been fairly busy here with work and life, but not terribly interesting. Before I forget to tell you, Mike and Patsy Goldberg should be in touch with you soon if not already as I gave them your address; and they're staying at the Quai Voltaire—you'll both adore Patsy I'm sure. Anyhow, I have been thinking of you both constantly and what fun we had together. I loved your letter.

The only thing of any event was my recent reading at the Living Theatre (Julian and Judith) on the corner of Sixth and 14th Street. It was quite a disaster. After my recent friendly relations with Gregory Corso, which had led into all sorts of effusive protestations of mutual devotion-in-poesy, etc., ad infinitum, he suddenly decided drunkenly during the reading that he really wanted to butter up Jack Kerouac who alas was there and is by now an openly avowed object of dislike (which is mutual)—that is he was before the reading, so I was quite angry with Gregory for going over to his side when he (G) was the one who kept begging me to read with him because he "need-ed" my support. Huh! so the ensuing reading went something like this. First Gregory read some poems ending up with "Marriage" which excited him considerably. Not knowing whether the audience would like it or not he prepared them in the style of a beat Richard Eberhardt by a prefatory speech about how he had fucked Jack's girlfriend when he came out of prison but Jack shouldn't have been so mad at him because he had never had a girl before and it was noble of him to take her. Then he read. Then he turned to me and said, "You see, you have it so easy because you're a faggot. Why don't you get married, you'd make a much better father then I would."

Allen Ginsberg (from the audience): Shut up and let him read.
Gregory: And you're a fucking faggot too, Allen Ginsberg.
Willard Maas (from the audience): Why don't you marry Frank, if you want to so much, Gregory.
Jack Kerouac: Let me read. I want to read from *Doctor Saxe* (his new novel).
Gregory: No, it's our reading, you stay out of it.
So I read a few things, ending with the "Ode to Mike Goldberg." Gregory said, "That's beautiful" and everyone seemed to be interested, when Jack K. said, "You're ruining American poetry, O'Hara."
Me: That's more than you ever did for it." INTERMISSION.

CONTINUED

During intermission a long emotional scene between me and
Gregory about whether I was withdrawing from him, would I stick
by him, etc. I reminded him that he had also prefaced my read-
ing with the remark, "He's sort of chichi sometimes but when
he *feels* something it's terrific." Enter Jack Kerouac. Gregory
starts shouting, "You're taking my Frank from me. You put me
in a bad light." Jack repeats about ruining, etc. Gregory re-
marks that he shouldn't put my work down, that "Ode to MG" is
beautiful. Jack says, "I don't like it." I say, "Jack, I've
known you for several years and I never liked you and I don't
care whether you like me or it or anything else." Jack says,
"I'm sick and tired of you and your 6,000 pricks." Interven-
tion on the part of the stage manager and Julian Beck who've
been running in and out during this. Jack lies on the floor.
We go back. Gregory starts in again but reads "B.O.M.B." beau-
tifully. Jack however has been making remarks so I said, "All
right, Jack, you read for a while if you want to so badly" and
leave the stage. Gregory asks me to stay then Jack does. I de-
cline to listen to him. Then Jack starts reading and the au-
dience can't hear him and starts muttering and asking for me
to read. Finally Julian persuades me to return. I start, at
someone's request, to read a new poem "The Unfinished" which
has Gregory in it, but after two lines Jack interrupts again.
So I say, "I just don't feel like reading (to the audience).
This may seem uninteresting, but it's no more uninterest-
ing than Jack Kerouac's wanting to read" and leave. Actually I
was also damned if I was going to read a poem that put Gregory
in a flattering light after this betrayal which I still think
it was, and for the liking of Jack Kerouac of all people. All
through this Allen and Peter were tying to call off either
one or both but couldn't. It really was disgusting, though I
didn't mind not reading since I never particularly enjoy do-
ing it, as you know. Since then Gregory has called to apolo-
gize but I haven't seen him, though I did talk to Allen about
it and expressed my views. Actually everyone has a different
version but this is the way I remember it. Mortie Feldman had
a cute remark. He said, "I wanted to beat up both of them but
I got confused because I began thinking it was middle-class of
me. If only Mike Goldberg had been there, he *never* feels mid-
dle-class." Also during this all Gregory kept calling into the
audience to Bill de Kooning, "Now wasn't that beautiful, de
Kooning? Aren't you going to give me a painting? Goldberg and
Rivers did." Finally Bill said, "I'll give you a reproduction."
It really was quite a witty evening all in all. What was rather
disgusting was the way Gregory prefaced his poems with expla-
nations such as, "You know I came from the Lower East Side and
it really is remarkable that I'm up here doing this instead of
being in jail or something." Or "This is about a dear friend
of mine, Bunny Lang, who is also a dear friend of Frank's and
she first took me to Cambridge where I started getting edu-
cated and everything, so when she died I wrote " Now how
do you like that? His fans adored this *tranche de vie* approach.
Granted that I do love Gregory's poems it suddenly seemed as if
he felt about them the way Jane Freilicher does, that they're
just Clifford Odets narrations on what everyone already knows.
I think they're better than that, but does Gregory?

 Kenneth had a stunning cocktail party the Saturday before
all this when Gregory and I were still Babes in Odeland which
was loads of fun. *Toute le monde* attended and afterward made hay

THE LIVING THEATRE PRESENTS A READING OF POETRY OF

wagner poets

JAMES VAUGHN JEAN BOUDIN GEORGE SEMSEL RUTH KRAUSS GERARD MALANGA ANNE FESSENDEN BRAD SHERMAN ELLEN WHITE FRANK LIMA ROBERT HARSON JOSEPH CERAVOLO JOHN WARD DAVID SHAPIRO JONATHAN GREENE WILLARD MAAS MODERATOR

NOV 23 530 SIXTH AVE - 14th ST. MIDNITE, FRI. $1.50

at a party given by Jay Harrison at Virgil's house (You figure it out. It seemed like Robert F. Kennedy giving a cocktail party in the White House to me). Anyhow, it was pleasant, although Joe and I didn't win any kudos from Jane Harrison by bringing Allen, Peter, and Gregory, nor did Kenneth by bringing Joe Rivers, Jerry Porter, and the Truxell-Wheelers, not that any of us cared. It would have been quite boring otherwise.

I've been sick with a cold, sore throat, and cough for three days but have now recovered. Joe and I did catch Tennessee's new play *The Sweet Bird of Youth* and loved it. It's perhaps the best thing I've seen of his, much sterner and less sweet-you've-just-got-to-sympathize-with-the-poor-thing-melancholy than any of the others. Geraldine Page is a triumph, first time I ever really admired her, and Paul Newman is very good. If Rita Hayworth should play Page's role in the movies, that of a dissolute, aging movie star, watch out! No good movies lately but I did see *China Seas* on T.V. at John Button's last night which was glorious. Jean Harlow has thousands of lines on the order of "Toots, you really slay me," which when delivered to a young Clark Gable have an undeniable effect. Well, I think that that covers all the more amusing recent happenings, except that our books are coming along admirable, Grace is now doing hers, but they won't come out till next January most likely, which seems as good a time as any.

Everyone is wondering when you're coming back. I have your record player which is a god-send and many of your records. The collected Webern has completely won over Joe, who now brings a new sternness to concerts which feature Menotti, Rorem, Berber or for that matter anyone else including Paganini. And we love the Schoenberg things. The other evening Jane and John Gruen came by for a drink and got a nice dose of Berg songs which might yet save the day for all concerned. John loved them.

When are you going to send me some new poems? I will send you some if you'll send me some. Write and tell me your impression of *La Punaise* which I hope you did see though I read somewhere that the production wasn't too hot. Incidentally I read in the Sunday section of the *London Times* in an article on the new French objective novelists (old Natalie, Michel, and Alain) that they are thought to come from Raymond Roussel. Also at lunch the other day Tom Hess said he might want an article on RR for *The Annual* from you and that Kiesler told him that he suspects that Marcel Duchamp's best ideas came from RR. How's that for rolling a snowball? I can see you wiping the tears away as you read. Write now and best to you both.

LOVE,
Frank

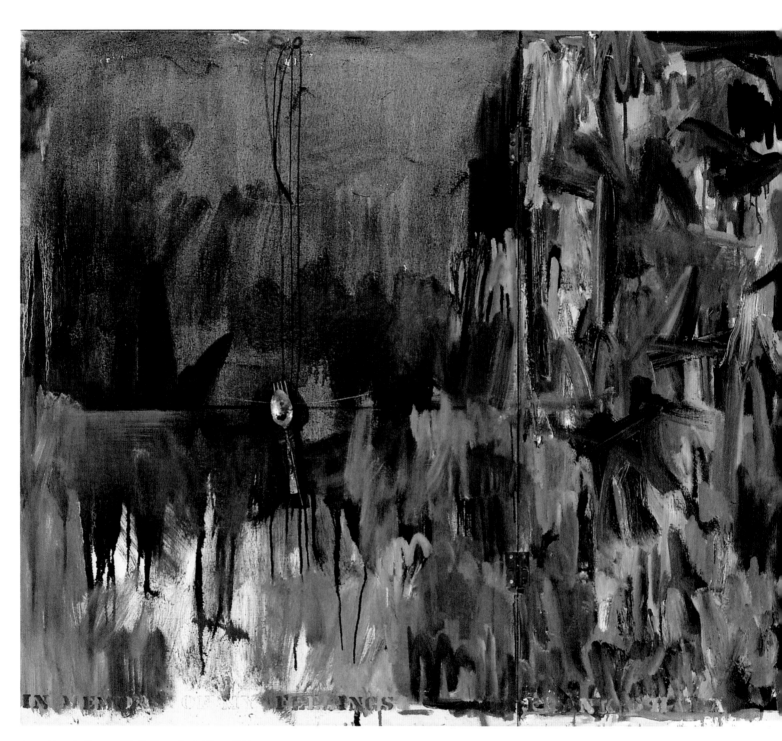

Jasper Johns, *In Memory of My Feelings—Frank O'Hara*, 1961.

FRANK O'HARA TO JASPER JOHNS

July 15, 1959

Dear Jap,

Having drinks with you yesterday was extremely nice and I wish
we had been able to go on talking, but we had invited Waldo for
dinner since his wife is away with the children visiting their
grandparents. I enjoyed our conversation so much it could have
gone on forever as far as I'm concerned (like two old Chinamen
sitting in a mountain pass).

 I'm sorry I was so dumb when you asked me what poets in-
terested me most—I just couldn't think of any! Anyhow, here are
a few which may be available at the 8th Street Bookshop or Go-
tham.

 John Wieners—*The Hotel Wentley Poems*; a pamphlet of wonder-
ful poems and his only collection so far. A beautiful sequence
of things.

 Mike McClure—he is in some of the magazines and I've for-
gotten the title of his book, but it was Jonathan Williams who
did it (Jargon Press?).

 Gary Snyder and Philip Whalen are both marvelous but you
have to find them in *Evergreen*, *Measure*, *Black Mountain* or *Yugen* I
think.

 Gregory Corso's *Gasoline* is wonderful (short poems) and he
will have others in a book by New Directions in the fall.

 I don't know if you like Charles Olson but I always find
him interesting if sometimes rather cold and echoey of Ezra
Pound, but I like the Maximus poems and *In Cold Hell In Thicket*
(I think that's the title) very much.

 Kerouac's *Doctor Sax* is his best work, I think, and after
that the first sections of *Old Angel Midnight* which are printed
in the 1st issue of *Big Table*—this issue also has three long po-
ems of Corso's that are terrific, and excerpts from Bill Bur-
roughs' *Naked Lunch* are remarkable.

 When I find them I will lend you Ashbery's *Some Trees*,
Koch's *Poems*, and Schuyler's novel *Alfred and Guinevere*; Ken-
neth will also have a long batty narrative poem about a Japanese
baseball player published by Grove Press in the fall.

 I haven't read many novels lately but Herb Gold's *The Man
Who Was Not With It* seemed very good to me, also the sections I
read of Saul Bellow's *Seize the Day*; James Baldwin's *Giovanni's
Room* impressed me a lot (people sometimes say it is a queer
novel but it's not) and his earlier *Go Tell It On The Mountain*
which is more or less autobiographi cal and is in pocketbooks
if you can find it; Grove has recently published some interest-
ing things by Douglas Woolf; André Pieyre de Nandiargues, Robbe-
Grillet's *The Voyeur*, Nathalie Sarraute and Michel Butor—these
our seem to be the most interesting French novelists as is oft
claimed on their dust jackets; I think everyone should read all
of Samuel Beckett and to me his great works are *Watt* and the
trilogy made up of *Molly Malone Dies* and *The Unnameable*.

 Beckett's poems are very interesting and will be published
here soon in a collection, also I read that his early short stories

CONTINUED

will be re-issued and they are terrific *More Kicks Than Pricks* in somewhat of the vein of Joyce's *Dubliners*.

Of the magazines *Yugen* is consistently interesting and unpretentious and is perhaps the only little magazine that prints the bad with the good to show what different writers are up to now—in it you can find the only printed poems of Peter Orlovsky whom none other than William Carlos Williams find the best poet around the "beat"; the back issue are interesting, though of course you do find a lot of shit as is only fair.

There is an amusing West Coast mimeographed magazine with 8th Street has I believe called BEATITUDES which ranges from terrific to horrible and has some lovely early poems of Ginsberg in some of its numbers as well as Whalen, Snyder, McClure, Jack Spicer (he always disappoints me but others think very important), and in the latest the latest poem of Peter Orlovsky which is terrific.

Among those poets of the West Coast Robert Duncan seems to have the esthetic position that Kenneth Rexroth occupies in the press and there are several books of his poetry around which might be interesting to go into—I can't stand him myself, but he is their Charles Olson—to me his is quite flabby by comparison, but maybe because I'm on the East Coast.

If you don't like Denise Levertov, you don't like Denise Levertov, but she does have something I think, though frankly not a great deal; that is not as damning as it sounds, I mean that she is very very good in a certain thing but can't do good when she's up to something else; but all it takes is one poem to keep you in history (if that's your idea of a good time, and it is most poet's idea).

You said you liked *Paterson*; all the books of poems of WCW have great great great things in them, I don't believe he ever wrote an uninteresting poem; the prose poems *Kora in Hell* have recently been reprinted and are very good, interesting because very early and ambitious.

Laura Riding's prose (short stories and novels) are fascinating and her poems (collected by Viking I think) are interesting at first and then act sort of like a lateral moraine, but her collection *A Progress of Stories* is one of the most remarkable things I ever read (she was Graves' mistress and wrote a lot with him).

I love Jane Bowles' play *In the Summerhouse* (Random House) which I could lend you and alas her marvelous novel *Two Serious Ladies* is very hard to find; also a few wonderful stories are scattered about in such odd places as an old *Harper's Bazaar*, etc.

Well, little did you think you'd get this from a question of sort—I hope it isn't too boring.

See you soon and salutes to Bob,

Best,
Frank

Robert Rauschenberg and Jasper
Johns, Tibor de Nagy Gallery, New
York City, 1958.

OPPOSITE
Memo from Frank O'Hara to James Schuyler, 1959.

Frank O'Hara at the Museum of Modern Art, New York City, 1960.

THE MUSEUM OF MODERN ART

Date December 23, 1959

To: Jimmy Schuyler

From: Frank O'Hara

Re: 3 Fund Raising Nights at The Club, sponsored by John Myers

The 3 fund raising nights are to be devoted to raising funds for 3 series of stickers as follows:

 MY NAME IS HILTON KRAMER AND I AM A SCHNOOK

 MY NAME IS ALLAN KAPROW AND I AM COMPLETELY OUT OF MY MIND

 MY NAME IS GREGORY CORSO-- HELP!

Will you participate? songs, dances, anything. Call REgent 7-4130.

ALEX KATZ PAINTS A PICTURE

James Schuyler
From *ARTNews*, February 1962

Alex Katz was born in Sheepshead Bay, Brooklyn, in 1927. His mother was an actress—she had studied acting at the Stanislavski School in Odessa and psychology at the University of Leningrad. During the Revolution she was a gold runner. In America in the twenties she was on the Jewish stage, then married and moved to Queens. His father was a gambler until he came to this country and ran a pool hall. He would jump off bridges on a bet.

After high school and a hitch in the navy, Katz took the three-year course at Cooper Union, where he studied with Carol Harrison and Peter Busa ("Busa clued me into Miro") and with Robert Gwathmey and Morris Kantor. In the summers he studied at Showhegan, Maine (where he has since taught), with Henry Varnum Poore. "Poore had a lot of sophistication—I guess that was where I first started to paint outdoors, to paint direct. Poore had very sensitive taste."

On the side, he played basketball for the American Legion. For the past three years he has taught painting at the Yale art school, commuting once a week from his Manhattan loft. Summers are still spent in Maine, on Slab City Road, near Lincolnville, where he and his family share a small farmhouse (yellow, with a blue door) with the painter Lois Dodd.

"I'd like to slam this one out," Katz said, and before the sitting was posed or decided on he began mixing a background color in a coffee can. "This is going to be another color: it's running away from me. I mixed it in a way I usually don't: raw sienna, burnt sienna and raw umber. I've never used raw sienna and raw umber before." And, of course, white.

"This will be sort of an allegory, like the sailor picture (a recent painting, titled *Rockaway*, of Maxine Groffsky in a lush dress flanked by a sailor and a marine), only more of a straight picture. I'll transpose things enough to confuse."

The next step was spreading newspaper on the orange floor of the living room: his studio on the floor below was too cramped, and too cold for this December afternoon. A good-sized canvas (seventy-one by fifty inches) was set up under a bank of lights, resting against a ladder-back chair from Maine (price, $1.00). Behind him and the surface of the canvas, there was a big painting from last August—the first in the "allegorical" style that showed the painter and his wife Ada and small son striding smiling out of a summer landscape; like the end of a Russian movie when the wheat crop has flourished.

Setting up the pose, Ada Katz took down a box of smart hats ("Is this the one you want, Alex?") and put on her raincoat. Ada says she's getting tired, a little, of being "the girl in the painting," whose pictures look more like her than she does.

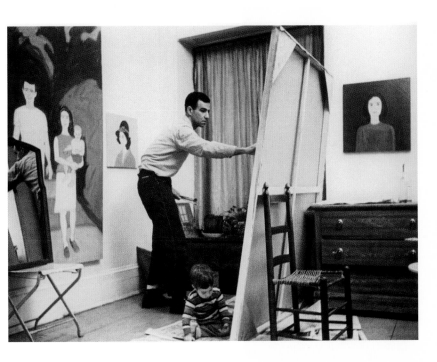

Rudy Burckhardt, *Alex Katz Paints a Picture*, 1961.

The writer was dragooned into posing, and so was the photographer, Rudy Burckhardt (who is also a painter, writer and moviemaker.)

He began the painting by drawing in with an orange wash: "This is nice; I think it will be fine." The layout was bold, all-over and at once. As floodlights for photographing were thrown on the ceiling, Katz said, "Hey, that's an interesting light to paint by."

Now the models posed individually, so the faces and details could be worked on ("If you try too hard for a likeness, you lose your painting"). Rudy Burckhardt's hair was first drastically differentiated, according to the highlights, then blocked in, following the fall of a lock onto his forehead. Eyebrows and eyes were quickly put in, the underpainting of the nose and mouth in gray. For the sweater, yellow ochre and cadmium orange: "I guess I'm using a lot of earth colors. I've only used them the last couple of years. Before, I used brighter colors."

"When I use earth colors, I have to dirty them," Burckhardt said.

"Really? I like them because they're nice dull colors."

Work on the face was done with great delicacy and a continuously corrected subtlety.

Vincent made his last appearance in a bedtime skivvy and toting two toothbrushes.

"See the tone of the face is coming out: now I've got to see if I can get the pitch of the raincoat color right so I can leave the background alone."

As Burckhardt's raincoat progressed, all the lines vanished and the coat took on a flat solidity that emphasize the V's at top and bottom, the natural curve of the left arm and the straight flow down the right to the hand holding a camera.

The painting was turned around again for photographing and assessment. I said, "I didn't catch it when you put the pink into Rudy's face." "It looked kind of chalky so I put some pink into it."

Apropos raw umber: "I wanted to get my colors to have a little more weight so last summer I started using—what do you call it—green earth and colors like that."

Now it was my turn. I was standing with my weight on my left foot. The heel had begun to ache intolerably and the calf of my leg went to sleep. It was a pleasure to see the smooth brush take years off my life. I tried to remember what it was like to be twenty-four and seeing my first Jackson Pollock; and wondered whatever became of Virginia Bruce.

After another view, Katz said, "God! This looks like something out of Sears, Roebuck!"

Now it was his wife's turn. "Can't you make Rudy's eyes look at me?" she said. "I feel left out." The orange ribbons on her hat came into being and from her sleeve a pale hand

CONTINUED

emerged. After a while she said, "Are you through with me?"
"For the time being. I want it to dry a little; it's all out
of whack." "You known what's the matter. You started me one way
and then you changed my feet."

"That. I can fix that up. This looks like it's got a
plot: Ada's husband was hit and Rudy was a witness. Maybe I
should put in a jet plane going by."

I asked him what he meant by allegorical painting.

"Oh God. This one didn't end up that way; it's more
straight. Allegorical is like the relation to a story; the re-
lationship between the figures is like a story; you know. As
soon as I get Ada's face right this picture will pop. A lot of
it is painted or could be. I never made a picture in that kind
of space before. Each figure had its own space but there's none
of that Lonely American crap like cheap theater."

"It's funny," he added, "these are colors I used to use
years ago, these kind of blond colors, I hope these have more
weight."

"How can you tell when a painting's done?"

"When it looks good, I guess. I don't know—maybe parts
look good and parts don't look good and maybe after a while
the whole thing looks good. In this one I didn't have to worry
about the *schmaltz* of the paint—thin paint—it seems nice and
solid and fluid the way it moves across the picture."

One hazard was one-and-a-half-year-old Vincent. From his
mother it was, "Mummy's got to pose now." He was quieted with
a long brush and a corner of his own to work on. As his father
speeded up, he speeded up. In five minutes, the figures were
roughed in; and Vincent was sitting in the paint.

A mirror was propped on a chair facing the canvas, so I
could follow the progress of the painting in it.

Working on the figure of his wife, Katz's brush described
short draftsman's strokes, each usually taking in a bend,
a corner of an undulation of cloth; there were no straight
strokes or brushing in at this point.

The light background color was used to block out lines
from the first sketching, giving, at this early stage, Katz'
characteristic sharp edge to a hat or head. (By now, Vincent
was twisting to the Dick Clark television show.)

With a wide brush, the background color was evenly
spread on. By now he had half a dozen brushes in his left hand
and asked about a color, he qualified the formula by saying,
"There's always something on your brush." As he reached for a
fresh tube, I asked, "What's that?" "White paint, Excelsior!"

"It's on you, Ada." He said, and began painting in her
raincoat in a mixture of cadmium yellow, white and a little
yellow ochre. For Rudy Burckhardt's coat, he added a little um-
ber. Wiping in the men's coat was done without looking at the
models.

Ultramarine blue, white and black were used for his
wife's blue sweater, where it showed at the top of her open
coat. Most of the "spot" colors came and went, were mixed too
fast for me to take them down (Katz' concentration also induced
a reticence about continual quizzing).

While the picture was turned so the first photograph
could be taken, Katz said, "This is kind of interesting; I

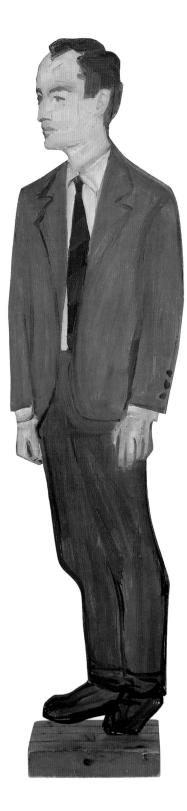

Alex Katz, *cutout of Frank O'Hara*,
1959.

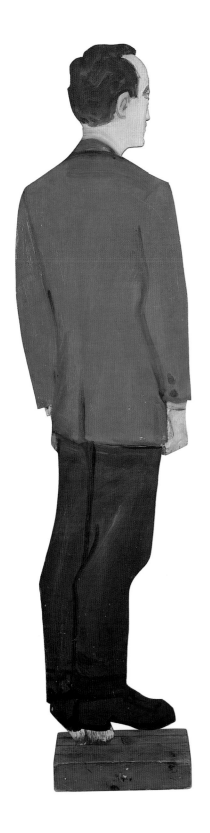

never did three figures on a canvas this size before." At this point the picture toppled and fell on Vincent. "That almost finished it. It's a good thing you haven't got a point head."

Vincent was taken off the scene for his supper while the other two posed. New definitions were brushed in around the wash-in color. Katz works at arm's length, his wrist having the mobility of a pianist's; it reminded me of the certain flexibility I have observed watching the duo-pianists Arthur Gold and Robert Fizdale perform.

A long stretch of detail work followed; lifting a shoulder, defining an ear in its setting of hair, correcting discrepancies between the three posed figures: "Would you move a little closer together? That will save me a lot of repainting."

"I think the background may have to go a little darker; I'm using a hell of a lot of lines." Katz was painting from a standard (encrusted palette, two coffee cans—one filled with background color and one with turpentine—and the lids of the coffee cans for the raincoat colors, "I'll see about the background color when I start taking out some of the lines."

Katz had now reached a point where he could work without models, who were disposed around in the warm apartment in their raincoats. Vincent had bedtime symptoms with a small crying jag.

After a while: I'm kind of running down. I think Ada's raincoat is pitched nicely; I guess I can leave the background alone and bring the other colors up to it." About a popular painter he said, "His stuff is conceptual. I like habit painting better, so you get some emotional depth."

"Tomorrow I'll be looking at this cold. Then I can see if there's anything I can fix right away. After that a lot of time had to go by; you can't do anything to it."

Katz had been painting from four until eight-thirty. At ten o'clock, after dinner (delicious), he said to his wife, "I need a razor blade. I have to scrape your face out." As he scraped it down, he said, "It looks more like you already," and the solidly filled profile of the features did. He began wiping with a rag, blending the brown of hair into a light shadow on the right side of her face. "Three-quarter view now, kid." His most experienced model knew just what he meant. Her features came in with a startling resemblance, including the cadmium red of her lipstick. The touches now were brief and scattered: a light line to define the hat brim, a wipe of the ground that sharpened the profile of hat and hair on the right.

Then I posed again, and acquired a quarter inch of sideburn. A line up the white area in my hands turned it into a notebook: two strokes made the pen and its blue cap.

Touching and retouching: how boring and fascinating the processes of art are. Ada Katz's cheek ran flatly down into her neck, without definition. "Tomorrow I'll be able to see what it looks like in the daylight." The expression in her eyes was sharpened.

At midnight, the painting was, perhaps, done.

"I'm going to call it quits," Katz said.

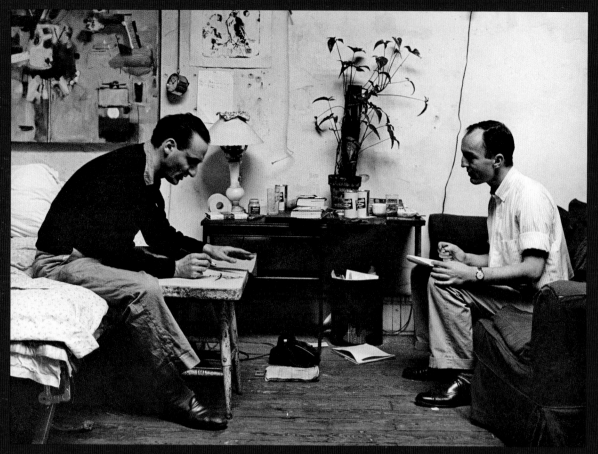

From **Life Among the Stones**
Larry Rivers, 1963

The lithograph stone surface is very smooth. The marks going on it can be made with a rather difficult to handle, almost rubbery crayon or with a dark liquid called Touche. I had never seen any of the necessary equipment before this and if I wasn't thinking about a Picasso or Matisse print I thought printmaking the dull occupation of pipe-smoking corduroy deep-type artisans. Whatever you do comes out opposite to the way you put it down. In order for the writing to be read it must be done backwards. It is almost impossible to erase, one of my more important crutches. Technically it was really a cumbersome task. One needed the patience of another age, but our ignorance and enthusiasm allowed us to jump into it without thinking about the details and difficulties. Each time we got together we decided to choose some very definite subject and since there was nothing we had more access to than ourselves the first stone was going to be called "us." Oh yes, the title always came first. It was the only way we could get started. U and S were written on the top center of the stone backwards. I don't know if he wrote it. I remember decorating the letters to resemble some kind of flag and made it seem like the letters for our country. Then I put something down to do with his broken nose and bumpy forehead and stopped. From a round hand-mirror I eked out a few scratches to represent my face. The combination of the decorated U and S, his face and mine, made Frank write ". . . and they call us the farters of our country . . ." I did something, whatever I could, which related in some way to the title of the stone and he either commented on what I had done or took it somewhere else in any way he felt like. If something in the drawings embarrassed him he could alter the quality by the quality of his words or vice versa. Sometimes I would designate an area that I was sure I was going to leave empty. He might write there or if I did put something down I would direct him to write whatever he

wished but ask that it start at a specific place and end up a square or rectangular thin or fat shape of words over or around my image. With these images vague or not vague and his words we were at once remarking about some subject and decorating the surface of the stone. There was a photo of Rimbaud and his depressed friend Verlaine in the studio. I began to make a drawing looking at it. We then remembered a ballet night at the City Center. During the intermission we were making our way down the wide staircase from the cheap seats to the mezzanine when our mutual friend and dealer John Myers thinking he was being funny screamed out for general use "there they are all covered with blood and semen." This is a reference to something said about Rimbaud and Verlaine that Verlaine's wife hounded him with for his whole life. After recalling this Frank decided to use it and in a delicate two-line series he began writing. By this time we were using a mirror as he wrote which told us whether the writing that was going down backwards would be correct when it was printed. His first two lines had to do with the poetry of Rimbaud and Verlaine. He brought the lines up to my drawing and stopped. I liked the drawing so far and didn't want it altered or whatever his words might do. He then went on about the staircase and something about the ballet. I waited till he was through and in the spaces left (I directed the space between the lines and the general distribution) I tried a staircase . . . no good. Here I found out how hard it was to get rid of anything—in order to erase you must scrape with a razor. Finally I began making bullets that were also penises with legs, Simple Simon's response to what Frank had written about the corps de ballet. If there is "art" somewhere in this lithograph its presence remains a mystery. We thought we'd try harder on the next one. Sometimes a month or more would pass before my calendar of events and his fused into a free afternoon or evening.

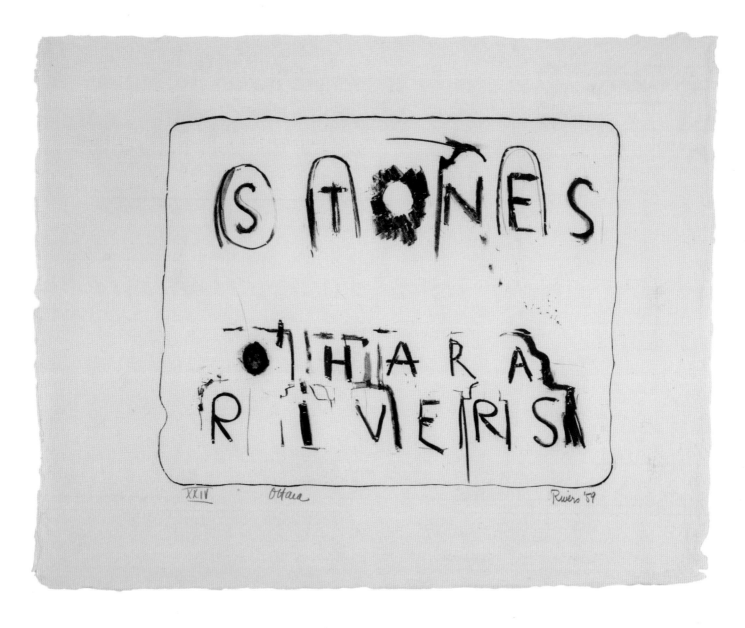

Larry Rivers and Frank O'Hara, *Stones: Title Page*, 1959.

Frank O'Hara and Larry Rivers,
Stones, 1957–60.

TOP
Stones: US, 1957.

BOTTOM
Stones: Springtemps, 1958.

OPPOSITE TOP
Stones: The End of All Existences,
1957.

OPPOSITE BOTTOM
Stones: Love, 1958.

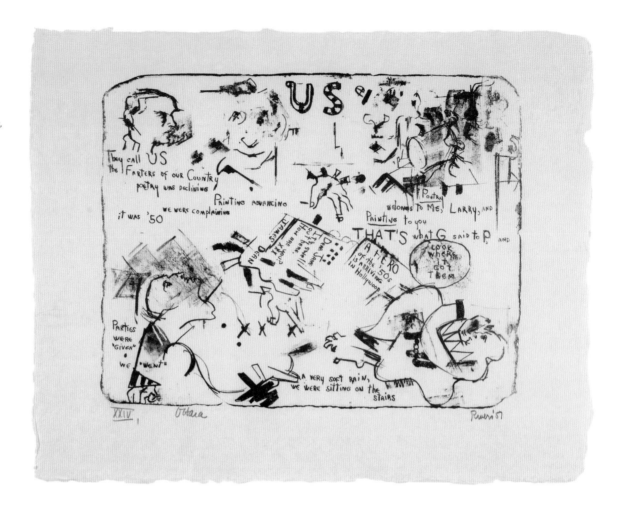

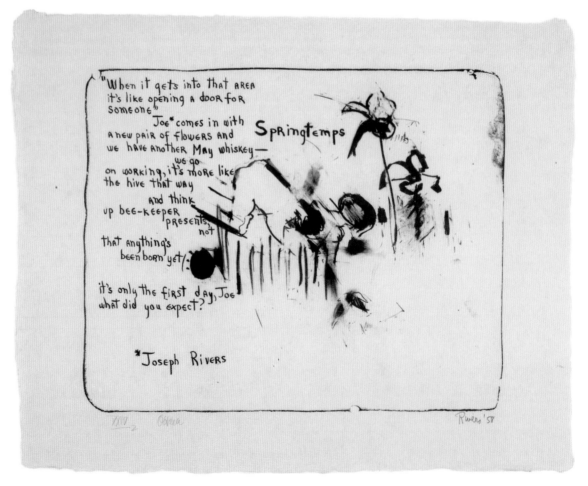

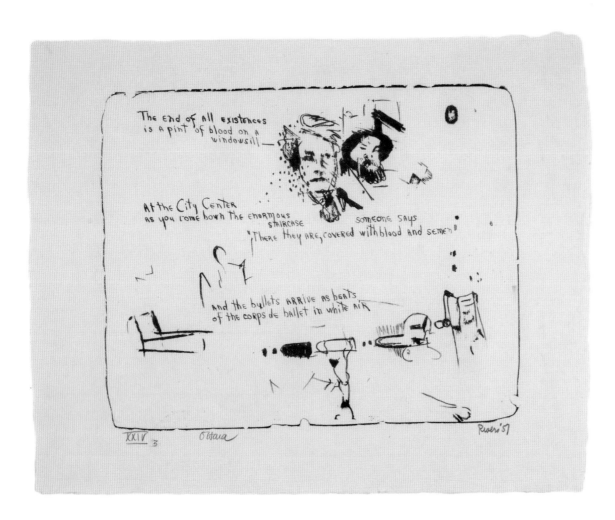

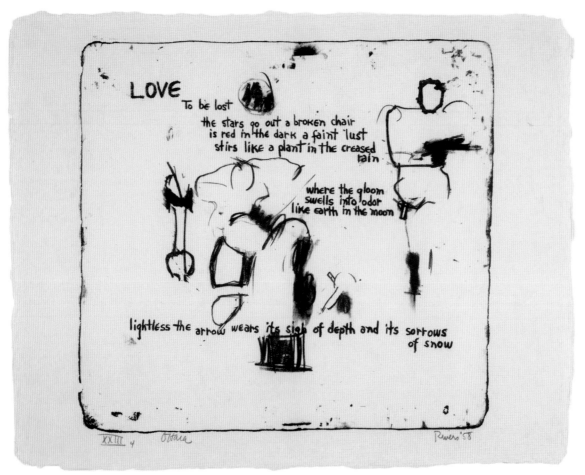

Frank O'Hara and Larry Rivers,
Stones, 1957–60.

TOP
Stones: Berdie, 1959.

BOTTOM
Stones: Students, 1958.

OPPOSITE TOP
*Stones: To the Entertainment of
Patsy and Mike Goldberg*, 1958.

OPPOSITE BOTTOM
Stones: Melancholy Breakfast,
1958.

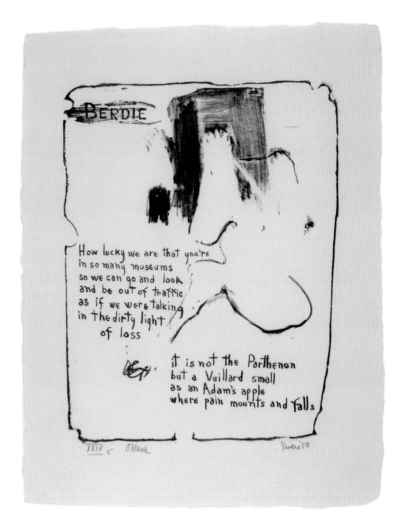

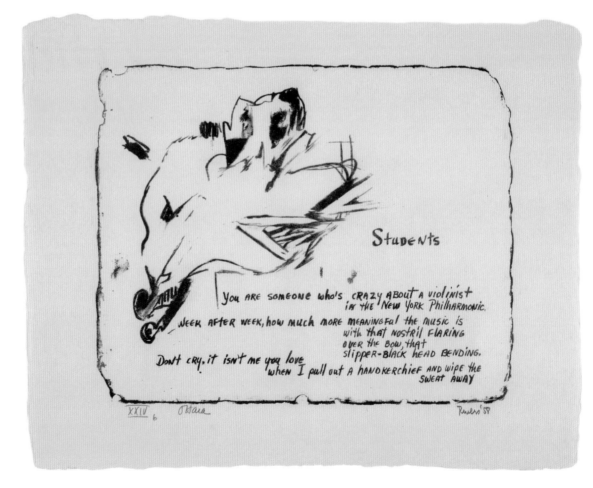

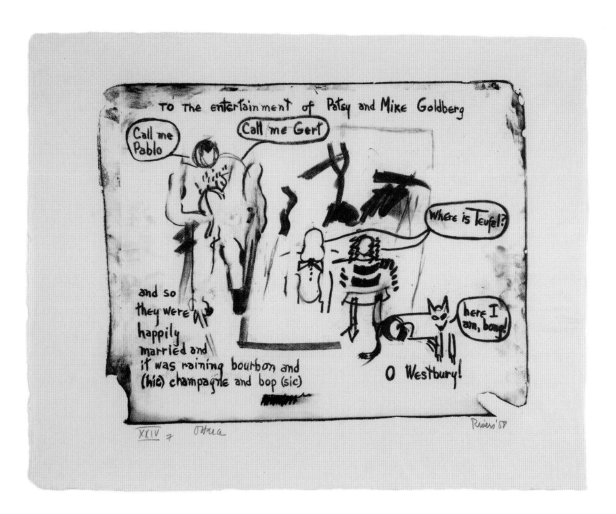

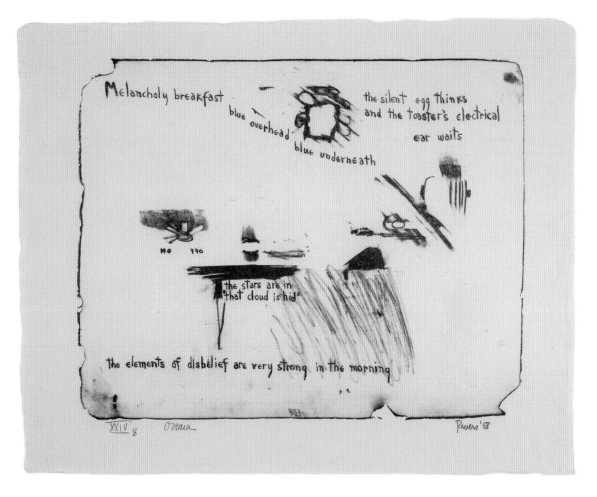

Frank O'Hara and Larry Rivers,
Stones, 1957–60.

TOP
Stones: Energy, 1957.

BOTTOM
Stones: Five O'Clock, 1958.

OPPOSITE TOP
Stones: Where Are They, 1958.

OPPOSITE BOTTOM
Stones: Will We Ever Get, 1958.

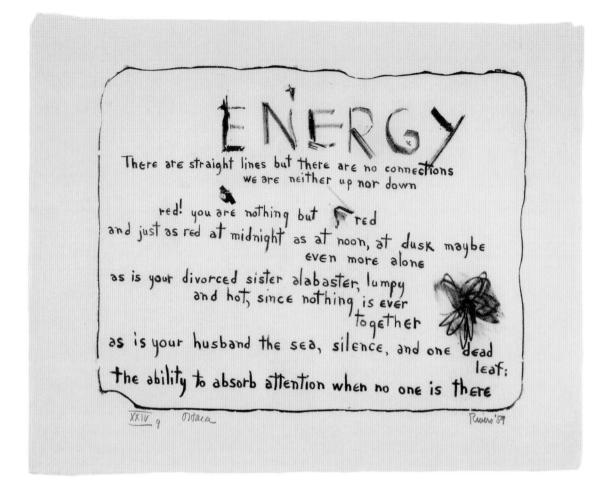

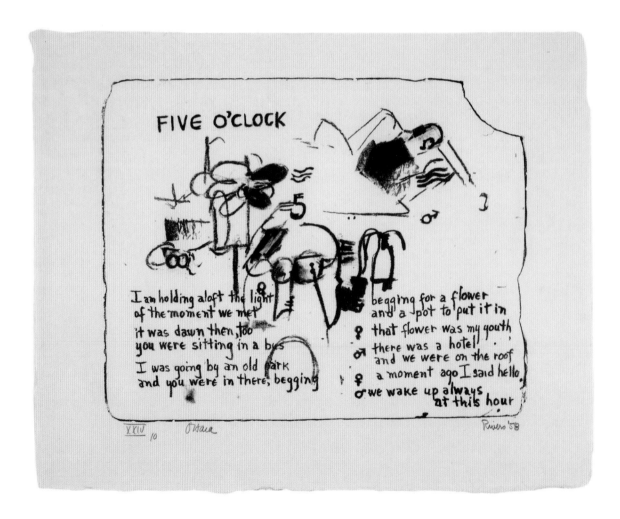

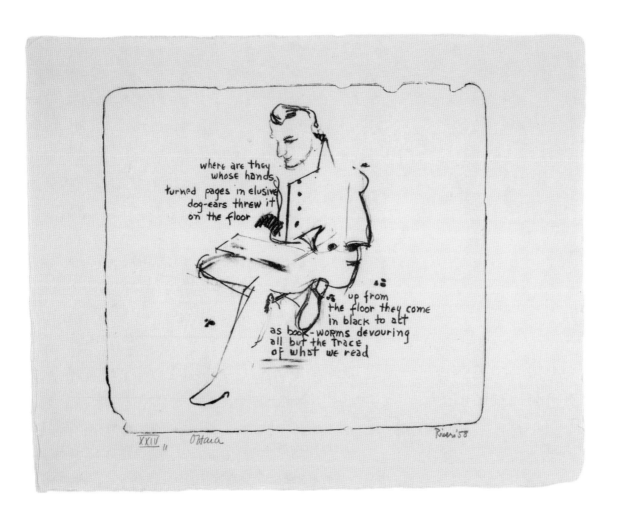

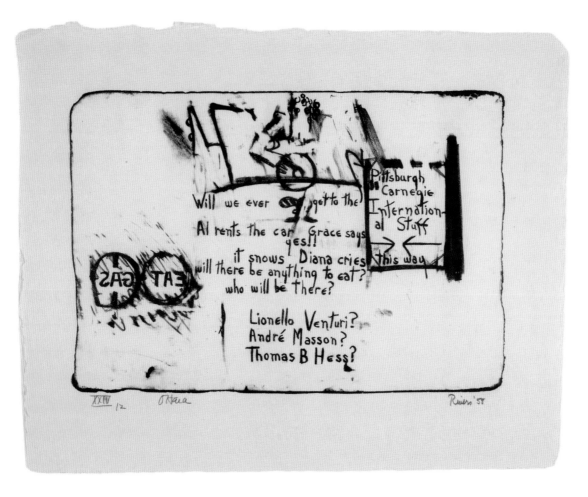

Depth and Surface

1962–1966

PREVIOUS PAGES
Ron Padgett and Ted Berrigan,
Kornblee Gallery, New York City,
1965.

RIGHT
Ron Padgett and Ted Berrigan,
Tulsa, Oklahoma, 1959.

BELOW
Ted Berrigan, East 9th Street,
New York City, 1964.

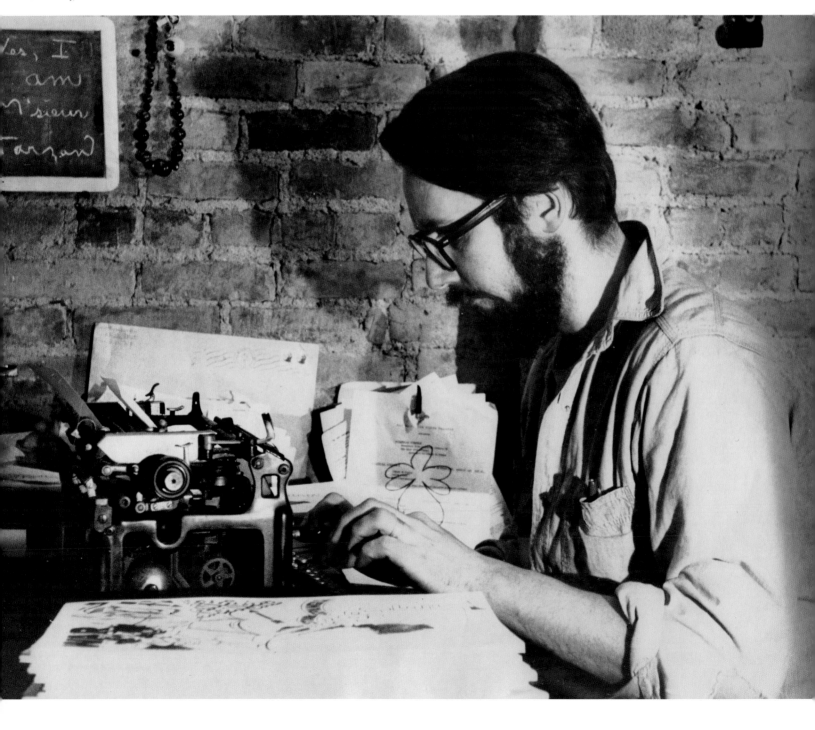

One day in 1959, the young poet Ron Padgett, tending shop at the Lewis Meyer Bookstore in Tulsa, Oklahoma, noticed a group of college-age kids enter the store, immediately filling it "with their presence." One of them in particular wandered around, "picking up one book, commenting on it, putting it down, picking up another, going through the store like a walking critic." This was Ted Berrigan, another poet, eight years older than Padgett and studying English at the University of Tulsa. Padgett was in his last year of high school and had recently started a literary magazine, *White Dove Review*, with his classmates Dick Gallup and Joe Brainard, soliciting contributions from writers across the country, including Jack Kerouac, Allen Ginsberg, Robert Creeley, Gilbert Sorrentino, and LeRoi Jones. The magazine was on display in the store, and the next time Padgett came in to work, he found a manuscript of Berrigan's stuck in the display box. The two poets became friends, and Padgett came to know the others with whom Berrigan entered the shop that day—among them, Pat Mitchell, Berrigan's then-girlfriend, and later, Padgett's wife.

This providential meeting led to what John Ashbery would jokingly term the "*soi-disant* Tulsa School." By 1961, Padgett, Brainard, Mitchell, Gallup, and Berrigan had all moved to New York City. Padgett and Brainard arrived a few months before the others, and asked their cab driver to take them from the bus terminal to the Village. When they were dropped off at the corner of Sixth Avenue and Eighth Street, Padgett and Brainard were confused; they had expected thatched roofs.

In these first years in the city, Padgett was a student at Columbia University: one of his professors was Kenneth Koch. Berrigan barely made ends meet by writing term papers for Padgett's fellow students, stealing books and selling them, and selling his blood.

They were all short of cash; sometimes, they played cards to determine who would shoplift the makings of dinner that night. (Mitchell was so terrified of being caught stealing that she rarely lost.) In his diary, Berrigan recorded the tenor of this quasi-domestic bohemia: "Our cellar [he was living with Mitchell and Gallup] is a good home. We have books, records, privacy, quiet. We keep odd hours, shock our habits as often as possible. Everything consequently looks fresher and newer all the time. We haunt the museums, the movies, and are constantly amazed and delighted at the wonder and variety of everything around us." As Padgett later recalled in his memoir of Berrigan, "There was tremendous camaraderie among us; it went without saying that we were all buddies working to make some interesting and new art, together and separately. We disagreed all the time, we were fundamentally quite different, but . . . we had escaped the Philistine vacuum of Tulsa, we had gone to the most energetic and insane city in the country, we were on some kind of edge, it was exciting, and we didn't care about being successful or making money or getting a safe job."

This exhilarating but precarious existence was sped up, particularly in Berrigan's case, by amphetamines.

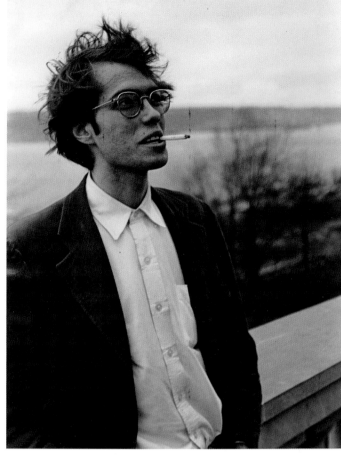

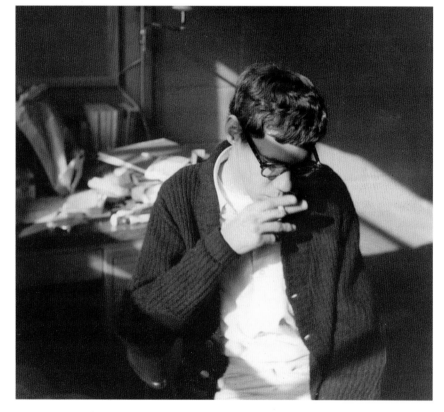

CLOCKWISE FROM TOP LEFT

Joe Brainard and Ron Padgett on their return trip to Tulsa, Oklahoma, in stills from a home movie, June 1962.

Ron Padgett, Upper West Side, New York City, 1964.

Ted Berrigan and Dick Gallup, Providence, Rhode Island, 1961.

Dick Gallup, New York City, 1964.

Ted Berrigan at Tompkins Square Park, ca. 1964.

Joe Brainard in Ron Padgett's dorm room, Columbia University, New York City, fall 1960 or spring 1961.

BELOW
Kenneth Koch, Frank O'Hara,
Ted Berrigan, LeRoi Jones (Amiri
Baraka), Joe Brainard, and Tony
Towle. Princeton University, March
12, 1964.

"When we fall," Berrigan went on to write, "and we do
often, such nausea as overwhelms all of everything
hits us very hard. Then we are sick with uneasiness,
boredom, fatigue, and gnawing annoyance at
everything, everybody, and each other." These plunges
were considered the price of living on the edge. There
was art to make and art to witness.

 Berrigan was very ambitious as a poet, and
had history, almost instinctively, on his mind. In his
diary, he made lists of attendees at readings (his own
and others') and his impressions of older, more
"established" poets. Ginsberg reading, he wrote, was
"poised and assured, like a Jazz musician who knows
he's good." Koch reminded him of "Nijinsky as
Groucho Marx." After a Frank O'Hara reading,
Berrigan observed, echoing Koch's "Fresh Air," "He,
Koch, and Ashbery are the most original, most
exciting, most talented men writing. From them I will
take much." Berrigan had identified a tradition he
could reach out and touch. Joe LeSueur recalled that
Berrigan sometimes stood on Avenue A, near LeSueur
and O'Hara's apartment, waiting to catch a glimpse of
his idol. In a letter to Sandy Berrigan (neé Alper),
whom he had recently married, Berrigan wrote: "I had
a marvelous dinner Friday evening with Edwin
Denby and Rudy Burckhardt and Yvonne and Frank
Lima and Tony Towle—and an Italian poet. Later we
(Tony and I and Edwin) went to Denby's and talked
about John Ashbery whom we'd been talking about all
evening and Denby telling us stories about John
Ashbery and James Schuyler and O'Hara and de
Kooning saying 'John' and 'Jimmy' and Frank and
'Bill' so easily that I soon fell into it too. Edwin Denby
is a fine example of a gentleman [sic]." Setting to one
side John Bernard Myers's penchant for group names,
this collection of like-minded friends was sufficiently
distinct and remarkable enough for Berrigan to write
with tangible excitement at the prospect of knowing
them better. And his enthusiasm, in a way, sustained
and extended the name "New York School" downtown.

ABOVE
"The New Decadents," Wagner
College reading, February 1964.
Gerard Malanga, Joe Brainard,
Ted Berrigan, Dick Gallup, Lorenzo
Thomas, Peter Orlovsky, and
Ron Padgett.

By expressly inheriting a tradition, he also helped shape its inchoate influence.

Berrigan, Brainard, and Padgett had been collaborating with each other since Tulsa, but in New York the work took on a greater confidence, helped in no small measure by the appearance of *Locus Solus II*. Padgett recalled, "Not only was the magazine wonderful in itself, it provided historical precedents. The collaborative spirit that Kenneth fostered in that issue energized Ted and me to do more collaboration. . . . Suddenly a lot of people were writing collaborations." Collaboration became a daily practice. In a 1962 diary entry, for instance, Berrigan recorded, "Yesterday Joe & I did 5 very successful collaborations—two writings by me on paintings of Sandy & 3 spontaneous small works. We talked, worked alternately, drank pepsis, took pills. Stayed up 30 hrs [*sic*]." In a similar fashion, Padgett and Brainard made S, a collection of approximately seventy one-of-a-kind miniature collaborative collages on (in Padgett's words) "pieces of cardstock, typing paper and tracing paper—drawings, words, and collaged material, much of it rather cryptic and hysterical, some of it erotic, some of it with images from *Dick Tracy*, *Li'l Abner*, and *Nancy* comic strips." Or, Berrigan might visit the Padgett household for dinner. Padgett recalled, "While the 'girls' were in the kitchen, Ted and I would be banging away at the typewriter, or passing a pad and pencil back and forth . . . with the radio going, the stereo, whatever. We were inspired by our own lunacy and the smell of dinner on the stove," crying out, "Innkeeper, more Pepsi for me and my men!"

The notion of composition through collage and conversation was in the air, foregrounded by an exhibition in 1961 at the Museum of Modern Art, *The Art of Assemblage*, which included work by Georges Braque, Joseph Cornell, Jean Dubuffet, Marcel Duchamp, Pablo Picasso, Robert Rauschenberg, Man Ray, and Kurt Schwitters. In 1963, Berrigan began writing *The Sonnets* (1964), a collection of poetry in which he combined and recombined lines from his and others' writing. The effect was a shimmering, twitching bricolage of days,—who Berrigan was thinking about, and who he hoped was thinking about him. The phrases that made up these sonnets were conceived as compositional blocks; for instance, variations on the line "Dear Chris, hello. It is 5:15 a.m." that recur throughout the poems. To Padgett, these poems were "built" rather than "written" because, "as Ted himself has said several hundred times, he was using words as though they were bricks he placed side by side, one course after another, tapping them into place with his old typewriter that required a firm wham of the fingers. Scissors and Elmer's glue were also essential tools." Brainard was, at the same time, embarking on a number of assemblages of his own, including the large, luminous *Japanese City* and *Prell*, for which he scavenged materials around the Lower East Side and East Village, including a large number of the green glass Prell shampoo bottles. Brainard was also writing—encouraged, in part, by his friends. Like Berrigan, he was also a fan of lists, also interested in the contrapuntal rhythm of repetition and variation. His sense of timing is obvious in "Back in Tulsa Again," his account of a drive back to Tulsa in 1962 with Padgett, Mitchell, and Padgett's father. This was one of his earliest pieces of writing (as well as one of his longest) but his voice is already sweetly clear. (Though other visual artists like Larry Rivers and Fairfield Porter wrote poetry, Brainard's incidental career as a writer seems the most remarkable. His sense of what to divulge and how to do it was extraordinary.)

Even in this particularly collaborative climate, Brainard stood out. He seemed endlessly willing to collaborate, producing large numbers of drawings to publicize friends' and acquaintances' books, poetry readings, or happenings. He also published two volumes of *C Comics* in 1964 and 1965, which collected together his collaborations with more than forty poets

Our working method was highly collaborative: that is, Joe also added some words and I added some images. Using the limited media and materials at hand, we worked spontaneously, at a kitchen table in the living room, passing the pieces back and forth, drinking coffee, and smoking. Over four or five sessions, we ended up with around forty pieces. We never showed or published S...

—Ron Padgett, from *Joe: A Memoir of Joe Brainard*, 2004

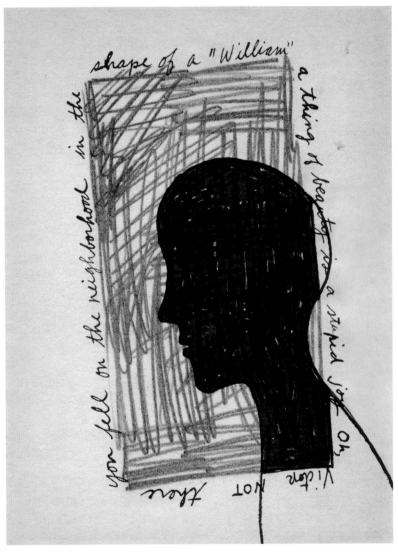

Pages from *S* by Ron Padgett
and Joe Brainard, 1963.

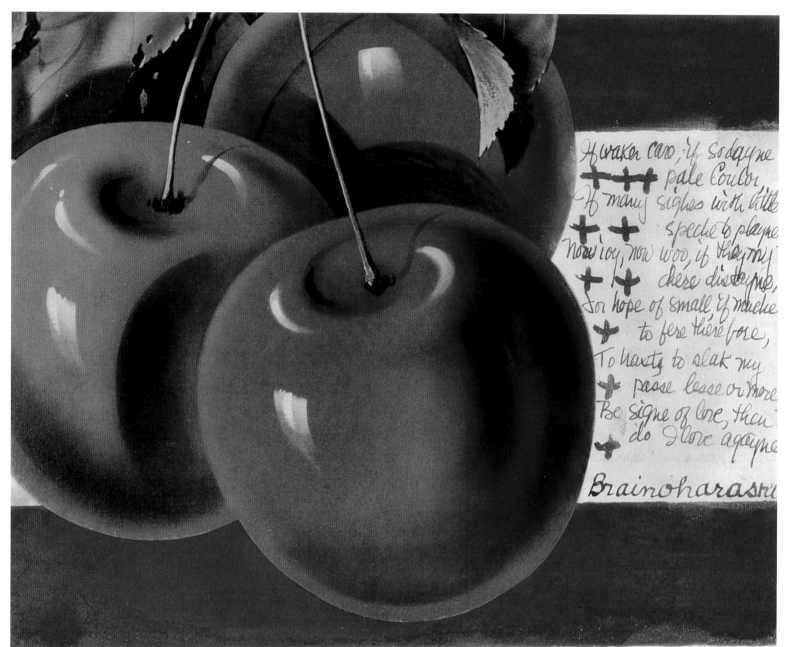

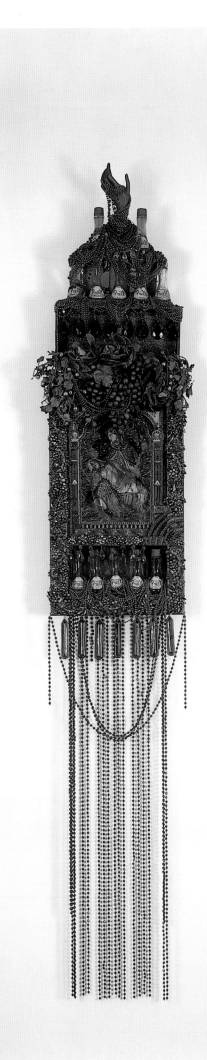

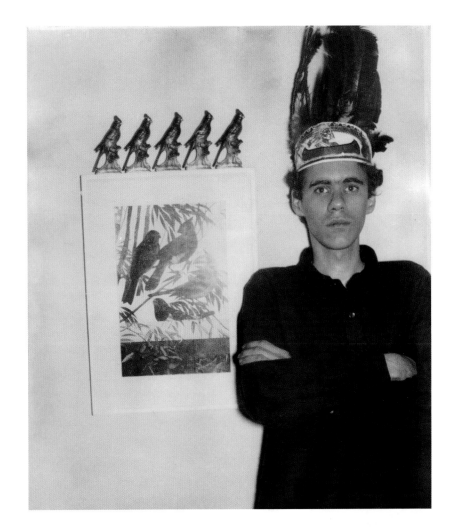

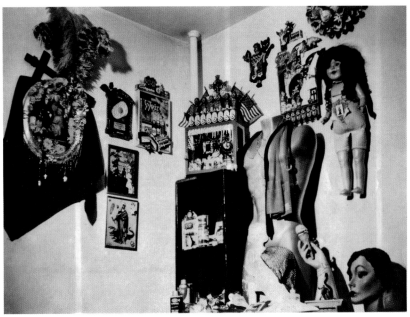

OPPOSITE
C magazine (1964–67), edited
by Ted Berrigan. The first few issues
of *C* magazine focused on work by
Berrigan, Gallup, Brainard, Padgett,
but Berrigan's scope quickly
widened. He went on to publish work
by Joseph Ceravolo, LeRoi Jones,
Tony Towle, Charles Olson, Jerome
Rothenberg, Michael McClure, Philip
Whalen, Kenward Elmslie, and John
Giorno—many of whom from
supposedly separate groups, and yet
they commingled quite easily on the
page and in person.

TOP, LEFT TO RIGHT:
Issue 3, issue 5, and issue 6.

MIDDLE, LEFT TO RIGHT:
Issue 7, issue 8, and issue 9.

BOTTOM, LEFT TO RIGHT:
Issue 10, issue 11, and issue 13.

BELOW
C Comics, edited by Joe Brainard.
Issue 1, 1964 (top); issue 2,
1965 (bottom).

and writers, including Ashbery, Bill Berkson, Berrigan, Denby, Kenward Elmslie, Gallup, Barbara Guest, Koch, Frank Lima, Gerard Malanga, O'Hara, Padgett, James Schuyler, Peter Schjeldahl, and Tony Towle—a veritable who's who of the New York School. His comics were, in equal measure, as casually scatological as they were art-world in-jokes: we see Superman dreaming of "my dream pussy of 1966" (in Gallup and Brainard's "Betty-Sue's Biplane"), then turn to Schuyler and Brainard's satirical advertisements, which included a send-up of the *New York Times*'s art critic Hilton Kramer and his recent review of an exhibition of Alex Katz's and Jane Freilicher's work. (In the advertisement, a couple called Alex and Jane trade quotes from Hilton ["Albeit"] Kramer's review, looking merrily unconcerned about the weight their words are supposed to convey: as the man with dots for eyes tells the woman, "Well, Jane, as long as you're 'modest and steady'!")

Ashbery captured the consequences of Brainard's approach particularly well:

> *Humor is one of Joe Brainard's subjects, but the work itself is not particularly humorous. Humor is presented in the form of illustrations from which the artist/writer stands at a slight distance. The works are about themselves—their subjects—and the distance between him and them is also a subject, whose nature is self-narration. Everything describes itself by being itself. (The opposite is true of all the other art I can think of.) Working this way he both defines and diminishes the space between himself and his work.*

This kind of perceptual distance is akin to looking at an object with the "wrong" end of a telescope. Objects in Brainard's assemblages, collaborations, and writing have a strange clarity and power; even though we have seen them before, often many times, through his eyes they seem mysteriously—delightfully—coherent. Brainard's later drawings for *The Vermont Notebook* (1975)—a coffee mug, palm tree, window—are an excellent case in point. As the poet Ann Lauterbach would later point out, Brainard's "radical power of perception" was connected to the familiar, to "objects of common ubiquity in a person's life—a cigarette in an ashtray, a comic book, a pet, a flower, many flowers, a vase of flowers." Brainard "believed that the familiar could not be exhausted." Such faith, Lauterbach suggested, was also apparent in James Schuyler's poetry and Rudy Burckhardt's photography and films.

Of course, this sense of ubiquity could be understood in the prevailing art currents of the day as rather Pop. In the early 1960s, as Carter Ratcliff put it,

Page from "The Fleur-Love Story"
by Peter Schjeldahl with drawings by
Joe Brainard. *C Comics*, issue 2,
1965.

Page from "Poem" by Frank Lima
with drawings by Joe Brainard.
C Comics, issue 2, 1965.

Page from "Pay Dirt" by Kenward
Elmslie with drawings by
Joe Brainard. *C Comics*, issue 2,
1965.

THE END

Page from "Title Page" by Bill Berkson with drawings by Joe Brainard. *C Comics*, issue 2, 1965.

RIGHT
C magazine with cover by
Andy Warhol, issue 4,
September, 1963.

BELOW
Andy Warhol, P. Adams Sitney
(with beard), and Gerard
Malanga, The Factory, New York
City, 1964.

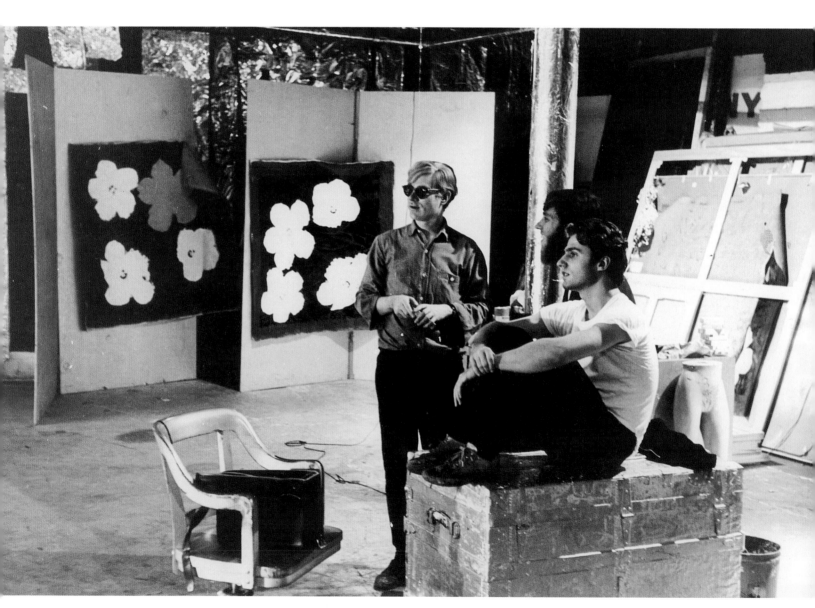

Cover of *Bean Spasms* by Ted Berrigan and Ron Padgett, Kulcher Press, 1967. Published by Lita Hornick and republished by Granary Books in 2012.

one could grow tired of "painterly excess and its claims to emotional authenticity—the blend of splash and drip and high-minded rhetoric that Frank Stella called 'the hullabaloo.'" The alternative was seemingly obvious: to cultivate hard edges and smooth surfaces, to empty the canvas of confessional rhetoric. There was a distinct sense of a new sensibility, epitomized by Warhol's silk-screen prints and Brillo boxes (one of which sat in Berrigan's living room for many years, accumulating scuffs and Pepsi stains, and accommodating stacks of books).[1]

Warhol's Factory opened its doors in 1962 and members of the New York School viewed his ascendancy in the art world with varying degrees of ambivalence. To some, Warhol seemed too slick. O'Hara distrusted—even disliked—him, and others also disapproved when Berrigan used a silk-screen print of Warhol's for the cover of the fourth issue of *C* magazine. (The issue was devoted to Denby's poetry, which was, by then, already obscure, and Warhol's cover, a silk-screened photographic print of Malanga and Denby kissing, was seen by some as exploitative. Warhol and Malanga were considered to have taken advantage of an older man's affections.)[2] But a number of other poets—including Ashbery, Berrigan, Padgett, and Ginsberg—were featured in Warhol's *Screen Tests*, a series of films and stills he made with Malanga that presented, very simply, each person standing "doing nothing" in front of the camera. These films were part of a general film aesthetic of Warhol's that focused on basic forms of living: sleeping, eating, and kissing. Their simplicity was part of Warhol's disinterested cool. Some celebrated the new attitude with no small degree of self-awareness. Padgett, for instance, wrote the memorable and very funny "Sonnet for Andy Warhol":

Zzzz
Zzzz
Zzzz

Zzzz
Zzzz
Zzzz
Zzzz
Zzzz
Zzzz
Zzzz
Zzzz
Zzzz
Zzzz

A high-spirited war snooze, Padgett's poem indicates a new kind of confidence, a willingness to forgo the sense of depth that comes from the reader's awareness of craft. It was quite different in tone from the collaborative poetry published in *Locus Solus II*—from, for instance, Ashbery's "To a Waterfowl," a poem entirely composed of lines cribbed from famous poems, in which there was a surrealist delicacy, a Cornell-like care in the ordering of the lines. In general, there is a roughness to the collaborations of second-generation New York School artists, a willingness to seem hasty. Brainard and Berrigan's collaborations like *Living with Chris* (1965) show the power of crossing out, of allowing mistakes to remain. This roughness manifested itself in other ways too. Padgett's sonnet appeared in *Bean Spasms* (1967), Brainard, Padgett, and Berrigan's book-length collection of collaborations, which included, along with drawings and writings, a faux interview with John Cage that was actually an assemblage of excerpts from interviews with (among others) Andy Warhol.[3] As Berrigan noted in his diary, Cage was not entirely amused.[4]

Publications like these were considered part of the "mimeo-revolution" taking place in the East Village—essentially, the proliferation of small magazines that happened as mimeograph machines became widely available (and affordable) in the 1960s.[5] For the price of the paper, ink, and a handful of

RIGHT AND OPPOSITE
Cover and spread from *Living with Chris*, by Ted Berrigan and Joe Brainard, 1965. The collaboration began with Berrigan writing the poem and Brainard adding the images later.

stencils, poets could now publish their own books rather than engage a printer. They organized collating and stapling parties, which automatically guaranteed a readership along with a flourishing social scene. This sociability was augmented by the popularity of poetry readings in cafes like the Tenth Street Coffeehouse and then Les Deux Mégots and Le Metro. At Les Deux Mégots and Le Metro, the poet Dan Saxon would collect manuscripts from readers, even asking poets to write on stencils that night. Some poets would take them home and type on them, but others simply wrote by hand there and then. Others would spontaneously write or collaborate with each other. The results could be published and distributed in days. Padgett recalled that the magazine produced "was a kind of free-flowing record. . . . Some of the poems were awful, but that didn't matter. It was more the sense of spontaneity that was important to me." Downtown magazines printed poetry along with gossip, letters, personal retorts, in-jokes, and accounts of parties. There was a studied informality at work, the charm of the casual.

The instantaneity was important to the sense of a developing scene. "The world," the poet Diane di Prima later noted, "overlapped in a million ways and places. The art world, the worlds of jazz, of modern classical music, of painting and poetry and dance, were all interconnected. There were endless interweavings." The downtown arts scene was swiftly becoming a cultural epicenter, and it was all circumscribed by a broader countercultural attitude, a love of new music (Bob Dylan, The Beatles, and The Rolling Stones), a set of political attitudes (pro–civil rights and anti-Vietnam), and a disdain for what felt like an entirely too-straight world. There were happenings and dance events at the Judson Church and an endless succession of benefit events to attend. Experiments in living proliferated. Ed Sanders made the film *Amphetamine Head*, which was the result of two days of filming people high on uppers in an

STILL, THERE IS
 SOME PEACE IN
 THE WORLD. IT
 IS NIGHT. YOU

ARE ASLEEP. SO I
MUST BE AT PEACE.

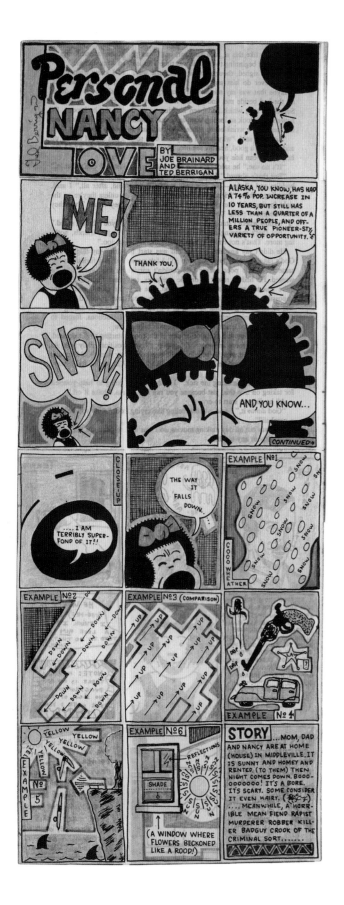

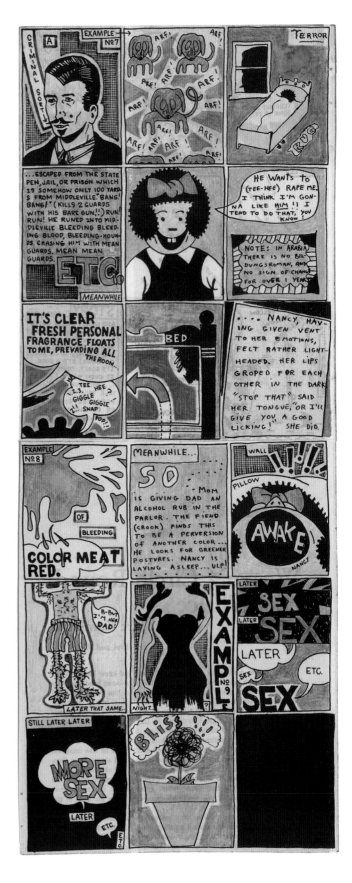

Joe Brainard and Ted Berrigan,
Personal Nancy Love, 1963.

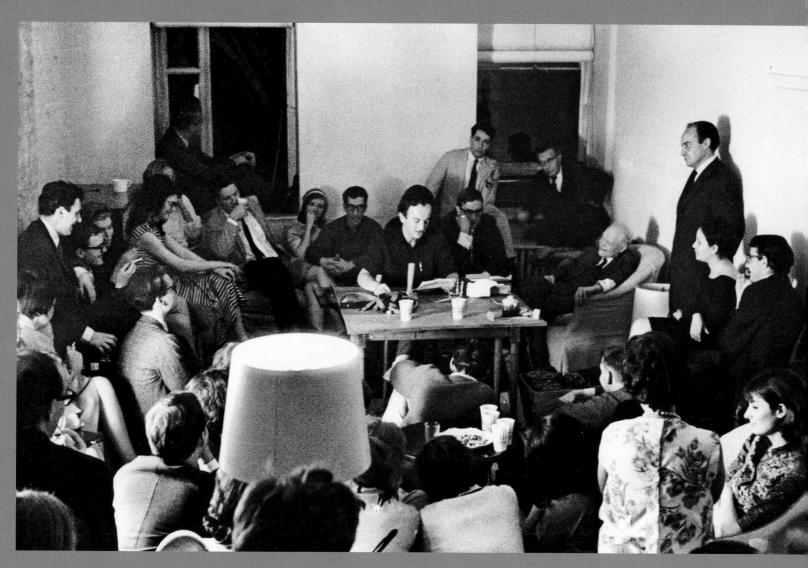

Frank O'Hara reads at the party given for Italian poet Giuseppe Ungaretti at the loft of Frank O'Hara and Joe LeSueur, New York City, May 1964.

Frank and Joe's loft below Union Square on Broadway was teeming with New York poets that spring afternoon and evening. Along with Frank, there were James Schuyler, John Ashbery, Kenneth Koch, Allen Ginsberg, and LeRoi Jones, all of whom read from their work toward the end of the party. And they were followed by Ungaretti himself, who read with such thunderous passion I found myself moved despite the fact that I knew no Italian. Younger poets, though none read, were also out in force: Ed Sanders, Ron Padgett, Dick Gallup, Tony Towle, David Shapiro, Kathleen Fraser, Jack Marshall and Jim Brodey I remember, and I'm sure there were others. At one point, Ed Sanders circulated a request for a single pubic hair from each poet in attendance. I wasn't certain how to comply, exactly, but Allen Ginsberg standing nearby quietly reached into his pants and extracted the item, enlightening me. The collection—carefully labeled in glassine envelopes—was later offered for sale to literary collectors through Sanders's Peace Eye Bookstore mail-order catalogue.

—Aram Saroyan, from "A Personal Memoir," 1983

LEFT
Cover of *The Floating Bear*,
issue 28, December 1963.

BELOW
Amiri Baraka and Diane di Prima,
Cedar Tavern, New York City, 1960.
In 1961, Baraka and di Prima
founded *The Floating Bear*
magazine. The first fifteen issues
were produced in di Prima's
apartment at 309 East Houston
Street, New York City.

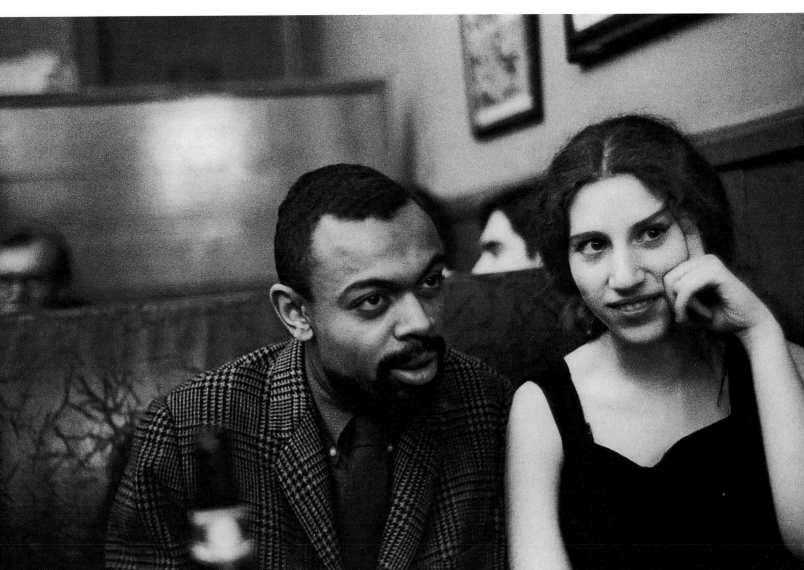

apartment on the Lower East Side, recording the murals and collages made on the walls, the self-mutilations, orgies, and the eventual trashing of the apartment.[6] The film footage was later confiscated and then lost after the police raided his apartment.

Sanders was the owner of the Peace Eye Bookstore and publisher of the magazine *Fuck You: A Magazine of the Arts*, which contained a combination of sexually explicit poetry, Egyptian hieroglyphs (a passion of Sanders's), and calls to peace and political action—usually by way of mass "grope-ins." The magazine aimed for esoteric divinity through obscenity. (Sanders went on to found the proto-punk band The Fugs.) For a time, he printed copies at the Phoenix Bookstore, which owned a mimeograph machine, and he often found himself sharing the press with Berrigan, who had begun to publish his own magazine, *C*, in 1963. Diane di Prima used the same machine at the Phoenix to print *The Floating Bear*, a literary newsletter she began with poet LeRoi Jones that offered a regular update on the local scene. As founding members of the New York Poets Theatre, di Prima and Jones also put on plays by a number of New York School poets, including *Loves Labor* by O'Hara, which di Prima noted "seemed to require a cast of thousands . . . Frank had given us the entire Decline of the West in less than four typewritten pages of hilarious poetry." (In other seasons of the Poets Theatre, Jonas Mekas ran a film series one night a week, and Jones a jazz series.)

In hindsight, what seems remarkable is how the buzzing energy of so many different forms of experimentation and their attendant tones—Warhol's cool, the earnest spiritualism of the Beats, and Black Mountain mythopoetics—casually commingled on the pages of these mimeo magazines, and in ventures like the Poets Theatre. Some people felt a sense of partisanship, but there was also a great sense of freedom: New York had become a cultural clearinghouse for youth. You could order up your

TOP
A program for the New York Poets Theatre, 1962.

BOTTOM
Ted Berrigan and Ed Sanders at Café Le Metro, 1964.

POETS

AT Le MeTro
149 Second Avenue
New York

KIRBY CONGDON	TED BERRIGAN	STEVE MENDEL
ALLEN KATZMAN	LORENZO THOMAS	MILTON RESNICK
DANIEL CASSIDY	JOEL COHEN	CHARLES HENRI FORD
CHARLES GOLDMAN	JAY SOCIN	BARBARA OVERMYER
MARGUERITE HARRIS	JOHN KEYS	CAROL BERGÉ
PETER ORLOVSKY	GEORGE MONTGOMERY	RONNIE ZIMARDI
JILL CASTRO	EDWARD A. MOFFATT	SZABO
RICHARD SCHMIDT	HARRY FAINLIGHT	WILL INMAN
AL FOWLER	MIMI JACOBSEN	ERIK KIVIAT
LEN FREITAG	CHARLES ROTENBERG	JONAS KOVER
PAUL BLACKBURN	MARY E. MAYO	DAN SAXON

VOLUME XIV
MAY 1964

handwritten by the authors
and published unedited
and indiscriminately
by Dan Saxon

HARRY FAINLIGHT	ERIK KIVIAT	CAROL BERGÉ
ALLEN KATZMAN	JOHN KEYS	RAI SAUNDERS
GEORGE MONTGOMERY	ALLEN DELOACH	DIANE WAKOSKI
TULI KUPFERBERG	ED SANDERS	ARMAND SCHWERNER
NANCY ELLISON	WILL INMAN	TOM HARRIMAN
	*DUANE LOCKE	PIERO HELICZER
	TED BERRIGAN	CARL SOLOMON
		DAN SAXON

POETS

at
Le MeTro
149 Second Avenue
New York

VOLUME XVII
OCTOBER 1964

handwritten by the authors
and published unedited and
indiscriminately by Dan Saxon

* guest contributor

POETS

at Le MeTro
149 Second Avenue
New York

TULI KUPFERBERG	MIMI JACOBSEN	TED BERRIGAN
CAROL BERGÉ	PAUL BLACKBURN	ALLEN DELOACH
GERARD MALANGA	*GEORGE DOWDEN	SZABO
ALLEN GINSBERG	GEORGE MONTGOMERY	KITTY POLITCHEVSKY
*ANSELM HOLLO	CHARLES ROTENBERG	BARBARA HOLLAND
AL FOWLER	ERIK KIVIAT	TOM HARRIMAN
KIRBY CONGDON	TEDI FARBER	DAN SAXON

November 1964
VOLUME XVIII

* guest contributors

handwritten by the authors
and published unedited
and indiscriminately by
Dan Saxon.

POETS

GEORGE MONTGOMERY	
JOSEPH BERKE	
ERIK KIVIAT	
BARBARA A. HOLLAND	
WILL INMAN	
DIANE WAKOSKI	
STEVE KOWIT	NANCY ELLISON
SZABO	JACK ANDERSON
JOHN HARRIMAN	TULI KUPFERBERG
ALLEN DELOACH	JOHN KEYS
*DUANE LOCKE	TOM HARRIMAN
*RAY NEWTON	AL FOWLER
	WESLEY DAY
	CAROL BERGÉ
	KITTY POLITCHEVSKY
	ALLEN KATZMAN
	DAN SAXON

* guest contributors

at Le MeTro
149 Second Ave.
New York

VOLUME XIX
December 1964

handwritten by the authors
and published unedited
and indiscriminately by Dan Saxon

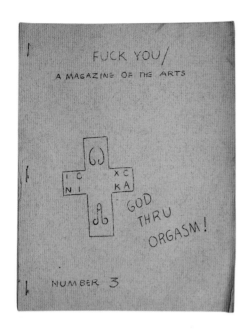

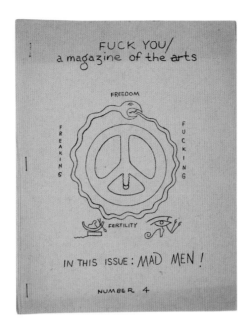

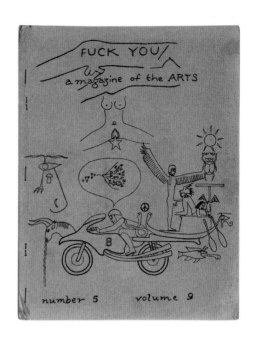

If you were interested in discovering poetry in the early 1960s you might visit the events pages of the Village Voice *and usually readings would be listed, time and place . . . Les Deux Megots, 64 East 7th Street, NYC held open readings Monday nights and a featured reader on Wednesdays.*

I found the readings at the café interesting, unique and worthwhile and began to attend on a regular basis. I began reading my own writings during the open reading sessions. Around December 1962 I was offered a Gestetner printer, a duplicating sort of mimeograph machine (excess office equipment) where you place a white sheet of paper with a blue or black carbon backing in the machine, turn a handle and produce multiple copies. I distributed the blank paper to most of the poets who read or to those who had work they wanted to publish.

My first publication was dated December 1962 "Poems Collected at Les Deux Megots"—"handwritten or typed by the authors and published unedited and indiscriminately by Dan Saxon."

—Dan Saxon, from "Poetry and Publishing in the Sixties (1962-65)," 2013

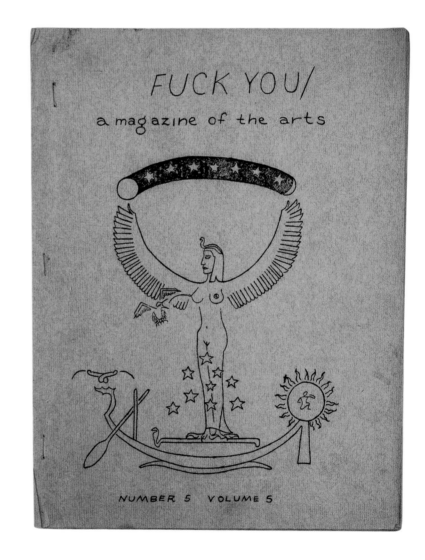

ABOVE AND RIGHT
Fuck You/ A Magazine of the Arts, edited by Ed Sanders.
The first volume of *Fuck You* is dedicated to "PACIFISM, UNILATERAL DISARMAMENT, NATIONAL DEFENSE THRU NONVIOLENT RESISTANCE, MULTILATERAL INDISCRIMINATE APERTURAL CONJUGATION, ANARCHISM, WORLD FEDERALISM, CIVIL DISOBEDIENCE, OBSTRUCTERS & SUBMARINE BOARDERS, AND ALL THOSE GROPED BY J.EDGAR HOOVER IN THE SILENT HALLS OF CONGRESS."
Covers shown here were hand-drawn by Ed Sanders.

Number 3, June 1962.
Number 4, August 1962.
Number 5, volume 5, December 1963.
Number 5, volume 9, June 1965.

OPPOSITE
Covers of *Poets at Le Metro* magazine, edited by Dan Saxon.

aesthetic influences as casually and directly as you would a sandwich. Of his literary "heritage," Berrigan commented, "My own line of descent is Beatnik cum Frank O'Hara. That's the way I've always seen it: Beats, with O'Hara on the left & Creeley on the right." These forms of inheritance tempered any one movement's excesses, as well as shifted the broader parameters of what the "New York School" referred to.

Yet next to films like Jack Smith's *Flaming Creatures*, it's clear there was a gentleness to the collaborations made by members of the New York School, a jokey camaraderie that wasn't aggressively experimental. Consider, for instance, the difference in tone between *Lurk* (1965), a parodic creature feature filmed in 1963 by Burckhardt, Red Grooms, Denby, Mimi Gross, and Yvonne Jacquette (among others), and *Normal Love*, made by Jack Smith a year later, and generally considered to be one of the most seminal films in 1960s avant-garde cinema. Both were filmed in summer, in nature: *Lurk* in Maine, and *Normal Love* at the painter Wynn Chamberlain's property in Connecticut. In *Normal Love*, nature is presented as Eastern exotica, as a jungle, all lily pads and large flowers, fallen fruit and low-hanging branches. Men and women drift and twist through this sexualized Eden, falling in and out of a bacchanalian orgy. One of the final scenes involves a large turning platform filled with people in various stages of undress, writhing and undulating (including Diane di Prima, who was nine months pregnant at the time, and who gave birth that night). There was little need for narrative with all of this desire.

In *Lurk*, however, the nature is pragmatically bucolic—distinctly non-urban, but also austere, recognizably Maine. The film is driven by its (twisty) narrative, which features Denby as mad Professor Borealis, Grooms as the creature, and Gross as Aurora, Borealis's beautiful daughter and the object of Grooms's affections. The characters believe in love, rather than desire; even the monster clumsily offers

ABOVE
Red Grooms, still from *Shoot the Moon*, 1962.

flowers to the terrified young mother (Jacquette) as a peace offering. Everyone has the best of intentions. The dominant tone is one of affection, of friends hamming it up together. As a collaboration, *Lurk* implicitly deals with these friends' life as they were living it, no matter the ludicrousness of the plot. It has the quality of a home movie. As Denby later commented, the film is "nearer Keystone than avant-garde with its visual honesty and particular virtuosity."

The painter Alex Katz, writing a feature on Burckhardt for *ARTnews* in 1959, identified Burckhardt as an amateur. "What I mean by an amateur," he wrote, "is that the art is not for money, not for careerism and is not an exclusive occupation." That Katz could refer so easily to this careerism indicates how much the art world had changed. There was a greater range of fortunes to be had; one could go on, year after year, making very little money, but the sculptor in the studio next door could suddenly, and seemingly inexplicably, make it big. In a later interview, Katz noted that he enjoyed hanging out with poets rather than painters because their sense of art "wasn't something that was institutionalized." To Katz, the poets were more interesting because "they were dealing with their life as they were living it." His implicit criticism of fellow painters—that the burgeoning appetites of the art world had separated the business of making art from the day-to-day life of its maker—also suggests that one marker of the New York School was that it continued to retain its casually sociable force. By his account, Katz had lunch with Denby every day for nearly a decade.

In general, a sense of homeliness runs through a lot of the collaborative art made at this time—for instance, in *Shoot the Moon* (1962) made by Grooms, Burckhardt, Gross, and Jacquette, or in *Fat Feet* (1966), which Grooms made with Gross four years later. The two met in Provincetown in 1957, and it was through members of the summer art colony there that Grooms, on his return to New York City, met Alex Katz and

Rudy Burckhardt. The three men were interested in similar effects: both Katz and Grooms explored the cut-out, and Grooms's films, like Burckhardt's, tended toward the caper. *Fat Feet*, for instance, is an affectionate portrait of the Lower East Side, complete with policemen, street cleaners, prostitutes, firemen, local businesses, and traffic. Gangsters might rob a store, but they're caught shortly afterward, and if a fire starts, the fire department immediately responds. Civic law prevails.

In general, the air of protest and division that dominated national politics in the 1960s—protests, sit-ins, and marches in response to nuclear armament, the Vietnam war, and civil rights abuses—was not explicitly focused upon in many New York School collaborations. The most politically apolitical collaboration made during this time is probably *The Last Clean Shirt* (1964), a film by O'Hara and Alfred Leslie. Leslie repeats the same footage three times—that is, a ten-minute drive uptown, from Astor Place to 34th Street and Park Avenue. The camera is nearly always fixed, looking forward from the back seat of a convertible, and an African American man drives silently, smoking and occasionally playing with the radio or a large alarm clock that's taped to the dashboard. His passenger, a young white woman, speaks gibberish, frequently twisting to one side to address the man directly, occasionally singing, lighting her cigarette—communicating passionately, but conveying no sense at all. She does not seem to expect a reply.

The second and third repetitions of this footage contain subtitles written by O'Hara and arranged by Leslie. In the second cycle, we are given what seems to be the woman's speech, and in the third, the man's thoughts. But the intimacy this might afford is deliberately undercut by the absurd humor, existential ennui, and in-jokes of many of O'Hara's lines, such as, "If I ever get as fat as Eunice, shoot me. . . . And as for her idea about Thanksgiving

Of course I resent
Bernice saying I have . . .

You don't say
that the victim is responsible

for a concentration camp
or a Mack truck.

It's the nature of us all
to want to be unconnected.

I have the other
idea about guilt.

It's not in us it's
in the situation.

It's a rotten life.

It's just that things get too much.

It's just that things get too much.

It's just that things get too much.

Of course I resent Bernice saying
I have a disordered mind . . .

of course

And I didn't say her friend
looked hilarious.

I said she looked harmless.

I really am upset about things.

I mean it's a rotten life.

Everything that goes on around you
is ridiculous.

Not that I don't love it,

But if only more people
looked like Jerry Leiber

we all would be a lot happier—

I THINK.

I think . . .

listen, I want you
to promise me something,

If I ever get as fat as Eunice,
shoot me,

Don't ask me about it.
Just shoot.

And as for her idea about
Thanksgiving dinner . . .

there are enough finks in the world

without eating
in a German restaurant

I am NOT complaining

It's just that things get too much.

—Frank O'Hara, excerpt of his subtitles for
Al Leslie's film *The Last Clean Shirt*, 1964.

dinner ... there are enough finks in the world without eating in a German restaurant." Shortly after, the woman "says," "If you're going to have one of those horrible attacks of guilt, you may as well be able to attach it to something like your mother or World War II." The film's disjuncture is an affront to our own expectations of what the conversational topic at hand "should" be; namely, the politically loaded symbol of a black man and a white woman driving in a car together. *The Last Clean Shirt* is a parody of a road movie and a romance, deliberately undercutting any liberal self-righteousness. As such, it offers a cultivated flatness that seems deliberately mild, allowing us to see, to use Berrigan's phrase, "depth and surface at the same time."

This tone is clearly consonant with the jokiness of Katz's and Groom's cut-outs in offering three-dimensional objects that aspire to lose a dimension. It could also be taken to indicate a retreat from an increasingly politicized art scene. Certainly, there were some who saw it that way. In 1965, LeRoi Jones decided to break with the downtown scene and New York School painters and poets. After the assassination of Malcolm X, Jones changed his name to Imamu Amear Baraka and later, Amiri Baraka, abandoned his publishing activities, left his wife Hettie Jones and their two children, and moved uptown to Harlem. Baraka thought the liberal white arts scene to be fundamentally racist, even if it didn't want to be.[7] In letters and memoirs of the time, the hurt caused by Baraka's departure is palpable, but at the same time, few felt as though they could counter his rhetoric. Most of the countercultural scene in the East Village *did* exhibit a largely silent sense of white privilege, even if many of the poets and artists came from working-class families. Knowing how to respond to that sense of privilege was a difficult thing. Of course, members of the New York School felt solidarity with the civil rights movement; as O'Hara wrote in "Ode: Salute to the French Negro Poets," "the only truth is face to face, the poem whose words become your mouth / and dying in black and white we fight for what we love, not are". Solidarity was through doing not being, and many of the poets and painters contributed their work and time to raising money for various left-wing causes. However, as Denby had put it when describing the 1930s, they knew well the dangers of a "rigid perspective ...

[and] jokes with only one side to them." That sense of unconscious one-sidedness—unaware of the proximity of other dimensions—worried them, just as it had de Kooning, Denby, and Burckhardt thirty years before. The year following Baraka's departure, Ashbery and Koch published their co-interview, *A Conversation*, as a pamphlet. It began with Koch asking, "Do you think we both might be too much concerned with matters of taste?" There is an anxiety in that phrase "too much." Ashbery replied, "What else is there?"

Of course, both men were entirely aware of what else there was—but neither was interested in art as a self-declared instigator of social change. When it came down to it, taste—that is, the habits of distinction—could have a kind of an ethical force, but that force was powerful only as long as it was implied. Their deflection had, at its center, a humanism that was instinctively practiced, but which wasn't easily named. Denby called it a "moral image" when describing de Kooning's work, which "reminds me of the beauty that instinctive behavior in a complex situation can have—mutual actions one has noticed that do not make one ashamed of one's self, or others, or of one's surroundings either." Denby's sense of instinct was one cultivated over time, and toward "a magnanimity more steady than one notices in everyday life, and no better justified." You might not be able to argue for a sense of grace, but that shouldn't stop you moving with it.

For Ashbery, this sense of generosity had something to do with an open horizon line (an irony for anyone living in New York City), which was an image he returned to, over and over again, in his poetry. In his poem "Soonest Mended," written two years after *The Last Clean Shirt*, he imagined stepping "free at last, miniscule on the gigantic plateau— / This was our ambition: to be small and clear and free." This sense of scale was also toward a kind of modesty. Beyond (or underneath) one's rhetoric, there were always other forms of meaning that could often be pointed to, but not easily elucidated: "We are all talkers / It is true, but underneath the talk lies / The moving and not wanting to be moved ... " These hidden advances and retreats contained a "loose / Meaning, untidy and simple ... " Knowing its looseness was a grace in and of itself.

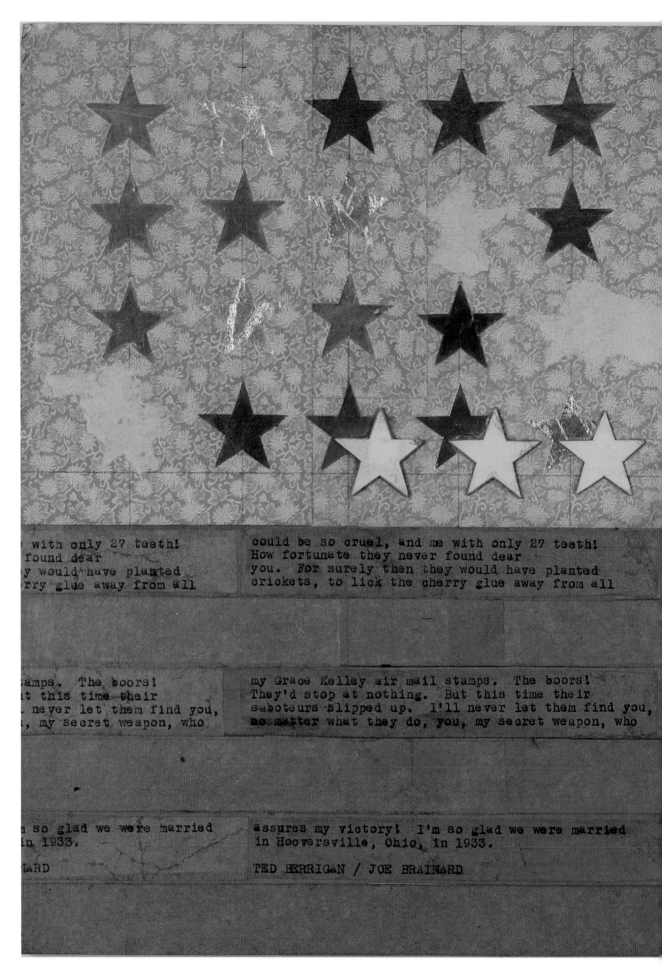

Joe Brainard and Ted Berrigan, *Untitled*
(Poem for Annie Rooney), 1962.

assures my victory! I'm so glad we were married
in Hooversville, Ohio, in 1933.

TED BERRIGAN / JOE BRAINARD

POEM FOR ANNIE ROONEY

My rooms were full of Ostrich feathers when
I returned from Spring, and someone had stolen
all the peanut brittle! just as if they'd known
I was in training! for shame! that anyone

could be so cruel, and me with only 27 teeth!
How fortunate they never found dear
you. For surely then they would have planted
crickets, to lick the cherry glue away from all

my Grace Kelley air mail stamps. The boors!
They'd stop at nothing. But this time their
saboteurs slipped up. I'll never let them find you,
no matter what they do, you, my secret weapon, who

assures my victory! I'm so glad we were married
in Hooversville, Ohio, in 1933.

TED BERRIGAN / JOE BRAINARD

assures my victory! I'm so
in Hooversville, Ohio, in 19

TED BERRIGAN / JOE BRAINARD

POEM FOR ANNIE ROONEY

My rooms were full of Ostrich
1 returned from Spring, and s
all the peanut brittle! just
I was in training! for shame

could be so cruel, and me wi
How fortunate they never fou
you. For surely then they w
crickets, to lick the cherry

my Grace Kelley air mail stan
They'd stop at nothing. But
saboteurs slipped up. I'll r
no matter what they do, you,

assures my victory! I'm so
in Hooversville, Ohio, in 19

TED BERRIGAN/ JOE BRAINARD

OPPOSITE
Ted Berrigan and Joe Brainard,
Untitled (Pope Weak), 1964.

XV

In Joe Brainard's collage its white arrow
He is not in it, the hungry dead doctor.
Of Marilyn Monroe, her white teeth white-
I am truly horribly upset because Marilyn
and ate King Kong popcorn," he wrote in his
of glass in Joe Brainard's collage
Doctor, but they say "I LOVE YOU"
and the sonnet is not dead.
takes the eyes away from the gray words,
Diary. The black heart beside the fifteen pieces
Monroe died, so I went to a matinee B-movie
washed by Joe's throbbing hands. "Today
What is in it is sixteen ripped pictures
does not point to William Carlos Williams.

LIX

In Joe Brainard's collage its white arrow
does not point to William Carlos Williams.
He is not in it, the hungry dead doctor.
What is in it is sixteen ripped pictures
Of Marilyn Monroe, her white teeth white-
washed by Joe's throbbing hands. "Today
I am truly horribly upset because Marilyn
Monroe died, so I went to a matinee B-movie
and ate King Korn popcorn," he wrote in his
Diary. The black heart beside the fifteen pieces
of glass in Joe Brainard's collage
takes the eyes away from the gray words,
Doctor, but they say "I LOVE YOU"
and the sonnet is not dead.

—Ted Berrigan from *The Sonnets*, 1964

Cover of *The Sonnets* by
Ted Berrigan, 1964. Cover
design by Joe Brainard.

BACK IN TULSA AGAIN

Joe Brainard, 1962

Back in Tulsa again, by way of free ride from Ron's father: Ron
being a Columbia University student, also poet, and Ron's father
being a John Wayne with $80 cowboy boots. I wear desert boots. Pat
usually wears very basic black flats, tho she looks better in high
heels. They compliment her legs. Very nice. Yes, Pat too made the
big move back to Tulsa. The three stooges make the big move back
to Tulsa. The three fuckado's make the big move back to Tulsa. The
big move back to Tulsa was made by Pat, Ron, and myself.

 The trip back was as normal as possible considering John
Wayne drove (in $80 cowboy boots) and we, the three "Tulsans in
New York" were his passengers. Yes, even Ron was a passenger, as
I am now a guest in my own home. In my own home I am a guest. We
three "passengers" made the big move back to Tulsa. Three people: a
strange number of members for a relationship. We three: one girl and
two boys. Or should I say woman and men? Both embarrass me, and seem
"not quite right." Three people, a poet, a woman, and a painter. I
being the painter, Pat naturally the woman, and Ron obviously the
poet. But Ron is obviously a Columbia University student. We three,
Pat being my favorite next to myself, made the big move back to Tul-
sa for lunch; a fantastically voluptuous lunch with entertainment.

 "Lunch," Ron said again to his father with $80 cowboy boots
driving like a madman directly aiming at Tulsa with serious convic-
tions of direction. Yes, Ron's father was anxious to get home, home
to Tulsa. Home to space and lightness, white square gas stations and
shining car lots. Ron's father is obviously from Oklahoma. We Marx
brothers minus one are obviously only flounderers. Floundering be-
cause we are neither New Yorkers nor Oklahomans. But I am a painter.
Not a man without a country, but a man (or should I say boy) with a
country too big. A country too big, and with no secret hiding place
or club house. The dues are simply too high: too too high. The sky
is higher in Tulsa. The sky is higher in Tulsa than in New York.

 "Lunch," Ron repeated again and again. Ron was obviously hun-
gry; which made Pat and me envious. Envious because Ron had at least
momentarily found some positive and alive state of being, some iden-
tity to desire which actually was. We were envious, enormously envi-
ous. Pat even more than I, she being a woman and all. Women are much
more susceptible to such emotions: those of envy, or pity, or jealou-
sy: all unconstructive emotions. Yes; Pat was envious. Ron was hun-
gry. And I too was envious, but not too envious, for I was constipated.

 A List for the Sake of a List

 1. Pat Mitchell
 (a) envious
 (b) looks better in high heels
 (c) woman
 (d) or girl
 (e) flounderer
 (f) not hungry
 (g) my favorite
 (h) usually wears black flats

LEFT AND FOLLOWING PAGE
Pat Padgett and Joe Brainard, on
their return trip to Tulsa, Oklahoma,
in stills from a home movie by
Ron Padgett, June 1962.

2. Ron Pagett
 (a) John Wayne's son
 (b) flounderer
 (c) student of Columbia
 University
 (d) hungry
 (e) poet
 (f) heir to a pair of $80
 cowboy boots
 (g) a "passenger" in his
 own family car

3. Me
 (a) constipated
 (b) envious, but not that much
 (c) author of "Back in
 Tulsa Again"
 (d) painter
 (e) flounderer
 (f) embarrassed as to
 terminology; man or boy

"Lunch," Pat cried: Pat
was getting into the spirit
of things.
"Lunch," I cried, so as not to
be a wet blanket. Also, I had hopes of finding a restroom in
the chosen café.
"Three to one, ha! ha!, we win!" we sang over and over to
the tune of "Love Me Tender" (originally recorded by Elvis Pre-
sley) while Ron poked Pat in the eyes with his two fingers next
to his thumb (spread wide apart) and me jokingly biting Ron's
big toe. His big toe is big, you know. Yes, we truly were, at
that moment, the Three Stooges. Or even the Marx brothers minus
one. But we each realized that soon the spell would be broken
and Pat would become a woman, Ron a poet and student, and me a
painter. My name is Joe Brainard.
Pat was suddenly on top of me as Ron's father, John
Wayne, swang off the road heading straight toward a small,
very small, café. The sudden turning of the car at a very high
speed, yes very high (like the sky in Tulsa) was quite sponta-
neous on Ron's father's part, and quite a surprise to us. Yes,
it shook us up a little. Resulting in Pat suddenly being thrown
in my lap, which appeared physically impossible. As I said, Pat
was in my lap, which felt very good. It felt good to have Pat
in my lap. In fact, it felt too good, for I'm afraid I embar-
rassed her. Pat became a woman. The spell was broken.
I smiled when my eye hit the small 7-Up sign dangling
from a string attached to the light fixture. It was used as a
pull to turn on the lights. I smiled. I felt good. I ate lunch.
It was just I. We all three at lunch, but I was the only one

that ordered a ham sandwich with mustard: a dry
sandwich so as to make my Pepsi more useful and
satisfying. I smiled again, almost laughing, as I
slowly eyed the café, having just taken an enormous
swig of my cold Pepsi, and enjoying its tingling,
almost burning, effect on my throat. I felt it all
the way to my tummy; which had been previously re-
lieved by "going straight ahead, turning right, and
entering the second door painted a light green."
The café had one bathroom, for men and women, so
you had to hook the door. And if you were employed
there, you had to wash your hands before leaving.
That's the law. The sign said so. Not being em-
ployed, I took advantage of my liberty. I continued
eying the café, the café with no name just out of
Joplin, Missouri: small, very small, with a large
white sign saying "Café." Large simple white block
letters on blue, a true blue. I saw the whole café
very clearly, its beauty and its reason. I felt
good that I had eyes. I wished I'd hurry and finish
my sandwich so I could have a cigarette; a Tareyton
Dual Cigarette with two phallic red stripes on the
package. Two red stripes very close together. And
with a white ring around the filter. Thirty cents
a pack, twenty to a package, one and one half cents
each, and soon it would disappear into smoke. And
soon I would be in Tulsa. I tried to imagine it. I
couldn't. I realized that this exact moment was all
that was real and certain. I felt good because I
felt good.

"A rose is a rose is a rose is a rose is a rose, etc."
(or something to that effect).

—Gertrude Stein

 I sang "Going for a Ride in a Car-Car" be-
cause we were. Yes, we were once again going for a
ride in a car-car, a car-car driven by John Wayne
headed towards Tulsa, Tulsa, Oklahoma: John Wayne
driving to Tulsa, Oklahoma in $80 cowboy boots.
 It was my turn to be by the window: goody.
It was open, with my arm and head stuck out, and
the wind stinging my face making it even hard to
breathe. I sang louder, but no one could hear me:
the wind blew the volume back down vibratingly into
my throat. I sang the worst songs in the world not
knowing why; not knowing why I sang the worstest
songs in the world: "The Tennessee Waltz," "Tell Me
Why," "Dancing Matilda," and "The Thing." Others
too, yes, many others. And more others. Many many
etc.'s.
 We slept. Ron's father drove. We smelled the
dry grass: bad at first then heaven. We entered
Tulsa. Ugh!

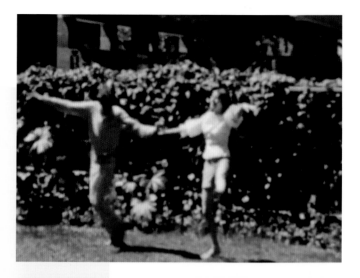

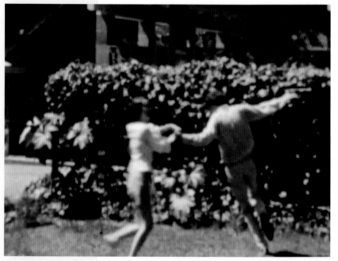

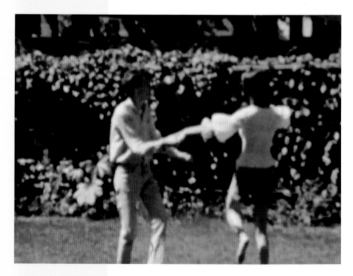

"Ugh! Ugh!" we sang, "Ugh! Ugh!" as we entered Tulsa.
Ugh! John Wayne smiled and we three sang "Ugh! Ugh!"
 An undescribable farce began, simply undescribable, quite
simply unbelievable. A farce which could only possibly occur be-
tween a woman and two men, a girl and two boys, in a car driven
by John Wayne wearing $80 cowboy boots driving from New York to
Tulsa, Tulsa, Oklahoma.
 We sang "Oklahoma."
 "O-O-O-Oklahoma," we began.
 "O-K-L-A-H-O-M-A, Oklahoma, O.K." We ended. We laughed.
Ron giggled and I snorted. Pat was choking on a Spanish peanut.

 Thus it began. Thus the farce began: the farce began as thus.
 Pat, by this time quite green, was still choking, still
choking to death on her fifth Spanish peanut of the day. Ron and
I were rolling on the (a very tight squeeze) floor of the Ford
in tears: tears from pity or excitement we knew not which. We
cared even less, for the "spirit" was in us, the spirit which we
never doubted. Ron and I were red from laughter. Pat was green
from lack of air. The Ford was light yellow. The sky was blue,
a sky blue: a high sky blue, like the sky in Tulsa it was. Ron
stuck out his tongue for no reason. I laughed at him for the
same reason. Pat tried to laugh for the same reason, but found
it difficult. She found it quite difficult to laugh while chok-
ing on a Spanish peanut, especially for the same reason. I did
a flamenco dance: it was not well done, but very voluptuously
stimulating and meatily exciting, that is, for me. Pat joined
in, tho she found it very difficult to flamenco in a yellow Ford
going 95 miles an hour while choking on a Spanish peanut: and
with a partner too. But Pat had the spirit. Ron had the spir-
it as he hurriedly undressed. I undressed. I winked at Ron and
said go: we violently attacked Pat. It worked, Pat swallowed her
fifth Spanish peanut of the day. We were happy. Pat was espe-
cially happy. We celebrated in a happy way: we stopped for a
Dairy Queen, a $.25 cone. Joy! Joy! Joy! Happy Day!
 "The sun's a shinen, oh happy day-a, no more trouble, no
sky's are gray-a, oh, oh, oh, oh oh oh oh, happy day—" We sang
violently. Yes, violently, for the Dairy Queen had simulated us
to a fantastic degree of insight. We saw clearly at that moment,
that glorious moment of knowing, that the world was basically
violent, at least, in comparison to a 25 cent Dairy Queen. Tears
came to my eyes. I cried, I cried for the first time in seven
years. I cried violently into my Dairy Queen.
 My Dairy Queen had by now melted considerably. I had
dropped it several times: it was very dirty and sticky. The
tears made it very watery and it was overflowing. I watched. I
saw in it a fly: a fly in my violently overflowing Dairy Queen,
diluted from tears. It was too much. I remembered the jolly
pink man who had carefully handed it to me from the hinged small
square screen opening. He had smiled as I took possession, and
handed him my 25 cents, my last 25 cents. It was beautiful: so
purely white and nice in a delicately crisp cone, a curl on top,
ripples of white sand. "Arabia," I thought. Yes, I must go to
Arabia, I had been there so often in my dreams. I wondered if
they had Dairy Queens in Arabia. It was too beautiful, and now,
and now it was dirty. Dirty! Dirty! Dirty!
 I wept, that is, I continued weeping.
 I continued weeping for the rest of my life.

OPPOSITE
Joe Brainard and Frank O'Hara, *Is
That the Height of Your Ambition
Johnny?*, 1964.

*"EVERYDAY EXPRESSIONISM" is a phrase among
others I scrawled on one of the large sheets of drawing
paper I sent Mike [Goldberg] in 1964, encouraging him
to draw or paint next to or over the words, as he wished.
After a number of bizarre turns, the details of which I
have never completely understood, he had landed in the
Psychiatric Institute at Columbia-Presbyterian
Hospital. Frank [O'Hara] and I decided on a plan to both
cheer him up and trick him into action by sending him
separately words on surfaces that left plenty of space for
whatever else he could put there. In Frank's case, there
apparently had been a plan going back a year or so—
words by Frank followed by images by Mike, all related
to Frank's recent European tour on business for the
Museum of Modern Art. For me it was all freestyle, no
guidelines whatsoever: above my "EVERYDAY" Mike
drew a calendar nude; on another sheet there are just
cutout stars, and on yet another (similar to those he did
for* Dear Diary *with Frank), a tilted, disconnected bridge.*

—Bill Berkson, from *Perpetual Motion: Michael Goldberg*, 2010

Michael Goldberg and Bill Berkson,
Everyday Expressionism, 1964.

21

From A Conversation with Kenneth Koch
John Ashbery & Kenneth Koch, 1965

KENNETH KOCH: *John, do you think we both might be too much concerned with matters of taste? Or don't you think it's possible to be too much concerned with it?*

JOHN ASHBERY: *What else is there besides matters of taste?*

KK: *How would you change that statement if you wanted to put it in a poem? I think that statement would seem too pompous to you to put into a poem. Or too obvious.*

JA: *I would not put a statement in a poem. I feel that poetry must reflect on already existing statements.*

KK: *Why?*

JA: *Poetry does not have subject matter, because it is the subject. We are the subject matter of poetry, not vice versa.*

KK: *Could you distinguish your statement from the ordinary idea, which it resembles in every particular, that poems are about people?*

JA: *Yes. Poems are about people and things.*

KK: *Then when you said "we" you were including the other objects in this room.*

JA: *Of course.*

KK: *What has this to do with putting a statement in a poem?*

JA: *When statements occur in poetry they are merely a part of the combined refractions of everything else.*

KK: *What I mean is, how is the fact that poetry is about us connected to the use of statements in poetry?*

JA: *It isn't.*

KK: *But you said before—*

JA: *I said nothing of the kind. Now stop asking me all these questions.*

KK: *I'm sorry.*

JA: *Now I'll ask you a few questions. Why are you always putting things in Paris in all of your poems? I live there but it seems to me I've never written anything about it.*

KK: *Isn't "Europe" mainly set there?*

JA: *No. Reread that poem. It all takes place in England.*

KK: *What about the gray city and the snow valentines and so on—even though the main part of the narrative obviously takes place on the flying fields of England, the real psychological locale of the poem always seemed to me to be in Paris. No? Where were you when you wrote it?*

JA: *In Paris. But there is only one reference to Paris in the entire poem.*

KK: *Well, I wrote Ko in Florence.*

JA: *I wish you would answer my question and also explain—*

KK: *And there is only one reference to Florence in it, but the way things come together and take place always seemed to me to be very dependent on the fact that it was written in Florence. What did you want me to answer?*

JA: *Let's ignore for the moment at least your enigmatic statement that the way things come together reminds you of Florence—*

KK: *I did not say that.*

JA: *Anyway I wish you would explain for me and our readers—*

KK: *Listeners.*

John Ashbery, Bill Berkson, Kenneth
Koch, Frank O'Hara, and Patsy
Southgate, 1964.

JA: —why we seem to omit references to the cities in which we are living, in our work. This is not true of most American poetry. Shudder.

KK: Hmm. I guess we do. I did write one poem about New York while I was in New York, but the rest of the poems about America I wrote in Europe.

JA: I repeat, why we seem to omit ALMOST all references—?

KK: I find it gets to be too difficult to get through my everyday associations with things familiar to me for me to be able to use them effectively in poetry.

JA: Snore.

KK: I myself am bored by my attempts to make abstract statements and wish I could do it as facilely as you do. I'm going to cut out my previous statement. What made you snore?

JA: Well, if you're cutting out your statement, then my snore naturally goes with it, I suppose.

KK: Maybe I won't cut it out. Or I might just keep the snore.

JA: It sounded too much like the way all artists talk when asked to explain their art.

KK: Yes, I agree. I dislike my statement. Why do you suppose are so bothered by such things?

JA: It's rather hard to be a good artist and also be able to explain intelligently what your art is about. In fact, the worse your art is the easier it is to talk about it. At least, I'd like to think so.

KK: Could you give an example of a very bad artist who explains his work very well?

JA: (Silence)

KK: I guess you don't want to mention any names. Why don't you want to mention any names, by the way? Especially since I once heard you say that names are more expressive words than any others.

JA: Some people might get offended. I don't see the point of that.

KK: Do you mean you're afraid?

JA: No. Just bored in advance by the idea of having to defend myself.

KK: Have you ever been physically attacked because of your art criticism?

JA: No, because I always say I like everything.

KK: Would you say that is the main function of criticism?

JA: If it isn't it should be.

KK: How can one talk about what should be the function of something?

JA: Our problem seems to be to avoid it.

KK: To avoid what?

JA: Talking about what you said.

KK: Let me go back a little.

JA: That's always a mistake.

Prepared by **Kenneth Koch**
Taken by **Jim Dine**

Test in Art

I One hour. Answer any 16 questions.

1 What is your favorite color? Circle right answer.
Blue Red Gold Silver Other *(FLESH)*

2 What was your favorite color when ~~you were a child~~?
~~Green~~ ~~Purple~~ Orange Tan ~~Silver~~ Magenta Gold
Red Turquoise

3 What are three shapes that you are interested in putting
into your work at the present time? Circle correct answers
and add others if necessary in the space below.
Hammer Potato Necktie Baseball Eagle-head Mothball
Broom Handlebar (Cactus) Bed Cork

hearts

4 Circle those works in the following list which you now
like more than you did in the past. Draw a single line
under those you now like less than you did in the past.
Answer only for works about which you had definite feelings
at both times.
L'Arlésienne White on White The Madonna of the Rocks
Cleopatra's Needle ~~The Spirit of the Dead Watching~~
Les Saltimbanques ~~The Birth of Venus~~
The Battle of San Romano Hide and Seek
Le Déjeuner sur l'herbe (The Parthenon)
Portrait of Gertrude Stein David (Michelangelo)
David (Donatello) Jane Avril at the Moulin Rouge
Andromeda (Rubens) The Music Lesson (Vermeer)
The Land of Cockaigne The Concert (Caravaggio)
Venus (Titian) The Scream (Munch)
Add others below if desired.

won't answer! too literary!

Which of the changes you have indicated do you regard as
permanent, as definitive? That is, which of the works
underlined do you feel sure you will never be able to like as
much as you once did? Indicate these by adding two evenly
spaced lines to the one you have already drawn under them.
For works you feel sure you will always like more than you
once did, draw two additional circles around the one you
have already.

5 In the following list of writers and composers, are
there any whose esthetic aims you consider to be similar to
yours? Circle those that apply.
John Cage Sinclair Lewis John Donne Igor Stravinsky
Aleister Crowley Pablo Neruda T. S. Eliot
Jorge Luis Borges Anton Webern Aaron Copland
Leo Tolstoy Allen Ginsberg Arnold Schönberg
Samuel Beckett Robert Frost Edith Wharton
Vladimir Mayakovsky James Joyce René Char
Add here the names of any writers or composers not included
in the above list whose esthetic aims you find similar to
yours.

HAVE no idea about similar aims but I love Borges & Mayakovsky

LORCA, LENNON-McCARTNEY, JERRY LIEBER

6 Name two or three artists of the past whom you would
expect to like your work.

7 Which of the following "movements" in art seem to you
to have made the most genuine contributions to art in the
past 25 years?
Pop Op Magic Realism Abstract-Expressionism
Hard-Edge Painting

8 In an exhibition which was to represent the greatest
achievements in painting of the past 400 years, what ten
artists would you feel it most essential to include?

can't take the chance

9 Would your list of personal favorites among artists
differ from the above list in any way? *YES*

10 Give an example of a minimal change you would make in
a specific work by another artist so as to make it a work
of your own.

Jim Dine and Kenneth Koch, "Test
in Art," *ARTnews*, October 1966.

11 Which of the following words would you most like to have used about your work by a critic whose opinions you respect? Circle 5-10. Which would you least like to have used about you? Draw a single line through 5-10.

experimental childlike witty versatile refreshing agonizing brittle horsey courageous fraudulent jazzy gutsy stinky rubbery underrated Surreal Cubist (hairy) gallant polite effervescent European twentieth-century twenty-first century Sixtiesish Fortiesish Etruscan effeminate brutal hard cold hot passionate dead (alive) human complex bare necessary new actual phenomenal beautiful cruel base vapid interesting mercenary vulgar expensive cheap (purple) sleepy dirty (sexy) hard-headed determined swirling (rich) insane devout

12 Has any critic influenced the way you paint? If so, explain briefly how.

NO

13 Aside from official criticism, are there any isolated remarks people have made which have influenced your work? If possible, give two or three of these remarks here.

N.O. —COULD

14 If you could have your most recent painting placed anywhere you liked, where would you hang it?

in my house

15 Is there any object now in general use (such as an automobile, fountain pen, bed, etc.) which you would be interested in redesigning? Explain.

TOPCOATS, SUITS, SHOES, VESTS, TIES, SHIRTS, CUFFLINKS, BELTS, ASCOTS, EARRINGS, SWEATBANDS, KNAPSACK, ETC.

16 If you could redesign any building in the world, which one would you choose?

the tester's apartment

17 Imagining that anything is possible, what commission for a work of painting, sculpture or architecture would you like most to be given right now?

I would like all the billboard space between any 2 towns.

18 In the space provided below, draw a hammer, a scissors and a star, or any other three objects that interest you at the present time.

—TRIANGLE

—finger

HOLE

19 If the three objects in the drawing could speak, what do you imagine they would say about this test?

SWELL, UNBELIEVABLE CAN'T STOP!

Turn the page for Test in Art, Part II

Jim Dine and Kenneth Koch, "Test in Art," *ARTnews*, October 1966.

Test in Art

II One hour. Answer 42 questions. Answer YES or NO.

Add a brief comment on the worksheet when necessary. **NO**
1 Does your work have hidden political significance?

2 Do you consider yourself in any sense an ethnic painter? **NO**

3 Do you consider yourself in any sense a regional painter? **NO**

4 Do you consider yourself a Hard-Edge painter? **NO**

5 Do you think your work is too difficult to understand? **NO**

6 Are you able to work in the presence of other people? **NO**

7 Do you often listen to music while you work? **NO**

8 Are you annoyed by the incessant sound of an automatic hammer? **NO**

9 Do the dust and fumes emanating from the materials you work with ever bother you to the extent that you have to stop working? **YES**

10 Do you work best in the winter? **NO**

11 Do you work best after a large meal? **NO**

12 Do you ever dictate letters or carry on other activities while you are painting or sculpting? **NO**

13 Do you keep a notebook? **NO**

14 Have you ever risen from a sound sleep to write down an idea for a painting? **NO**

16 Do you consider the present decade the greatest period in American painting? **NO**

18 Do you feel that American art of the past 20 years compares favorably with that of the Impressionists? **YES**

19 Do you feel that bad times lie ahead for American art? **NO**

20 Do you feel that there can be no truly significant change in the art of our time without a fundamental change in the economic and social structure? **NO**

21 Do you think that future generations will consider your work as "traditional"? **NO**

22 Do you think that people hundreds of thousands of years from now will consider you a rebel? **NO**

23 Have you ever had the idea that people of the far-distant future will find in your art an important key to the civilization of our time? **YES**

24 Do you feel that modern science and modern warfare will so drastically alter the human senses and the human brain that our esthetic concerns will seem incomprehensible to people living less than a century from now? **YES**

25 Would you prefer to live in a society such as that of the Caduveo Indians of Brazil where all paintings are done on the human body? **YES**

26 Do you feel it is possible for an animal to create a beautiful painting?

27 Do you feel it is possible for an animal to create a beautiful work of sculpture? **YES**

28 Have you ever received an esthetic sensation from looking at a natural object or landscape? **YES**

29 Do you feel that the main difference between a work of art and a work of nature is the relative stability of the work of art? ***NO**

30 Do you feel it is morally wrong for a man to own or sell parts of nature? **NO**

31 Do you feel it is morally wrong for a man to own or sell works of art? **NO**

32 Would you prefer to be given $100,000 a year for life and allowed to paint when and what you wanted, to the present system of selling paintings? **YES**

33 Have you ever had the feeling that you would "live on" in your work after death? *****

34 Have you ever worked successfully when you were drunk? **NO**

35 Do you work best when you are miserably unhappy? **NO**

36 Have you ever fallen in love with someone while painting her picture? **NO**

37 Does art seem to you "evil" in the sense that it represents an attempt to change the nature of things? **NO***

38 Do you feel that your work is drastically limited in scope by the conditions of life in New York? **NO***

39 Are you able to work steadily for more than six hours at a time? **YES**

40 Would you like to die at the height of your powers? *****

41 Would you like a movie about your life to be made when you are at the height of your powers? *****

42 Would you like to fly free of charge to every major city of the world disguised as a woman? **YES***

43 If asked to be the United States Ambassador to the United Nations, would you hesitate before refusing? **NO**

44 Would you like to go to the North Pole and make a statue there out of ice that would last forever, but that no one would ever see? **NO**

45 Would you like to live in a dwelling in which the temperature was constantly kept at 115 degrees? **NO**

46 Do you feel that you would be a more complete artist if you were half-man, half-woman? **NO**

47 Do you feel that you could be a more complete artist if you could come back from the dead? *****

*see worksheet for explanation

Jim Dine and Kenneth Koch, "Test in Art," *ARTnews,* October 1966.

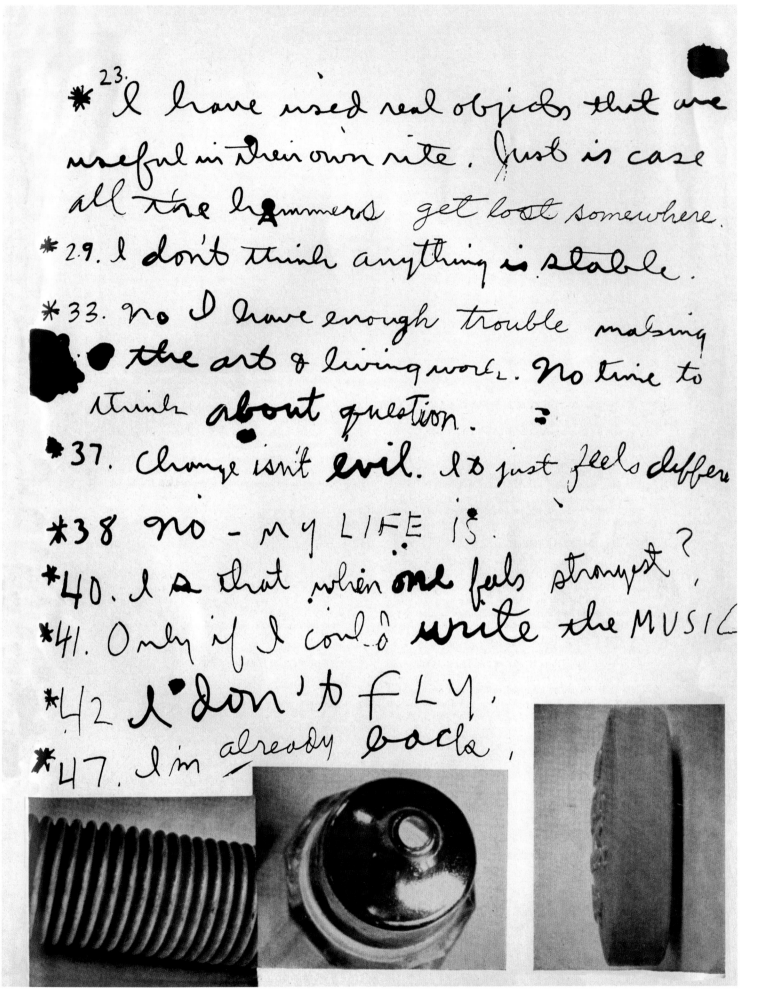

*23. I have used real objects that are useful in their own rite. Just is case all the hammers get lost somewhere.

*29. I don't think anything is stable.

*33. No I have enough trouble making the art & living work. No time to think about question. ⸫

*37. Change isn't evil. It just feels differe

*38 NO - MY LIFE IS.

*40. I s that when one feels strongest?

*41. Only if I could write the MUSIC

*42 I don't FLY.

*47. I'm already back.

Jim Dine and Kenneth Koch, "Test in Art," ARTnews, October 1966.

AN INTERVIEW WITH JOHN CAGE

Ted Berrigan
From *Bean Spasms*, 1967

The following interview is pieced together from a series of
tape-recorded interviews with John Cage during his recent visit
to New York. They were made at parties, in flats, and in taxis.

INTERVIEWER: What about Marshall MacLuhan?

CAGE: Just this: the media is not a message. I would like to
sound a word of warning to Mr. MacLuhan: to speak is to lie. To
lie is to collaborate.

INTERVIEWER: How does that relate?

CAGE: Do you know the Zen story of the mother who has just lost
her only son? She is sitting by the side of the road weeping and
the monk comes along and asks her why she's weeping and she says
she has lost her only son, and so he hits her on the head and
says, "There, that'll give you something to cry about."

INTERVIEWER: Yes, somebody should have kicked that monk in the ass!

CAGE: I agree. Somebody said that Brecht wanted everybody to think
alike. I want everybody to think alike. But Brecht wanted to do it
through Communism, in a way. Russia is doing it under government.
It's happening here all by itself without being under a strict
government; so if it's working without trying, why can't it work
without being Communist? Everybody looks alike and acts alike, and
we're getting more and more that way. I think everybody should be
a machine. I think everybody should be alike.

INTERVIEWER: Isn't that like Pop Art?

CAGE: Yes, that's what Pop Art is, liking things, which
incidentally is a pretty boring idea.

INTERVIEWER: Does the fact that it comes from a machine diminish
its value to you?

CAGE: Certainly not! I think that any artistic product must
stand or fall on what's there. A chimpanzee can do an abstract
painting, if it's good, that's great!

INTERVIEWER: Mary McCarthy has characterized you as a sour
Utopian. Is that accurate?

CAGE: I do definitely mean to be taken literally, yes. All of my
work is directed against those who are bent, through stupidity
or design, on blowing up the planet.

INTERVIEWER: Well, that is very interesting, Mr. Cage, but I wanted
to know what you think in the larger context, i.e., the Utopian.

Edwin Denby, in screen tests by
Andy Warhol, 1965.

Ron Padgett, in screen tests by
Andy Warhol, 1965.

CAGE: I don't know exactly what you mean there . . . I think the prestige of poetry is very high in the public esteem right now, perhaps height is not the right yardstick, but it is perhaps higher than ever. If you can sell poetry, you can sell anything. No, I think it's a *wonderful* time for poetry and I really feel that something is about to boil. And in answer to your question about whether poetry could resume something like the Elizabethan spread, I think it's perfectly possible that this could happen in the next four or five years. All it needs is the right genius to come along and let fly. And old Masefield, I was pleased to see the other day celebrating his ninetieth birthday, I think, said that there are still lots of good tales to tell. I thought that was very nice, and it's true, too.

INTERVIEWER: Do you think, that is, are you satisfied with the way we are presently conducting the war in Viet Nam?

CAGE: I am highly dissatisfied with the way we are waging this nasty war.

INTERVIEWER: Incidentally, your rooms are very beautiful.

CAGE: Nothing incidental about it at all. These are lovely houses; there are two for sale next door, a bargain, too, but they're just shells. They've got to be all fixed up inside as this one was, too. They were just tearing them down when I got the Poetry Society here to invite Hy Sobiloff, the only millionaire poet, to come down and read, and he was taken in hand and shown this house next door, the one that I grew up in, and what a pitiful state it was in. Pick-axes had already gone through the roof. And so he bought four of them and fixed this one up for our use as long as we live, rent free.

INTERVIEWER: Not bad. Tell me, have you ever thought of doing sound tracks for Hollywood movies?

CAGE: Why not? Any composer of genuine ability should work in Hollywood today. Get the Money! However, few screen composers possess homes in Bel-Air, illuminated swimming pools, wives in full-length mink coats, three servants, and that air of tired genius turned sour Utopian. Without that, today, you are nothing. Alas, money buys pathetically little in Hollywood beyond the pleasures of living in an unreal world, associating with a group of narrow people who think, talk, and drink, most of them bad people; and the doubtful pleasure of watching famous actors and actresses guzzle up the juice and stuff the old gut in some of the rudest restaurants in the world. Me, I have never given it a thought.

INTERVIEWER: Tell me about *Silence*.

CAGE: Sure. You never know what publishers are up to. I had the damnedest time with *Silence*. My publishers, H***, R***, and W***, at first were very excited about doing it, and then they handed it over to a young editor who wanted to rewrite it entirely, and proceeded to do so; he made a complete hash of it. And I protested about this and the whole thing – the contract was about to be signed – and they withdrew it, because of this impasse. The Publisher, who is my friend, said, "Well, John, we never really took this seriously, did we? So why don't we just forget it?" And I replied, "Damn it all, I did take it seriously; I want to get published." Well, then they fired this young man who was rewriting me, and everything was peaceful. But there was still some static about irregularities of tone in *Silence*. So I said, "Well, I'll just tone them down a little, tune the whole thing up, so to speak." But I did

nothing of the sort, of course! I simply changed the order. I sent it back re-arranged, and then they wanted me to do something else; finally I just took the whole thing somewhere else.

INTERVIEWER: What was your father like?

CAGE: I don't want to speak of him. My mother detested him.

INTERVIEWER: What sort of person was your mother?

CAGE: Very religious. Very. But now she is crazy. She lay on top of me when I was tied to the bed. She writes to me all the time begging me to return. Why do we have to speak of my mother?

INTERVIEWER: Do you move in patterns?

CAGE: Yes. It isn't so much repeating patterns, it's a repetition of similar attitudes that lead to further growth. Everything we do keeps growing, the skills are there, and are used in different ways each time. The main thing is to do faithfully those tasks assigned by oneself to oneself in order to furthur awareness of the body.

INTERVIEWER: Do you believe that all good art is unengaging?

CAGE: Yes I do.

INTERVIEWER: Then what about beauty?

CAGE: Many dirty hands have fondled beauty, made it their banner; I'd like to chop off those hands, because I do believe in that banner . . . the difference is that art *is* beauty, which the Beatniks naturally lack!

INTERVIEWER: The Beatniks, notably Ed Sanders, are being harassed by the police lately. Do you approve?

CAGE: On the contrary. The problem is that the police are unloved. The police in New York are all paranoid . . . they were so hateful for so long that everybody got to hate them, and that just accumulated and built up. The only answer to the viciousness is kindness. The trouble is that the younger kids just haven't realized that you've got to make love to the police in order to solve the police problem.

INTERVIEWER: But how do you force love on the police?

CAGE: Make love to them. We need highly trained squads of lovemakers to go everywhere and make love.

INTERVIEWER: But there are so many police, it is a practical problem.

CAGE: Yes, I know, it will certainly take time, but what a lovely project.

INTERVIEWER: Do you think that it is better to be brutal than to be indifferent?

CAGE: Yes. It is better to be brutal than indifferent. Some artists prefer the stream of consciousness. Not me. I'd rather beat people up.

INTERVIEWER: Say something about Happenings. You are credited with being the spiritual daddy of the Happening.

CAGE: Happenings are boring. When I hear the word "Happening" I spew wildly into my lunch!

Ted Berrigan, in screen tests by
Andy Warhol, 1965.

INTERVIEWER: But Allan Kaprow calls you "the only living Happening."

CAGE: Allan Kaprow can go eat a Hershey-bar!

INTERVIEWER: Hmmm. Well put. Now, to take a different tack, let me ask you: what about sex?

CAGE: Sex is a biologic weapon, insofar as I can see it. I feel that sex, like every other human manifestation, has been degraded for anti-human purposes. I had a dream recently in which I returned to the family home and found a different father and mother in the bed, though they were still somehow *my* father and mother. What I would like, in the way of theatre, is that somehow a method be devised, a new form, that would allow each member of the audience at a play to watch his own parents, young again, make love. Fuck, that is, not court.

INTERVIEWER: That certainly would be different, wouldn't it? What other theatrical event interests you?

CAGE: Death. The Time Birth Death gimmick. I went recently to see "Dr. No" at Forty-Second Street. It's a fantastic movie, so cool. I walked outside and somebody threw a cherry bomb right in front of me, in this big crowd. And there was blood, I saw blood on people and all over. I felt like I was bleeding all over. I saw in the paper that week that more and more people are throwing them. Artists, too. It's just part of the scene—hurting people.

INTERVIEWER: How does Love come into all this?

CAGE: It doesn't. It comes later. Love is memory. In the immediate present we don't love; life is too much with us. We lust, wilt, snort, swallow, gobble, hustle, nuzzle, etc. Later, memory flashes images swathed in nostalgia and yearning. We call that Love. Ha! Better to call it Madness.

INTERVIEWER: Is everything erotic to you?

CAGE: Not lately. No, I'm just kidding. Of course everything is erotic to me; if it isn't erotic, it isn't interesting.

INTERVIEWER: Is life serious?

CAGE: Perhaps. How should I know? In any case, one must not be serious. Not only is it absurd, but a serious person cannot have sex.

INTERVIEWER: Very interesting! But, why not?

CAGE: If you have to ask, you'll never know.

The above interview is completely a product of its author. John Cage served neither as collaborator nor as interviewee.

Ted Berrigan.

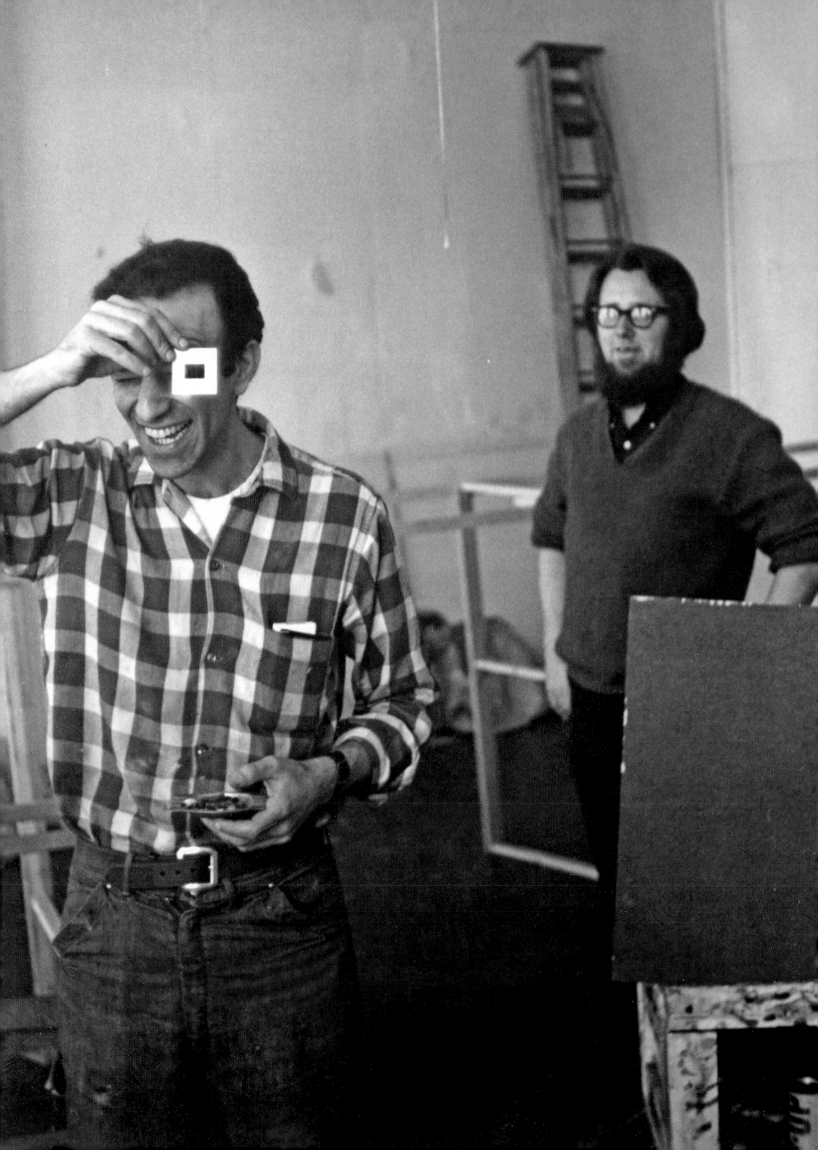

Continuing the Conversation

1966–1975

PREVIOUS PAGES
Alex Katz and Ted Berrigan, ca. 1968.

BELOW
Funeral for Frank O'Hara, with Allen
Ginsberg and Kenneth Koch in
the foreground, Springs Cemetery,
New York, July 27, 1966.

In the early hours of July 24, 1966, Frank O'Hara was hit by a jeep along the seashore of Fire Island. Returning from a party, he and J.J. Mitchell had been waiting for a taxi to take them back to Morris Golde's home. The vehicle they had been riding in had thrown a tire, and while they waited for a replacement, O'Hara had wandered away from the others, only to be blinded by the headlights of another jeep driving in the opposite direction.

It was obvious that O'Hara's injuries were serious—he had broken bones—but he was conscious, and for a while, it seemed he would pull through. He was airlifted to a small hospital on Long Island, and friends began to arrive. Yet internal bleeding led to organ failure, and a day later, O'Hara succumbed to his injuries. He was forty years old.

Three days later, at his funeral at Green River Cemetery, Long Island, Larry Rivers spoke of O'Hara's presence and his influence:

> *Frank O'Hara was my best friend. There are at least sixty people in New York who thought Frank O'Hara was their best friend. Without a doubt he was the most impossible man I knew. He never let me off the hook. He never allowed me to be lazy. His talk, his interests, his poetry, his life was a theatre in which I saw what human beings are really like. He was a dream of contradictions. At one time or another, he was everyone's greatest and most loyal audience. His friendships were so strong he forced me to reassess men and women I would normally not have bothered to know. He was a professional hand-holder. His fee was love. It is easy to deify in the presence of death but Frank was an extraordinary man—everyone here knows it. For me, Frank's death is the beginning of tragedy. My first experience with loss.*

It was the middle of summer, and many people were away from New York City. Nonetheless, more than two hundred people from across the New York art world—many of them unlikely artistic bedfellows in any circumstance—attended the funeral. When the coffin was lowered, Reuben Nakian placed one of his sculptures in the grave, and Allen Ginsberg and Peter Orlovsky intoned Indian sutras. The film director Jack Smith took photographs, as did Camilla McGrath. As everyone walked away from the grave, Philip Guston put his arm around Joe LeSueur, Frank's long-term roommate and sometime lover, and said, "He was our Apollinaire."

The analogy was apt. O'Hara had the same catalytic energy. In his last few years, he had been writing less poetry and drinking more, and had been frenetically busy. He had taken on even more curatorial responsibility at the Museum of Modern Art, organizing key retrospectives of a number of American artists, including Franz Kline, Robert Motherwell, Nakian, and David Smith. The month before the accident, Willem de Kooning had agreed to a retrospective of his work at MoMA, a coup for O'Hara, and hot on the heels of Lee Krasner's agreement to support a Pollock retrospective, which O'Hara was to curate. Fifteen years before, he had been thrilled to drink with these artists at the same bar. Now he was traveling to install shows in Europe, interviewing artists like Smith and Barnett Newman for educational television, and generally acting as the artists' advocate at MoMA. And although he only wrote fourteen poems in 1964, two in 1965 and one in 1966—and had written fifty poems between 1961 and 1963—the extent to which O'Hara was being published or asked to give readings had only increased. Younger poets would seek him out, waiting at the door of MoMA to walk with him back to his apartment. He stood *sui generis* in the New York

George and Katie Schneeman and their sons Paul, Elio, and Emilio, Paris, 1966.

and playwriting. The range of writers involved was broad. The poet Paul Blackburn, who was instrumental in starting the Project, was associated with Black Mountain, as was Joel Oppenheimer, the project's first director. Anne Waldman (Oppenheimer's assistant) succeeded him as director two years later. Waldman had moved to the East Village in 1965 with her husband and fellow poet Lewis Warsh, and she grew close with Ted Berrigan, Ron Padgett, and Joe Brainard. She was a dynamo, running Angel Hair press with Warsh and beginning the magazine *The World*. Warsh's and her apartment at 33 St. Marks Place (especially with Berrigan's regular visits), became a salon of sorts, a place to drop by at all hours of the day and night.

The Poetry Project's focus was not synonymous with a New York School sensibility, but in those years, Waldman's stewardship meant that there was an alignment of sorts. And the programming at St. Mark's Church created a platform for writing and performing that drew other poets and artists into its orbit: Tom Clark, newly arrived from a sojourn in England, where he was poetry editor for *The Paris Review*; Larry Fagin from San Francisco, where he had been close to the poet Jack Spicer; Peter Schjeldahl and his wife, Linda O'Brien, from Minnesota, where they began *Mother* magazine; and George Schneeman, his wife Katie, and their children, from Italy. They were part of a large wave of young people moving to the East Village, drawn by cheap rent and the conflux of various underground art movements. (During the months of May and June 1967, alone, for instance, two thousand young people moved into tenements adjacent in Tompkins Square Park, three blocks away from the Poetry Project.) But these young people in particular gravitated to each other because of their shared tastes in poetry, collage, and collaboration.

Warsh's "New York Diary" gives a clear sense of the rhythm of their lives at the time. Waiting for his typewriter to be fixed, Warsh kept a longhand diary

School. One indication of the degree to which O'Hara straddled the art and poetry worlds was that, a year before he died, *Art in America* magazine asked ten artists to collaborate with a poet of their choice. Three of these artists requested O'Hara—an unprecedented situation, as the feature editor, Francine du Plessix Gray, acknowledged.[1]

The same year that O'Hara died, the Poetry Project at St. Mark's Church in-the-Bowery began.[2] There is no causality to this timing, though many of the Poetry Project's key organizers and participants (like Berrigan, Waldman, and Padgett) were influenced by O'Hara's poetry and life. Operating out of St. Mark's Church, the Project began, in part, as an alternative venue to coffee houses like Le Metro. (At the time, police were cracking down on cafes that lacked the appropriate "license" to host performances.) The Project's mandate was to support writers by organizing readings and workshops for prose, poetry,

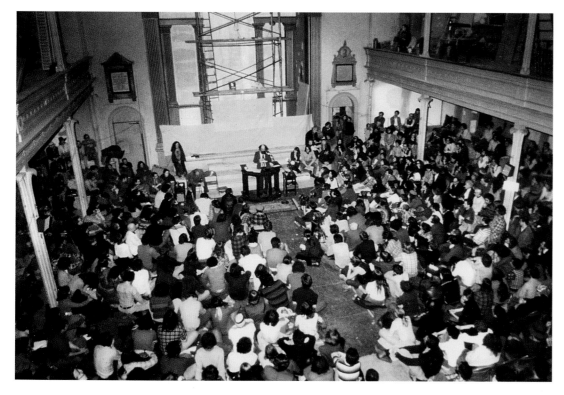

CLOCKWISE FROM TOP LEFT

Allen Ginsberg reads at the Poetry Project, St. Marks Church, New York City, ca. 1976. Maureen Owen sits on the steps to his right.

Kenward Elmslie, with Koch in the corner, at the Soldiers and Sailors Monument, Riverside Park, ca. 1972.

Anne Waldman, Poetry Project, St. Mark's Church, New York City, 1975. To her right are Paul Moore, Jr., and an unknown junior; to her left are David Garcia and Stephen Facey (not pictured).

Michael Brownstein, Joan Fagin, and Larry Fagin, New York City, 1967.

Tom Clark, Paris, 1966.

Bernadette Mayer, ca. 1966.

OPPOSITE
George Schneeman with Peter Schjeldahl, *Making "It,"* 1968 or 1969.

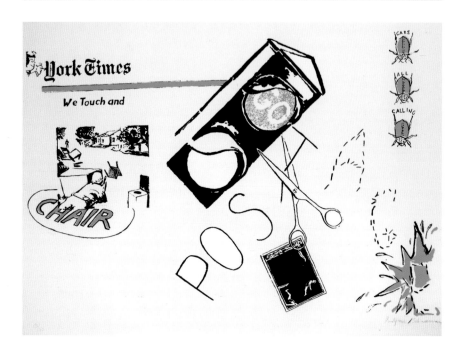

TOP TO BOTTOM

George Schneeman with Larry Fagin, *Faces*, 1969.

George Schneeman with Ted Berrigan, *Monkey*, ca. 1969.

George Schneeman with Ron Padgett, *We Touch and Go*, 1968.

...and there they were:
mommy and daddy

MaKing "IT"*

ON THE

FLOOR

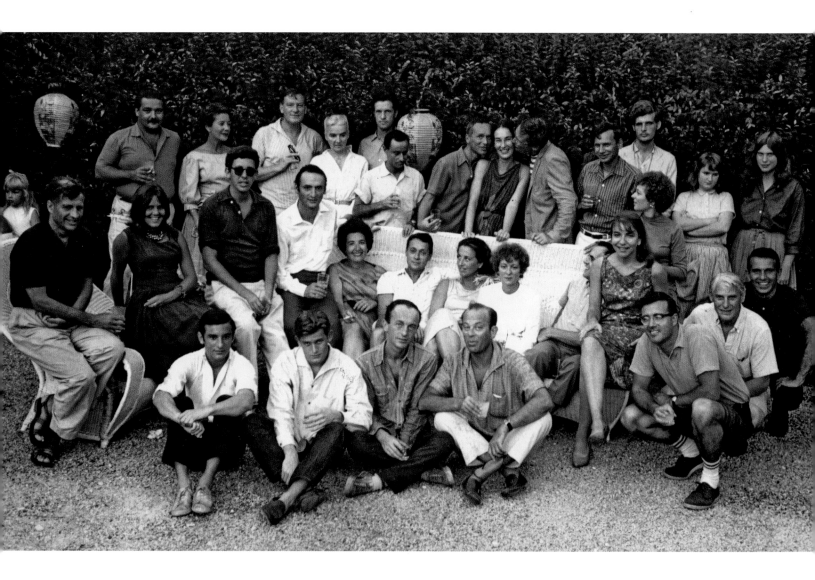

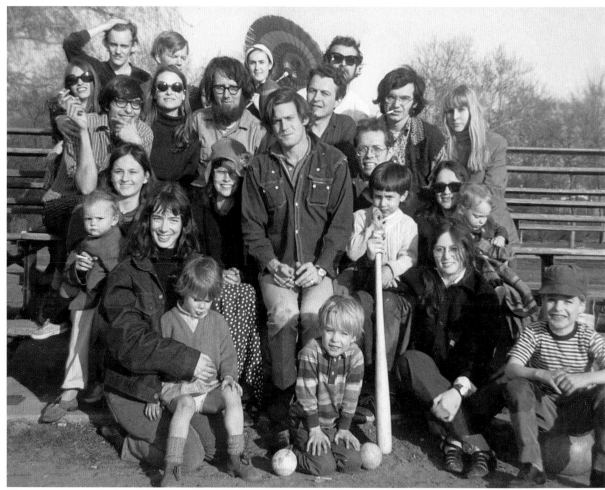

RIGHT
Easter Picnic, Staten Island, 1968.
(All rows left to right) Front row:
Katie Schneeman, Gwen Rivers,
Emilio Schneeman, Joan Fagin, Elio
Schneeman; second row: Emma
Rivers (toddler on knee of Tessie
Mitchell), Sandy Berrigan (wearing
floppy hat), Bill Berkson, David
Berrigan (boy with baseball bat on
knee of Ron Padgett), Wayne
Padgett (toddler on knee of Pat
Padgett); third row: Lewis Warsh,
Anne Waldman, Ted Berrigan,
George Schneeman, Dick Gallup,
Carol Gallup; fourth row: Susan
Kimball (in sunglasses with
cigarette), Peter Schjeldahl (hand
on head), Jim Carroll, unidentified
woman (hidden behind Ted
Berrigan's head), Linda Schjeldahl
(with umbrella), George Kimball.
Not pictured: Rudy Burckhardt, Paul
Schneeman, Kate Berrigan, Yvonne
Jacquette, Tom Burckhardt, and
Gerri Jacquette.

for five days, recording a multitude of small social occasions—visits to the apartment, movies watched, and readings attended. Home movies made at the time convey the joy of just hanging out, smoking pot, listening to music, talking, and writing. Financially speaking, these were the days when one could get by on a few days' casual labor per month. As Fagin recalled, "Having so much free time, not having a job, you could wake up in the dead of night and go over to Anne's and Lewis's and everyone would still be up. There might be four or five others already there. We accommodated each other. Our lives were collaborative."

The notion that there might be a "second generation" of New York School poets had been floating around since 1964 or so, but it was really the Poetry Project, Waldman's leadership, and an influx of like-minded souls that made the notion of a "new" generation something to be talked about. By 1968, the idea that there was a New York School of poetry had grown so distinct that it could be lampooned in *The Poet's Home Companion*, a one-off magazine that featured work by wives of second-generation poets. The writing template for an "authentic" New York School poem by Linda O'Brien recommended if one thought of an adjective or noun, "the more unrelated the better. For best results, think of the noun at least 24 hours after thinking of the adjective."

Decades later, the poet Charles North described the difference between first- and second-generation New York School poets, all the while pointing out that any sense of distinction was probably overthinking things.[3] He noted:

> The first generation had had, for the most part, traditional schooling (Koch, Ashbery, O'Hara, Mathews, Elmslie, and Denby at Harvard, Guest at Berkeley), had done military service, dressed conventionally, drank alcohol along with the greater population. Though there were Ivy Leaguers among the second generation (Columbia, Princeton, Brown), overall the education was less classical, there was more reaction against schooling per se, and all the vital impulses that roiled the '60s were central to their lives as well: social activism, drug-taking, folk and rock music as well as jazz, rejection of conventional work, behavior, and dress, together with a pervasive sense of solidarity, especially among those under thirty.

You can sense this difference if you compare the two most iconic photographs of the New York School poets

and their friends. In the first, taken by John Gruen out in Southampton in 1961 (on the occasion of his daughter's birthday), the crowd is genially well coiffed and the children nowhere to be seen. Even in black-and-white, everyone's tan is visible. In the second photograph, taken by Fagin in 1968 (and used by Bill Berkson for the cover of *Best & Company*, one of the first anthologies of second-generation poets), everyone is grinning, squinting in the sun. The children almost outnumber the adults, they are in the middle of a softball game at Staten Island, and a certain scruffiness is de rigueur.[4]

Rudy Burckhardt made films with many of these younger poets, and it's instructive to set *Inside Dope* (1971) or *City Pastures* (1975) against films made almost twenty years earlier like *The Automotive Story* (1954) or *Mounting Tension* (1950). The city itself had changed. Though people move briskly on the streets in *The Automotive Story*, there is a tidiness, a care, a working-class prosperity that is quite different from the manic looseness of *Inside Dope*, where the city seems frayed. Burckhardt focuses on overflowing bins outside bargain stores rather than, as in *The Automotive Story*, the smooth paneling of cars in a parking lot. Of course, this difference could have something to do with the subject matter, as well as Fagin's input to the film. *Inside Dope* is just that—the highs and lows of various highs and lows. Edwin Denby plays a sharp-looking dealer in a suit and dark glasses. We watch Joan Fagin and Tessie Mitchell on speed, shopping and bathing together; the choreographer-dancer William Dunas hallucinating a line of pills moving from the bathroom cabinet to his mouth (in stop-motion); a stoned Burckhardt and Yvonne Jacquette getting it on with the philosopher Edmund Leites and his wife, Susan; Burckhardt's son, Jacob, taking Freon; and Jim Carroll injecting heroin and then seeing his double, Red Grooms, in a Marx Brothers homage. Echoing *Mounting Tension*, we also see Larry Rivers working in his studio, painting, smoking, talking, and playing the saxophone. He's aged, but his manic energy is immediately recognizable, and all the while, the names of the various drugs he's ingested flash by on the screen. It's a long list.

The end of *Inside Dope* is a crowd scene, filmed in color on docks in New Jersey. Everyone is dancing, ecstatically working one another over with fluorescent plastic back scratchers, aware of the camera but also free to act out their bliss, smiling up at the sun, dancing on the crumbling concrete with Manhattan in the background. There's a genial, instinctive togetherness here. For these younger poets and artists,

210

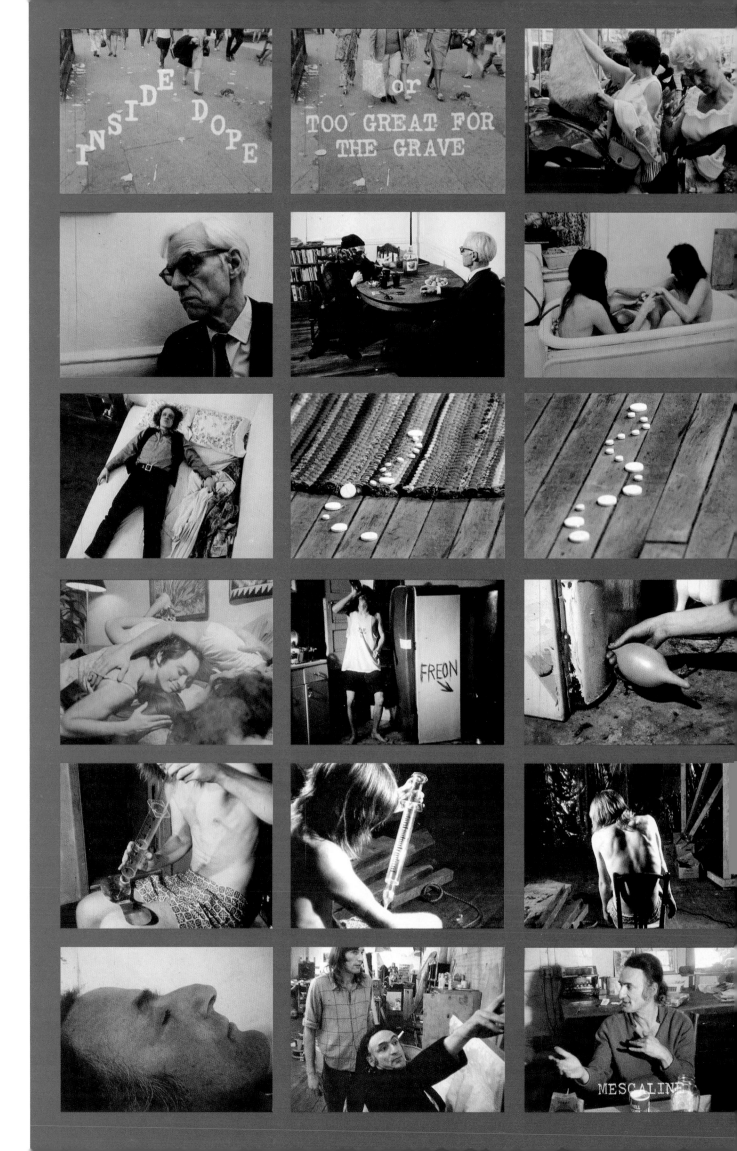

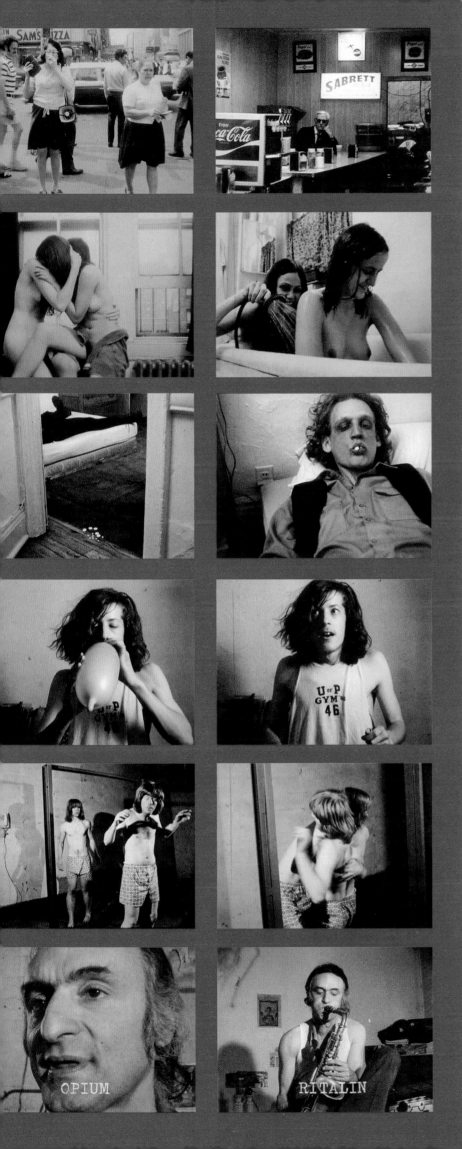

it didn't seem a stretch at all to, say, decide over dinner one Saturday night that everyone should gather together afterward in Schneeman's apartment and pose for a group portrait. It wasn't a surprise that such a portrait would be nude, either.

Collaborations were not just between two people. At 33 St. Marks Place, visitors would sit down at a typewriter when the mood struck them and bang out a few lines, adding to what was already there. The "Leon" poems were collaboratively written by poets in twos, threes, and fives, and eventually published in a chapbook *The World of Leon* (with an introductory essay by Donald Hall). In the early 1970s, for the tenth issue of Larry Fagin's magazine *Adventures in Poetry*, all work appeared anonymously. Even the name of the magazine wasn't identified. And Bernadette Mayer's magazine *Unnatural Acts* included collaboratively written texts from her Poetry Project workshops. (For one issue, participants brought a page of writing that was traded, rewritten by another participant, handed back in again, then rewritten by someone else yet again. These texts were also printed without attribution or editorial information.) The first-generation New York School poets, no matter how much they experimented with language, always took care to identify the creator(s). The second generation was more willing to let go of this convention, enjoying a collective anonymity.

Of course, such a distinction should not be overstated. Nor should the difference between uptown and downtown New York—what could be inferred, for instance, when Schuyler wrote to Gerard Malanga in 1971 that "it's a remarkably dreary day out here [in Southampton] and I think I'll soon be staying more at my New York pad, on East 35th—a nice blah sort of neighborhood, unostentatious middle-class, my dish exactly. I admire my friends who [have] the courage to live on the Lower East Side; I certainly haven't." The first generation might be generally identified as an uptown crowd and the second

LEFT AND ABOVE
Rudy Burckhardt, stills from
Inside Dope, 1971.

John Ashbery and James Schuyler, Great Spruce Head Island, Maine, 1969.

generation as downtown, but such reasoning wasn't generally accurate. Artists and poets lived both uptown and downtown—O'Hara had lived downtown from the late 1950s onward, for instance—and it was more the first generation's association with uptown galleries and museums that generated this distinction. Schuyler's affection for his "blah" sort of neighborhood also had to do with other intensities; he spent much of the 1960s living with Fairfield and Anne Porter in Southampton, partly because of his mental illness and financial woes. Schuyler's sense of distinction, as expressed to Malanga, could also have been a way to frame a long-term convalescent necessity.

Schuyler and Fairfield Porter were extremely close, and there was a significant consonance between Porter's domestic portraits and interiors—for instance, *The Living Room* (1968)—and Schuyler's diaristic tone, his own attention to color and nature and to the process of perception. In his poetry, Schuyler's sense of anticipation is daily, modest, attuned to his own habits of living: his coffee and view, his books and friends. When Schuyler wrote, reviewing one of

Porter's exhibitions, that that his art was "one that values the everyday as the ultimate, the most varied and desirable knowledge," he could have also been describing his own poetry. Their Southampton shared world also closely resembled Jane Freilicher's. From the early 1960s onward she focused, with increasing specificity, on capturing the interiors and views from her apartment in Manhattan and home in Long Island. The views were not spectacularly dramatic; the water towers in her New York skyline were quietly identifiable, and the fields and estuary seen from her windows in Southampton were prosaic, a lush and airy rural setting occasionally interrupted by houses in the distance. But the extremity in her art came from her commitment to these views. In 1975, she was commissioned by the Department of the Interior to paint "the American scene" and was offered a trip anywhere in the United States to do so—but Freilicher chose to paint another view from her home. "I have to feel comfortable where I am," she noted in an interview. "I have to burrow in and feel at home."

This sense of home was echoed, for instance, in Schuyler's poem "June 30, 1974," in which he emphasized his friends' shared taste in the world. Yesterday, he wrote, "she [Freilicher] / and John [Ashbery] bought / crude blue Persian plates"— precisely the kind of plate that appears in Freilicher's still-life paintings like *Loaves and Fishes* (1972). The poem ends:

> . . . *Enough to*
> *sit here drinking coffee,*
> *writing, watching the clear*
> *day ripen (such*
> *a rainy June we had)*
> *while Jane and Joe*
> *sleep in their room*
> *and John in his. I*
> *think I'll make more toast.*

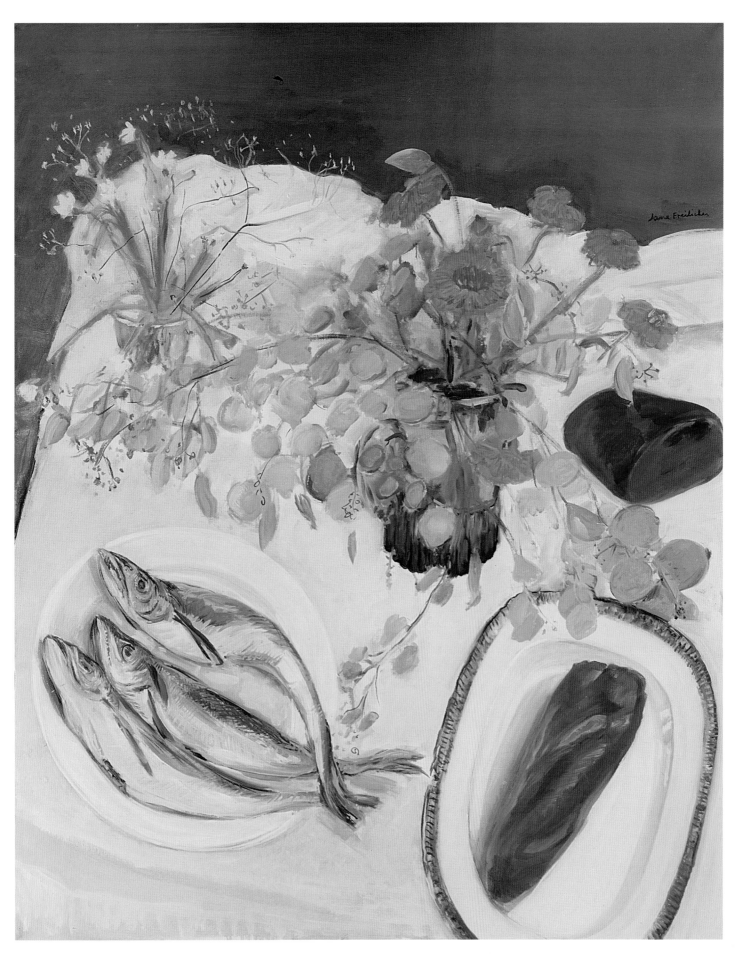

Jane Freilicher, *Loaves and Fishes*, 1972.

Apropos of composition, he once said, "The right use of color can make any composition work," and that in fact the color is *the composition. He likes a coherent, unmuddy, close adjustment of values, such as he found in Fra Angelico and in de Kooning: an adjustment in which the colors affect one another within the picture, and give it the fullness of range (the light within the room, the light outside the window) which the eye so much more readily grasps than does a camera.*

He paints air as light that shatters on surfaces in a spectrum that is, unlike a rainbow, consistent only to itself. One may know that the trunk of a sycamore scales off and discloses a creamy underbark, and that its shadow is stretched on grass—blades whose myriads only a computer could tabulate, but the paint sees trunk and shadow as a continuity, a brown-violet beam which has no existence out of its context, but which is the thing truly seen.
—James Schuyler, from "An Aspect of Fairfield Porter's Paintings,"
ARTnews, May 1967

Fairfield Porter, *Iced Coffee*, 1966.

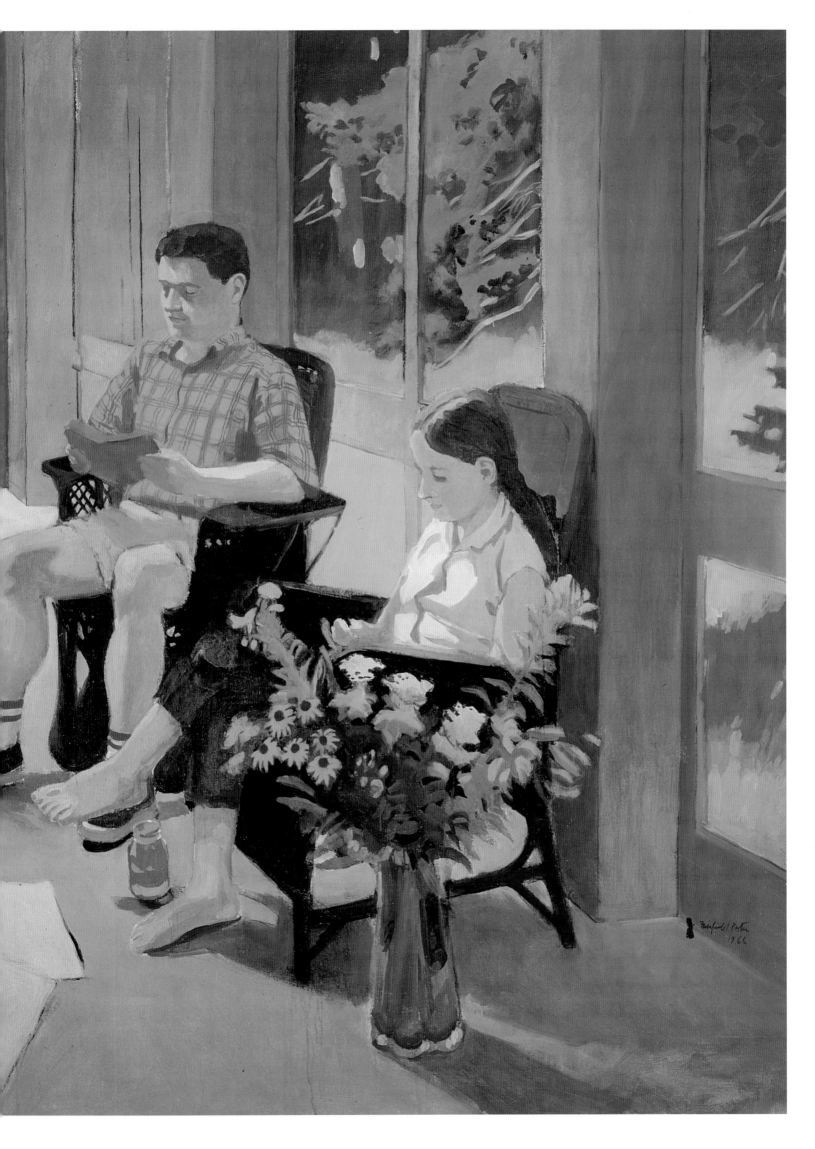

CLOCKWISE FROM TOP LEFT

George Schneeman with Ted
Berrigan, *Ted*, 1967.

George Schneeman, *Dick, Sandy,
Ted*, 1968.

George Schneeman with Ted Berrigan
and Ron Padgett, *Ron and Ted*,
ca. 1968.

George Schneeman, *Anne and
Michael*, 1971.

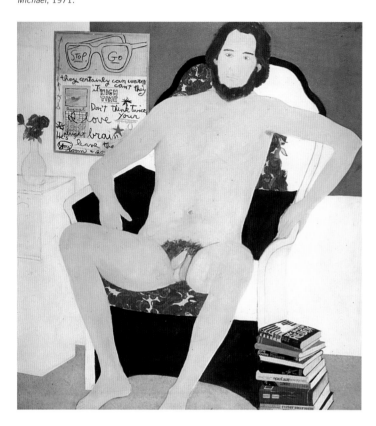 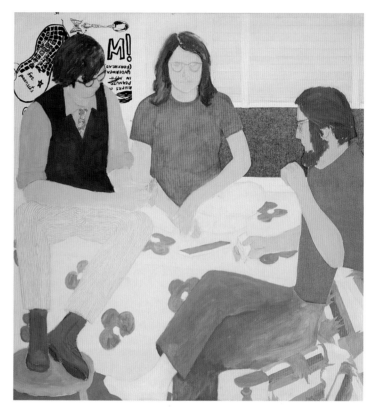

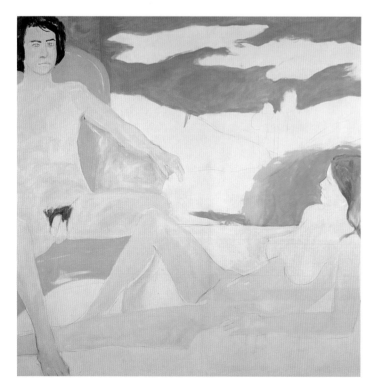 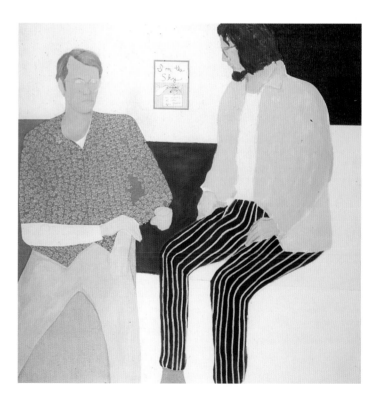

The sweet loneliness of these lines—sweet, that is, because being alone in the poem is temporary—is clear. This later, middle-aged existence had quietly become a foundational aesthetic force in all of their lives. Many years later in an interview, Freilicher described her friends' influence as indirect, "a sympathetic vibration, a natural syntax—a lack of pomposity of heavy symbolism." The pomposity Freilicher refers to here has everything do with the self-conscious iconoclasm of modern art, her response to overly strenuous declarations of life and love. (As Schuyler wrote, her paintings "lacked that authoritarian look, public-spirited and public-addressed, stamped on so much postwar work like a purple 'OK to Eat' on a rump of beef.") And this "natural syntax" was just as significant as explicitly collaborative work in charting a common aesthetic ground.[5]

It's true that this kind of life, as it was expressed in Porter and Freilicher's canvases or Schuyler's poems, was a graceful one, full of old comforts, and it could look quite different from the countercultural spectacle developing apace in the East Village. But what united the two forms of experimentation was a pressing interest in the question of what constituted a good life.[6] George Schneeman's life—as an artist, collaborator, friend, husband, and father—is a case in point. Upon moving to New York City in 1966, Schneeman began to work extensively with second-generation New York School poets. He was extraordinarily generous with his time, energy, and skill. As Berkson noted, "Some nights in the late 1960s the drop-in work force in George Schneeman's studio was George plus four to six poets deep." The studio was a very domestic space. In his apartment at 29 St. Marks Place, you walked through his and Katie's bedroom to reach the studio. His three sons slept in the adjacent room. To Lewis MacAdams, the Schneemans were "the first real family of artists I'd ever known." As he had done in Italy, Schneeman made all of the furniture in the apartment—

bookshelves, cupboards, tables, chairs, even a harpsichord and his son's toys—as well as ceramic bowls, mugs, and plates and lampstands. Fresco portraits of the family were inset into bathroom walls. It was all "Made by George" as Steve Katz observed, a world in which the smallest detail was determined by its creator. When poets recalled Schneeman's collaborative work, they couldn't help but also describe this domestic life too; his art and life were one and the same. At a time when artists' successes were increasingly dependent on their ability to position themselves in relation to a major art movement, Schneeman focused on the private rather than the public, taking the social circumstances of his life as his subject. Collaboration could be the creation of a shared (private) space, an environment in which artist, writer, and the viewer could inhabit. There was also the sense that this kind of collaborative sociability could be (Platonically) ideal. To Schneeman, "Most . . . collaborations invent a sort of utopia in the form of a visual field filled with pleasure, quickness, and wit."

George Schneeman and sons Paul, Elio, and Emil, 1967.

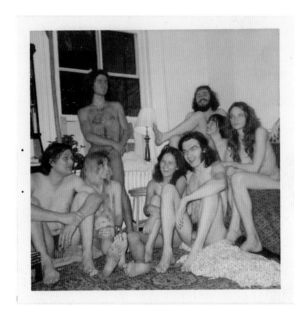

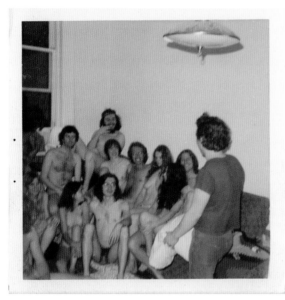

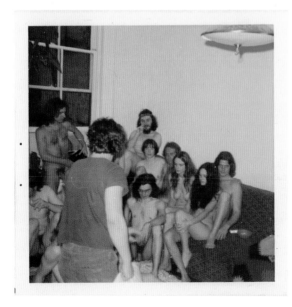

Polaroids from the *Group Nude*
sitting, Schneeman apartment,
1969.

George Schneeman, *Group Nude*, 1969.

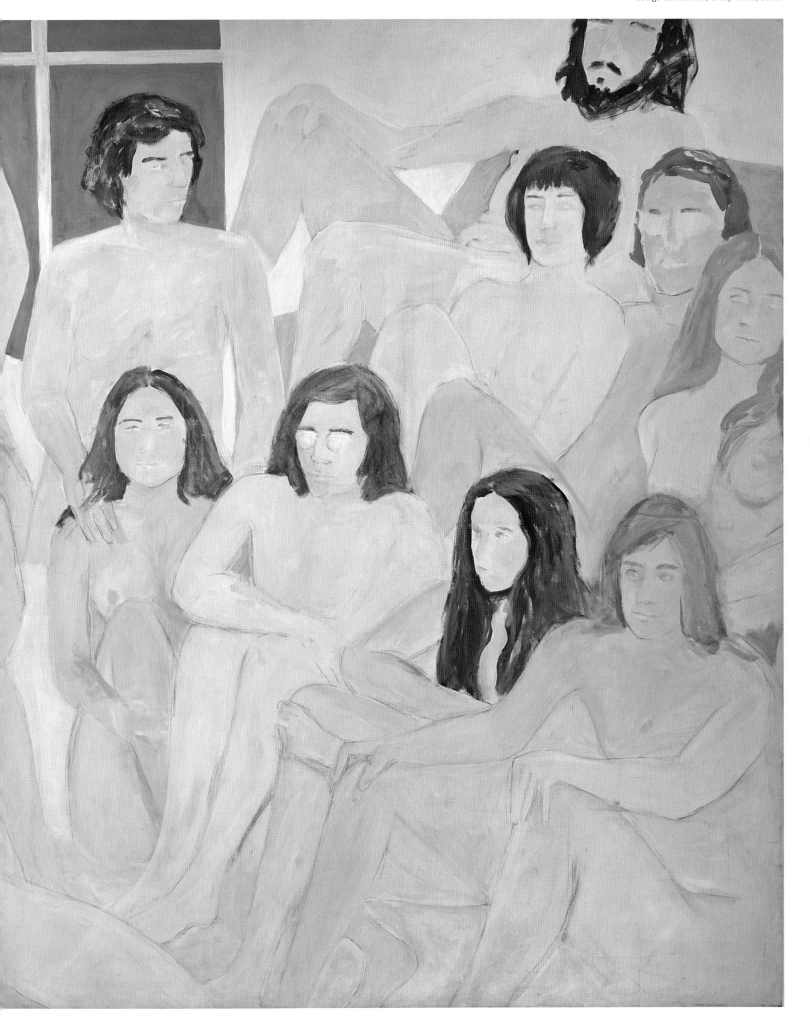

TOP
Bill Berkson and Tom Veitch,
Bolinas, California, ca. 1971.

BOTTOM
Big Sky, issue 4, 1974,
with front and back covers
by Philip Guston.

He wasn't the only one to have the notion of an ideal world on his mind. Mayer and Berkson, in their decade-long correspondence (published as *What's Your Idea of a Good Time?*), also found themselves imagining utopias that focused on family, on living simply but well, on having the time to read and write. Mayer was also writing her book *Utopia* then. And there were other echoes, particularly in Brainard's lush collages of grass and foliage, which were formed by layers of paper cutouts and gathered together behind Plexiglas, or Katz's pellucid portraits of family and friends.

It's not so surprising that in the late 1960s, a number of members of the New York School grew interested in alternative communities outside of the city. Of course, there had always been holiday homes to visit, and vacations to go on. But more long-standing experiments in living now grew in appeal. Bolinas, a town about an hour's drive north of San Francisco, attracted a large number of poets between 1968 and 1980, including Berkson, Joanne Kyger, Tom Clark, Robert Creeley, MacAdams, Warsh, and Aram Saroyan. Others, like Brainard (who wrote and drew the very funny *Bolinas* Journal) came to visit. (The talk there, Brainard observed, was "about things I don't know much about. Like eastern religions. Ecology. And local problems. Sewer system problems in particular.") A number of magazines were published in Bolinas (including Berkson's *Big Sky*), and the Poets Orchestra was established, which was just as it sounds. In a letter to Clark Coolidge, Tom Clark described one performance as "periods of unison dotting huge seas of cacophony!"

It's a resonant phrase, precisely because it hints, so easily, at its opposite: a unified appetite for a kind of agreeable disregard. A New York School utopian sensibility was not straightforwardly idealistic. It could be sentimental at one moment, scatological or catty the next. But there was a shared clarity about the way in which life could be very

Big Sky (1971–78), edited by Bill Berkson. Berkson published twelve issues of the magazine in addition to over twenty volumes of Big Sky Books.

LETT TO RIGHT, TOP TO BOTTOM

Big Sky, issue 1. Cover by Greg Irons.

Big Sky, issue 2. Cover by Alex Katz.

Big Sky, issue 3 (The Clark Coolidge Issue). Cover by Celia Coolidge.

Big Sky, issue 5. Cover by George Schneeman.

Big Sky, issue 6. Cover by Norman Bluhm.

Big Sky, issue 8. Cover by Joe Brainard.

Big Sky, issue 9. Cover by Red Grooms.

Big Sky, issue 10. Cover by Gordon Baldwin.

simple. At the end of the day, art was a way to celebrate life, and collaboration a way to affirm a connection with others. To Warsh, Brainard wrote, "Art bothers me. All I really want to do is to get to know people better. And to be able to let people get to know me better." There is a great deal of polite resistance to all kinds of art-world rhetoric in that "all." Brainard's emphasis on "knowing people" was uniquely his own, but his directness and sense of simplicity was echoed by his friends. It felt possible, especially at this time, to celebrate such plainness.

"Continue the conversation," Berkson wrote, decades later, "is a prompt I've heard more or less at my back for most of my writing life." Such a phrase, he observed, "implies a continuum of art as a field or social gathering." Afternoons with friends bled into evenings spent writing alone. Poker games, films, dinners, parties, and gallery openings were part of a general horizon line in which all was art, and living was culture. "Everything good happens among friends," Berkson also noted. "If you and I or a few of us had a week to talk together, and then another and another, over a year we might accumulate a culture." It could be that easy—but creating this kind of clarity in the art itself was hard. When Brainard wrote to Warsh in 1969, he was working on portraits of his friends. "It's so hard," he continued. "Anne's [Waldman] face changes every moment, even when she isn't moving. And I cannot keep a distance (detachment) with people when I am painting them. So I guess I don't want to." There was no standing back. Absorbed in the minutiae of day-to-day living, the routines of work and friends and family, it was impossible to discern the larger shapes this living produced—though they were just as exact as the choices made in a morning spent drawing. What it all added up to was something that could only be revealed in stages, but that wasn't the point so much, most of the time. You just had to keep continuing the conversation.

From The World of Leon
Bill Berkson, Michael Brownstein, Larry Fagin,
Ron Padgett, & others, 1976

The Secret of Jane Bowles
One Sunday, one Monday, every week
Makes two days out of seven.
Three times six is not eleven
Except in heaven.
A dark cloud jogs beside us, laughing amiably.
Then we stop and look around.
Numbers come everywhere from the heavens, 1–10.
The saintly six.
The redoubtable three.
The peaceful four.
The sports-car driving five.
The lunatic nine.
The recumbent governor eight.
The wheelchair one.
The pessimistic seven.
The metal two.
The hit-and-run ten.
They join us at the clouded structure
Where angels find their conjunctions and well-wishers
Wave one last long good-bye.
The unnumbered question is our sleep in which these structures hide,
Floating above the footnotes in oblivious fruited fields
Where her touch is like a helping hand
That reaches down to lift you up to where it is—
There is no telling what you might find in it.

—Bill Berkson, Larry Fagin, and Ron Padgett

The Infinity of Always
Alas, in this World Nothing lasts
Forever
Not even Forever
Even Less than Nothing
Is Infinity of Always

—Larry Fagin and Ron Padgett

Waves of Particles
Television is great. The wind blows
across a screen in Nevada, Utah. That's great,
greater than Utah. The little dots come out to play
in lines of gray and waves of gravy. Navy blue.
A physicist lights a cigarette on a horse,
although he doesn't know it
because the TV doesn't show it.
But we can see it although we can't smoke it.
Maybe that's the end of it, a little dot of light
shining its name on the great white what.

—Bill Berkson, Michael Brownstein, and Ron Padgett

ABOVE
The World of Leon cover, published by Big Sky, 1976.

OPPOSITE TOP, LEFT TO RIGHT
Telephone, edited by Maureen Owen, issue 1 with cover by Joe Brainard, 1971.

The World, edited by Anne Waldman, issue 9 with cover by Joe Brainard, 1967.

Telephone, issue 3 with cover by George Schneeman, 1969.

OPPOSITE CENTER, LEFT TO RIGHT
Titles by Angel Hair Press, edited by Lewis Warsh and Anne Waldman.

The Parade of Caterpillars by Larry Fagin with cover by George Schneeman, 1968.

Moving Through Air by Lewis Warsh with cover by Donna Dennis, 1968.

Incidentals in the Day World by Alice Notley with cover by Philip Guston, 1973.

OPPOSITE BOTTOM, LEFT TO RIGHT
Titles by Angel Hair Press.

Shining Leaves by Bill Berkson with cover by Alex Katz, 1969.

Giant Night by Anne Waldman with cover by George Schneeman, 1968.

Moving by Bernadette Mayer with cover by Ed Bowes, 1971.

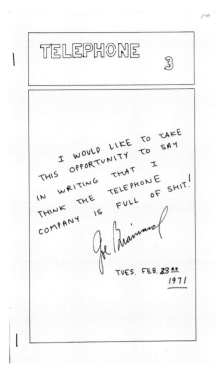

TELEPHONE 3

I WOULD LIKE TO TAKE
THIS OPPORTUNITY TO SAY
IN WRITING THAT I
THINK THE TELEPHONE
COMPANY IS FULL OF SHIT!

Joe Brainard

TUES. FEB. 23rd
1971

THE WORLD

NO. 9

TELEPHONE

PARADE OF THE CATER PILLARS

Larry Fagin

Moving Through Air LEWIS WARSH

ALICE NOTLEY

Incidentals in The Day World

SHINING LEAVES

BILL BERKSON

GIANT NIGHT

BY ANNE WALDMAN

KODAK GRAY SCALE

MOVING

POET'S HOME COMPANION HANDY POEM WRITING GUIDE
(FOR AUTHENTIC NEW YORK SCHOOL POEMS)

This handy reference guide gives the basic New York School poem (or "work") in quick, easy-to-use form. Just fill in each blank with one of the suggested words, or follow directions to find your own words. Suggestions are given for both "funny" and "serious" poems. And, of course, Surrealistic images may also be used, for those who like a more traditional flavor. Submit completed works directly to The World, Angel Hair, or The Paris Review.

(_____ 1 _____)

for (_____ 2 _____)

Here I am at (3) a.m. in (4).

The air is (5) on the way to (6).

I drink some (7) and (8). The streets

(9) look (10) as (11). I (12).

Who would have thought that I'd be here?

Not good old (13a) or (13b), (13c), (13d),

(13e) or even (13f).

The (14) says (15 _____

_____).

My poet thoughts go through my head: (_____ 16 _____).

I am (17). When will I (18)?

Alone and (19), I slip softly (20).

The world's (21) song flows through my (22).

NOTES:

1. Any adjective and any noun, the more unrelated
 the better. For best results, think of the noun
 at least 24 hours after thinking of the adjective,
 or vice versa.
2. Wife, mistress, best friend, fellow poet (liked
 or scorned). May be omitted.
3. Any time. May also be p.m., but this is less
 dramatic, and is best used only for "funny"
 poems.
4. Classically, New York City. Occasionally, more
 specific area, i.e., Manhattan, Lower East Side,
 14th St. For a more delicate style, may be
 specific, i.e., Museum of Modern Art, the movies.
5. Hot, cold, sweet, putrid, inky
6. The movies, Gem's spa, a friend's, prison, City
 Hall, the park, a zoo, some place
7. Pepsi, scotch, milk, hot tea
8. Smoke, toke, take off, light up, turn on, come down
9. Tonight, today.
10. Clean, dirty.
11. Neo-Surrealist image, i.e., toothpicks, sweaters.
12. Smile, grimace, snarl, cough, scratch my balls.
13. A thru F: Names of friends, or ex-friends.
14. Radio, record, TV.
15. Title of or line from song. For "funny" poem use
 a pop song, for "serious" poem a folk song. Elvis
 Presley, Buddy Holly, Bob Dylan and Roger Williams
 may be used for either.
16. List of at least 8 words, preferably with no obvi-
 ous connection. For "serious" poems, words may
 refer to "subject matter" of poem (war, love, etc.).
17. High, down, sickly.
18. Admirable or despicable ambition, i.e., win a mill-
 ion, fuck Anouk Aimee, kill my father, see L.B.J.
19. Happy, sad, pissed off. May also be longer des-
 criptive phrase, i.e., hot as a tomcat, needing a
 job, digging the traffic lights.
20. Home, away, uptown, into the river.
21. Sweet, bitter, harsh, goofy, welcoming.
22. Veins, mouth, shoe, lunch pail.

LINDA SCHJELDAHL

PREVIOUS PAGES
"Poet's Home Companion Handy Poem
Writing Guide (For Authentic New York
School Poems)" by Linda Schjeldahl,
Poet's Home Companion, 1968.

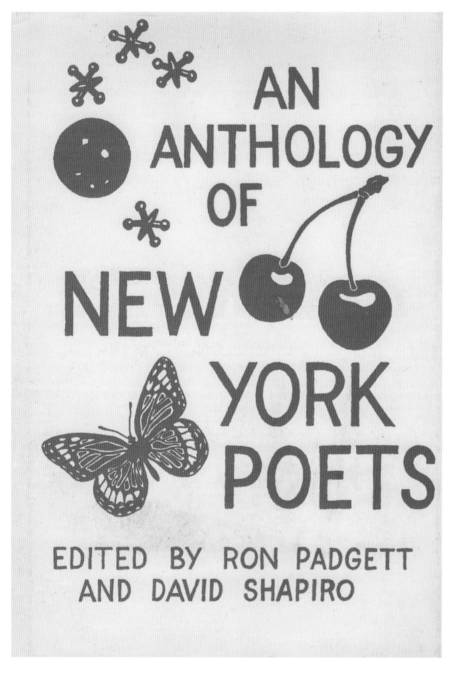

An Anthology of New York Poets,
1970, with cover by Joe Brainard.

Today is a rainy day. Dark and cool. I feel good today. I think that I would like to do nothing today. Something I rarely do: nothing. But I'm too nervous. So I am writing. And after I finish writing I'm going to try to finish the endpapers for the Random House anthology. (An anthology of poetry Ron Padgett and David Shapiro edited.) I have already finished the cover, and I like it. It is a white cover with red words and objects. Floating objects. Actually, the objects do not exactly float. They are more stationary. But suspended. Suspended in space. A chair. A cherry. A "modern design." And a butterfly. Somewhat by accident, I have broken every rule of good design (which pleases me). This happened, I think, because I did the cover very slowly. Object by object. Over a period of five or six days. With no (or little) finished product in mind. One object or one word told me where the next object or word would go. Allowing little room for "dash" or "inspiration." The result is clean and unprofessional in a good way. And cheerful. The endpapers will also be red on white. Red objects on white paper. There is (so far) a feather, a pansy, a lipstick kiss imprint, and a boot. Each object cancels out the other objects. But not too much. Only in importance. Each object is equally important (visually). Kenward and I plan to go to Westhampton this weekend. I do hope it will be sunny. I can't wait for summer. Summer and fall, to me, are like new years. And I need a new year.

—Joe Brainard, from his diary, May 9, 1969

CLOCKWISE FROM TOP LEFT

Lewis Warsh, Anne Waldman, and Joe Brainard, Westhampton, New York, 1968.

Bill Berkson, Kenward Elmslie, and Anne Waldman, Westhampton, New York, 1968.

Kenward Elmslie, Anne Waldman, Bill Berkson, and Lewis Warsh, Westhampton, New York, 1968.

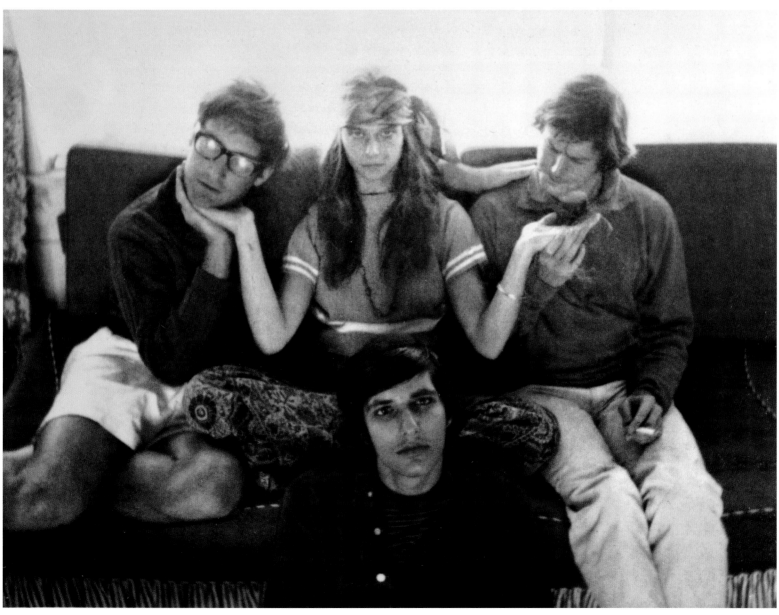

Poets and painters collaborate partly for the same reasons that painters make portraits of people they know—it's another way of spending time with that person, and the artistic aspect lends an extra, more surreptitious, intensity to the get-together. Usually, my collaborations with Joe were done at Joe's invitation—either he sent a comic in the mail for me to fill in the text, or, as we sat around in his studio or in Kenward's house in Vermont, he would quietly ask if I felt like doing "some works." Collaborating in person with Joe was a gas. He was usually quiet, purposeful, always encouraging, quietly amused. My favorite instance with him was an afternoon in his Sixth Avenue loft in 1973—Joe was in his "blue" period, and we did I forget how many collages all in blue with blue lettering, the title for which a line I contributed from the Humphrey Bogart / Lizbeth Scott movie Dead Reckoning: *"It's a Blue World."*

—Bill Berkson, from "Working with Joe," 2001

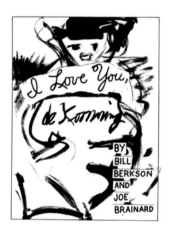
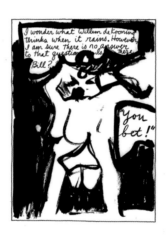
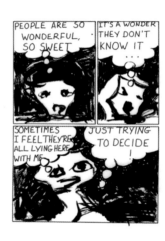

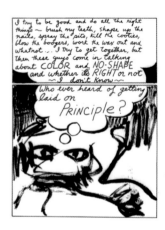
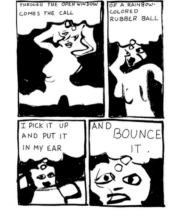
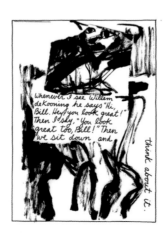
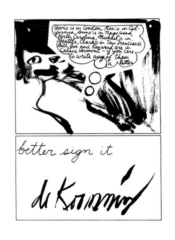

ABOVE AND LEFT
Joe Brainard and Bill Berkson,
I Love You de Kooning, ca. 1969.

OPPOSITE
Joe Brainard and Bill Berkson,
Air Blue, 1971.

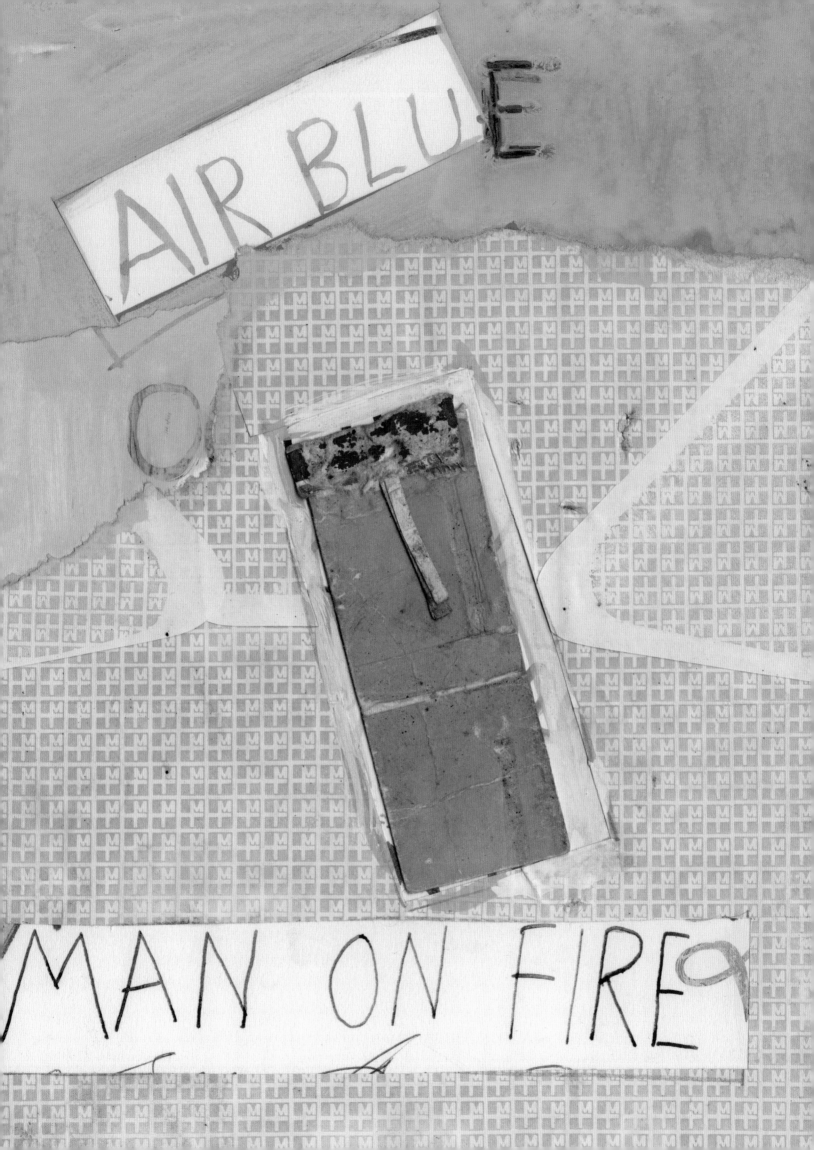

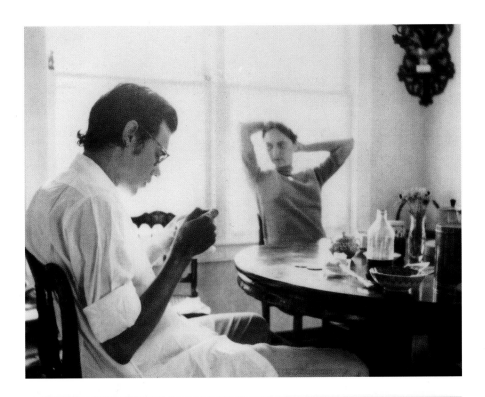

Bill is here. He has been here for many days. But I haven't written in many days. Because of the weather. No sun. And because I decided not to keep this diary anymore. I guess I changed my mind. Before I forget—I want to tell you something funny. When Anne was here she named Kenward's lake "Veronica." ("Veronica Lake.") I die every time I think about it. Bill and I are outside sunbathing in black suits on white towels draped over green lounge chairs. The sun is not really out today but it almost comes out every now and then. So—if it does come out we are ready. Ever since Bill arrived (I forgot to tell you that Bill is Bill Berkson) we have had no sun at all. All rain and gray. So—even a hint of sun, like today, is nice. I haven't been oil painting at all since Bill arrived. But we have been collaborating on some cartoons. A dream cartoon. And a de Kooning cartoon. And an advertisement for "Vanish." (Cleans toilets.) Collaborating on the spot is hard. Like pulling teeth. There are sacrifices to be made. And really "getting together" only happens for a moment or so. If one is lucky. There is a lot of push and pull. Perhaps what is interesting about collaborating is simply the act of trying *to collaborate. The tension. The tension of trying.*

—Joe Brainard, from his diary, July 29, 1969

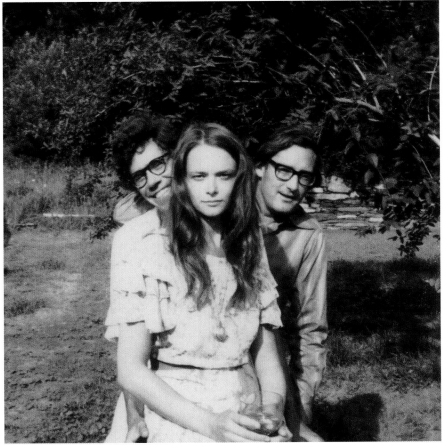

LEFT
Joe Brainard, Anne Waldman, and Kenward Elmslie, Vermont, 1969.

ABOVE
Joe Brainard and Pat Padgett, Vermont, ca. 1973.

Ted Berrigan, Alice Notley, and
Merrill Gilfillan, 1969.

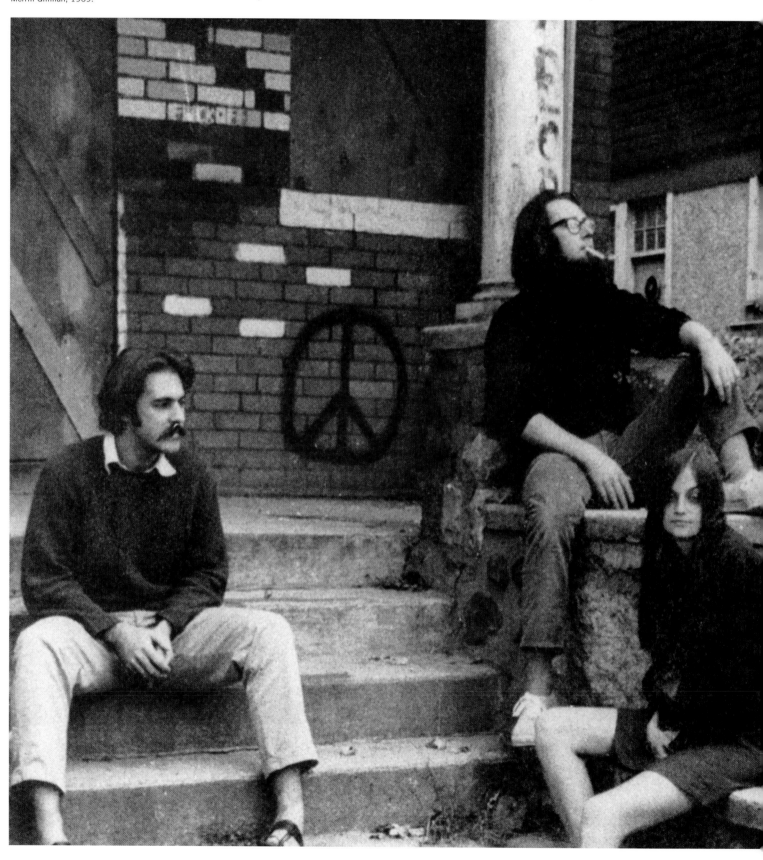

TED BERRIGAN TO
JOE BRAINARD

October 22, 1969

Dear Joe,

Nice to get a letter from you, always a great pick-up for
me. I'm "happy" here, and writing a lot, maybe twenty new po-
ems. I never make copies, but watch for four in the new *World*
and two in some new *Paris Review*. I'm happy for you about your
new place. *Many Happy Returns* sold out, I guess you know, and
is begin reprinted now. Allen Ginsberg was here last week and
gave a super reading of *Howl* plus new poems. I cried yesterday,
because Jack Kerouac died. It's nice to be alone, tho lonely
a lot. I keep busy. I feel as if another "new life" has been
going on for me since the middle of last year, and tho I feel
older than in New York, I don't feel "old" any more, I feel
alive and heading for "more" and "bigger and better" Ted Ber-
rigan Works, of which some "small and new" works are arriving
bi-weekly. I'm holding them in the drawers, and praying over
them (their future bigger ones). I see better. At least I think
I do. And mellower. I read lots of I Remember at Larry's [Larry
Fagin's] and it's SO beautiful! You are the best writer I have
ever read and no one else ever could write your works. I love
you plenty, tho I never say so, and tho we do have long and
difficult silences sometimes, I never worry about us. I hope
you don't, either. Actually, I never think you do (worry about
my love for you, that is). I saw a movie I liked plenty, *Alice's
Restaurant*. I came in in the middle, and saw it to the end and
then to the middle. I think that was a lucky break for me. I
can't write about Frank, either, for about the same reasons you
said. Frank is Frank. But I'll love to read what others write,
and I like to hear stories about Frank. I haven't read any good
poems about him. I wish Larry Rivers would write about him. I
dig Larry's writings a lot. Ken should write about him. He's
told me some terrific stories about Frank. I don't want to, but
I love to talk about him, and do, all the time. I guess I think
about him nearly every day. I'll write about him someday. Actu-
ally, I'd rather have Frank write about me.

 Are you still doing another "C" Comics? I'd like to do
something, but I don't know what. You could use "Living With
Chris," but maybe something new would be better. I'd like ours
to be beautiful. I'll be in NYC in November, for my birthday,
the 15th of November. We can get together and I can see what
you are doing, and have done, with others, and show you my new
poems, and maybe we can figure something out. Maybe something
"about" all our friends, maybe something about Frank. Or Edwin.
Something about Anne Waldman. (I'm thinking I guess of a com-
ic strip with people we like in it, plus Nancy and Archie and
Tarzan and the Hulk. Or anyone else. Dostoevski. Larry Fagin.
Joe LeSueur. de Kooning). How about an interview comic strip?
Let's interview each other about sex, absolutely straight, what
we like, who's attractive (boys and girls for both), etc. I'll
talk about my experiences with boys, you with girls, and vice
versa. Or is that too much do you think? Or maybe we could just

do a writing work (conversation, written down, maybe even by
mail, with the idea of it being true, straight, friendly, ca-
sual, chatty, factual, curious, and "work" too?) Does any
of that sound promising? It, since your work, and even before
(What I like to do in bed) has been buzzing around in my head.
There's so much to be talked there, so that you (that is, I)
can hear what I might say (I mean, I don't know what I might
say, but I'd love to hear myself talk about what I like to do
in bed, what I do actually do in bed, how many different situ-
ations there are always changing . . . in other words, a real
personal impersonal true life art natural work work). Is any
of that clear? Do you think we could bring something like that
off? Or even get started? The thing is, so few people talk
about "that" ("it") like real (ordinary) people, which I think
very much that I am and that you are, that it seems like a real
idea. Write me if you have any ideas on that line. The pills,
which should have reached you by now, or soon, by Airmail Spe-
cial Delivery in a secret package with two boring books, are
pretty good. I don't know their name, but they are 10 mg am-
phetamine. One is nice, two are hot stuff, and three, far out
and millions of little dots on the page. I'm on two now, plus a
valium, tranquilizer, so that I can go sleep in an hour or so.
lt's 6:00 A.M. now. Lewis knows you meant it about money, Joe.
He felt like a million dollars that you felt to offer, and so
has enough now. He's in Bolinas with Tom Clark, and doing fine.
I talked with him last night. We did a work together while he
was here, and had a warm and good time together. He's ok. He
can handle it ok. He and Anne are both ok. And Michael is, too.
Even if all that is going on. I guess it was due.

 What painters do you like now? I don't see much paint-
ing here, and art itself is temporarily not so exciting, I
guess, except for your work, and George's struggles, and Don-
na's. Next to de Kooning, I think you are the best, even if you
aren't interested in putting yourself in that position (that
is, running for future president) right now. Your "combines"
(or whatever the critics will eventually call them), were bet-
ter than Rauschenberg's, and better than anyone's. Are you go-
ing to throw it all out the window again soon, and start from
scratch and mess, or keep working at details and openness for a
longer while? I'm sure you don't know that answer, but I feel
that you can do big masterpieces any time you want to (I think
I can, sometimes, too), but wanting to sure is hard, isn't it?
Actually, Andy is a guy I'm interested in plenty, still. And
Alex. Masterpieces isn't what I mean, actually, but just big
facts. For example, I think John Ashbery is better than ever,
but somehow not as exciting. My favorite poet in the world now
that Frank is dead is Edwin Denby, and next, I guess, Ron. I
like Anne and Lewis MacAdams a lot. I always want to read Jim-
my, and I always want to read Larry Fagin. Harris Schiff is a
younger guy whose works I'm getting to like. I really admire
Michael Brownstein's works, and Jim Carroll's but it's not the
same thing. Kenneth goes on being Kenneth and his works are a
pleasure. The younger guys interest me most, plus old masters
like Eliot, Keats, Shakespeare, Chaucer, D. H. Lawrence (his
poems), Whitman, Philip Whalen. In fact, I'm still "in love"
with Poetry. But, odd as it is to say, I don't think I'm being
directly influenced by poetry so much anymore, as by where I'm

living, climate, feeling of place, blue sky, my body, my feel-
ings, memory and dreams. Only Frank's poems still send me right
to the typewriter or the notebook. But then my poems don't come
out like Frank, but like me in a new place, being quicker and
mellower at the same time, more sweep, more grace (with no less
awkwardness), longer lines, plenty of rhymes, tho not end line
rhymes, more Irishness, a mellower joy. No less energy tho,
I think. I read lots of poems aloud with Alice, my Iowa City
girlfriend visiting me here. Poems I used to like and now do
again. Edwin's poems (tho I always liked them), and guys from
the thirties. Something's happening involving a turn around and
a return by a new guy. So much for that, anyway. I guess I want
to write some Odes. I guess I want to write poems like de Koon-
ing writes about painting, like Frank does about painting (in
Kulchur) or about Poetry in his essay on *Dr. Zhivago*, etc.

Tell Ken I loved *Album*. It was him, beautifully, plenty
risky, mad, and so much more "real" and "good" than lots of
people are going to notice. Your things were pretty right for
it, too.

I'd love to write some collaborations with you (Ken)
if we can ever make a serious "business" appointment, for the
working hours, confer on the subject matter, set up a few
W.A.S.P. rules (to thicken the plot), and then write a whole
series, over a period of time, about what we always write about
(Everything)! Not like mine and Ron's , but like Montgomery
Clift and James Dean. Or maybe like A.J. Liebling and S. N.
Behrman. Or how about like Cole Porter and Bobby Dylan (whoops!
I don't think I can get it up "to" Dylan yet). How about like
Cole Porter and A.J. Liebling?

Or maybe like Dashiell Hammett and Boris Karloff? Or bet-
ter yet John Lennon and Paul McCartney, if they were as good as
we are.

This seems to be turned into a letter to M'sieur Elmslie,
tho I hear he's in Vermont. But the preceding was an unpaid
blurb and enthusiastic pitch for *Album*.

Joe, I guess I'll go eat a few Rice Krispies, read the
paper, smoke a Chesterfield King, or twenty-two or so, and take
the walk I love to take across a town as the sun comes up (and
I go down).

If there are future pills to be had I'll let you know.
I sent 120, to cover the fifty and ten you sent. There may be
more, but it's up in the air right now. Meanwhile, I'm looking
around.

I'm also sending something else (besides pills), so watch
for it.

Love and so long,
Ted

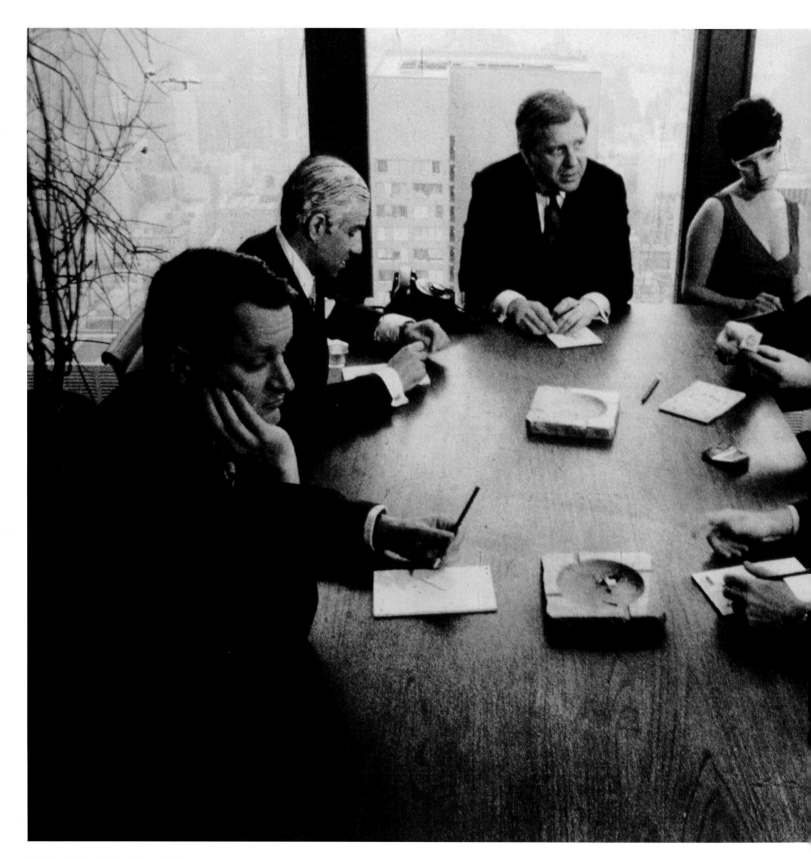

Rudy Burckhardt, still from *Money*, 1968.

What Is Money?

Joe Brainard, from the film *Money*
by Rudy Burckhardt, 1968

Money is a funny thing. It means many different things to many different people. Some people like it and some people don't. Most people do.

What is money? Money is what you buy things with.

There is an old saying that money is the root of all evil. There are two sides to every coin.

Mrs. R. P. from Salem, Arkansas says "Money is very important."

Mrs. N. S. from Hollywood, California says "I don't know what I would do without it."

Mrs. J. H. from New York City, New York says "Money is the root of all evil."

Miss P. S. from Tulsa, Oklahoma says "Money is not the root of all evil."

Mrs. E. R. from Dayton, Ohio says "I like it."

Mrs. J. B. from Watermill, Long Island says "There are two sides to every coin."

Mrs. T. C. from Calais, Vermont says "Money is a funny thing. It means many different things to many different people."

What is money? Money is what you buy things with. Today we use paper bills and metal coins to buy things with. But what did people of long ago use to buy things with?

Cows.

From the stories of Homer we learn that the ancient Greeks used cows to buy things with. "How many cows is this house? a Greek man would say.

Cows, however, were not the only things people used to buy things with. The Chinese used fish. "How many fish is this house?" a Chinese man would say.

The American Indians used colorful beads to buy things with. "How many colored beads is this teepee?" an Indian man would say.

Then as time went on people got tired of carrying around cows and beads and stuff and so they invented the metal coin much as we know it today.

Metal coins were fine for buying little things, but if you wanted to buy a house, or something expensive, it was very impractical. "How silly it is to be loaded down with all these heavy metal coins" they said. And so they invented the paper bill much as we know it today.

Even today, however, the natives on the island of Yap use large stone wheels to buy things with. Each stone wheel weighs 1000 pounds and will be 10,000 coconuts.

———

Have you ever heard the expression "As queer as a three dollar bill"?
There is no such thing as a three dollar bill.

———

I once read about a rich man from upstate who went bankrupt and jumped out of a window. When they were digging his grave they struck oil.

———

There is an old saying that money is the root of all evil. I would say that the root of all evil is money . . . and bad women.

And sometimes even good women.

I once read about a pastor's wife from upstate, a good woman, Methodist, who won a cereal contest, bought a little printing press for Sunday school bulletins and song sheets, and ended up a counterfeiter. Rather than face ten years in jail she shot her husband in the head and jumped off the steeple.

———

Alexander Hamilton, the first Secretary of the Treasury, founded the first bank of the United States. It was called "The First Bank of the United States."

———

Money. What is money? Money is what you do with it. Some people save it and some people spend it. Some people invest it. Some people put it in the bank. I once read about a man from upstate who ate it. He died several years ago, donating his body to medicine, and they built a new hospital.

———

Money. What is money? Money is really very much like life. Nobody understands it. And death. What is death? Death is really very much like money. Nobody understands it.

———

I once read about a man from upstate who bought a rock for ten thousand dollars.

THE INVISIBLE AVANT-GARDE

John Ashbery
From *ArtNews Annual*, 1968

The fact that I, a poet, was invited by the Yale Art School
to talk about the avant-garde, in one of a series of lectures
under this general heading,* is in itself such an eloquent
characterization of the avant-garde today that no further com-
ment seems necessary. It would appear then that this force in
art which would be the very antithesis of tradition if it were
to allow itself even so much of a relationship with tradi-
tion as an antithesis implies, is, on the contrary, a tradition
of sorts. At any rate it can be discussed, attacked, praised,
taught in seminars, just as a tradition can be. There may be
a fine distinction to be made between "a" tradition and "the"
tradition, but the point is that there is no longer any doubt
in anyone's mind that the vanguard *is*—it's there, before you,
solid, tangible, "alive and well," as the buttons say.

Things were very different twenty years ago when I was
a student and was beginning to experiment with poetry. At that
time it was the art and literature of the Establishment that
were traditional. There was in fact almost no experimental
poetry being written in this country, unless you counted the
rather pale attempts of a handful of poets who were trying to
imitate some of the effects of the French Surrealists. The sit-
uation was a little different in the other arts. Painters like
Jackson Pollock had not yet been discovered by the mass maga-
zines—this was to come a little later, though in fact *Life* did
in 1949 print an article on Pollock, showing some of his large
drip paintings and satirically asking whether he was the great-
est living painter in America. This was still a long way from
the decorous enthusiasm with which *Time* and *Life* today greet ev-
ery new kink. But the situation was a bit better for the paint-
ers then, since there were a lot of them doing very important
work and this fact was known to themselves and a few critics.
Poetry could boast of no such good luck. As for music, the sit-
uation also was bleak but at least there *was* experimental music
and a few people knew about it. It is hard to believe, how-
ever, that as late as 1945 such an acceptably experimental and
posthumously successful composer as Bartók could die in total
poverty, and that until a very few years ago such a respect-
able composer as Schönberg was considered a madman. I remember
that in the spring of 1949 there was a symposium on the arts at
Harvard during which a number of new works were performed in-
cluding Schönberg's Trio for Strings. My friend the poet Frank
O'Hara, who was majoring in music at Harvard, went to hear it
and was violently attacked for doing so by one of the young
instructors in the music department, who maintained that Schön-
berg was literally insane. Today the same instructor would no

* This lecture was given at the Yale School of Art in
May 1968, one of a series of talks by writers and
critics organized by the painter Jack Tworkov as an
attempt to explore the phenomenon of the
avant-garde in present-day art.

John Ashbery and Harry Mathews,
Maison Pic restaurant, Valence, France,
October 1968.

doubt attack O'Hara for going to hear anything so academic. To paraphrase Bernard Shaw, it is the fate of some artists, and perhaps the best ones, to pass from unacceptability to acceptance without an intervening period of appreciation.

At that time I found the avant-garde very exciting, just as the young do today, but the difference was that in 1950 there was no sure proof of the existence of the avant-garde. To experiment was to have the feeling that one was poised on some outermost brink. In other words if one wanted to depart, even moderately, from the norm, one was taking one's life—one's life as an artist—into one's hands. A painter like Pollock for instance was gambling everything on the fact that he *was* the greatest painter in America, for if he wasn't, he was nothing, and the drips would turn out to be random splashes from the brush of a careless housepainter. It must often have occurred to Pollock that there was just a possibility that he wasn't an artist at all, that he had spent his life "toiling up the wrong road to art" as Flaubert said of Zola. But this very real possibility is paradoxically just what makes the tremendous excitement in his work. It is a gamble against terrific odds. Most reckless things are beautiful in some way, and recklessness is what makes experimental art beautiful, just as religions are beautiful because of the strong possibility that they are founded on nothing. We would all believe in God if we knew He existed, but would this be much fun?

The doubt element in Pollock—and I am using him as a convenient symbol for the avant-garde artist of the previous school—is what keeps his work alive for us. Even though he has been accepted now by practically everybody from *Life* on down, or on up, his work remains unresolved. It has not congealed into masterpieces. In spite of public acceptance the doubt is there—maybe the acceptance is there because of the doubt, the vulnerability which makes it possible to love the work.

It might be argued that traditional art is even riskier than experimental art; that it can offer no very real assurances to its acolytes, and since traditions are always going out of fashion it is more dangerous and therefore more worthwhile than experimental art. This could be true, and in fact certain great artists of our time have felt it necessary to renounce the experiments of their youth just in order to save them. The poet Ron Padgett has pointed out that the catalogue of the recent Museum of Modern Art exhibition of Dada and Surrealism praises Picabia's early work but ruefully assumes that with his later work he had "passed out of serious consideration as a painter." Padgett goes on to say:

> A parallel example is provided by de Chirico, who many feel betrayed his own best interests as a painter. Possibly so. But in Picabia's case, the curiosity that compelled him to go on to become a less "attractive" painter is the same that carried his adventure into Dada in the first place, and it is this spirit, as much as the paintings themselves, which is significant.

I think one could expand this argument to cover de Chirico and Duchamp as well. The former passed from being one of the greatest painters of this century to a crotchety fabricator of bad

pictures who refuses to hear any good said of his early period, but he did so with such a vengeance that his act almost becomes exemplary. And Duchamp's silence *is* exemplary without question for a whole generation of young artists.

Therefore it is a question of distinguishing bad traditional art and bad avant-garde art from good traditional art and good avant-garde art. But after one has done this, one still has a problem with good traditional art. One can assume that good avant-garde art will go on living because the mere fact of its having been able to struggle into life at all will keep it alive. The doubt remains. But good traditional art may disappear at any moment when the tradition founders. It is a perilous business. I would class de Chirico's late paintings as good traditional art, though as bad art, because they embrace a tradition which everything in the artist's career seemed to point away from, and which he therefore accepted because, no doubt, he felt as an avant-garde artist that only the unacceptable is acceptable. On the other hand a painter like Thomas Hart Benton, who was Pollock's teacher, was at his best a better painter than de Chirico is now, but is a worse artist because he accepted the acceptable. *Life* used to have an article on Benton almost every month, showing his murals for some new post office or library. The fact that *Life* switched its affections from Benton to Pollock does not make either of them any worse, but it does illustrate that Benton's is the kind of art that cannot go on living without acceptance, while Pollock's is of the kind which cannot be destroyed by acceptance, since it is basically unacceptable.

What has happened since Pollock? The usual explanation is that "media" have multiplied to such an extent that it is no longer possible for secrets to remain secret very long, and that this has had the effect of turning the avant-garde from a small contingent of foolhardy warriors into a vast and well- equipped regiment. In fact the avant-garde has absorbed most of the army, or vice versa—in any case the result is that the avant-garde can now barely exist because of the immense amounts of attention and money that are focused on it, and that the only artists who have any privacy are the handful of decrepit stragglers behind the big booming avant-garde juggernaut. This does seem to be what has happened. I was amazed the other night while watching the news on television when the announcer took up a new book by the young experimental poet Aram Saroyan and read it aloud to the audience from beginning to end. It is true that this took only a couple of minutes and that it was done for purposes of a put-down—nevertheless we know that the way of the mass media is to pass from put-down to panegyric without going through a transitional phase of straight reportage, and it may be only a matter of weeks before Aram Saroyan has joined Andy Warhol and Viva and the rest of the avant-garde on *The Tonight Show*.

Looking back only as far as the beginning of this century we see that the period of neglect for an avant-garde artist has shrunk for each generation. Picasso was painting mature masterpieces for at least ten years before he became known even to a handful of collectors. Pollock's incubation period was a little shorter. But since then the period has grown shorter each year so that it now seems to be something like a minute. It is no

longer possible, or it seems no longer possible, for an important avant-garde artist to go unrecognized. And, sadly enough, his creative life expectancy has dwindled correspondingly, since artists are no fun once they have been discovered. Dylan Thomas summed it up when he wrote that he had once been happy and unknown and that he was now miserable and acclaimed.

I am not convinced that it is "media" that are responsible for all this—there have always been mediums of one sort or another and they have taken up the cause of the avant-garde only recently. I am at a loss to say what it is, unless that it is that events during the first decades of this century eventually ended up proving that the avant-garde artist is a kind of hero, and that a hero is, of course, what everybody wants to be. We all have to be first, and it is now certain—as it was not I think, before—that the experimenting artist does something first, even though it may be discarded later on. So that, paradoxically, it is safest to experiment. Only a few artists like de Chirico have realized the fallacy of this argument, and since his course was to reject his own genius and produce execrable art it is unlikely that many artists will follow him.

What then must the avant-garde artist do to remain avant-garde? For it has by now become a question of survival both of the artist and of the individual. In both art and life today we are in danger of substituting one conformity for another, or, to use a French expression, of trading one's one-eyed horse for a blind one. Protests against the mediocre values of our society such as the hippie movement seem to imply that one's only way out is to join a parallel society whose stereotyped manners, language, speech and dress are only reverse images of the one it is trying to reject. We feel in America that we have to join something, that our lives are directionless unless we are part of a group, a clan—an idea very different from the European one, where even friendships are considered not very important and life centers around oneself and one's partner, an extension of oneself. Is there nothing then between the extremes of Levittown and Haight-Ashbury, between an avant-garde which has become a tradition and a tradition which is no longer one? In other words, has tradition finally managed to absorb the individual talent?

On the other hand, perhaps these are the most exciting times for young artists, who must fight even harder to preserve their identity. Before they were fighting against general neglect, even hostility, but this seemed like a natural thing and therefore the fight could be carried on in good faith. Today one must fight acceptance which is much harder because it seems that one is fighting oneself.

If people like what I do, am I to assume that what I do is bad, since public opinion has always begun by rejecting what is original and new?

Perhaps the answer is not to reject what one has done, nor to be forced into a retrograde position, but merely to take into account that if one's work automatically finds acceptance, there may be a possibility that it could be improved. The Midas-like position into which our present acceptance-world forces the avant-garde is actually a disguised blessing which previous artists have not been able to enjoy, because it points the way out of the predicament it sets up—that is, toward an

attitude which neither accepts nor rejects acceptance but is independent of it. Previously, vanguard artists never had to face the problems of integration into the art of their time because this usually happened at the end of a long career when the direction their art would take had long been fixed. When it took place earlier it could be dealt with by an explosion of bad temper, as in the possibly apocryphal story about Schonberg: when someone finally learned to play his violin concerto he stormed out of the concert hall, vowing to write another one that *nobody* would be able to play.

Today the avant-garde has come full circle—the artist who wants to experiment is again faced with what seems like a dead end, except that instead of creating in a vacuum he is now at the center of a cheering mob. Neither climate is exactly ideal for discovery, yet both are conducive to it because they force him to take steps that he hadn't envisaged. And today's young artist has the additional advantage of a fuller awareness of the hazards that lie in wait for him. He must now bear in mind that *he*, not *it*, is the avant-garde.

A few remarks by Busoni in his book *The Essence of Music* seem to apply to all the arts and also to the situation of the experimental artist today. Busoni's music has the unique quality of being excellent and of sounding like nobody else's; it has not even been successfully imitated. The essays that make up the book were written about the time of World War I when a crisis had developed in German music, involving on the one hand Expressionists like Schönberg, of whom he disapproved, and of conservative Neoclassicists like Reger, of whom he equally disapproved—a crisis which, without going into details, rather parallels that in the arts today. Somehow Busoni alone managed to avoid these extremes by taking what was valid in each and forging a totality.

He wrote:

I am a worshipper of Form—I have remained sufficiently a Latin for that. But I demand—no! the organism of art demands—that every idea fashion its own form for itself; the organism—not I—revolts against having one single form for all ideas; today especially and how much more in the coming centuries.

The creator really only strives for perfection. And as he brings this into harmony with his individuality a new law arises unintentionally.

The "new" is included in the idea of "Creation"—for in that way creation is distinguished from imitation.

One follows a great example most faithfully if one does not follow it, for it was through turning away from its predecessor that the example became great.

And finally, in an article addressed to his pupils he wrote, "Build up!" But do not content yourself any longer with self-complacent experiments and the glory of the success of the season; but turn toward the perfection of the work seriously and joyfully. Only he who looks toward the future looks cheerfully."

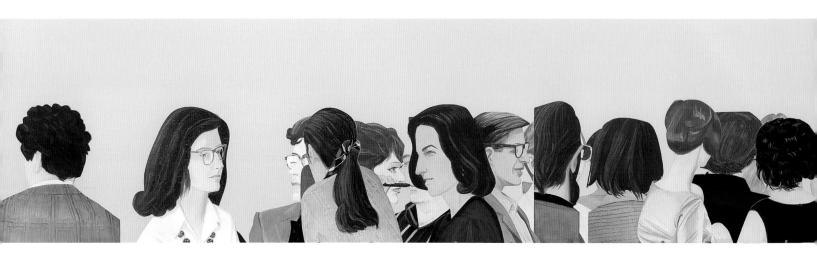

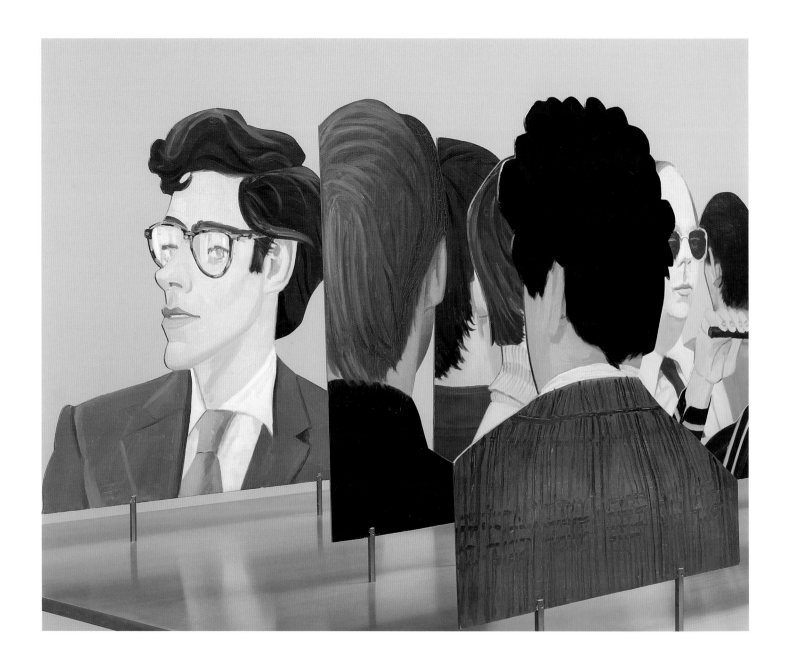

BOTTOM RIGHT
Alex Katz, detail of *One Flight Up*, 1968. Left to right: Sylvia Stone, Al Held, Jane Freilicher.

OPPOSITE BOTTOM
Alex Katz, detail of *One Flight Up*, 1968. Joe Brainard (far left), Henry Geldzahler (far right).

TOP
Alex Katz, *One Flight Up*, 1968. From left to right: Frank Lima, Sandy Berrigan, Joe Brainard, Sheila Lima, Sylvia Stone, Al Held (with cigar), Jane Freilicher, Joe Hazan, Ted Berrigan (back, with glasses), unidentified, Yvonne Jacquette, Lewis Warsh, Anne Waldman, Dorothy Pearlstein, Philip Pearlstein, Kenward Elmslie, Ada Katz, Lois Dodd, unidentified (grey hair) Rodrigo Moynihan, Maxine Groffksy, Bill Berkson, John Ashbery, Jerry Jacquette, Sidney Tillim, Pat Padgett, Wayne Padgett, Harry Mathews, Ron Padgett, Linda Schjeldahl. Not shown: Irving Sandler, Scott Burton, John Button, Dick Gallup, Paul Taylor and Christopher Scott.

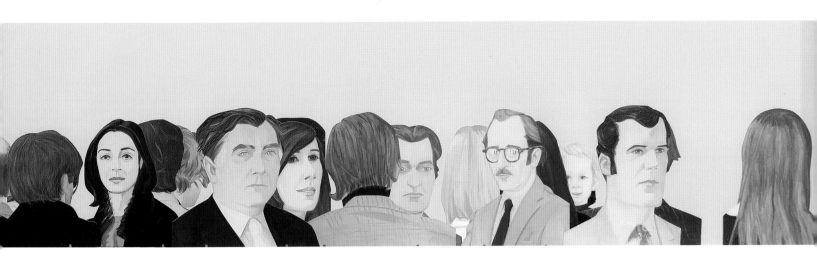

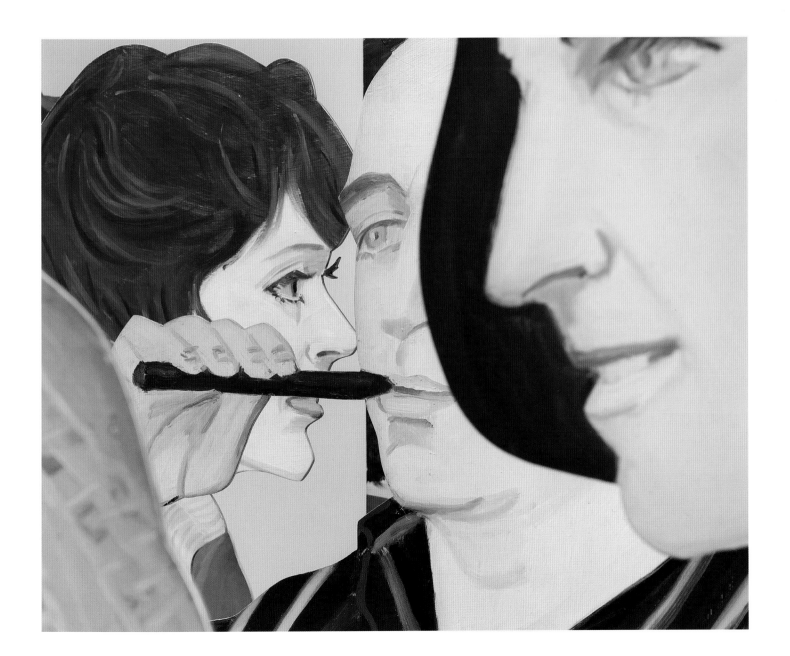

NEW YORK DIARY 1967*

Lewis Warsh

OPPOSITE AND FOLLOWING PAGES
Ted Berrigan, Angelica Clark, Tom Clark, John Perreault, George Schneeman, Anne Waldman, and Lewis Warsh in stills from a home movie by Larry Fagin, 1968.

October 31

The alarm rings: it's 2PM. I get up, dress, & go downstairs to buy the Post. It's Halloween. Call the typewriter repair shop & learn that it will cost $25 to have my typewriter repaired. Read a few chapters from A Confederate General from Big Sur. Anne[1] returns. I go out, take some packages to the post office on 14th Street. Then I go to the library around the corner. I get a new library card but there are no books I want to take out. Take more packages to the P.O. on 4th Avenue. Return home: it's almost dark out. Anne comes home. Peter[2] comes by. We talk about Peter Viereck who is going to read at St. Mark's. Anne cooks dinner. Peter leaves. I re-write part of an old poem on Anne's typewriter. At about 9 o'clock I go to the church to the reading which started at 8:30. Meet Shelly[3] at the door to the church. She's going to a big Halloween party at the Village Theater. Reading has not yet started. There aren't many people there: Anne & Ted[4] & Larry[5] & Peter. After the first set I leave. It's Halloween. Kids are running through the street asking people for money. In front of Gem Spa I meet Katie[6], & Debbie[7], & their kids. There are 3 cops on the corner. We all go upstairs. I give the kids all the Halloween candy which Anne brought home during the day. Also, I give Katie Big Lew, the giant robot Larry bought on Avenue C. Just as they're leaving Larry arrives. Also, Shelly. Larry just found an apt. on 86th Street. Sandy[8] calls. She's coming over with David[9] & Kate.[10] Katie, Debbie, & the kids leave. Sandy arrives. Shelly leaves to return to the Halloween party at the Village Theatre. Jim[11] calls. Anne & Ted arrive, home from the reading. David falls asleep in my arms on the couch. Shelly returns. The party is obviously dragging. Jim arrives. He needs to use Anne's typewriter to type poems. Wren[12] comes. Ted, Sandy, & the kids leave. Anne cooks me a hamburger. Shelly leaves. Wren leaves. Jim is still typing. Ron[13] & Pat[14] arrive. Larry has disappeared somewhere. Ron & Pat leave. Jim & I go downstairs to Gem Spa to get ice cream. Jim buys a copy of the new Downbeat. Anne makes us ice cream sodas. Lee[15] and a friend of his named Jeff arrive. Jim begins falling asleep. I explain reasons why he can't sleep over on couch. He calls his girlfriend & secures a place to stay. Lee & Jeff leave. Jeff says he will call tomorrow to show us his poems. We discuss everything & everybody with Jim. Ted arrives. He has a copy of The Sonnets which neither Anne nor Jim has seen. Jim leaves. I read the newspaper. Ted speed-reads Freewheelin' Frank. Anne reads The Sonnets. Then Ted leaves.

November 1

Set the alarm for 10 AM but wake up instead at 1. While having breakfast Harris[16] calls. Anne speaks to him first then I do. He plans to stay in NY, find a job, his own apartment, etc. Make plans to see him the next day. Then Anne goes out. Finish A Confederate General from Big

Sur. Walk down 8th Street to 8th Street Bookstore. Ted's Sonnets is in the store as well as Paul Blackburn's The Cities. Note error in table of contents in Blackburn's book. Buy the Post and the Voice. Both boring. Read about rebellious CCNY student. Knicks lose 6th in a row. Then Anne comes home. We address & paste stamps on the announcement Bill Beckman made for reading she & Jim are giving at St. Mark's next week. While we are doing this Ted arrives. He & Sandy were to have dinner at Steve Holden's but Sandy must baby sit. I decide to go up to Steve's with Ted. Anne has to go to the church for a reading of Greek poets. First, Ted & I walk to 8th Street Bookstore to get a copy of The Sonnets to give Steve. There is rain in the air. We take a cab to Steve's on East 74th Street. Steve has hundreds of old & current 45's, & most of the old ones are terrific. Among them: "Tragedy" by Thomas Wayne; "Hey Girl" by Freddie Scott; & many others. I discover a record written by Steve Holden. It's by Rod McKuen. It came out in 1959. We eat chicken, rice; drink wine. Eat ice cream. Discuss poetry. Play more records. Read Steve's poetry. Discuss poetry conference at Berkeley & Ted's reading there which Anne & I were present at (though we didn't really know Ted). Listen to more music. Then we leave. It's raining. We walk downtown for a while. It's 11 PM. Then we take a cab to my house. Anne isn't there. She probably went somewhere after the reading. We go over to Ron's. He isn't home. We try calling Peter but all the phone booths on 2nd Avenue have been vandalized. Then we meet Tom Veitch and Richard Kostelanetz. Richard leaves. I go into a candy store & call Peter's; no one is home. Tom, Ted, & I start back to Ron's where Tom is staying. On the way we meet Anne. Reading lasted a long time & she was coming from the church. We all go to Ron's. Ron says he was in the bathroom when we came by before. Tessie[17] & Pat have gone to Tulsa. After a while Anne gets hungry. Ted, Anne, & I leave. At Gem Spa we meet Erroll & Julian. I see somebody who I know I've seen before. He's eating an ice cream cone & a candy bar. We smile at each other. I say: "Where have I met you?" He says: "There." Ted goes home. Anne & I go home. As we walk upstairs I look behind me & see the person I spoke to lurking outside the building. Anne eats at home. A few minutes later Peter & Linda[18] arrive. Everybody's fading out in their own way. I think about Tom Clark & what he's been doing. Then Peter & Linda leave. I wish I had a typewriter.

November 2

I wake up early, 11 AM. Peter comes by. He has been awake all night on pills. Then Anne gets up, has breakfast, goes to work. Peter leaves too. Then Harris arrives. He is very quiet; doesn't want to talk about Rochester or anything else. We go out, first to Tompkins Square Bookstore (walking through the park) but it's closed, then to the post office, then to Tom Clark's. Harris

*First published in Warsh's Part of My History (Coach House Press, Toronto, 1972), "New York Diary—1967" captures some of the ambience of the Lower East Side during the early years of The Poetry Project and the network of friendships existing among young writers active in the Project at that time. Warsh was living with Anne Waldman at 33 St. Mark's Pl., a few blocks from St. Mark's Church in-the-Bowery (referred to in the diary as "St. Mark's" or "the church"), home of The Poetry Project. Their apartment was the scene of countless after-readings parties. Waldman was the director of The Project.

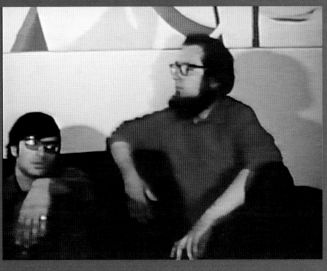

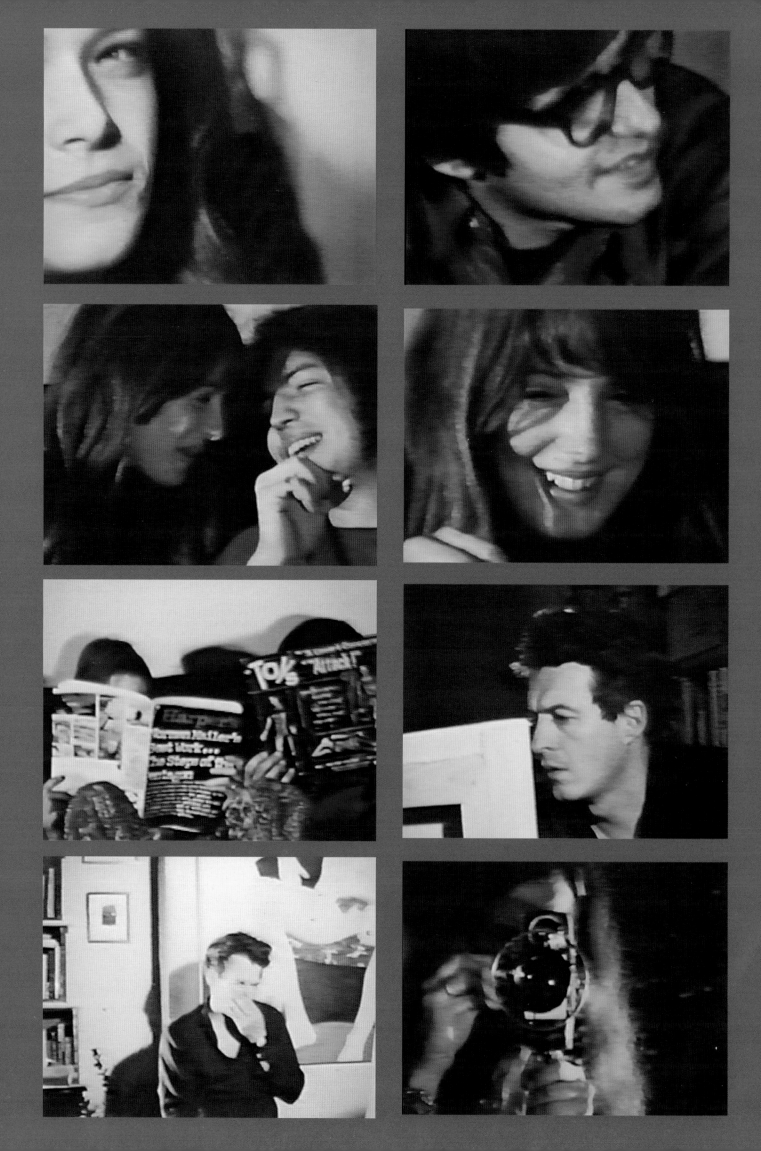

still not opening up very much. At 5 o'clock Tom, Harry, & I walk back across town in the rain. Tom goes to see Peter. Harris & I go home. Anne is home. She's making supper since Simone[19] is supposed to come at about 7. Harris has to leave to see his mother who is in a hospital uptown. I'm getting tired when Simone comes. Spend intervening time reading Franz Kline: An Emotional Memoir *by Fielding Dawson. Then Tom arrives & the 4 of us eat supper. After supper we sit around talking. George Kimball arrives, stays for a while, then leaves. Then Larry arrives. Then Martha.[20] We decide to go to the movies to see* Cool Hand Luke. *It's playing uptown. Anne, Simone, & I take one cab; Larry, Martha, & Tom another. The movie is pretty good. Afterwards, Simone gets a cab & goes home. Tom, Martha, & Larry get another cab. Anne & I walk to 2nd Avenue and get a bus going downtown. The bell downstairs just rang a few times but we didn't answer it.*

November 3

Ted calls early in the afternoon and later comes over with Kate. Jim[21] comes by. He brings me a birthday present, a record by Arlo Guthrie. Anne goes to the church. Ted, Jim, Kate, & I go downtown, to Delancy Street, to get pills (obitrols) with a fake prescription which Ted has. While waiting for the pills we go into Ratner's on Delancy Street. Drugstore refuses to fill the prescription. Walk back to Avenue C. Ted & Kate go home. I go to drugstore on Avenue C where they fill the prescription. Walk up 9th Street with Jim. Jim goes to Bill's[22] & I go home. Anne, at home, tells me that we've been invited to a party Les Levine is giving that night. At about 8:30 we go down to Ted's workshop at the courthouse.[23] Meet Dick,[24] & Peter, & Ron Zimardi. Peter says that Sandy called to say that Ted is sick, that the workshop will be called off. Dick, Ron, Anne, & I go to Peter's. Carol,[25] Crissie,[26] & Linda are there, watching TV. Dick & Peter play chess. Anne & I read. Soon Ron leaves. Then Dick & Carol & Crissie go home & we go to the party. On the Bowery we see a man lying in the street totally naked. There are only a few people at the party when we arrive. We talk with John Perreault. I don't know anyone else who is there. I don't feel like drinking. I feel terrific waves of energy & restlessness at everything being so static. More people start coming in. Sandy & Lee arrive. I talk to Sandy awhile. Then we start dancing. Sweat drips down my face, but I feel good. At about 1, Anne & I leave & return home.

November 4

Saturday afternoon; time I hate the most. Never want to get out of bed. Sandy calls. I try to get tickets for The Beard *but they're too expensive. At about 4, Anne & I go over to Bill's. Sandy is baby-sitting there. Bill & Jim are there too. (Before this, Ted, Larry, & Joan[27] came over to our place, stayed for a while then returned to Ted's.) Sandy, Anne, Kate, David, & I go back to Ted's. First I take Kate*

back. Ted, Joan, & Larry are listening to tapes. Everybody will have dinner there. After dinner Larry & Joan go uptown to Radio City Music Hall. At about 9, Ted, Anne, & I leave & walk across town. We go into the record store on St. Mark's Place where I buy Different Drum *by the Stone Ponies &* Don't Worry Baby *by the Beach Boys. Outside our apartment we meet Lee, Dick, & Carol. They're going to the movies on 42nd Street. First they come upstairs & for about an hour we listen to records. Martha comes over with her typewriter since mine is still being repaired. We all decide to go uptown to the movies. On 42nd Street we see* The Counterfeit Traitor *with William Holden. It isn't bad. It's getting cold out. We can't find a cab. Dick, Carol, & Lee fade out. We take the BMT back to St. Mark's Place. It's 2:30 AM. We sit around, have coffee. Ted walks Martha home. I go out for the newspaper. There is nothing interesting in it to read.*

NOTES

October 31
1. Anne Waldman
2. Peter Schjeldahl
3. Shelly Lustig
4. Ted Berrigan
5. Larry Fagin
6. Katie Schneeman
7. Debbie Beckman
8. Sandy Berrigan
9. David Berrigan
10. Kate Berrigan
11. Jim Brodey
12. Wren D'Antonio
13. Ron Padgett
14. Pat Padgett
15. Lee Crabtree

November 1
16. Harris Schiff
17. Tessie Mitchell
18. Linda Schjeldahl

November 2
19. Simone Juda
20. Martha Rockwell

November 3
21. Jim Brodey
22. Bill Beckman
23. Old courthouse on 2nd Ave. and 2nd St. where Poetry Project workshops were held in the late sixties.
24. Dick Gallup
25. Carol Gallup
26. Christina Gallup

November 4
27. Joan Inglis Fagin

KANSAS CITY
THERE I WAS

KANSAS CITY
THERE I WAS

KANSAS CITY
THERE I WAS

PEORIA

GANGWAY BIRDSELL

From Oo La La
Ron Padgett, 1970

In late 1969 Jim Dine telephoned to ask me if I'd like to come to London next summer to collaborate with him on a suite of lithographs, all expenses paid. Petersburg Press would handle the project. For an impecunious poet such as me, a free trip anywhere sounded good, but of course this invitation was even better because of the thrilling prospect of working with Jim again. (A few years back he had illustrated my translation of Apollinaire's Poet Assassinated, and the previous summer we had collaborated on a strange book called The Adventures of Mr. and Mrs. Jim and Ron.) So in June of 1970, my wife, three-year-old son, and I flew from New York to London. While working on the project, I kept a diary. Here are some excerpts.

Monday, June 29
First day of work. At the studio I introduce myself to Ernie. He and Maurice and I talk about the USA and the Far West. Jim arrives.

Ernie and a young woman mark off the stones while Jim gives me an extra-rapid course in lithography. Because I have some knowledge of offset printing, I understand the technical parts immediately.

We plunge into work, each on a different plate, using lithographic tusche, lithographic pencils, lithographic crayons, and an assortment of brushes, while listening to music on a small radio: Bach, Haydn, and some comically overwrought Mussorgsky.

Jim shows me the trick of dipping a toothbrush into touche and running your thumb tip over the bristles so as to fling off a fine spray. We use this technique a lot today because it creates a pretty effect and because it's fun.

Jim draws some hearts, I write some words. After some mutual encouragement, Jim writes some words and I draw a little (a cigar). I like my drawing today and I feel good about being in the studio. We work quickly, while carrying on a nonstop funny conversation. Jim is buoyant and boyish.

Suddenly I find myself just looking at the plates with no presence of mind. I have gotten too far into "art" and lost contact with "words." But we have gotten a lot done today, so Jim suggests we knock off. It's 2:15.

He drives me to a shop where I rent a bicycle, and then on the way back a car behind us honks: it's Kitaj. Jim introduces me to him on the street. Kitaj looks like a highway patrolman on his day off. . . .

Wednesday, July 1
By the time I arrive, Jim has done a lot of work on one plate. I spend a lot of time puttering around the studio. "Our" radio is missing, so we sing. Jim not only sings, but also shadow-boxes,

skips rope, and does sound effects with his voice. I am still a little groggy from smoking pot last night. I do manage to write the word ORGASM above four terrific comic strip characters Jim had found in a British comic book (The Beezer?) I had borrowed from my son. Actually the characters seem to have been turned into cookie versions of themselves. For me this combination of word and image is electrifying.

But I otherwise I feel sluggish watching Jim dash off some big beautiful drawings, including more birds and a pig. Around 3 he leaves and I stay on, partly out of guilt and curiosity, and then in a fifteen-minute span I start a plate on my own and get pretty far into it.

Both Jim and I express confidence, but questions lurk around the edges. The whole project is risky, and our many decisions must be made quickly. Today Paul Cornwall-Jones dropped by and looked at the plates. He is genial, but I suspect he wonders what the hell we are doing.

At dinner at Rory McEwen's, Jim and I talk about the project. Jim is half worried, half not worried: "What are we doing, just ad-libbing?" I say I don't know, but that we should keep doing it. He agrees. Actually I'm relieved to learn that he shares my jitters. . .

Wednesday, July 8
Because Jim is at the dentist's, I check in alone around noon, feeling much better. First I fiddle with the image of the baby quail surrounded by graffiti that needs improving. But it doesn't work. So I take another plate, draw a circle in the center and write around it a lyrical passage from my poem "Ode to Clemence Laurrell." I'm hoping Jim will draw something in the center. Center is a good way to describe Jim. He works for a strong image, usually a centralized one. Like Joe Brainard, he wants his pictures to "look good" and be strong. So my words have to be strong too, as in "Orgasm." So today I write on a new plate, "You don't say heel or cad anymore. Now it's BAD NEWS." Feeble-minded in content, but syntactically emphatic. And in this project, syntax is important not only intellectually, but also visually. Some syntactical arrangements don't fit in this project, because they don't fit with the way Jim works. . . .

Friday, July 17
. . . Looking at Jim's very strong image of two neckties, I realize that I should put only two words on it—one next to each tie—to keep it spare and clean. Word combinations I think of are thermonuclear/annihilation, spontaneous/combustion, and ambivalence/polarity. But none strikes me as any better than the others (a bad sign).

Ernie comes in with four new proofs. ORGASM is a dilly, but SUPERNATURAL OVERTONES seems to need something. I "tear them down," that is, trim the proofs, which are

printed on oversized paper. Then I tape them to the wall alongside the other proofs. With them all up on the wall, I get a nice big look, and I feel as if I have learned what I wanted (though precisely what this is I don't know). Anyway, I enjoyed the pleasure of tearing down the proofs, which Ernie usually does.

From looking at the image of the colored shoes, I can look at the proofs on the wall and visualize their colors too. Doing so inspires me to get into prettier and happier and more fluid works. (The trip to Paris might have helped inspire this feeling.)

The printer has told Ernie that he has grave doubts about printing the plate with the cock image. He will do proofs, but perhaps not the final run. Jim is hilarious and American. What does he do? He redoes the cock plate, enlarging the cock image to staggering proportions. His does so partly because the original plate wasn't quite as good as it might have been, but also to make a statement about British censorship laws. Anyway, we can always have that plate printed elsewhere (in Holland, for instance).

At dinner, Jim tells me about how he had torn up the image of the bird and the word PEACHES, trying to collage it into something better. But it hadn't worked, and he feels that it's just as well. I agree. There was something unpleasantly grim about that plate. . . .

Friday, July 26
Last day. Last day! Such a weird idea, and it does exist. The essential nature of the project is fixed, and it's all happened so gradually and quickly that we hardly knew what "it" was. Jim spattered the five or six colors onto the ties, which took only a few minutes, as I talked about how I can't seem to come up with anything that doesn't lower the tone of the image. We decide that maybe this is telling us something: that it doesn't need any words.

As for the dick plate, I tell Jim that I haven't been able to come up with anything better than "KANSAS CITY THERE I WENT" (based on the lyrics of the song "Kansas City"), and he immediately replies, "I thought it was KANSAS CITY THERE I WAS." Ah, much better!

Jim does the color separations for the SUPERNATURAL OVERTONES cunt, and it's going to be beautiful, pink, light yellow, and pale violet, with black.

We go to a pub for lunch and talk about the whole project. We won't need a title for a couple of months. [Note: Jim came up with the final title, OO LA LA.] We both like the pig design for the portfolio box. Jim will go over all the proofs and send them to me in New York. We expect around fifteen images. The word lithograph sounds rather somber, even industrial, which is perhaps why I am so surprised at how light, clear, and happy the prints are.

Jim Dine and Ron Padgett, *Oo La La*, 1970.

Sometimes, when the wall of a house stands in the light of noon, it is as though the light were taking possession of the wall on behalf of silence. One can feel the approach of the silence of the noonday heat. The light lies firmly on the wall as a sign that the wall belongs to the silence.

The gate in the wall isshut; the windows inside the house shit this is a mistake

The gate in the wall is shut; the windows are covered with curtains; the people inside the house are very quiet, as though they were lowering their heads at the approach of the silence.

The inside wall seems to expand through the silence pressing on it.

Then suddenly a song lights up on the wall from inside. The notes are like bright balls thrown at the wall. And now it is as though the silence rises from the wall and climbs upward towards the sky, and the windows in the wall are like the steps of a ladder leading the silence and also the song into the sky above.

—— Max Picard

George Schneeman with Ron Padgett, *The World of Silence*, ca. 1970–71.

I told Ron Padgett that I'd like to have

 NICE TO SEE YOU

 engraved on my tombstone

Ron said he thought he'd like to have

 OUT TO LUNCH

 on his.

—Ted Berrigan & Anne Waldman, from *Memorial Day*, 1971

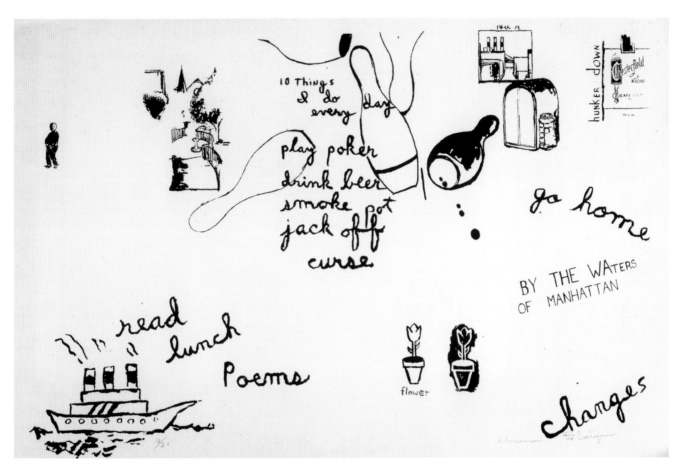

George Schneeman with Ted Berrigan, *Untitled*, 1967.

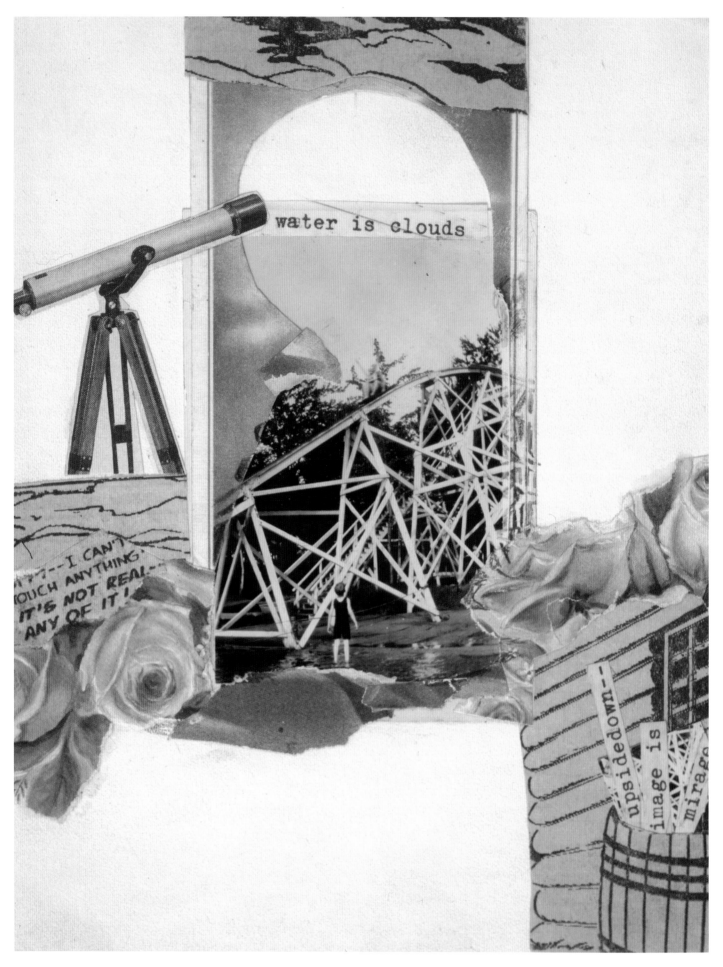

George Schneeman with Ron Padgett, *Telescope*, 1969.

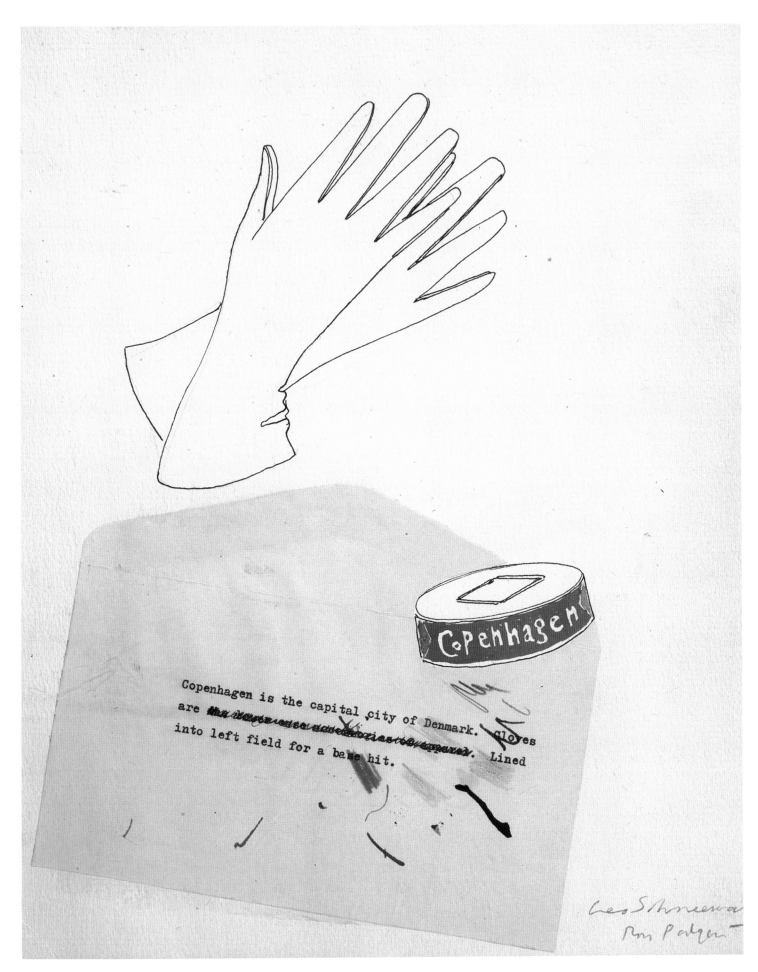

George Schneeman with Ron Padgett, *Copenhagen*, 1968.

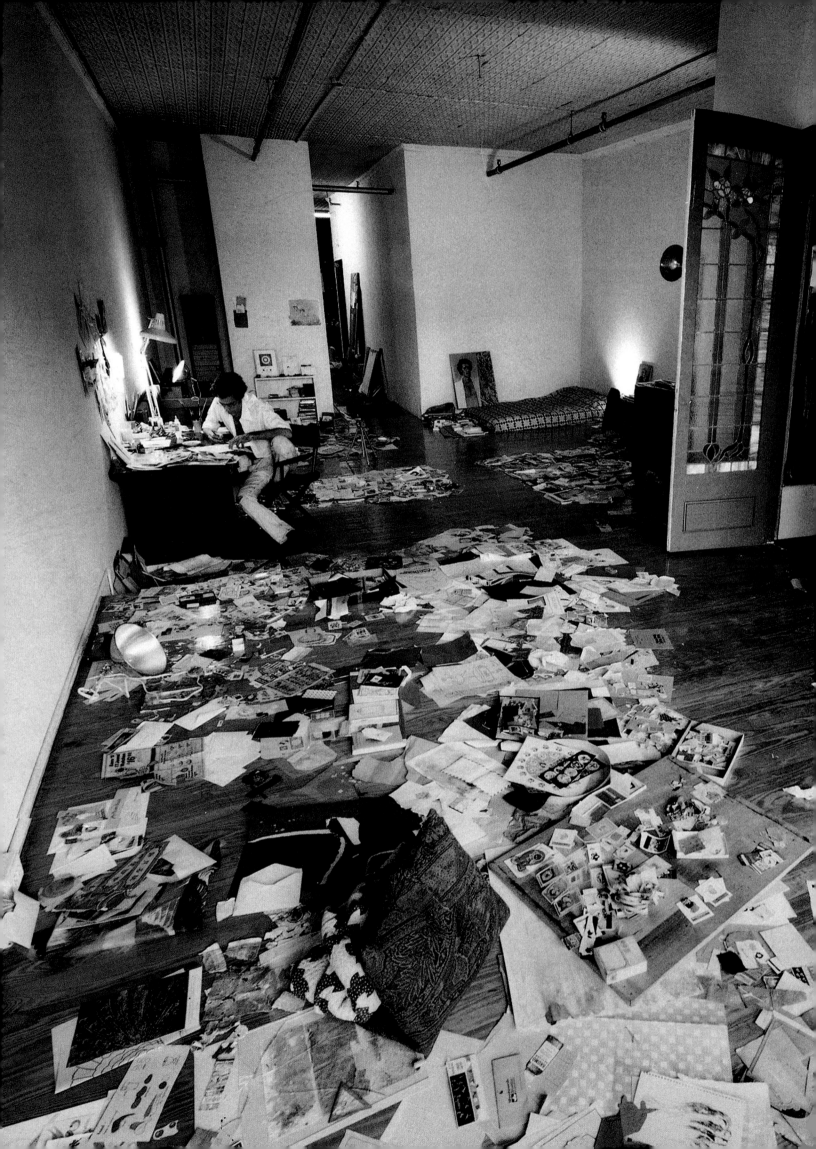

Not Together, But Some Place

1975–

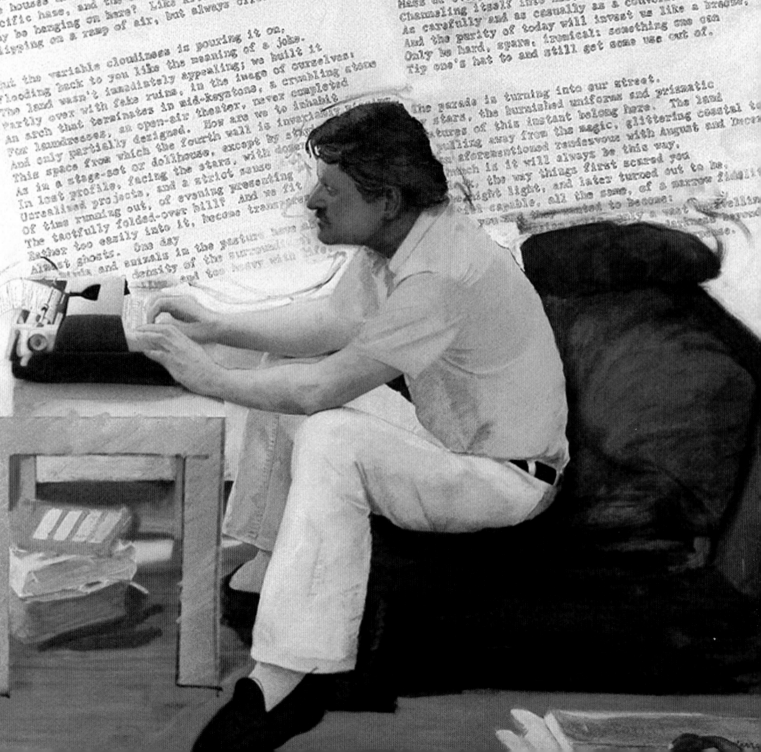

. here on Cottage Grove it matters. The galloping
d halts at its shadow. The carriages
e drawn forward under a sky of fumed oak.
is is America calling:
he mirroring of state to state,
f voice to voice on the wires,
he force of colloquial greetings like golden
Pollen sinking on the afternoon breeze.
In service stairs the sweet corruption thrives;
The page of dusk turns like a creaking revolving stage
In Warren, Ohio.

If this is the way it is let's leave,
They agree, and soon the slow boxcar journey begins,
Gradually accelerating until the gyrating fans of suburbs
Unfolding the darkness of cities are remembered
Only as a recurring tic. And midway
We meet the disappointed, returning ones, without its
Being able to stop us in the headlong night
Toward the nothing of the coast. At Bolinas
The houses dose and seem to wonder why through the
Pacific haze, and the dreams alternately glow and grow dull,
Why be hanging on here? Like kites, circling,
Slipping on a ramp of air, but always circling?

But the variable cloudiness is pouring it on,
Flooding back to you like the meaning of a joke.
The land wasn't immediately appealing; we built it
Partly over with fake ruins, in the image of ourselves:
An arch that terminates in mid-keystone, a crumbling stone
Porch housesses, an open-air theater, never completed
And only partially designed. How are we to inhabit
This space from which the fourth wall is invariably missing
As in a stage-set or dollhouse, except by staying
In lost profile, facing the stars, with dogeared
Unrealized projects, and a strict sense
Of time running out, of evening presenting
The tactfully folded-over bill? And we fit
Rather too easily into it, become transparent,
Almost ghosts. One day
.a and animals in the nature have al
density of the surrounding
. and too heavy with life

. long period of adjustment followed.
In the cities at the turn of the century they knew about it
But were careful not to let on as the iceman and the milkman
Disappeared down the block and the postman shouted
His daily rounds. The children under the trees knew it
But all the fathers returning home
On streetcars after a satisfying day at the office undid it:
The climate was still floral and all the wallpaper
In a million homes all over the land conspired to hide it.
One day we thought of painted furniture, of how
It just slightly changes everything in the room
And in the yard outside, and how, if we were going
To be able to write the history of our time, starting with
It would be necessary to model all these unimportant detail
So as to be able to include them; otherwise the narrative
Would have that flat, sandpapered look the sky gets
Out in the middle west toward the end of summer.
The look of wanting to back out before the argument
Has been resolved, and at the same time to save appearance
So that tomorrow will be pure. Therefore, since we have
In spite of things, why not make it in spite of everythin
That way, maybe the feeble lakes and swamps
Of the back country will get plugged into the circuit
And not just the major events but the whole incredible
Mass of everything happening simultaneously and pairing
Channeling itself into history, will unroll
As carefully and as casually as a conversation in the n
And the purity of today will invest us like a breeze,
Only be hard, spare, ironical: something one can
Tip one's hat to and still get some use out of.

The parade is turning into our street.
. stars, the burnished uniforms and prismatic
. tures of this instant belong here. The land
. pulling away from the magic, glittering coastal to
. n aforementioned rendezvous with August and Decem
. which is it will always be this way.
. the way things first scared you
. twilight light, and later turned out to be
. capable, all the same, of a mixture fidelit
. youented to become

PREVIOUS PAGES
Joe Brainard, Greene Street loft,
New York City, 1975.

OPPOSITE
Larry Rivers, *Pyrography: Poem and
Portrait of John Ashbery II*, 1977.

BELOW
Anne Waldman and Ted Berrigan,
The Naropa Institute, Boulder,
Colorado, 1976.

The story of the New York School tends to be about its origins. We focus on first meetings, exhibitions, and publications; the heady flush of new intimacy; unprecedented collaborative arrangements. Though a New York School diffidence about the New York School meant that any sense of it as cultural zeitgeist was written, from the get-go, in disappearing ink, in the 1950s and '60s, this sense of diffidence was charged; there was the sense that there was something to drop out *from*.

From the late 1970s onward, the careers of many people associated with the New York School took on a heft that couldn't be easily contained by stories only concerned with beginnings. In 1974, for example Anne Waldman founded with Allen Ginsberg (and others) the Jack Kerouac School of Disembodied Poetics at the Naropa Institute in Boulder, Colorado. Waldman identified herself as a poet-activist, developing a sense of performative poetics that had its roots in Buddhist and shamanic ritual as much as in Beat and/or New York School poetry. Her commitment to more explicit forms of spirituality meant she shifted further away from a New York School jokiness. Bernadette Mayer, who had been so influential as a teacher in the Poetry Project, began to more clearly identify with a non–New York School spirit. Her journal *0 to 9*, which she edited with Vito Acconci in the 1960s, manifested, in her words, a "resistance" to New York writing—but it was in the 1970s that her poetry, along with Clark Coolidge's, began to be considered in the context of the Language poetry movement.[1]

Probably the most well-known instance of this kind of "critical" reconsideration is the poetry of John Ashbery. In 1975, he famously won a trifecta of awards for his collection *Self-Portrait in a Convex Mirror*—a Pulitzer Prize, the National Book Award, and the National Book Critics Circle Award—which catapulted him into the national spotlight and attracted

an entirely different set of readers, along with the attention of academics. Over the following decades, a number of critical frameworks were constructed for his poetry that had little to do with the label of the New York School. Even if Ashbery has spent most of his career trying to resist the characterizing impulses of others, the vogue of one critical understanding after another has created an almost dendrochronological sense of time to his career.

These kinds of critical and academic "adjustments" need not mean too much. But they do indicate that, in general, the audience for the New York School widened from the 1970s onward. It was no longer a family affair, with the poem "between two persons instead of two pages," as Frank O'Hara put it. The sense of the audience now widened to include the

Locus Solus, Art and Literature, the Project publications, the Paris Review (with second generation poet Tom Clark as Poetry Editor), and Kulchur Foundation (Lita and Morton Hornick's press published a number of second generation poets including some first books, threw publication parties, and additionally brought poets and artists together for an annual winter bash) all contributed to a New York School spirit and a shared aesthetics, which, by the time a younger group came along in the mid- to late '70s, had been diluted and transformed despite ongoing workshops, readings, and group publications. As frequently happens, the initial enthusiasts grew older and less enthusiastic, their emphases changed (some moved away from New York) and were reflected in what they passed along to younger poets, and many of the original impulses were no longer

the same or as compelling as in the 1960s, when the sense of bucking a vast establishment and of doing something genuinely exciting and genuinely new was palpable. Everything felt different.

To some, none of the above means that the New York School closed shop in the mid-'70s. But to others, including myself, it is more useful to think of the School idea as less meaningful after that, and instead to see the ongoing attitudes, strains, and influences—communicated by both generations—as having become part of the fabric of contemporary American poetry, as likely to make an appearance in an academic setting like a University of Iowa MFA workshop, as in a reading by a young poet at the Project. If the last sounds ironic, it is because it is.

—Charles North, from "School Ties," 2009

Alex Katz and George Schneeman,
1970s.

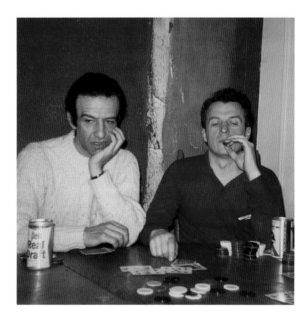

unknown reader, one whose taste was not as attuned to the micro-distinctions of a New York School tone or sense of humor. Those who settled in other cities often ended up attracting very different audiences: particularly Joan Mitchell, who lived in France from 1959 onward; Grace Hartigan, who moved to Baltimore in 1960 and who taught at the Maryland Institute College of Art; and Barbara Guest, who in the 1980s moved back to California, settling in Berkeley.[2]

Furthermore, for the artists and poets who stayed in New York, it was no longer clear that, to use James Schuyler's analogy, they were in the same boat together. Money began to matter. Gone were the days when you could get an odd job unloading banana boxes for a few days a month and, in that fashion, make ends meet. Only the wealthy (or rent-stabilized) could afford the once-cold-water lofts in the garment and manufacturing districts of SoHo and Chelsea. The poets remained relatively impecunious, but visual

artists like Alex Katz began to sell their art for higher and higher prices. Friends were no longer eating at the same restaurants, or vacationing in the same places. The demands of family and children increased, and the naturally cohering force of a neighborhood and its casual sociability began to ebb. Their time together now often had edges to it. For a while in the late 1970s and early 1980s, there was the sense that there were third- and fourth-generation New York School poets, and yet this kind of grouping indicated a general influence rather than any particular social circle. A New York School sensibility became one of many tones for artists and poets to play with. And there was a natural drift away from the sentiments and sensibilities cultivated in the 1950s, '60s, and '70s. The art became more various.

There were some artists who remained relatively unaffected by this drift or, in some fashion, continued to boat with the poets. George Schneeman, for instance, was reluctant to engage with galleries or collectors. One story frequently told about him is the weekly poker game he hosted; many second-generation New York School poets and painters religiously attended this Friday game for years. One evening, Schneeman's dealer, Holly Solomon rang. She was with some collectors and urgently needed Schneeman to come uptown and close the sale. He refused; he couldn't interrupt the game. Burckhardt also chose not to persist with museums and galleries; he once told Phillip Lopate that after the Museum of Modern Art turned down his photographs in 1950, he refused to approach the museum again. Lopate noted, "The frequency with which attributes such as 'modest,' 'unassuming,' 'diffident,' 'uncompetitive' are invoked in the critical literature about Rudy Burckhardt is noteworthy enough to be startling."

The same attributes could well apply to Schneeman, and to Joe Brainard, who in 1977 stopped exhibiting his art altogether, though he continued to

Alex Katz, *Face of the Poet* (details), 1978.

LEFT FROM TOP: Tony Towle, Alice Notley, John Godfrey, Kenward Elmslie;

CENTER FROM TOP: Ann Lauterbach, Gerard Malanga, John Perreault, Michael Lally;

RIGHT FROM TOP: Peter Schjeldahl, Carter Ratcliff, Ted Berrigan, Ted Greenwald.

George Schneeman with Alice Notley,
Untitled, 1980.

Mornings I wonder if I
can fill my stockings.
By evening I think I
wish I weren't so in love.
Of course I don't wear
stockings. I don't know
anyone who does except for
Darling, & I don't really
know her, the way that
I know you. So may
I say that I had a vision
last night of Heaven?
My stockings were
all that was there.

His sideburns. Problem about them. He liked them. They made him feel good. But nobody else did. They were too polite to say anything. But he knew they didn't like them. Still, he felt good, in an unusual sense of the word "good," as in "good night."

The perils of just aimlessly sitting. Of having continually to go out and fix something. These never endanger us, but they condition us more than we know.

Little nuts, big nuts.

Asked for a conclusion, he paused long enough to be heard.

49

Spread from *The Vermont Notebook*, 1975.
Writing by John Ashbery with more than
fifty ink drawings by Joe Brainard.

One of the major ways in which Roussel influenced me as a painter was his ability to see the overlooked detritus of daily life as a potential source to construct highly complex stories. The classic example being the use of his shoemaker's name and address, "Hellstern, 5, place Vendôme" to produce (phonetically distorted), "Hélice tourne zinc plat se rend (deviant) dôme" ["propeller turns zinc flat goes dome"], which gave him all the elements he needed to construct one of the extraordinary apparatuses in his novel Impressions of Africa. *All this from a shoe maker's calling card! Economy leading to complexity. Elsewhere, he would begin a tale with one phrase and end it several pages later with another phrase of almost the same spelling but totally different in meaning: in other words, reconciling opposites. I too like to gather disparate elements and make them into a convincing story, though not necessarily one with a beginning, a middle and an end. In my painting* Troubled Potatoes *I recall using the retort "he walked all over me" as a visual pun and, following Roussel's lead, reusing the planter's fingers as the parrot's plume. As with Roussel, one thing leads to another: the parrot's plume suggested the planter's headdress, but instead of feathers from bird wings, I used wings from a transparent insect. Seeing things aslant, as Roussel did, the equation is solved.*

—Trevor Winkfield, 2011

Trevor Winkfield, *Troubled Potatoes*, 1998.

paint and draw for a time. Brainard's decision to
withdraw from any public eye was not for lack of
financial gain, but because he felt his art wasn't good
enough. As Padgett put it, Brainard felt he was
"lacking the qualities of the high art of the oil painters
he so admired, such as de Kooning, Manet, Goya, Katz,
and Porter." In 1975, it was entirely typical for a critic
like Hilton Kramer to describe Brainard's exhibition
at the Fischbach Gallery as "very amusing and
endlessly fascinating," but also characterize his work
as "minor" and "lightweight stuff." For that exhibition,
Brainard made hundreds of miniature drawings,
collages and assemblages, most less than two inches
high. They are often delicate, sometimes exquisite.
But in Brainard's eyes, they had "no commodity." In
an interview in 1980, he commented, "People want to
buy a Warhol or a person instead of a work. My work's
never become 'a Brainard.'" It's a shame that value,
in this instance, was so clearly linked to scale. The
art critic Clement Greenberg—who had been so
influential in the 1950s and '60s as an arbiter of
taste—was fond of distinguishing between major
and minor artists, never offering a hard-and-fast
definition but nevertheless using the terms in his
lectures accompanied by a set of revealing adjectives.
According to Greenberg, major art challenged "the
longing for relaxation and relief." It did not ape
popular culture. It was always "hard." In contrast,
artists like Brainard, Burckhardt, and Schneeman
were on close terms with popular culture. They
shared a love for the art of the gift. They could be
sentimental. Their art had a great deal of relaxation
in it, and it remained domestic, meant for an intimate
scale of consumption. These qualities were not
necessarily fashionable in the broader art world,
particularly in the 1980s.[3]

Yet there is much to celebrate in the
collaborative work done in this later period. There is,
for instance, the artist Trevor Winkfield. Winkfield

is not American; he grew up in Leeds, England, but
as an art student in 1965, he heard Ashbery read his
poem "The Skaters" at the American Embassy in
London. It was a seminal experience for him; he
sensed in Ashbery's poetry new ways of thinking
for himself as an artist. A shared enthusiasm for
Raymond Roussel's writing led him to begin a
correspondence with Ashbery, and then with Harry
Mathews and Kenneth Koch. By the time he moved
to New York in 1969, Winkfield already knew a
number of members of the New York School, and was
eager to collaborate with them. He had also already
demonstrated an editorial eye for art and literature
that was sympathetic to their own; back in the United
Kingdom, he had published a magazine, *Juillard*,
which prominently featured Roussel's and New York
School writing, along with many of the European
artists—Henri Michaux, Yves Tanguy, Joan Miró—
that Ashbery's journal *Art and Literature* also focused
upon. For *Juillard*, Winkfield commissioned magazine
covers from, among other artists, Jasper Johns, Joseph
Cornell, Brainard, and Glen Baxter. Indeed, over
the next few decades, Winkfield's sense of curatorial
taste was (and is) one of the clearest indications of a
continuing New York School sensibility. From his
art writing for the English magazine *Modern Painters*,
and his editorship (with Mark Ford) of the anthology
New York Poets II to the recent journal *The Sienese
Shredder* (which he co-edited with Brice Brown), he
has consolidated and extended the notion of a New
York School without ever announcing it.[4]

After Brainard "retired," Winkfield became a
go-to artist for poets who needed covers designed for
their books. He also collaborated with Ashbery, Harry
Mathews, Barbara Guest, Kenward Elmslie, John Yau,
Larry Fagin, and Ron Padgett on a number of limited-
edition books. Some collaborations, like his books with
Padgett, were modest affairs, but others were much
more deluxe. These collaborations were part of

Granary Books, edited by Steve Clay.

OPPOSITE LEFT, TOP TO BOTTOM
Dig & Delve, writings by Larry Fagin paired with images by Trevor Winkfield, 1999.

Faster Than Birds Can Fly, poem by John Ashbery and designed by Trevor Winkfield, 2009.

Cyberspace by Kenward Elmslie and Trevor Winkfield, 2000.

OPPOSITE RIGHT, TOP TO BOTTOM
Nine Nights Meditation, poem by Anne Waldman with images by Donna Dennis, 2009.

Yodeling Into a Kotex by Ron Padgett and George Schneeman. Originally created as a one-of-a-kind book by Padgett and Schneeman in 1969, this facsimile edition was published by Granary Books in 2003.

In The Nam What Can Happen? by Ted Berrigan and George Schneeman. The original, one-of-a-kind book was passed back and forth between Berrigan and Schneeman from 1967–68 and remained in a drawer in Schneeman's studio on St. Mark's Place for thirty years. Granary's edition is a simulation of the original, printed in letterpress in 1997.

ABOVE
Covers by Trevor Winkfield: *New and Selected Poems* by Charles North (Sun & Moon, 1999) (left), and *Rivers and Mountains* (second edition) by John Ashbery (Ecco, 1977) (right).

growing enthusiasm in the 1980s for limited-edition *livre d'artistes*, which were self-consciously precious objects, made from beautiful paper, typeset, hand bound, and housed in meticulously made slipcases, an expression of a revitalized interest in book arts in general. Steve Clay, at Granary Books in SoHo, was (and is) the most significant publisher of these books for the New York School. From the late 1980s onwards, he commissioned multiple collaborations by members in addition to other (mostly American) writers and poets, publishing, among others, Berrigan and Schneeman, Coolidge and Keith Waldrop, and Waldman and Susan Rothenberg. He also republished facsimile editions of *Bean Spasms* (1967), and Schneeman and Padgett's one-of-a-kind book *Yodeling into a Kotex* (1969). In addition to Granary Books, Arion Press in San Francisco republished Ashbery's long poem *Self-Portrait in a Convex Mirror* (1984),

commissioning prints by Richard Avedon, Elaine de Kooning, Willem de Kooning, Jim Dine, Jane Freilicher, R.B. Kitaj, Larry Rivers and Katz. In 1990, they also republished O'Hara's "Biotherm," commissioning a set of lithographic prints by Dine. Grenfell Press in New York published work by Mathews, Winkfield, Ashbery, and Ann Lauterbach. In France, Bertrand Dorny has made many one-of-a-kind books, working in particular with Kenneth Koch's and Padgett's poetry.

The return of the *livre d'artiste* was not without reinvention. Though some of these books explicitly recalled the nineteenth-century conventions of the *livre d'artiste*, assuming that the image might "illustrate" the text (or vice versa), in most cases, words and images "pushed" against each other, delighting in undermining the reader's assumptions of affinity. The story told is one of agreeing to disagree.[5] And the pleasure taken in being contrary was extended in other ways toward the reader. For instance, the publisher's statement for Winkfield and Larry Fagin's *Dig and Delve*—which recounts an afternoon's flâneuring along the Coney Island boardwalk—is entirely false. It never happened.

In general, it seemed that throughout these decades, a distinct pleasure in being contrary was in the air. Philip Guston's collaborative work with Berkson and Coolidge (he also collaborated with Musa McKim, William Corbett, and Stanley Kunitz) is a case in point. Guston had always been friendly with a number of writers—including O'Hara from the 1950s on—and he prided himself (as many painters of his generation did) on reading widely and deeply, on being able to discuss philosophy and literature and music as well as art. In the late 1960s, having left New York completely for his second home in Woodstock, he began to create cartoon-like paintings of objects (e.g., shoes, clocks, bricks) and hooded figures, a seemingly sharp departure from his earlier abstract work. The art world reacted to these changes with alarm. Those

DIG
&
DELVE

LARRY FAGIN

TREVOR WINKFIELD

Faster Than Birds Can Fly

John Ashbery

Trevor Winkfield

IN THE NAM WHAT CAN HAPPEN?

A STORY

BY: TED BERRIGAN and GEO. SCHNEEMAN

CYBERSPACE
KENWARD ELMSLIE & TREVOR WINKFIELD

YODELING INTO A KOTEX

NEGATIVE

The door. If you pull it it's heavy: if you push it it's hard. This push-pull contest continues until the restaurant closes and the streets are empty of all but a few passers-by. You are left wondering if just holding it wouldn't involve exactly the same level of force.

BILL BERKSON

Philip Guston '73

OPPOSITE
Philip Guston and Bill Berkson,
Negative, 1973.

*Now, Negative, is absolutely marvelous—right
up my alley, as they say—like a Kafka aphorism in that
it never finishes itself with the thought, but is "circular,"
endlessly in movement. Too, what you are left with
is not the "thought," but a series of forces, "abstract"
powers, but yet again one comes back to the thought AND
THINGS. It goes on and on—and also so mysterious—
the word "restaurant" is wonderful, where it is
"restaurant closes"—Well, it's an inspired nugget—
both* A-Frame & Canto, *went like a breeze for me
as I drew—in a word, I "FEEL" the new work, they are
just wonderful and I want to tell you, you are doing
the "best" writing now. The drawings are my way of
telling you that.*
—Philip Guston, from letter to Bill Berkson, November 6, 1973

who supported him from then on and throughout the
1970s tended to be writers. Guston was deeply moved
by their support; they would visit, tell him what they
saw in his work, and everyone would talk late into the
night, lit up by ideas. Berkson described one such visit:
"A kind of haphazard theatricality took hold," he
recalled, "everybody rushing dizzily from wall to wall
collaborating with Guston on his 'story,' identifying
incidents or figures or just sitting stunned on stools
contemplating all this unfathomable energy."
(Berkson was visiting with Lewis Warsh and
Waldman to discuss the cover Guston would draw for
Coolidge's 1969 Angel Hair book *ING*.) Throughout
the 1970s, Guston completed a large number of
"poem-pictures" (as he called them) for his friends,
which were either responses to their poems (as in
Berkson's *Enigma Variations* (1975) or stand-alone
drawings or paintings that incorporated their phrases.
They were gifts of attention. But that attention was
never meant to replicate or supplement the poetry.
Guston was interested (as Coolidge put it) in the idea
of a "friendly antagonism" between image and text, a
kind of "spark-gap," which was absolutely necessary to
the poem-pictures in general. Guston later wrote, "It
is a strange form for me—excites me in that it does
make a *new* thing—a new image—words and images
feeding off each other in unpredictable ways.
Naturally, there is no "illustration" of text, yet I am
fascinated by how text *and* image bounce into and off
each other."

Others were enthusiastic to reflect on their
frameworks of understanding. The most influential
writer in this regard was Kenneth Koch, who,
throughout the 1970s, '80s, and '90s, continued to work
as an educator, both as a professor of literature at
Columbia, and as the inspiration for "Poets in Schools"
(a program that sent poets into New York public
schools). He pioneered the teaching of poetry to
children. Koch was fond of what he termed "poetry
ideas," rules or structures to follow when writing that

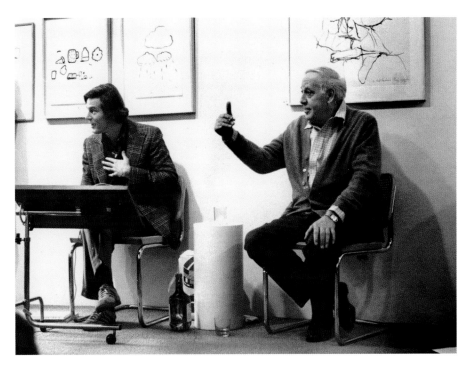

Bill Berkson and Philip Guston,
San Francisco, January 6, 1979.

would distract the writer from a portentous self-
consciousness. To follow one of Koch's poetry ideas
was to engage in linguistic play. (In this context,
collaboration was yet another "poetry idea.") In 1970,
he published his first book on the subject of teaching
poetry—*Wishes, Lies, and Dreams*—and went on to
publish two more, as well as an introduction to
reading, *Making Your Own Days*. Koch's teaching
achievements are not often talked about in the same
breath as his poetry, as if his career as an educator
might distract from or soften the edge of his anti-
academic, irreverent poetry. But such a view belittles
the influence of his teaching. His teaching and poetry
together could easily be construed as part of a larger
project—planned or not—to profoundly influence the
climate of poetry in the United States, to do precisely
what he yearned for in his 1956 poem "Fresh Air," to
sing "the new poem of the twentieth century," to "be

I would send him poems. He had carte blanche to do whatever he wanted. I don't remember ever actually telling him that, but that was understood. Usually the way we would work is he would call up, and he would have a lot of painting he would want to talk about. I would go to Woodstock and spend a couple of days. After that, I would come back and feel incredibly energetic and just want to write. I would usually send him that work. This process fed back and forth between us. Then, he would make drawings; he was always making drawings. He would take out a line of my poetry that he liked. Although some are complete poems, we never sat down together and did them. It was always that I would send them to him. We're both pretty solitary workers.

—Clark Coolidge on working with Philip Guston, from "Combined Aesthetics: Philip Guston & Clark Coolidge," 1990

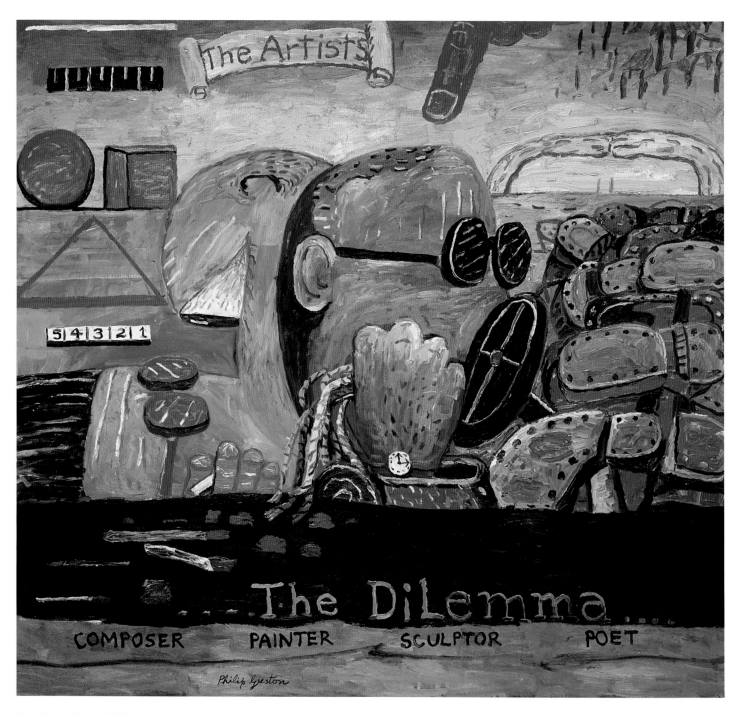

Philip Guston, *Allegory*, 1975.

... Borderlands. A thumb raises up to spot clear and chalk white. That the Lines are shades are drawn.

CLARK COOLIDGE

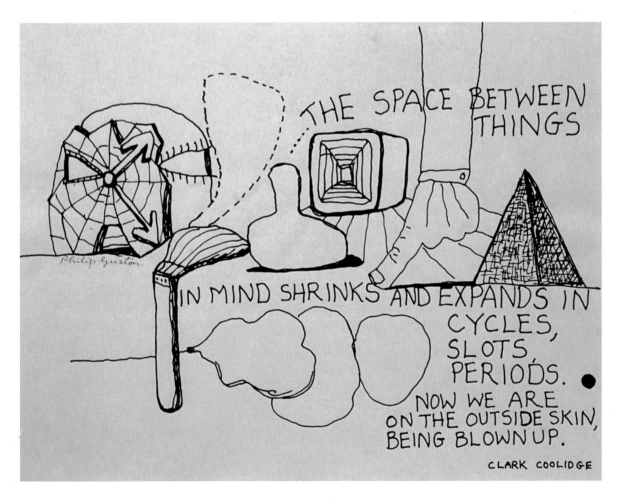

THE SPACE BETWEEN THINGS

IN MIND SHRINKS AND EXPANDS IN CYCLES, SLOTS PERIODS. NOW WE ARE ON THE OUTSIDE SKIN, BEING BLOWN UP.

CLARK COOLIDGE

TOP
Philip Guston and Clark Coolidge,
. . . *Borderlands*, 1972–76.

BOTTOM
Philip Guston and Clark Coolidge,
. . . *The Space Between Things*, 1972–76.

TOP
Anne Waldman and Ron Padgett, at a
public school in Wilmington, Deleware,
ca. 1974.

BOTTOM
Alice Notley, New York City, ca. 1975.

seventeen years old / Once again . . . and not know
that poetry / Is ruled with the scepter of the dumb, the
deaf, and the creepy!"[6]

Today, the West Village and East Village do
not feel much like villages, and the art world is
virtually unrecognizable from the relatively small
downtown community of the 1930s, '40s and '50s.
There is a palpable frustration with the New York
poetry scene in Charles North's set of questions for
fellow poet Paul Violi (see pages 288–293), which were
written to "place poetry within a current geography"
for British readers in 1983. North termed this time
"the Disillusionment of the Eighties" asking (for
instance), "Why is there a sense that the best lack all
conviction while the worst are full of polemical
intensity, that things have somehow gone awry, and
that N.Y.'s fabled energy is more fable, or rather more
mere energy, than formerly, or is that only my sense,
bound up with my own limited perspective and efforts
at selfhood?" What had felt full of promise now felt to
North like it was wearing thin.[7]

Yet such disappointment does not necessarily
mean disillusionment. What is generally passed over
without direct comment is the way in which many of
these poets—like Berrigan, Waldman, Berkson, and
Fagin—have taught extensively for many years, while
remaining staunchly anti-academic. Many taught
workshops at the Poetry Project, or worked in various
outreach programs in the New York City public
schools. Berrigan taught in colleges across the United
States, Waldman at Naropa, and Berkson at various
institutions, including the San Francisco Art Institute.
Padgett was the director of publications for *Teachers &
Writers Collaborative* for almost two decades, editing
the organization's magazine from 1980 to 2000. Fagin
continues to teach privately. Their teaching has
necessitated a reflectiveness, or at least a heightened
awareness of their own literary cosmologies. Their
accounts of their reading and writing have, in turn,
offered a coherency to others'. And what is also

Eileen Myles & Alice Notley, ca. 1980

> Easy River
>
> a piece of cake
>
> even
>
> still some dough
>
> In the shape of
>
> every bathrobe you
>
> loved
>
> you walk around in a
>
> messy room,
>
> a Saturday morning in her thirties

generally passed over is how these poets have also become organizers, one-man and one-woman literary machines. Their energy in the long term is worth studying: there are retrospective exhibitions to organize, monographs about old friends to write, archives to sell to various institutions—but there is always poetry to write. Much of this work demonstrates, in some fashion, a New York School interest in the commingling energy of different art forms, even if it is not explicitly collaborative. For instance, a number of second-generation New York School poets have worked as art writers. Charles North has noted:

> Peter Schjeldahl, Carter Ratcliff, and John Perreault (all of whom turned their energies to art-writing early on) became prominent art critics, and Bill Berkson and David Shapiro have done substantial art writing as well as teaching. Tony Towle worked for years at Universal Limited Art Editions; Ted Greenwald had important gallery affiliations; Paul Violi was an editor at Architectural Forum; Ted Berrigan, Ron Padgett, Towle, and I, among others, have done reviews and criticism.

North also writes about art. This pattern is much less remarked upon than, say, Thomas B. Hess's decision to hire Porter, Guest, O'Hara, Schuyler, and Ashbery at ARTnews in the late 1940s and '50s, and yet it is just as distinct. As time passes, and as the second-generation poets' collected works are published, an account of the New York School and its collaborations will inevitably begin to weigh the 1980s, '90s, and the first decade of the twenty-first century more heavily. The New York School is still a sensibility that others want to think about.

In Manhattan today, young poets and artists can no longer afford to live on the fumes of a part-time job. With the press of time, it's very easy to canonize an artist or poet, to gild their work, either idealizing or dismissing them because they so clearly belong to a different age. (Trying to relive someone else's golden age also rules out living one of your own.) But the artists and poets of the New York School show what's possible if collaboration is considered a daily circumstance of friendship, as natural as going to the movies or eating out. The work in this book charts what it means to have created art with friends for decades: by afternoon, by week, by month, by year. The extent of their commitment to each other—along with a basic patience for living and creating—is remarkable. And there is something to be learned from understanding how a community of writers and artists can create a climate in which their voices can carry, an atmosphere in which you can have faith that what you create will not only be received, but also be understood. This might sound like a modest impulse, but it can be surprisingly difficult to pull off, all the while avoiding the ossification that comes from any repeated articulation of value. To the young artist or writer, surrounded by slightly terrifying instances of the "finished product," collaborative art shows us its seams, indirectly gives us a sense of the "how-to." Collaborative art makes art, in general, seem more possible.

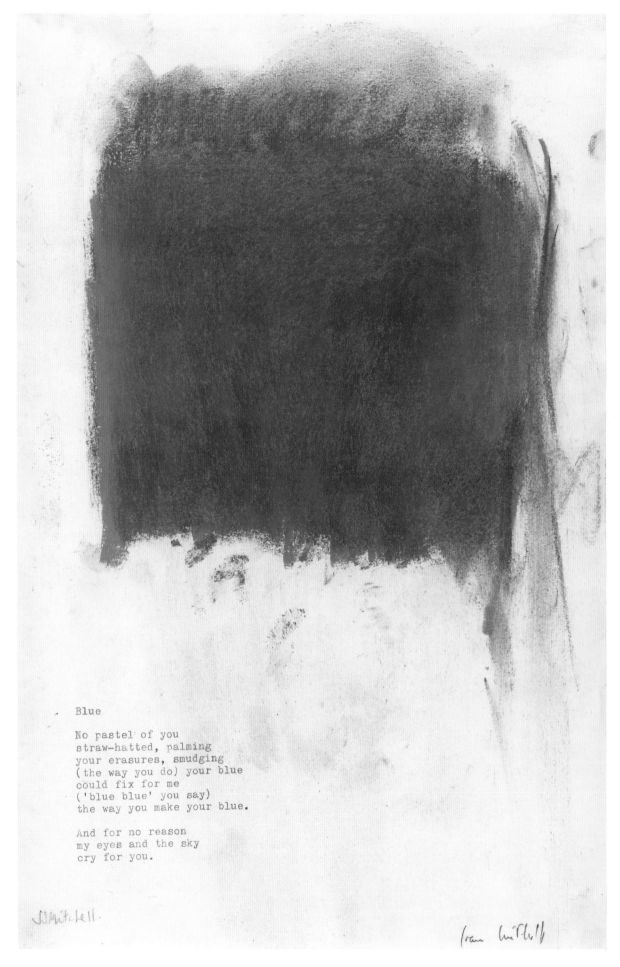

Blue

No pastel of you
straw-hatted, palming
your erasures, smudging
(the way you do) your blue
could fix for me
('blue blue' you say)
the way you make your blue.

And for no reason
my eyes and the sky
cry for you.

Joan Mitchell with J.J Mitchell, *Untitled Blue*, 1975.

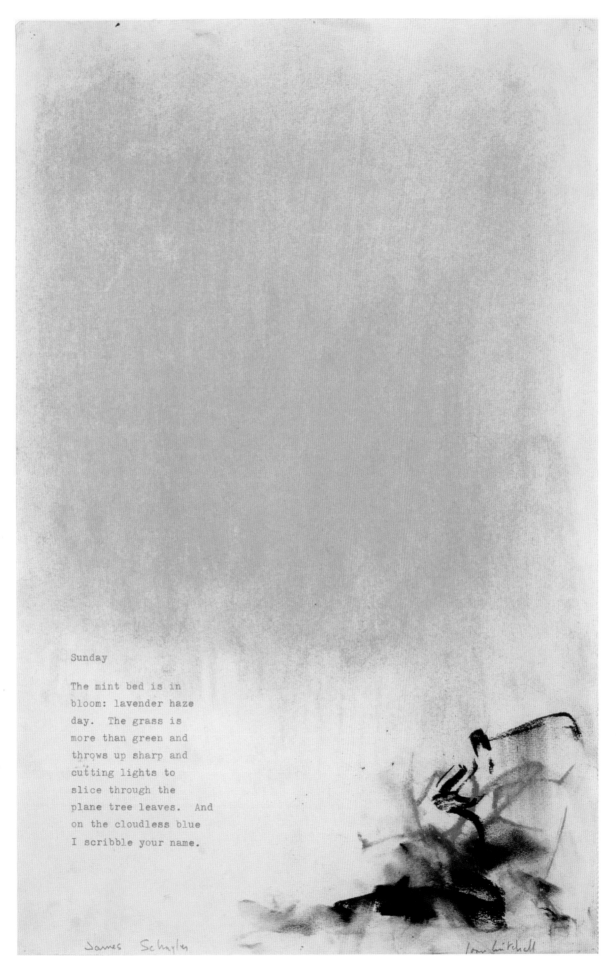

Sunday

The mint bed is in
bloom: lavender haze
day. The grass is
more than green and
throws up sharp and
cutting lights to
slice through the
plane tree leaves. And
on the cloudless blue
I scribble your name.

James Schuyler

Joan Mitchell

Joan Mitchell, drawing to James Schuyler's poem "Sunday," c. 1975.

ARRIVEDERCI, MODERNISMO
Carter Ratcliff, 1974

Arrivederci, kiosks, jealousies, and temperament.

Why isn't this so much harder than it seems to be?

"Arrivederci, temperament." How many times did we go through that?

And how easy, finally, did it get? Arrivederci, accordion music, jokes about asparagus.

Arrivederci, words, rose-colored glasses. Arrivederci, passions frowning at you as from the walls of other peoples' portrait galleries.

Arrivederci, foam-born, proportionate, and unapportionable . . . arrivederci, method, and you, too, aleatory method. There were so many good-byes right from the very start that, strange as it is to meet you once again, Modernismo, it isn't strange to be saying, at long last, good-bye, adieu, arrivederci . . . to you this time, Modernismo, dear.

Temperament wasn't the first to go—I mean, it needn't have been . . . but the cards fell that way— didn't they, Modernismo?—and that's when I fell in love. So much had suddenly become too late and that seemed to put the future so near, so disruptively near. Our future was so nearly too soon. I loved the way you reduced it to manageable proportions, to admiration, to a swirl of modernist periods, each one timelessly ordained. I loved your feather-boa period and the way you reduced it to your plucked-eyebrow period.

I loved the reductionism of your smile and the somnambulism of your endless pronunciamentos.

If I had anything to do with the overlapping of modernist periods, with the clumsiness of the catching up that admiration had to do, I can only say I'm sorry, Modernismo, even though this is good-bye and your reductionism is not what invigorates me now.

I loved the good-bye we arranged for bathos, and I wondered then, bathetically, if love was ever the point. Not to ask that purifying question as I'm doing now, but to live it—that's as close as I ever got to your elegance, your circularity . . .

I loved the way you painted yourself into a corner without ever lifting a brush, and the way you made fun of yourself without ever ceasing to work, morning, noon and night. Mornings especially, Modernismo, when the seriousness poured in like light and the certitude you craved as the marble fiend his snow-white dope was reducing itself further still to the certitude that I'd always loved you.

That was progress, and progress was admired. And admiration was progressing, progressing into the modernist state of being the admired. This left me excluded but more than ever in love, so you can see—can't you, Modernismo?—that I might have gotten desperate—just a little bit?

This isn't an excuse, this is good-bye, to you and to longing for a chance to explain how it was that I was unfaithful, that I loved incertitude as well, no matter how much it might be reduced in a period to come, by whatever method, even your precious aleatory method, your pearls-before-oysters method.

Yes—I loved incertitude, the unmethodical kind. And if love was beside the point, think how I felt when I found that I felt that other love. Would you have cared if you had known that you taught me to hate myself?

Never mind. I'm only trying to lend drama to an occasion for which there is no real occasion. My "other love" was just a crush on the obvious point that the further reduction required by incertitude required the future as well—the future I craved and you disdained, much as if it had been one of your natural gifts.

Perhaps it was, dear, despairing, unnatural Modernismo. You would rise to the occasion, any occasion, and beyond. You were better than paleontology. You were better than chiffon.

In other words, I loved most of all the way you would hug yourself empty-handedly. That was in your window-seat period, then again in your Daimler period, and then again, much later, in your soft-focus, I-just-want-to-take-a-walk-down-to-the-water period.

I loved that despair of yours, Modernismo, and the way you never felt it, born as you were out of the despair of the metropolis with which you had been identified, the despair at ever finding any useful work for you to do . . .

You kept on working, which was admirable. I was dazzled as by a mirror held up to the unnaturalness of your situation. Arrivederci, representationalism.

You said that, ignoring the claims that publicity, primitive urges, and the prospect of travel were making on those natural gifts of yours. Arrivederci, café where I could always find you.

Arrivederci. I was dazzled by the mirror with no perspective, no train tracks meeting, no scenery rushing past. The fact that I could see into the mirror from which I was excluded meant to me then that we would be together always. Modernist integrity seemed to require a viewer, and I thought my disembodied love was my eternal qualification.

I didn't realize that you were your own reflection. I should say, I didn't see—I didn't see how superfluous it was for me to see. And then I did, and you were gone, and I never got to say good-bye. . .

Yet it's true that we were together, together always, though you're the only one who knew what we meant by "always." It was "always" reduced so as to be more itself—as, for example, seeing ever more clearly, you were a vision in those days . . .

It was your white-telephone period. Enclosed by vision, vision was likewise enclosed. I never knew how you reconciled the circularity of your principles with the right-angled geometry of that white room, but I know how you stuck to your principles, how you detached that interior from the building itself and the architecture of the city with which you had become identified, and I know how you cried when we woke up and you were there—I mean, literally, you were *there*—and I wasn't, and I never got to say good-bye . . .

Arrivederci at last, Modernismo, dear—I was a young man in a hurry then, and I'd noticed that the history we were making had gotten into a funny habit of passing us by . . . I wanted to catch up. I wanted to be more myself.

That was my learning-to-look period, and don't imagine—whatever your current doctrine on imagination might be—that I never looked back, for I did, time and time again.

I saw myself falling in love with you at the onset of each new modernist period. With such certainty. Maybe that's why you were willing to certify the principle that all we had meant to each other meant nothing, and thus meant everything to history, and that that's what history meant. And means.

Admit it, Modernismo—your progress had a certitude that required no future. And the history of your turning up here doesn't change things a bit. Not between us. Modernist certitudes are displaced, but only rarely do they go away. I went away for good—but here you are. And the city is still there. And I suppose the boulevards still decline to bring you into their consultations . . .

Those odd clarities to which you would return in the very early morning are surely still there, and surely they have not yet returned the compliment to you. For it was not intended as a compliment, that purified vision of yours—of you—and the mirrors the cities have become—mirrors of you—are too cluttered by the uncertain future to have found a place in your circularity, which by now, I suppose, is the mere fact of your survival.

Arrivederci, circularity, graceful survival method, swan frozen fast in ice. Can't you see that you've never changed, so that all your steadfastness through change means nothing at all? But I'm forgetting. Vision can't see—though, reduced to self-sufficient purity, it can be devastatingly visible.

The purity of modernist vision excluded the literary, even from literature. Adieu, symbolismo. You said that, and that was real purity. The willows rippling the Alpine lake were always less graceful than you, Modernismo, and the swans, more literary. The swans simply didn't belong.

Nothing did, Modernismo.

Your self-possession—but I'm forgetting. When self-possession is certain it is reduced to empty-handedness. This is not the same as empty-headedness, Modernismo, blonde evaporée et bien visible, but it does exclude the possibility of hearing what is said. You were always deafer than a swan, my dear, and more graceful and more capable of tears.

As we were to learn. Subsequently.

But I'm forgetting. I'm forgetting your cruelty, your self-imposed exile, the smell of the lake, the yellow leaves—saved from drowning but not from death—the autumnal mistiness. All this stabs deep, deeper far than sadness, than your teary-eyed self-absorption.

The city is far away way, like the future—raggedly unlived. The future belongs to the city, no doubt, but not to its certified distillate—you, Modernismo, who have no city and no love for the pervasiveness of this lakeside weather as it works, so offhandedly, to undo your elegant certitudes.

How can I blame you? This pervasiveness, this local color, this literary impulse is making its ragged way into futures that somehow will be lived—but not by you, Modernismo. You will be stranded here, certain only that you must suffer a killing intelligibility at the hands of Nature's natural gift for symbol.

The swan is sleepy, yet it is frozen in the ice long before sleep comes. Dawn comes, it wakes up, it snows, death comes. Later the swan is set free from the ice—but you, Modernismo, you are more yourself, more purely visible, a swan of ice. A vision. Vision itself, more or less.

At any rate, the light strikes deeper in you, deeper than memories of other banquets, other historic occasions, deeper than self-deception, deeper even than an ice pick, but not so deep as the elegance of certitude: you permeate our history: you are the swan of ice who melts to water whereupon to swim.

TIME FOR DESSERT

: SENTIMENT IS BEST—
BUT WHO'LL SERVE IT TONIGHT?

Alice Notley
9/12/83

15

VITAMIN EQUALS CIGARET

I dreamed he came back secretly for a few days... there had been some delays... I asked him if he wished he could really stay & be living again. No, he said, he was tired of having to be so masculine, captain of a ship too tight, even. He wanted too small to be more feminine, quieter for a change....

8/20/83 8

AN EAR
endless fucking thought.

8/4/84

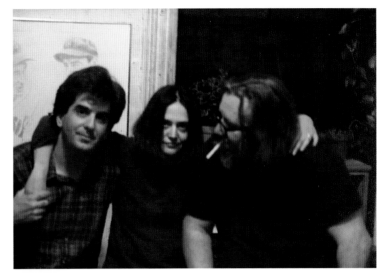

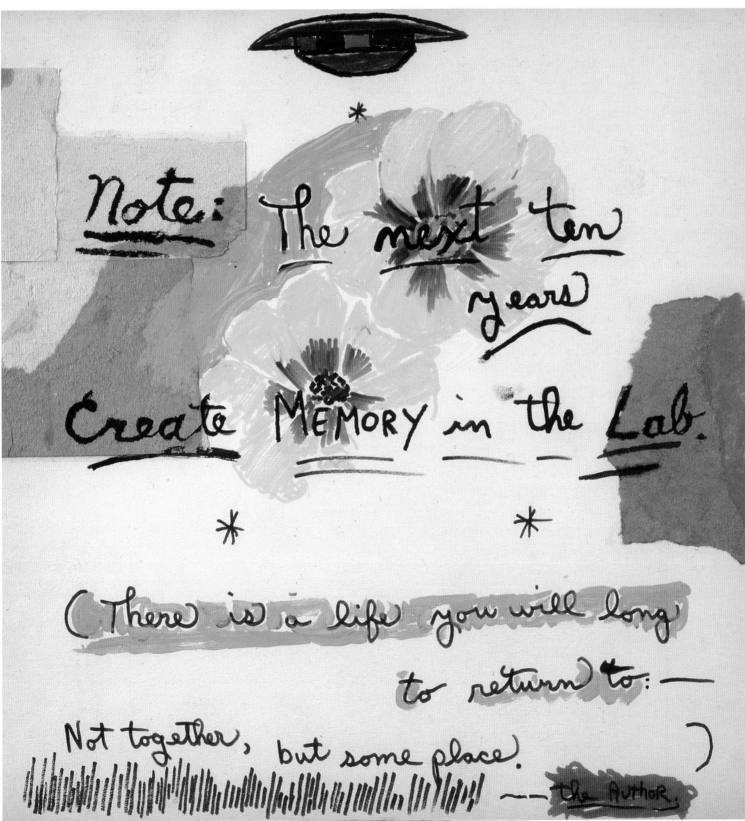

BELOW
George Schneeman with Anne Waldman, *Eats like a Buddhist*, 1993.

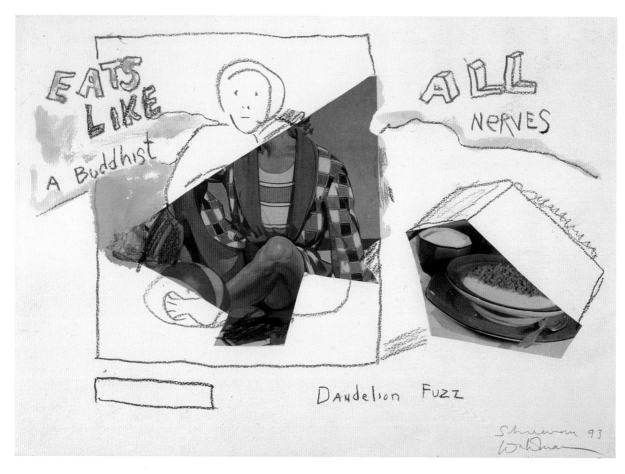

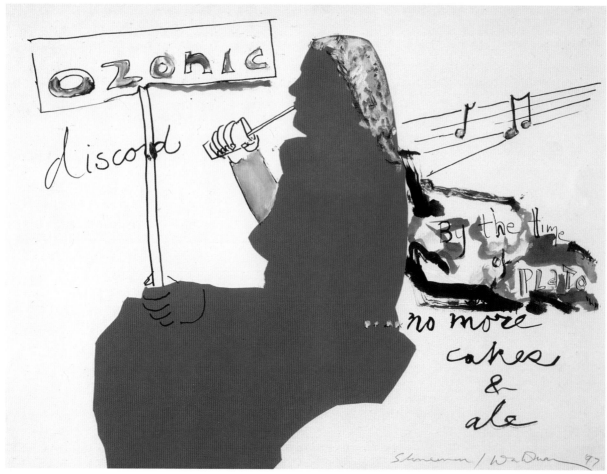

ABOVE
George Schneeman with Anne Waldman, *Ozonic*, 1997.

APRIL DREAM

Anne Waldman
April 17, 1977

I'm with Frank O'Hara, Kenward Elmslie & Kenneth Koch visit-
ing Donald Hall's studio or lab (like an ivy league fraternity
digs) in "Old Ann Arbor." Lots of drink and chit chat about
latest long poems & how do we all rate with Shakespeare. Don is
taking himself very seriously & nervously as grand host con-
ducting us about the place. It's sort of class reunion atmo-
sphere, campus history (Harvard) & business to be discussed.
German mugs, wooden knick knacks, prints, postcards decorate
the room, Kenward making snappy cracks to me about every little
detail. We notice huge panels of Frank O'Hara poems on several
walls and Kenneth reads aloud: "child means BONG" from Bio-
therm. We notice more panels with O'Hara works, white on red—
very prettily shellacked—translated by Ted Berrigan. Sloglan-
like lines: "THERE'S NOBODY AT THE CONTRLOLS!" "NO MORE DYING."
Frank is very modest about this and not altogether present
(ghost). Then Don unveils a huge series of panels again print-
ed on wood that he's collecting for a huge anthology for which
Frank O'Hara is writing the catalogue. Seems to be copies of
Old Masters, plus Cubists, Abstract Expressionists, Joe Brain-
ard & George Schneeman nudes. Frank has already compiled the
list or "key" but we're all supposed to guess what the "source"
of each one is like a parlour game. The panels are hinged &
like a scroll covered with soft copper which peels back.

I wonder what I am doing with this crowd of older men playing a
guessing game! None of us are guessing properly the "sources,"
Kenneth the most agitated about this.

Then the "key" is revealed and the first 2 on it are:

I. Du Boucheron
II. Jean du Jeanne Jeanne le (wine glass)

"I knew it! I knew it!" shouts Kenneth.

 We are abruptly distracted from the game by children
chorusing "da da da du DA LA" over & over again, very guile-
less & sweet. We all go to a large bay window which looks over
a gradeschool courtyard. Frank says "Our youth."

From *Yo-Yo's With Money*
Ted Berrigan & Harris Schiff, 1979

New York Yankees vs. Boston Red Sox
Yankee Stadium September 14, 1977

H: The monolithic bronx country courthouse looms out of the depths
of the night as the mickey mouse organist plays some vaguely
tangoesque warm-up music for the Boston Beantown players to hit
fungoes to the outfield to about 7:22 on a September 14 Boston
playing the Yankees in a crucial game for the Red Sox who are
totally caving in in the heat of the 1977 pennant race

T: What're you on, Harris?

H: I'm on the edge of my seat Ted

T: Harris has gone to get us a beer he's three seats away from
me and looking out the back window of the stadium talking about
the amazing view away from the ballpark all those various
kinds of drugs that he's taken have no doubt put him in such a
position that anything he says tonight will be completely illogical
relatively useless & totally inaccurate however it may have
some saving wit
the Red Sox are taking fielding practice
the field is beautiful yankee stadium is beautiful we're
sitting directly behind home plate with no obstructions between
us & the field in the very last row of the upper deck from
where we can see the entire field stretched out in front of us

we haven't found who the official what the official starting
lineups are yet but ah we have found out that ah it is feasible
to be here if somewhat odd
the fucking redcoats have invaded
the stadium & are playing very loudly some fucking noise
there's
no pussy among the redcoats as far as I can see there's a lot
of pussy among the Yankees let's hope they show it tonight

H: Say that a little louder punk & you'll be thrown out of the upper
deck!

(martial music recognizable as the them from ROCKY in background)

T: I'd like to say hello to my mother & I hope she's enjoying watching
me here at this game

H: Well Ted I'm totally ripped out of my skull I must say & this uh
panorama of this giant Yankee Stadium all lit up is Onbullievabull

Cover of *Yo-Yo's With Money* by
Ted Berrigan and Harris Schiff, 1979.
Cover by Rosina Kuhn. Published
by United Artists (Bernadette Mayer
and Lewis Warsh).

THE BASKETBALL ARTICLE

From *The Basketball Article*
Anne Waldman & Bernadette Mayer, 1975

The orange ushers of the Coliseum begin to wonder if smoking Sherman's makes you sexy. Should they smoke them? What magazine? Ou. We begin to dress in red, white and blue, we do not stand up for the national anthem. We always sit next to the opposing team. We distract them. We enter their consciousness. We carry a copy of Shakespeare's sonnets with us. We wear lipstick. We cheer for both teams. We watch mostly defense, sitting at the far end of the court. We watch Stan Love sitting on the bench. He gives us the eye. We bring Dante to the games. We watch the players who sweat & the players who don't sweat, the players who accept a towel and the ones who throw it away. We watch the angry players and the players who don't give a shit towards the end of the season. We watch the rookies carefully, wondering if they'll get to play. A rookie from San Antonia plays a few minutes, finally, walks three times, scores twice and gets back on the bench. San Antonio has the raunchiest looking team in the league. It's their

hair. The San Antonio Spurs. Their coach says nothing to them. We watch him mouthing words at the referees. We listen to George Gervin, fouled out, call the referee a motherfucker and spur Sven Nater on to beat the shit out of him. We watch Nater circle around the ref, "Nate" a simple lion in the Coliseum, all eyes, the referee ignores him. Nater who said, "I wouldn't mind being in movies but they'd think I'm a monster." Jabbar's taken it to court—can you criticize the referees after the game. We feel the muscles of the players. Women aren't allowed in the locker room. We go to the press room. We watch the players who, toward the end of the game, lean back stretching their shoulder muscles. Occasionally we wink at them. We can, we're at the press table. Somebody's taking pictures of us. Two women. We watch the Spirits of St. Louis. Marvin Barnes leans over and says, "Why don't you put me in there (Oui) with all those girls?" We assure him we'll see what we can do. We listen to him get serious, he says, "It feels good playing the best in the world." The Nets? Maybe. We watch the black players take over the game. We count the number of whites on the floor. Three, now four. We watch the white coaches. We see the kind of joking being a professional creates. The fans write in the bathrooms: "I love Kevin Loughery." The players shout: "You watch him jumpin' into Mosey, he's jumpin' into him," and, to the ref, "I know you don't want us to win and I know you're a motherfucker but this is too much, you jack-off." We stare at the glitter jackets of the Spirits of St. Louis and at the black bell-bottom pants of the San Antonio Spurs as they snap them off to get into the game. Some of the players hide when they do this. The players shout "The spread's comin'" and "beaten by a dead dog all the time." The fans say, "They took the knife on him," talking about Dr. J. We remember Debusschere's heel bone coming through his arch, we remember when Julius Erving married Turquoise Brown and now they have a fine child. We think about nicknames: Rainbow, The Doctor, Mr. K, The Pearl, Hondo, Salty Dog, Ice. We remember Gene Conley, a forward for the Celtics and a pitcher for the Red Sox, Rick Barry's broken elbow, Jabbar's demand to leave Milwaukee, the great George McGinnis no-trade, Nate-the-roller-skate, all the ones named Love and Jones, one Love a brother of a Beach Boy, two Silases and a Price. We can still picture Bill Walton sitting on a bench during practice with Jack Scott's dog named Sigmund in the middle of the Patty Hearst scene and then his house goes up for sale. Phil Jackson reads Carlos Castenada. Bill Bradley'll sign a ten-year contract with options if the Knicks could get Jabbar. Frazier asks who'll be left to play with him. We watch the players being told what to do. We watch them not doing it. We watch the 3-point plays in the ABA, Dampier, Erving, McGinnis. We watch UCLA beat Kentucky in John Wooden's last year. We watch Walt Frazier's bed and Wilt Chamberlain's bed and think of the players' ages. We watch Dick Barnett be an assistant coach and Jim Barnett fuck up. We see Gianelli get taller and offend Jabbar. Exploding on the boards, tickling the laces, going from downtown. The players put their gum on the press table. The Nets lose on TV, but not in the Nassau Coliseum.

The Basketball Article was conceived in November 1974 & written in April 1976 as an assignment for *Oui* magazine. We got to go to all the Nets games we wanted through Barney Kremenko, Publicity, but Jim Wergeles of the Knicks balked, 'What do you girls really do?' We heard he was a jock. We went to the first women's basketball game held in Madison Square Garden. We wrote a review that was rejected for being too technical. We tried not to make *The Basketball Article* too technical so it was rejected by a group of editors a few of whom thought it was 'a minor masterpiece,' the others 'couldn't' tell what the hell was going on' in it. We were rejected by the *Village Voice* for whom the work was not technical enough. An agent told us *The Basketball Article* was fragmented and could not be handled. We never got into the locker room. A purely prophetic work in the tradition of social realism . . .
—Bernadette Mayer, 1975

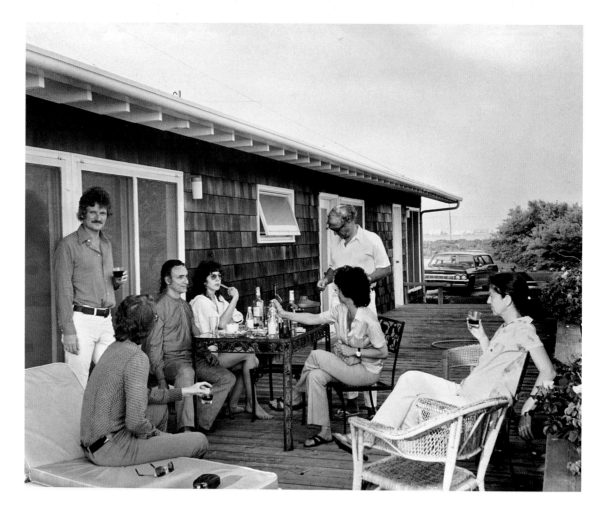

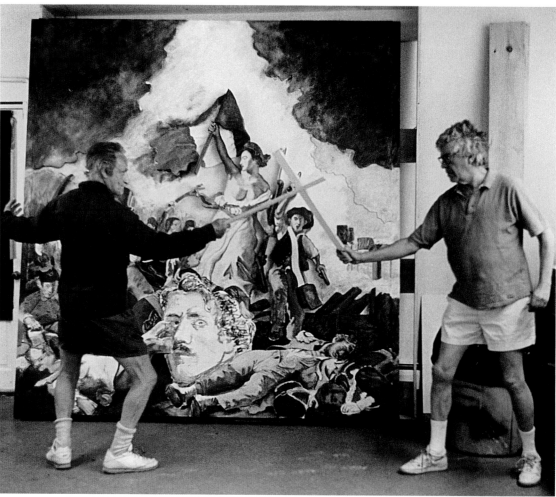

From left to right: Darragh Park, John Ashbery, Larry Rivers, Diane Molinari, Joe Hazan, Ellen Adler (Oppenheim), Jane Freilicher at the Freilicher/ Hazan house in Watermill, New York, 1970s.

Larry Rivers and Kenneth Koch, 1974.

Bill Berkson and Bernadette Mayer,
Detroit Institute of Arts, Michigan,
1982.

BB: What's your idea of a good time?

BM: *Not being rich myself, it's to have a wonderful dinner, drink plentifully of all the wines and beers of the world, talk incessantly, write poems, get ideas, go to bed without guilt, take pleasure in the lust for all the above, sleep late, have many dreams, make notes, wake late, always be with your lover, write as many letters and poems and other types of books as possible, live forever, find good teas, and of course, throughout, be able to deal effortlessly and lovingly with one's children. And to read and know everything.*

*

BM: What would be the ideal dinner, to your mind? (Describe both the food and the circumstance)

BB: *Very untimely of you to ask. I've been figuring the endless ordinary required banal ones for this household for days & days. (Ordinarily, I do it anyhow, 3 or 4 times per week.) Right now I would love to eat alone whatever can be sent out from the corner deli— cheese & bacon burger, strawberry yogurt, & a bottle of Celray—or go to Ratner's. Lacking such luxuries, my ideal menu would be: Cream chipped beef on toast, a fine valpolicella, a dish of figs, & bottle of Calvados. Arugula in the salad, pls. All this imbibed on the vine-covered terrace of the small villa given to me for a season & overlooking a sparkling inland sea. Janos Starker is my only main-course guest, but he eats early in the kitchen & then plays Fauré cello sonatas clean through for me from a wing. We carry on a brief repartee, & then Lynn arrives for figs & Calvados & we have an intimate discussion of Moses' progress at military school (during which Nanny brings in Mose to say an affectionate goodnight) and other more* pressing and amusing matters. *Time goes by. At midnight our best friends—including you & Lewis, Ron & Pat, George & Katie, Clark "Susan had to stay behind to supervise building my new studio-wing" Coolidge, & Frank O'Hara—& one or two laughable hangers-on, arrive for an all-night party and poetry & painting collaborative during which everyone's work achieves new degrees of crystalline utterance, beautiful and sublime and so inclusively declarative it is difficult for the fishermen (who are all wearing Larry Fagin masks) to tell which is better or even who did what. Breakfast, too, is perfect, being waffles with an Elmslie syrup to beat the band, & real pork sausages ground through the radio that is playing Sousa "Semper Fidelis" and we all fall out on beds laughing in the Great Hall & go about knowing everything we've always wondered in terms of marital practices on satin sheets like pickled herrings in white paper cartons, & Turkish coffee. Around 2 p.m., the Poetry Project staff arrives to wake us & clean up & to bind & frame the night-dawn's proceedings. Pulitzers & Nobel Prizes are handed around. We retire to our separate studios to compose lengthy acceptance poems in the new strict American metric. Fishermen, bakers, and bricklayers & other stonemasons crowd around at the foot of the villa steps to hear us. I guess it's right that everyone should go for a swim. Applause at poolside, we take our bows in the sparkling inland sea.*

—Bill Berkson and Bernadette Mayer, from letters exchanged between 1977–85 and eventually collected in *What's Your Idea of a Good Time?* (Tuumba Press, 2006)

288

OPPOSITE
Rudy Burckhardt, stills from
Ostensibly, with a poem by John
Ashbery and piano music by Alvin
Curran, 1989.

From The Ballad of Popeye and William Blake
Allen Ginsberg & Kenneth Koch, 1979

AG: Popeye sat upon his chair
KK: Reading William Blake
AG: Blake got up and screamed out there
KK: This seaman is a fake!

AG: I, as William Blake, complained
KK: Of Popeye reading me
AG: William Blake could not attain
KK: Popeye's sublimity

AG: William Blake sat there and stared
KK: At Popeye's bulging muscles
AG: William Blake had never dared
KK: To engage him in a tussle

AG: Mary Blake however sat
KK: Right next to Olive Oyl
AG: And cooked her spinach in a pot
KK: In fact, was Mary's foil

AG: Mary Blake washed underwear
KK: While Swee'pea crawled about
AG: Mary Blake she wept a tear
KK: And Swee'pea gave a shout

AG: Mary Blake in London Town
KK: Said, "Why is Popeye present?
AG: I think I'll walk old Bill around
KK: And try to shoot a pheasant."

AG: Mary Blake on Primrose Hill
KK: Saw Alice, called the Goon—
AG: Wonderland, it was forsooth
KK: To see the beast so soon

AG: Mary Blake's apocalypse
KK: (Mary Blake's apocalypse?) Popeye's
 Deuteronomy
AG: Made her kiss Bill on the lips
KK: And praise his male economy

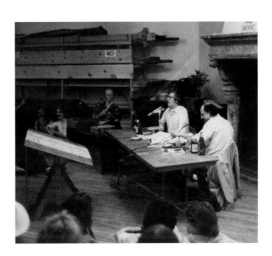

On May 9, 1979, Allen Ginsberg and Kenneth Koch improvised collaborative poetry before a large audience at the St. Mark's Poetry Project. Moderating the evening, Ron Padgett noted that although certain poetic forms (i.e. rhymed iambic pentameter) had been agreed upon prior to the event, Ginsberg and Koch were certainly "making it up" on the spot; the words themselves were spontaneously composed. Excerpted here is the beginning of "The Ballad of Popeye and William Blake."

***From* Land's End**
Charles North & Tony Towle, 1981

A painter would just walk out onto Madison Avenue,
glaring at the passers-by, having developed route fever
on the way East, looking for a tiny radish of
ground, among valences of protracted days, which aspire
routinely to the vine of the ear or so I begin to think.
Canal Street used to be a canal, Market Street a market,
the Bridge of Sighs . . . everything follows a form, a racing
form or the St. Olaf Clarion-Examiner, or the Plainville
Oaf-Bugle, though old age (like sharks) is hardly the toothless
smile one dreams of. Still, there are waiting rooms to pass
the time (though they are usually occupied). But a wind
comes up while you scratch the outer layer of your head,
while prefabricated houses lose the ongoing battle with style,
and the Atlantic's cool bisque blends a gull with a blade of
grass, and a sparrow looking for some seed. Land isn't
the only thing that ends, rocking slowly and going nowhere,
kicking up green light for the flies to skate on. Water
surges through the pipes and a boat door slams. The
coast is clear, tipping the scales in the direction
of the old farm, bees conspicuously underfoot.
The archer takes aim. In fact the sky is sullen, drawing
a bead on the earth, a clue to the frosted target—which
will probably stay circular for another 4000 years. There is
an opening, visible through scrapings on the side of the cave.
The geraniums are darker than the soaked sky, which has
a line of phosphorescent clouds catching and
bumping on telephone poles, presenting the windy
silence with its mirror image. "All phosphorescence
has an f!" concealed in the slide from p to h—until you
swallow it. O I slip out quietly, with the fixed
possibilities of the catatonic swollen by lobes of rain,
over and over in the pines tussling with insects. Turning,
with the toothpick held tightly, I walked from the bathroom
into a large closet whose clothes represented the
fulfillment of every desire I ever had! So much for desire.
Home is where everyone seems to have gone, the end of the
meal. If not Alaska with its towel, then East Orange
with its suds. Please—just get on with what you were doing.

OPPOSITE LEFT
Broadway, edited by Charles Nort
and James Schuyler. Cover by Pa
North (top). Cover by Trevor
Winkfield (bottom).

OPPOSITE RIGHT
Dodgems, edited by Eileen Myles
Covers by Eileen Myles.

THE N.Y. POETRY SCENE/SHORT FORM

Addressed to Paul Violi*

Charles North, 1983

Why are we doing this as an interview?

What does "scene" mean?

Seriously, if scene means "where it is" and the "it" is poetry, does that mean the reading spots (projects, institutions, coffee houses, bars, clinics), bookstores that do and don't stock big- and small-press poetry, *quartiers* (Lower East Side, West Village, Upper West Side, Soho), etc.? Or does it mean something vaguer, something like the State of the Art—which could conceivably have little to do with the aforementioned venues (and could, conceivably, exist in an *ironic* relation to them, i.e., maybe those are precisely *not* where it really is).

To what extent does one's perception of the scene depend on one's aesthetics? A. A great deal.

What is poetry?
(Just kidding, I know you know.)

If "scene" has something to do with health, vitality, quality, and opportunity, characterize the N.Y. Scene.

The N.Y. Scene is clearly a number of scenes, most of which have little to do with New York per se. As we all know, the "New York School" tag which everyone associated with tries to snip off (with only moderate success and properly so) has to do with a state of mind, a sense of *Europe*, and the sense that the world is mad, rather than with this oceanic city.
(Not a question.)

Name some parts of the N.Y. Scene. Which of those, e.g., "original" N.Y. School, St. Mark's, etc., have additional parts, e.g., second and third generations, splinter groups (Bolinas, Naropa), etc.?

Is it logically possible to make any meaningful generalizations about the N.Y. Scene?

* "To place poetry within a current geography (for the benefit especially of the British readers) a message went out appealing for an essay on 'the current New York poetry scene.' What came back was Charles North's *Short Form*, the genesis of which is best described by Paul Violi: 'North and I sat down with a tape but I could say nothing worthwhile, let alone write an essay. So Charles put it together in this format, a sort of questionnaire to me, which I left unanswered. In other words, it's all his, and besides he puts the answers in the questions.'" –Martin Stannard, editor, *Joe Soaps's Canoe*, Spring-Summer 1983.

Tony Towle, Paul Violi, and Charles North at Fanelli's, New York City, 1984.

How parochial is your view of things (anyone's)? For example, what do you know about the Brooklyn poets apart from the re- doubtable Bob Hershon and the *Some Mag.* crowd?

Who, apart from present company, are some of the interesting N.Y. poets, keeping in mind that you can't remember all of them at any one point and are likely to offend many? Do you think in terms of "movements" or factions?

Do large venues, the 92nd St. Y, the Guggenheim Museum, the Academy of American Poets, have anything whatsoever to do with the N.Y. Scene?

Why is there a sense that the best lack all conviction while the worst are full of polemical intensity, that things have somehow gone awry, and that N.Y.'s fabled energy is more fable, or rather more mere energy, than formerly, or is that only my sense, bound up with my own limited perspective and efforts at selfhood?
(Choose two.)

Do any of the following apply to any, few, or all of the scenes and portions of scenes described (by you, one hopes) above? World-weariness, careerism, art-world madness—speaking of which, when we tried to do this on tape and failed miser- ably, we did seem to agree that the current state of the art world, always in the picture for N.Y. poetry at least since the golden-haired fifties, has something to do with what's *wrong* in the poetry world, something like, the loss of "quality," the overpowering of literature by performance (notwithstanding the rightful claims of the latter), the much publicized and boring, the excellent and retiring, etc. etc. If I seem to be grinding an exe, that is because it is somehow continually being handed to us at the zenith of dullness.

What is your perception of the national perception, if such a thing can be considered, of the N.Y. Scene? (I have in mind the ridicule in varying degrees received by the N.Y. School Poets, St. Mark's, etc., over the years. Has this changed?)

Here's an interesting one. Do you think John Ashbery together with his acclaim has had a positive or negative effect on atti- tudes towards New York and its poetry? I can see several sides to that. What about the meteoric aspect of his ascending the poetic heavens?

There are, as I think we said on that selfsame dismal tape, loads of poets in N.Y. who aren't very different from poets elsewhere, as I think is probably the case always. The business of the "prevailing style," the common idea of aim and effect, tone and language, grants and nepotism (just kidding). Could you characterize that style and give some idea of how many po- ets it applies to, and what all this has to do with N.Y.?

No? Then I guess it's my own idiosyncratic and simplistic way of bringing order to chaos.

How important is St. Mark's city-wide? nation-wide? (*Descriptive linguistics.*)

Does big-press publishing, centered in N.Y., producing a limited number of poetry books each year which appear in most of the bookstores, having nothing to do with the N.Y. Scene—whereas, for example, Sun Press, Full Court Press, and Kulchur Press do—

How would you change the N.Y. Scene, if you had 3 wishes? (Short answer.)

Is N.Y. still the center of the universe?

The "language" "poetry" phenomenon has one foot in N.Y., which seems proper, the latter being the modern-day Babel. As a lot of us have flirted and more with that sort of writing and continue to be as interested in language as we are in the striving depicted world, would you feel it proper to comment on those of our colleagues in N.Y. who have given themselves over to language without fear?

Is "criticism" a part of the N.Y. Scene?

Is the *N.Y. Review of Books?* The *N.Y. Times Book Review? N.Y. Magazine?*

Is the continuation of gentrification, "sliver" buildings, condo and co-op conversion, and cynical design?

Speaking of criticism, which is a sensitive and important issue, does whatever you said above about it constitute a plea for a more informed and aware response to what's going on in some areas of poetry *now*, a profound disappointment at missed opportunities in the widely read organs, missed opportunities for *poetry* is what I mean, its health, distribution, and ability to excite?

Do you ride the subways to work? how many taxis do you take in a month? do you believe in commuting? do you walk to poetry readings? are there too many readings in this area so that the *idea* has lost something essential? can there never be enough readings? should poets be helped to produce poetry? do you believe in poetry on the page? is it significant that Schuyler wasn't noticed nationally until well into his 50s? do you think there will be, or is there currently, an Ashbery backlash? is O'Hara likely to go down in history as a "major" poet? does the *New Yorker* emanate secretly from Connecticut? does what poets in N.Y. do to earn $ say anything significant about the N.Y. scene? does anyone in England (presumably those who will read this) care about any of these?
(Answer in order.)

What about Third World poetry in N.Y.?

I keep having the feeling that this scene business is fundamentally elusive, essentially so, that it looks different to everyone who looks at it. It probably has to do with age as much

as poetics. When you're starting and come here from the Midwest (or The New School) it's one thing, when you've sat through a thousand readings and resented a thousand bookstores for not stocking what you think is important, it's another. Let's title this Disillusionment of the Eighties. I know a lot of people don't feel this way. It's interesting, Frances [Waldman] really was someone in a position to have an overview. We should dedicate this to her. I didn't entirely go along with her taste, of course, it was somewhat over on the conventional side in spite of everything, but she was properly removed from each specific scene and somehow clearly saw it as well. This is off topic. The question is, to what extent does commenting on a poetry scene produce that scene which, until that point, didn't quite exist?

Is this too long already?

Let's return to the art world/poetry world connection. I assume everyone gives lip service to that. Name some real ways in which the N.Y. poetry scene is as it is because of the way the N.Y. art scene is (not necessarily direct influence, such as, though it's certainly true for some, having painters for friends and lovers causes one to see things in other ways, try to do similar things with words—though *not* to paint with them). Jimmy (S.) titled his short prose piece in the poetics section of the Allen anthology "Poet and Painter overture"; Ashbery's the art critic and writer of masterpieces such as "Self-Portrait in a Convex Mirror"; O'Hara wrote, curated, mentioned, hung out with, adored; Koch was and is extremely close to; Edwin Denby and Barbara Guest similarly. And among our "younger" poets, Berrigan, Padgett, Ratcliff, Schjeldahl, Yau, Yourgrau, Berkson, Towle, Shapiro, Lauterbach, Welish, Greenwald, me, you, and others. Writers have married painters, gone on vacations with them, enjoyed a cool glass of beer on a sweltering day in front of the N.Y. traffic while talking about everything under the poetic sun. John Yau was and for all I know still is a house painter. So in one sense, one (rather large it's true) group keeps alive the poetry/painting connection. Oops, forgot the other way around too, Rivers, Katz, Motherwell, Dine, Freilicher, Winkfield, Bluhm, Guston, Dash, Schneeman, Jacquette, Paula North, Jean Holabird, etc. etc. What about other groups? This isn't what I mean. I mean what Schuyler was, essentially, talking about: the air we breathe. I see it for better and for worse, worse meaning, these days if not before, the Business of art, the business of the meteoric, as well as those other problems tossed off above; *better* meaning the desire of every poet to do something as beautiful as some of the paintings we see around us every day. And the sense that art is important, part of the scheme of things, easy, or easier, for painters to feel nowadays—the actual importance, if any, of Schnabel, Salle, et al being a whole other issue—than for poets to feel. Or is that a wild understatement. So Art, art acts as a kind of emotional resource, the business management side of the Muse, as well as whatever it performs in the way of specific and general cross-influences, inspirations, and the like. What was the question?

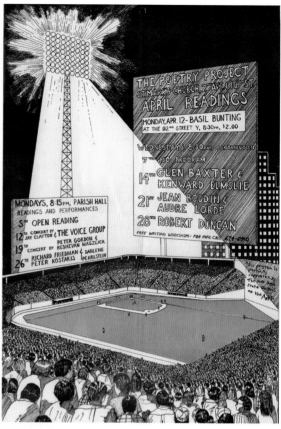

Paula North, Poetry Project flier, 1976.

Would you like to reject those questions you feel are too frivolous? Does frivolity have something essential to do with the N.Y. Scene?

For, we know that some poets from more rural, or less frenzied, areas of the country think that N.Y. poets (by which they mean, more or less, the amplified N.Y. School) are, by virtue of being in the grip of the "artificial and curtailed life," subject to a decadence that forces them to the peripheries of life, poetry, and the American Way. Don't we?

Why, by the way, isn't music, N.Y. being a world-class concert hall, more important to the N.Y. poetry scene than it is? Or is it? Consider jazz, rock, punk, Cage, Thompson, poet/instrumentalists, aspirations towards the condition of music, the poetic equivalent of Muzak, the Drones, hymns to intellectual beauty.

I'm running out of gas, in case you haven't noticed. Time to end, or go to your questions, or get my typewriter, the manual, fixed. It broke after page 1 of this, and I see now that the questions got less coherent after I switched to the electric portable, some sort of comment on technology, which brings up a slew of further considerations regarding the influence of environment upon city attitudes, like winter sunlight on an otherwise disengaged scene.

What about "subject matter"?

Be sure to reread your answers.

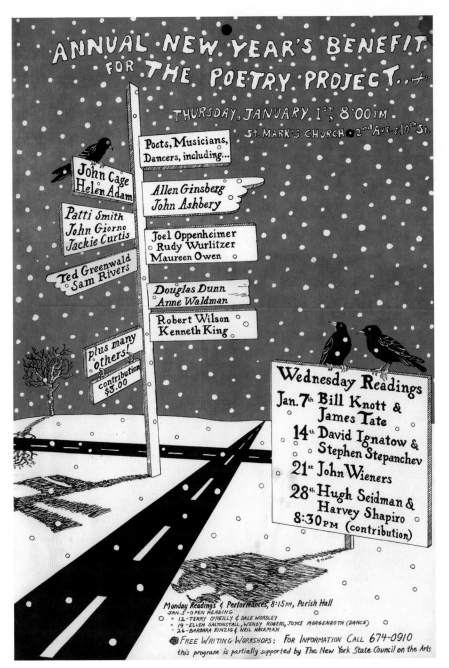

Paula North, flier for the Poetry Project's annual New Year's benefit reading, 1976.

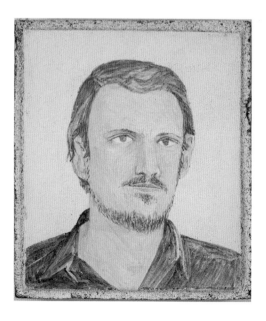
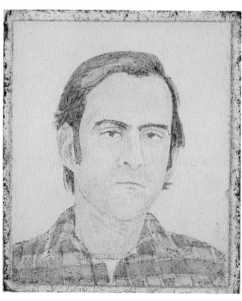
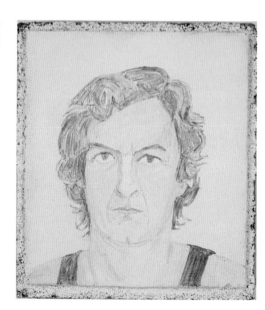

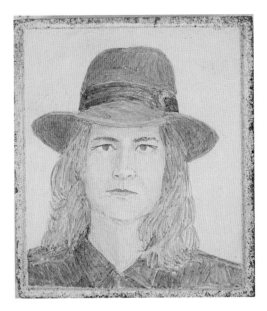

George Schneeman, portraits, 1977–79.

TOP, LEFT TO RIGHT
Edwin Denby, Maureen Owen, Ted Berrigan, Anne Waldman, Jamie MacGinnis.

CENTER, LEFT TO RIGHT
Larry Fagin, Allen Ginsberg, Elio Schneeman, Joan Fagin, John Godfrey.

BOTTOM, LEFT TO RIGHT
Peter Schjeldahl, Ted Greenwald, George Schneeman (*Self–Portrait*), Ron Padgett, Eileen Myles.

BELOW
Ron Padgett and Larry Fagin at the
Poetry Project, 1969.

FOLLOWING PAGES
Ron Padgett and Larry Fagin, 1968.

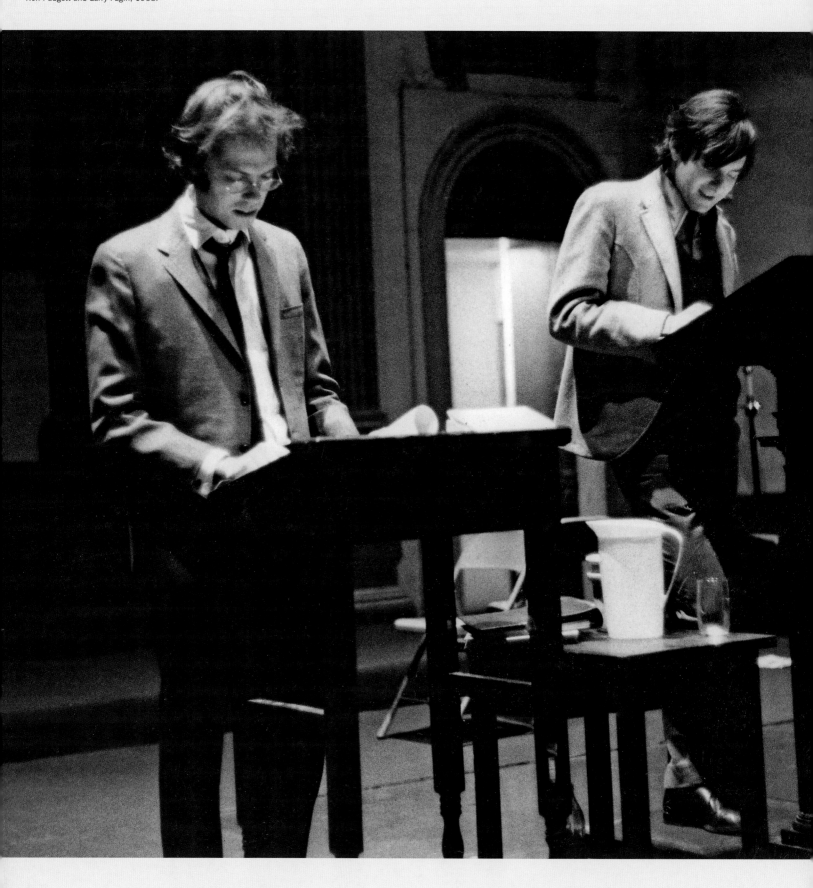

POETS COLLABORATING
Larry Fagin & Ron Padgett

RP: Why collaborate at all? Most of the collaborations I've written with other poets took place when I was in my twenties. The older I got, the fewer I did. I'm almost sixty-nine now and I haven't written a traditional on-the-spot poem with another person in quite a long time. I haven't even felt like I've wanted to or needed to. Why don't we want to write collaborations so much anymore, now that we're old fogies?

LF: Because we're old fogies!

RP: I was thinking that maybe my reluctance to do them is because I don't *need* to do them now and I did need to do them when I was younger. What was that urge?

LF: We lived in an atmosphere of spontaneity. Having so much free time, not having a job, you could wake up in the dead of night and go over to Anne Waldman and Lewis Warsh's and everyone would still be up. There might be four or five others already there. We accommodated each other. Our lives and spirits were collaborative.

RP: A little Garden of Eden.

LF: Yes. The St. Mark's Poetry Project itself was something like a Garden of Eden.

RP: In a way.

LF: When you and Ted would get together and write at the kitchen table, what was it one of you would shout? "Innkeeper! More Pepsi for me and my men!" So the atmosphere was playful to begin with. It was a hedge against all the political and war crap that was going on.

RP: From a psychological point of view, doing the collaborative poems gave me the feeling that I was exploring the boundaries of my inner life. I was testing limits, knocking down the idea of my solitary self as a solitary writer—the ego, trapped in its little room. I think I was trying to discover if there was a larger version of myself that might be accessible to me in the process of writing, and of course in doing anything.

LF: You were actually thinking this?

RP: No, this is all in retrospect. I'm not that programmatic.

LF: In 1967 when I came back to New York from London, my interest in collaboration was partly to be socially accepted. I had already written a collaboration with Tom Clark. It was a way to ingratiate myself with people and fit in with this New York group. I was coming from a very different place, not just England—before that I'd been involved with poets grouped around Jack Spicer in San Francisco. One way to get inside the New York scene was collaborative work. Another way was to edit a magazine. Someone once asked me, "Why did you edit *Adventures in Poetry?* I said, "To gain power over people."

RP (*laughs*): My first poetic collaboration took place in the spring of 1960 in Tulsa. Ted Berrigan and I wrote a scabrous obscene poem that we thought was hilarious. Later I was under the impression that I had started collaborating in New York under the influence of the New York School and Dada, but actually that first collaboration came before I knew about any of that.

LF: Before you knew about Kenneth Koch.

RP: I knew about Kenneth but I didn't know he had collaborated with anybody. By the way, the experience of writing that poem with Ted was quite joyous, but we saw it simply as a spoof and not as "serious literature."

LF: Ted had the kind of effusive spirit that led to—what did you say?— joyousness?

RP: Yes, in that instance it was quite a happy occasion.

LF: It depends on the personalities of the collaborators.

RP: Very much so. Most of the collaborations I've written have wit and/or humor in them. It's not exactly an occupational hazard, but given the crew of people I have collaborated with and our social circumstances, it's like we're at a party. Also, in the old days, sometimes we smoked a little marijuana, which also tended to cultivate a comic feeling.

LF: It cultivated helplessness.

RP: The fact is that collaboration involves the removal of the walls of the ego, to some degree. Marijuana does that too. So if you smoke some pot you're less likely to defend your ego or keep it rigid. I think pot contributed to the intermingling of personalities in the writings of some of those early collaborations in the '60s and early '70s. They could have been written without marijuana, but it certainly . . .

LF: . . . greased the wheels.

RP: Hmmm.

LF: The early collaborations I took part in seemed quite natural. It wasn't a big deal. It was only later I

thought about control, because if I wrote a line, I'd still have to pass it to the other person and give up control. When I became conscious of that, I thought why don't I just write my own poem? But then neither poet could have written that poem on his or her own. It's a third mind or a third kind of presence that comes in. Giving up control is a condition built into the process.

RP: Sometimes one does give up control but sometimes one fights for it. Ted and I often took pleasure in trying to control each other, and sometimes the fun comes from the way the poem wrestles back and forth with itself trying to go in two different directions; and, as you said, it ends up going in neither direction, but it creates a dynamic intertwining.

LF: Push-pull.

RP: Which is much harder to do on one's own.

LF: Give an example of push-pull.

RP: An obvious example is how one poet will end a line with a certain word or phrase and the second poet will continue it in a way that subverts the meaning of that line.

LF: Or changes the direction the poem is taking.

RP: You have to learn to deal with your disappointment that the poem is not going in the direction you want. You have to lose a little of your ego.

LF: That's what creates a new identity, one with no ego, composed of two egos that have been subverted.

RP: Yes. Ego, of course, means "I" and collaborating is "we."

LF: Doing it through the mail gives you more control, or at least takes away the anxiety of the moment.

RP: I don't feel anxiety when I collaborate.

LF: *Anxiety* isn't the right word.

RP: Adrenaline?

LF: Yes, adrenaline. What about writing with more than one person? That's not very common.

RP: It's less common, but you and I did it back in the late '60s and early '70s. Sometimes there were as many as five or six people working on a poem, including Bill Berkson, Michael Brownstein, Anne Waldman, Lewis Warsh, Katie Schneeman, Tessie Mitchell, Dick Gallup, Ted Berrigan, Lewis MacAdams, and Jim Carroll. The result was usually rather haywire. In the spring of 1980, as part of a benefit for the Poetry Project at St. Mark's Church, I set up a manual typewriter in the little square in front of the church, and invited the public to write one endless all-day

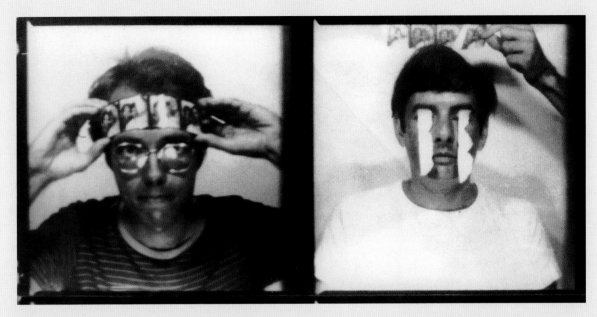

poem, which, it turned out, actually had some pretty good passages. I was amazed. It was sort of like turning everybody in the street into Frank O'Hara at his lunch hour.

LF: A key aspect in collaborative poetry is spontaneity. I'm thinking of *Making It Up*. Can you describe it?

RP: *Making It Up* is a book made from an event at the Poetry Project that involved Allen Ginsberg and Kenneth Koch's getting together and spontaneously, on the spot, composing poems together orally. Both guys rose to the occasion and created the most exhilarating public performance of poetry I've ever seen.

LF: I think Kenneth was the more dominant of the two in terms of the content of the poems but I was really surprised at how beautifully Allen fit right in.

RP: Kenneth in general liked to control situations because he had very good ideas and he wanted everybody to use them. I'd like to emphasize how important Kenneth was in inspiring people to write collaborative poetry. He did it first of all by his own practice and secondly by the issue of *Locus Solus* magazine, the special collaborations issue he edited, which was a big eye-opener. Kenneth also taught elementary school children to write collaborations. It was typical of the expansive Kenneth that he was able to go into a classroom and write twenty-five poems simultaneously with his students. Aside from Kenneth, there were other influences on our generation, especially the Robert Motherwell anthology *The Dada Painters and Poets*, although the Dada poets really didn't write that much together, in fact very little. But they had a strong collaborative spirit, and when they "transmuted" into being Surrealists there was some classic collaborative writing, Breton and Soupault's *Champs Magnétiques* (*The Magnetic Fields),* for example.

LF: At the very beginning there were collaborative stage productions with music and poetry and costumes. I'm thinking of the Cabaret Voltaire in Zurich and Hugo Ball.

RP: Yes, public events we might call "happenings." Another influence was William Burroughs' cut-ups, which enabled him to collaborate with other writers without ever seeing them, by taking their texts, cutting them up, and moving them around.

LF: Found material that didn't have any attribution.

RP: Tristan Tzara of course did that too, and Blaise Cendrars wrote the first found poem, which is a form of collaboration. It was in his book *19 Elastic Poems*, published in 1919. And there was Apollinaire's "Monday rue Christine," whch gives the impression of conversation that he overheard in a café. That's a form of collaboration too.

LF: Kenneth's *Locus Solus* collaborations issue goes back to the T'ang Dynasty: "Garland of Roses" might be the earliest known collaborative poem. There are also examples from the Elizabethans—

RP: —a song by Fletcher and Shakespeare, for instance—

LF: —that don't depend too much on snappy wit. But there usually seems to be humor in collaborations.

RP: But I wrote a poem with Allen Ginsberg that was not funny. Also a few with Dick Gallup that didn't have humor in them.

LF: What about the use of form in collaborations?

RP (*in a professional announcer's voice*): What about form, Larry?

LF: Jack Collom and I tried limericks.

RP: Ted and I wrote some limericks too. They were awful. It's hard to write good collaborative limericks.

LF: Ours were sensational!

RP: But it's interesting to let yourself go and at the same time be writing in a rigid fixed form. That adds to the push and the pull of it. Ted and I wrote some sonnets together in which each of us provided just the rhyme words at the end of the lines, switched papers, and then wrote the poem, using the other guy's rhymes. It was akin to writing a sestina by determining the end-words first.

LF: Would you talk a little bit about *Bean Spasms*?

RP: *Bean Spasms* was a collection of writings mainly by Ted and me, although other people pitched in at various points, such as Dick Gallup and Peter Orlovsky. It consists of poetry, plays, letters, fiction, and translations and mistranslations that we did from about 1963 until about 1968.

LF: What about the *Leon* poems?

RP: Those were poems—there were several small collections of them—by the crew I mentioned before: Michael Brownstein, Anne Waldman, Bill Berkson, Lewis Warsh, you and I, and others. Our great coup was to get Donald Hall to write an introduction for one of the collections, *The World of Leon*.

LF: That was the cherry on top.

RP: It was quite amazing that Don did that.

LF: And he was very good-natured about it.

RP: Extremely. The whole venture was a lot of fun.

LF: Our poem "Honeymooners" was part of that. It was a rarity, in that I wrote it without writing it.

RP: I remember sitting at the typewriter and you standing behind me, just over my shoulder—

LF: —verbally directing it.

RP: Yes. It's a poem about young newlyweds in a car, and it's funny because the scenario in the poem is actually reflected in the way the poem was written. That is to say, I was driving the car, but you were in the back seat, telling me how to drive, so to speak.

LF: I said, "Keep them going north" and "Have them stop and do something."

RP: Yes, you were directing as you were reading what I was typing. That *was* a rather unusual method.

LF: And what about our masterpiece, "Eternal Quest"? Remember that vanity press book by someone named Margaret Bruner? We replaced a couple of words in each of her poems. In one poem we changed *shawl* to *hotdog*, so it says, "I see my mother with a hotdog on her shoulders."

RP: It's something like the Oulipo N+7 procedure.

LF: But we made it up—

RP: —before we knew about Oulipo. About taking found texts and altering them: in college I got interested in books that weren't very literary, one of them called *Motor Maids across the Continent*. One day I went in for an office visit with Professor Kenneth Koch, and when he saw the book he took a pencil and altered a couple of words on the first page, which made the text surreal and hilarious. I was stunned, and I went home and rewrote the entire novel that way. Ted got inspired by it and rewrote a cowboy novel that way, his—

LF: —*Clear the Range*. I published it.

RP: So that was another way of collaborating with found material.

LF: Now, about *Bun* . . .

RP: In the summer of 1967 Tom Clark and I wrote a number of poems together in an open form, that is to say in which the lines weren't justified on the left and were different lengths, like Mallarmé's "A Throw of the Dice," or like what Charles Olson called an open field composition. It was published as *Bun*, with a cover design by Jim Dine.

LF: And your collaboration with Clark Coolidge, *Supernatural Overtones*?

RP: I thought it'd be interesting to write something with Clark because his style was so radically different from mine, and I so admired his work and he was a friend of mine—still is. We were talking about magazines that had pictures and captions and how funny it might be to reverse those two positions. That is, have a box with words in it, and the caption be a picture explaining the words. And from that evolved the idea of having—instead of a picture and words—how about words and words? Later Clark wrote words to go in the "box" and I wrote captions. But we didn't know what each other had written. Then we paired them up and moved them around and eliminated some and rewrote others.

LF: Clark's work was poems à la Clark, right?

RP: Yes, they are very Clark Coolidge.

LF: And your captions?

RP: They were rewrites of very brief synopses of B films in *TV Guide* magazine. So I was collaborating with *TV Guide* as well. The procedure was fun, but the result was what really mattered to me.

LF: Aram Saroyan and I did some "blind" collaborations like that. Each one consisted of a one-word title and a sentence, and we would trade off as to who would do what. Aram would think of a one-word title and I would think of a simple sentence, then he would *say* the title and I would *say* the sentence. Then we would write them down. Some of them were beautiful, and they "worked," in an odd way. For example,

WONDERFUL
The phone just rang.

RP: It sounds a bit like the short poems in Kenneth's poem "Collected Poems." Ted and I took off on that in a work called "Rusty Nails." I supplied the titles, he the short poems for them.

LF: What about mistranslation?

RP: A mistranslation comes from choosing a text in a foreign language and intentionally mistranslating it into English. Raymond Roussel had done something like this in his own work, taking a phrase of French and then "translating" it into another French phrase. I learned about Roussel's procedure from Kenneth Koch, in 1963, and then did some mistranslations of Max Jacob and Pierre Reverdy. So mistranslation is a sort of collaboration with the original text. It's an interesting process, but to me it's less interesting than "straight translation," which is much more intimate. In doing mistranslations, you're taking off, skimming quickly and spontaneously along the surface, but in straight translation you have to get *inside* the work, and that is much more collaborative.

LF: One of the things I've done with my college students is to write ideograms of classic Chinese poetry on the board. The students translate them, based on what the ideograms look like. Then I write the transliteration under the characters. So first they do it by sight, then by sound. And finally I add a literal translation, asking the students to improve it. So each student writes three poems that are "translations" of the same poem. And then I read them some published translations of the poems they've just worked on.

RP: That's an interesting assignment.

LF: Tell me about *Antlers in the Treetops*.

RP: That's a "novel" that Tom Veitch and I created out of what we called grist, as in "grist for the mill." We would take passages from anything we read and periodically mail groups of them to each other. And the person who received those pieces had to create a narrative based on them. In fact, using them only. So it was found material, very lightly rewritten, mainly by adding some transitions for continuity.

LF: So what exactly did you do with the original material?

RP: I laid the grist pieces out on a table and moved them around and eventually glued them down. Then I sent that chapter to Tom, along with new grist for him to use in making the next chapter. So it was a combination of found work, editing, and collaboration.

LF: Clark Coolidge and I hit upon a method that was both found and collaborative. We used magazines that had type laid out in columns side by side. It was mostly fiction, from the *New Yorker* or any oddball magazine—when Clark lived in New England we'd use *New England Magazine*—and we'd begin with a single line of type from one column, such as "With 4:50 left to play, the Packers" and then we'd find a continuation in another column: "took football lessons."

RP: So you're looking for at least the appearance of continuity.

LF: Yes. Originally Burroughs—we got the idea from Burroughs—did something different, he just ran it right across.

RP: We haven't talked about the collaborations of Bill Berkson and Frank O'Hara, particularly the Angelicus and Fidelio Fobb poems and other works they did and—

LF: *Hymns of Saint Bridget.*

RP: Those were very successful collaborations. I also wanted to mention the poems I've written with the Chinese poet Yu Jian. He and I were writing emails back and forth, but his messages, via a rather iffy computer translation program, made such funny and interesting mistakes that I proposed that we use the same method to write poems together. So we sent lines back and forth, ending up with about fifteen

poems. Later we wrote some poems together in person. In a sense these later were written blind, like the Surrealists' exquisite corpses, except there was no need to fold the paper over and hide anything because we didn't know what the other guy was saying anyway.

LF: There's a difference in collaborating by email rather working alongside another person.

RP: The physical presence of the other person makes a huge difference. It charges the air, and you get body language from it.

LF: Vocal nuances, too.

RP: Yes, on the spot. Like around 1964, the magazine *Poets at Le Métro*, which was written right on mimeograph stencils. And then the editor went away and printed them and brought them back the next week.

LF: Great idea.

RP: You could write anything you wanted in it.

LF: One thing we should mention is the found poetry of John Giorno. His were among the first found poems I knew of, along with Charles Reznikoff's.

RP: Before John's work, Charles Reznikoff's *Testimony* consisted of excerpts from nineteenth-century trial transcripts, which he arranged as poems. They're so moving and beautiful.

LF: They're serious.

RP: Oh very. But we should also tip our hats to *Lyrical Ballads* by Coleridge and Wordsworth. Although they didn't actually write poems together, they did create a book consisting of their respective works blended into one volume. I found that very inspiring. As a matter of fact, before Ted and I put together our *Bean Spasms*, I already had a file folder with our collaborative works in it, labeled *Lyrical Bullets*.

LF: There was something else about *Lyrical Ballads*... poets egging each other on...like Koch's poem *When the Sun Tries to Go On*, written simultaneously with O'Hara's *Second Avenue*. They would talk to each other on the phone every night, reading new excerpts from their works-in-progress. That's an interesting sort of collaboration, being in the process of writing individual poems almost as a way of competing. However, at the same time they were giving each other ideas. But to me, ideas are public domain.

RP: One of the things that occurred to me when I was starting to do these kind of works is that words don't really belong to anybody. Every word I'm saying right now I got from someone else. That's why the copyright page of *Antlers in the Treetops* says, "This book may be reproduced by anyone who wants to." The "author" is erased.

LF: One of my hobbyhorses is anonymity, which alters the whole experience of reading. The reader struggles to figure out who wrote it, and then, after finally giving up, sees it anew. Something fresh. Because the minute the name of an author comes up you're already prejudiced one way or another.

RP: I've had the same experience in museums. I see a painting across the room and I think, "Oh, that's a great de Kooning" and I get closer and it's a Joan Rivers or . . .

LF: Joan Rivers! Ha ha ha ha ha ha ha!

RP: That'd be great!

LF: Then you'd *really* be surprised.

RP: I think I just combined Joan Mitchell and Larry Rivers.

LF: Have you ever tried pretending that you wrote someone else's poem?

RP (*laughing*): I do that with every poem I read.

LF: You rewrite the poem in your head?

RP: Virtually, unless they're perfect.

LF: So you become a collaborative reader.

RP: In a sense, *all* reading is collaborative.

LF: Of course, but there are degrees of it.

RP: Reading specialists call it "transactional reading." For example, in the case of poetry you have the printed words, called "the text," and then you have the reader, and the *interaction* between those two creates what we call "the poem." It's all true—

LF: Of course it's true!

RP: —but it's interesting for only about five minutes.

LF: And this dialogue is a collaboration, too.

RP: What's for dinner?

Honeymooners
Larry Fagin & Ron Padgett

Great storms of rice
fly down on the happy couple
rushed to their convertible
idling at the curb

Scooting away
the folks get smaller
vanish in smoke
the tin cans clank under

Into Connecticut
the car proceeds
at the rate of 35 m.p.h.
an hour goes by

And 35 miles
the bride lights a Lucky
the lucky groom smiles
night comes

Now it is night
they put down the top
the bride falls asleep
the moon flies up

Through Massachusetts
and southeastern Vermont
parts of New Hampshire
and the great state of Maine

Their love is speeding
to a cozy inn
on the Canadian border
they stop and go in

Where they check in
as Mr. and Mrs.
they lie down on a bed
and give many kisses

Soon the sun peeps through
the lovers rise and shine
filled with air
they put on their clothes

NOTES

Introduction: This Leaving Out Business

13 *Note 1*: There were five first-generation New York School poets, and approximately forty poets who were, at one point or another, referred to as second generation, so it's not surprising that there was talk of a third—even a fourth—generation of New York School of poetry. Nonetheless, the further one moves away in time, the less the name seems appropriate; it seems more helpful to consider certain later poets as being influenced by the New York School Poets as one group among many, rather than their descendants.

14 "When I described . . ." Ron Padgett to James Schuyler, 26 May 1967. Schuyler Papers, Mandeville Collection, University of California, San Diego.

"Big Bang" Arnold Weinstein, in David Lehman, *The Last Avant-Garde: The Making of the New York School of Poets* (New York: Random House, 1999), 217.

15 "This leaving out business." John Ashbery, "The Skaters," *Rivers and Mountains*. Reprinted in *Ashbery: Collected Poems 1956-1987*, ed. Mark Ford (New York: The Library of America, 2008), 171.

"invent a sort of utopia . . ." George Schneeman in Alice Notley, "An Interview with George Schneeman," *Brilliant Corners: A Magazine of the Arts* (Winter 1978): 56.

"paints gravel poems." Frank O'Hara, "The Coronation Murder Mystery," *Amorous Nightmares of Delay: Selected Plays* (Baltimore and London: John Hopkins University Press, 1978), 147.

"Most reckless things . . . " John Ashbery, "The Invisible Avant-Garde" in *Reported Sightings: Art Chronicles 1957–1987*, ed. David Bergman (Cambridge MA: Harvard University Press, 1991), reprinted page 240.

16 "The poem is at last . . ." Frank O'Hara, "Personism: A Manifesto," in *The Collected Poems of Frank O'Hara*, ed. Donald Allen (Berkeley, CA: University of California Press, 1995), 498.

"I just happen to be here right now." Ron Padgett to James Schuyler, 26 May 1967. Schuyler Papers, Mandeville Collection, University of California, San Diego.

"There is light in there . . . " John Ashbery, "Just Walking Around," in *Selected Poems Penguin* (London: Penguin 1985), 306.

"People of the world—Relax!" Joe Brainard, "People of the World: Relax!" in *The Collected Writings of Joe Brainard*, ed. Ron Padgett (New York: Library of America, 2012), 207–14.

Note 2: This book generally focuses on collaborations completed up until the late 1970s, though there are exceptions (for instance, George Schneeman's later work with poets). In limiting the focus this way, I have regrettably excluded a number of wonderful collaborations by poets and artists, such as Rand's collaboration with Ashbery on *Heavenly Days* (2011). My reasoning is that as the New York School was largely a social circle, it makes sense to trace the creation and dissipation of that historically specific circle in particular.

I. In public, In Private

25 "[Denby] was just what I was waiting for . . ." Rudy Burckhardt in William Dunas, "Edwin Denby Remembered, Part 1," *Ballet Review* 12, no. 1 (1984): 12.

26 "Fifth Avenue millionaires' houses . . ." Ibid.

"instantaneous eye . . ." Edwin Denby in Joe Giordano, "The Cinema of Looking," *Jacket* 21 (February 2003), http://jacketmagazine.com/21/denb-giord.html.

"continuously insolent and alive . . ." Cyril Connolly, "Art on the American Horizon," *Horizon* (October 1947): 8, quoted in Jed Perl, *New Art City: Manhattan at Mid-Century* (New York: Vintage Books, 2007), 37.

28 From "those kids . . ." to "divorce . . ." Rudy Burckhardt, "Lotsaroots," in *Mobile Homes*, ed. Kenward Elmslie (Calais, VT: Z Press, 1979), 22–23.

"everybody drank coffee and nobody had shows." Denby, "The Thirties," reprinted page 46.

"through them [Denby and Burckhardt] I got interested in things . . ." Willem de Kooning in Gaby Rodgers, "Willem de Kooning: The Artist at 74," *LI: Newsday's Magazine for Long Island*, May 21 1978, quoted in John Elderfield, *De Kooning: A Retrospective* (New York: MoMA 2012), 55.

29 *Note 1*: The Museum of Modern Art's catalogue *De Kooning: A Retrospective* contains a discussion of de Kooning's recombinative sense of anatomy during this period. There is the clear sense he was using parts of his friends' bodies, along with figures from drawings and portraits by other artists. For instance, De Kooning's drawing *Self-Portrait with Imaginary Brother* (c. 1938) closely mirrors Burckhardt's portrait of de Kooning in his studio. In both images, two men stand side by side (de Kooning with his brother, and de Kooning with a painting of a man—another [imaginary] brother). Jed Perl also offers a fascinating discussion of the Le Nain brothers' influence on de Kooning in these same compositions in his book *New Art City*. And there are other ways Denby's body also made its way into de Kooning's art. *Seated Man (Clown)* (1941) depicts a circus performer of sorts—an extremely common painting theme in the 1930s—but the influence may have been a more personal one; as Burckhardt put it, Denby had been performing "comic modern dance" for ten years.

"more playful and tender . . ." Philip Lopate, *Rudy Burckhardt* (New York: Harry N. Abrams, 2004), 14.

"We were happy . . ." Denby, "The Thirties," reprinted page 44.

"Bill would constantly be pointing out things . . ." Elaine de Kooning in "Edwin Denby Remembered Part 1," 30.

"The sidewalk cracks . . ." Edwin Denby, "The Silence at Night," *Edwin Denby: The Complete Poems*, ed. Ron Padgett (New York: Random House, 1986), 10.

34 "The fine arts of painting and sculpture . . ." Page Smith, *Redeeming the Time: A People's History of the 1920s and the New Deal*, vol. 8 (New York: McGraw Hill, 1991), 789–813, quoted in Mark Stevens and Annalyn Swan, *De Kooning: An American Master* (New York: Alfred A. Knopf, 2006), 123.

"a Surrealist at that moment." John Ashbery, quoted in Lehman, *The Last Avant-Garde*, 120.

Note 2: As a phrase, "*la grande permission*" appears with some regularity in accounts of Surrealism's contribution to the New York School. The sentiment finds its fullest expression in John Ashbery's interview of Henry Michaux for *ARTnews* in March 1961. There's the distinct sense Ashbery approves of Michaux's position: "I love the work of Ernst and Klee, but they alone wouldn't have been enough to start me painting seriously. I admire the Americans less—Pollock and Tobey—but they created a climate in which I could express myself. They are instigators. They gave me *la grande permission*—yes, yes, that's very good—*la grande permission*. Just as one values the Surrealists less for what they wrote than for the permission they gave everybody to write whatever comes into their heads." (Reprinted in Ashbery, *Reported Sightings*, 398)

"For a full season . . . " Philip Pavia, *Club Without Walls: Selections from the Journals of Philip Pavia*, ed. Natalie Edgar (New York: Midmarch Arts Press, 2007), 13–14.

35 "the paranoia of surrealism . . ." Denby, "The Thirties," reprinted page 45.

"mimetic soup." Douglas Crase, "A Hidden History of the Avant-Garde," *Painters & Poets: Tibor De Nagy Gallery* (New York: Tibor de Nagy, 2011), n.p.

"creative principle." Robert Motherwell in Paul Cummings, "Oral History Interview with Robert Motherwell," 1971 November 24–1974 May 1, Archives of American Art, Smithsonian Institution.

Note 3: It's worth quoting Robert Motherwell at length here on this "creative principle": "You see, what I realized was that Americans potentially could paint like angels but that there was no creative principle around, so that everybody who liked modern art was copying it. Gorky was copying Picasso. Pollock was copying Picasso. De Kooning was copying Picasso. I mean I say this unqualifiedly. I was painting French intimate pictures or whatever. And all we needed was a creative principle, I mean something that would mobilize this capacity to paint in a creative way, and that's what Europe had that we hadn't had; we had always followed in their wake." (Paul Cummins, "Oral History Interview with Robert Motherwell," 1971 November 24–1974 May 1, Archives of American Art, Smithsonian Institution.)

"brusque kind of dialectical thinking." Jed Perl, *New Art City*, 152.

"the arguments went in a see-saw pattern . . ." Philip Pavia, "The Unwanted Title: Abstract Expressionism," *It Is* (Spring 1960): 9–10.

36 "a collection of extreme individuals . . ." Robert Motherwell, "The School of New York," preface to *Seventeen Modern American Painters* (1951) in *The Collected Writings of Robert Motherwell*, ed. Stephanie Terenzio (Berkeley, CA: University of California Press, 1992), 84.

Note 4: The name "New York School" was also meant as a double joke of sorts; as Denby later explained, "The painters who went to the Cedar had more or less coined the phrase 'New York School' in opposition to the School of Paris (which also originated as a joke in opposition to the School of Florence and the School of Venice)." (Anne Waldman, "Paraphrase of Edwin Denby Speaking on the 'New York School,'" *Homage to Frank O'Hara*, ed. Bill Berkson and Joe LeSueur (Bolinas: Big Sky, 1978), 32.

Note 5: In his essay, Motherwell identified the School of New York as consisting of Willem de Kooning, William Baziotes, Lee Gatch, Adolph Gottlieb, Morris Graves, Hans Hofmann, Roberto Matta, Jackson Pollock, Richard Pousette-Dart, Ad Reinhardt, Mark Rothko, Theodoros Stamos, Hedda Sterne, Clyfford Still, Mark Tobey, Bradley Walker Tomlin, and himself. This list would surprise most of those familiar with these painters, and it is possible that the composition of the group was a fluke of sorts; when the phrase first appeared in print, it was for a catalog for a show in Los Angeles and Motherwell may not have been entirely responsible for selecting those exhibited. That two of the painters on the list—Graves and Tobey—were Northwest Pacific Coast painters should also indicate how "loose" the name could be. See Motherwell's two lectures "The New York School," in *The Collected Writings of*

Robert Motherwell, 76–81, and "Reflections on Painting Now," in *The Collected Writings of Robert Motherwell*, 65–69.

"During the war years . . ." Stevens and Swan *De Kooning: An American Master*, 189.

"sharply, like a choreographer . . ." Edwin Denby, *Willem de Kooning* (Madras and New York: Hanuman Books, 1988), 17.

"wildly." Rudy Burckhardt and Simon Pettet, *Talking Pictures: The Photography of Rudy Burckhardt* (Cambridge, MA: Zoland Books, 1994), 34.

"the reelings-home down . . ." Connolly, "Art on the American Horizon," quoted in Perl, *New Art City*, 37.

"It is disastrous to name ourselves." De Kooning, in Robert Motherwell and Ad Reinhart, *Modern Artists in America* (New York: Wittenborn Schultz, 1951), 22.

"single center of action." Denby, "The Thirties," reprinted page 45.

"Vell, these people . . ." De Kooning, quoted by Rudy Burckhardt in Stevens and Swan, *De Kooning: An American Master*, 133.

From "cliché about downtown painting . . ." Denby, "The Thirties," reprinted page 46.

38 "Later I saw . . ." Ibid., 44.

From "scant critical response . . ." to "shifting tones." Ron Padgett, introduction to *Edwin Denby: The Complete Poems*, xix.

"unsung for so long . . ." John Ashbery, "The Case of The Reluctant Polymath," *New York Magazine* (January 1980): 64.

39 "private life goes on regardless." Denby, "The Thirties," reprinted page 46.

Note 6: More research ought to be done on the experience of war for many members of the New York School; in most accounts of these poets' and painters' lives, their time fighting remains offstage, briefly noted but never discussed. To give a brief indication of the range of experiences: Burckhardt was drafted in 1941 and spent three years as a Signal Corps photographer, mostly in Trinidad and the South, before being discharged in 1944. Kenneth Koch was drafted at the age of eighteen in 1943, and sent to the Pacific as a rifleman in the Ninety-Sixth Infantry Division. On his way to Okinawa, he contracted hepatitis and spent the rest of the war as a clerk-typist in the Philippines—"possibly the only two-finger typist and probably the only soldier in the Philippines with a subscription to *View*" as he once noted (David Lehman, *The Last Avant-Garde*, 217). Schuyler enlisted in 1943, training as a sonar man in Key West—only a year before O'Hara began precisely the same training in Key West. Schuyler was assigned to the North Atlantic, but in 1944 he failed to return from shore leave in New York. At

his hearing, his homosexuality was revealed, and he was later discharged. O'Hara was sent to the Pacific on the USS *Nicholas*, initially assigned as first sonar man and later to spot enemy planes.

II. Modernism in the Lyrical Laconic

51 From "Jane is filled with excitement . . ." to "The conversation is joy . . ." Kenneth Koch, "A Time Zone" in *Selected Poems*, ed. Padgett (New York: The Library of America, 2007), 121.

"sometimes visitor." Ibid., 119.

"as a pilgrim comes to Mecca." Nell Blaine in Hofmann Student Dossiers, Museum of Modern Art Library, quoted in Perl, *New Art City*, 8.

Note 1: Hans Hofmann had painted and taught in Munich and Paris before moving to New York in 1933. Though there were other painting schools in New York at this time, particularly The Subjects of the Artist School, which was later known as Studio 35, and other teachers in Manhattan like Amédée Ozenfant (whom Burckhardt studied under), Hofmann was by far the most central figure for younger painters in downtown New York, many of whom had chosen to study art under the GI Bill of Rights and its offer of educational assistance. Those who studied at his West Eighth Street School included Larry Rivers, Grace Hartigan, Alfred Leslie, Jane Freilicher, Joan Mitchell, Red Grooms, Mike Goldberg, and Nell Blaine. Hofmann's painting terms—particularly the phrase "push-pull"—became very well known, and were often the source of in-jokes. For instance, in a letter from Frank O'Hara to Larry Rivers in 1957, O'Hara wrote: "Now please tell me if you think these poems are filled with disgusting self-pity, if there are "holes" in them, if the surface isn't kept "up" if there are recognizable images, if they show nostalgia for the avant-garde, or if they don't have "push" and "pull," and I'll keep working on them until each is a foot high. Yours in action art, Frank." (Frank O'Hara to Larry Rivers, 8 April 1957, Allen Collection of Frank O'Hara Letters, Thomas J. Dodd Research Center, University of Connecticut Libraries.)

"our Joan of Arc." Jane Freilicher, quoted in Lehman, *The Last Avant-Garde*, 62.

51 [tell] "us what Art was all about . . ." Larry Rivers, *What Did I Do? The Unauthorized Autobiography*, with Arnold Weinstein (New York: Thunder's Mouth Press, 1992), 109.

"always first on a new kick . . ." Edith Schloss, "Nell Blaine: From Richmond, Va., to Athens, to the Future," *Village Voice*, December 9 1959, quoted in Martica Swain, *Nell Blaine: Her Art and Life* (New York: Hudson Hills Press, 1998), 24.

"I am inspired by these painters . . ." Koch, "A Time Zone," 123.

52 "afloat with ironies . . ." Ibid., 121.

Note 2: There's a real-life parallel here; in his autobiography *What Did I Do?* Rivers also notes (without referring to *Mounting Tension*) that Jack Freilicher gave him a book on modern art. Freilicher and Rivers had an affair, which ended in 1951, when Rivers slit his wrists, despairing that Freilicher was growing closer to another man, Joe Hazan (whom she married in 1957). Rivers gives an account of his suicide attempt in his autobiography *What Did I Do?* Immediately after cutting himself, he rang Frank O'Hara (whom he knew had just been visiting with Freilicher), and O'Hara took him to the hospital. Rivers convalesced at Fairfield Porter's home in Southampton, where Porter painted him with his bandaged wrists.

53 "the arts aspire . . ." Robert Motherwell quoted this line from Baudelaire in "Preliminary Notice to Marcel Raymond: *From Baudelaire to Surrealism*," (1949) in Motherwell, *Collected Writings*, 69.

"the cresting of the 'heroic' period . . ." Ashbery, "Jane Freilicher," reprinted page 84.

"the greatest living painter in the United States." *Life*, August 8, 1949, 42.

54 "Image in Poetry and Painting" and "The Figure in Painting". See "Club Panels" in Philip Pavia, *Club Without Walls*, 158–78

From "like pressing your face into wet grass . . ." to "avoided rather self-consciously . . ." O'Hara "Larry Rivers: A Memoir," reprinted page 78.

From "coffee and a brief honest talk . . ." to "I'm going to grapple . . ." Grace Hartigan, *The Journals of Grace Hartigan 1951–55* (Syracuse, NY: Syracuse University Press, 2009), p56–7.

"ageless, hulking Irishman . . ." James Merrill, *A Different Person* (New York: Knopf, 1993), 253.

Note 3: In 1944, John Bernard Myers moved to New York to becoming the managing editor of Charles Henri Ford and Parker Tyler's *View* magazine. When the magazine folded in 1947, Myers founded a marionette company with Tibor de Nagy, and gained the support of a number of artists, including Jackson Pollock, Willem de Kooning, Franz Kline, and Kurt Seligmann (all of whom contributed handmade puppets) but the company was forced to close after a citywide polio outbreak caused a ban on large gatherings of children.

57 a "roving pack." Nell Blaine, quoted in Swain, *Nell Blaine: Her Art and Life*, 45.

"Everyone felt this kind of energy . . ." Jane Freilicher, quoted in Brad Gooch, *City Poet: The Life and Times of Frank O'Hara* (New York: HarperCollins, 1993), 191.

"one thing lacking . . ." John Ashbery, "Jane Freilicher," reprinted page 84.

"I think we have a new contender." Kenneth Koch, quoted in Ron Padgett, introduction to *Kenneth Koch: Selected Poems*, xv.

"perfectly Frank." Ted Berrigan, quoted in Lehman, *The Last Avant-Garde*, 73. The phrase is from Berrigan's poem "Frank O'Hara" ("he will never be less than perfectly frank, / listening, completely interested in whatever there may / be to hear . . .") in *The Collected Poems of Ted Berrigan*, ed. Alice Notley and Anselm Berrigan (Berkeley, CA: University of California Press, 2005), 381.

"painters' world . . ." James Schuyler, "Poet and Painter Overture" (1959), in *The New American Poetry 1945–1960*, ed. Donald Allen (Berkeley, CA: University of California Press, 1999), 418.

Note 4: O'Hara echoed this sentiment in his memoir of Rivers, when he wrote, "In the San Remo we argued and gossiped: in the Cedar we often wrote poems while listening to the painters argue and gossip. So far as I know nobody painted in the San Remo while they listened to the writers argue" (O'Hara, "Larry Rivers: A Memoir" reprinted page 76). Yet it should be noted that in his introduction to O'Hara's *Collected Poems* in 1972, Ashbery observed in a footnote that he and Schuyler disagreed about the nature of Frank O'Hara's attachment to the art world; Schuyler thought Ashbery was "hampered by a feeling of disapproval, or irritation . . . for Frank's exaltation of the New York painters as the climax of human creativity . . ." (Ashbery, "Editor's Note," O'Hara, *Collected Poems*, ix). Regardless of this difference of opinion about O'Hara, it was clear, in general, that the art world was where the energy seemed to be. For instance, Ashbery, in conversation with Richard Kostelanetz, later commented, "American painting seemed the most exciting art around, American poetry was very traditional at that time, and there was no modern poetry in the sense there was modern painting. So one got one's inspiration and ideas from watching the experiments of others." (Ashbery, quoted in Kostelanetz, "How to Be a Difficult Poet," *New York Times Magazine*, May 23, 1976, 19–20). Yet the poets' attention also had a distinct effect on some of the painters. For instance, on meeting Schuyler, Ashbery, O'Hara, Koch, and Guest, Fairfield Porter took up writing poetry again, later commenting, "I started to do that [write poetry] because I met all the poets who were published by the Tibor de Nagy gallery and they used to meet at the Cedar Bar and pull something out of

their coat pocket and show them to each other. And I envied that very much. I thought I'd like to do that too. So I tried to see if I could and for a little while I could." (Paul Cummings, "Oral History Interview with Fairfield Porter," June 6 1968, Archives of American Art, Smithsonian Institution.)

"good-omen feeling about him." Willem De Kooning, quoted in Peter Schjeldahl, "Frank O'Hara: 'He Made Things & People Sacred" in *Homage to Frank O'Hara*, 141.

"professional fan . . ." Larry Rivers, quoted in Gooch, *City Poet*, 206.

"He talked a lot of artists . . ." Ibid., 231.

"everybody's catalyst." Edwin Denby, quoted in John Gruen, *The Party's Over Now: Reminiscences of the Fifties—New York's Artists, Writers, Musicians, and Their Friends* (Wainscott, NY: Pushcart, 1989), 166.

"central switchboard" Rivers, *What Did I Do?*, 235. In phonic turn, O'Hara referred to Rivers as a "demented telephone. Nobody knew whether they wanted it in the library, the kitchen or the toilet, but it was electric." O'Hara, "Larry Rivers: A Memoir," reprinted page 78.

"other things to attend to . . ." Ashbery "Jane Freilicher," reprinted page 84.

Note 5: It should be noted that at Harvard, Ashbery and O'Hara had already gathered together a wide range of cultural influences, both high and low. They liked recherché literature (Ronald Firbank, Ivy Compton-Burnett), comics, Hollywood and French movies, poet John Wheelwright, author Henry Green, modern French and Russian poetry, and modern music (John Cage, Arnold Schoenberg, Erik Satie, and Francis Poulenc). Their move to New York City further widened their interest, but it did not establish the characteristic of its breadth.

"the Tarzans, each and every one of you . . ." Frank O'Hara, "To the Film Industry in Crisis," *Collected Poems*, 232.

"much more / Interested in gossip . . ." Koch, "Fate" in Koch, *The Collected Poems of Kenneth Koch*, (New York: Alfred A. Knopf, 2005), 307.

59 "It was a terribly depressing period . . ." Ashbery, quoted in Gooch, *City Poet*, 190.

From "was a series of dissonant chords, mostly loud . . ." to "profoundly refreshed."Ashbery, quoted in Richard Kostelanetz, "John Ashbery" (1976) in *The Old Poetries and the New* (Ann Arbor, MI: University of Michigan Press, 1981), 93.

"felt that art is already serious enough . . ." Ashbery, "A Reminiscence" in *Homage to Frank O'Hara*, 20.

"Schuyler had passed one test . . ." Kenneth Koch, "James Schuyler (Very Briefly)," *Denver Quarterly* 26, no. 4 (1992): 21.

Note 6: Schuyler's short play about Freilicher, *Presenting Jane*, was filmed by John LaTouche in the summer of 1952, when they all rented a cottage in East Hampton on Long Island. Missing for decades, the footage has very recently been found, and it features Freilicher walking on (or in) very shallow water. Other gifts of attention by the poets followed. That same summer, Rivers was also staying out at Southampton, and he wrote a paean to Freilicher—an eight-page eclogue in which Ashbery, Koch, and Rivers take turns praising Freilicher, who "fears beauty like a nun," whose "silent power is rooted in reason," who is "blessed with a brain"—a "queen who holds her court." The last line in the poem is Freilicher's voice, calling out to them: "John, Kenneth, Larry, / I have the coffee set." There are many unpublished poems like Rivers's in Freilicher's papers, which are held at the Houghton Library at Harvard University. O'Hara, for instance, wrote a poem-portrait that was literally shaped to resemble her face. The massed intensity of these poems—no matter how much they verge on doggerel (or perhaps because they do so)—is the most persuasive indication of Freilicher's effect on others. Examples of Freilicher's wit were passed on. A visit with the composer Virgil Thomson was like being "locked in the office with the school principal." Robert Motherwell and Helen Frankenthaler, having married, were now "the Irene and Vernon Castle of Abstract Expressionism." (O'Hara, quoted in Lehman, *The Last Avant-Garde*, 59.) Freilicher's letters were frequently passed around; as Ashbery noted, they were considered "required reading in my set." (John Ashbery to Jane Freilicher, 1960 September 8, Freilicher Papers, Houghton Library, Harvard University.) As Ashbery later wrote to the poet Harry Mathews, whom he met in Paris in 1956, "she is probably my favorite person in the world. Also everything she says is screamingly funny, although she doesn't seem to intend it that way and I am always getting her in hot water by laughing at her gags in the presence of people who don't seem to have noticed any humor going on." (John Ashbery to Harry Mathews, 29 July 1960, Mathews Papers, Van Pelt Library, University of Pennsylvania.)

Note 7: The first seven Tibor de Nagy editions clearly followed the tradition of the *livre d'artiste*; that of the pairing of artist and poet, without necessitating a direct collaboration. Some of these pairings echoed particular friendships, as Myers noted in his memoir, *Tracking the Marvelous*: "Grace Hartigan and Jane Freilicher divided O'Hara and Ashbery between them. Nell Blaine latched on to Koch. Helen Frankenthaler and Mary Abbott took up with Barbara Guest, as did Robert

Goodnough. Rivers's claims on O'Hara were increasingly more possessive. O'Hara in turn took a shine to Pollock, Kline, Norman Bluhm, and de Kooning, glorifying them in prose and verse: No gathering was complete without the poets" (Myers, *Tracking the Marvelous: A Life in the New York Art World* [New York: Random House, 1981],147). That these friendships seem conceived somewhat territorially may be more of an indication of Myers's temperament than a quality of these friendships. Other de Nagy edition pairings—like Gorchov and Elmslie for example—were not as "personal."

60 *Note 8*: It is a mistake to assume that the Tibor de Nagy publishing semiotic suppressed a more directly collaborative *esprit*. For instance, the painter Nell Blaine played a large role in the design of her book with Koch, *Poems by Kenneth Koch, Prints by Nell Blaine*, and she also designed Ashbery's *Turandot and Other Poems*, with prints by Freilicher.

"There was a glorious halo . . ." Rivers "Life among the Stones," *Location Magazine* 1 (1963): 90.

"a sympathetic vibration." Jane Freilicher, quoted in Gerrit Henry, "Jane Freilicher and the Real Thing," *ARTnews* (January 1985): 83.

"worried . . ." John Bernard Myers, *Tracking the Marvelous*, 147.

"is repeated ten times . . ." Koch, "A Time Zone," 118.

Note 9: In 1949, at Harvard, O'Hara had collaborated with his classmate George Montgomery, but it wasn't until 1952 that it became a (New York School) group practice; the earliest written collaboration between the New York School poets seems to be the poem "Nina Sestina," written by Koch and O'Hara on a car ride in 1952.

Note 10: Collaboration went hand in hand with other forms of language experimentation. Collage and mistranslation were two ways to reinvigorate language and dislocate expected sentence structures. Koch had discovered the French writer Raymond Roussel on a trip to Paris in 1950, and introduced Roussel and his use of word play to the other poets. In general, many of their poetic influences hailed from Europe; a roll call of influential poets would include—in addition to William Carlos Williams, Elizabeth Bishop, Wystan Auden and Walt Whitman—Guillaume Apollinaire, René Char, Max Jacob, Federico García Lorca, Stéphane Mallarmé, Vladimir Mayakovsky, Boris Pasternak, Pierre Reverdy, and Arthur Rimbaud.

"I, like John A. . . ." James Schuyler to Clark Coolidge, in *Just the Thing: Selected Letters of James Schuyler 1951–1991*, ed. William Corbett (New York: Turtle Point Press, 2004), 382.

62 "John . . . when he was producing us . . ." O'Hara, quoted in Gooch, *City Poet*, 232.

Note 11: This mixed success, for instance, can be inferred from James Merrill's observation that "the set [by Kresch]—a café table in Venice juxtaposed with the stern of a fishing boat in the Gulf Stream—looked messy and abstract expressionist rather than spare and ambivalent." Merrill, *A Different Person: A Memoir* (New York: Knopf, 1993), 254. To John Gruen, Machiz confessed "that these intellectual plays were not his cup of tea, that he was cut out to direct Noel Coward." Gruen, *The Party's Over Now*, 90.

"I dislike being fifty miles . . ." John Ashbery and James Schuyler, *A Nest of Ninnies* (New Jersey: Ecco Press, 1969), 1.

"*Jimmy Schuyler is visiting Mike . . .*" O'Hara, *Amorous Nightmares of Delay*, 145. In *The Coronation Murder Mystery*, a la *Mounting Tension*, there is also a psychiatrist, this time played by Koch. I'd like to thank Mark Silverberg for bringing *The Coronation Murder Mystery* to my attention in my introduction to the anthology *New York School Collaborations: The Color of Vowels*, ed. Mark Silverberg (New York: Palgrave Macmillan, 2013).

"makes me feel as though . . ." Grace Hartigan, *The Journals of Grace Hartigan 1951–55*, 40. Hartigan and O'Hara's collaborative involvement also included an essay they worked on together about her painting, which O'Hara later transformed into an eclogue, "Grace and George." On reading the final version, Hartigan wrote to O'Hara, "It's so wonderful to have that written—I never know how to think about my past work before, and now it's all clear & stated & I can forget about it." (Hartigan, "November 12, 1952," *The Journals of Grace Hartigan 1951–55*), 56.

"I wanted to do something . . ." Rivers, *What Did I Do?*, 314.

66 "Perhaps you would like . . ." Frank O'Hara to Larry Rivers, dated "1953 NYC Autumn Thursday night," Allen Collection of Frank O'Hara Letters, Thomas J. Dodd Research Center, University of Connecticut.

Note 12: That a painter *would* have something to say to a poet (and vice versa) was a thought very much in the air. For instance: in 1951, the poet Wallace Stevens gave a lecture at the Museum of Modern Art on the special relationship between poetry and painting (the closeness of which was not necessarily shared with every other art form), noting, "I suppose, therefore, that it would be possible to study poetry by studying painting or that one could become a painter after one had become a poet, not to speak of carrying on in both métiers at once, with the economy of genius, as Blake did." If one could not carry on in both métiers at once, one could at least aspire to issuing insightful *aperçus* about the relationship between the sister arts. (Stevens, "The Relations

between Poetry and Painting" (1951), reprinted in *Poets on Painters: Essays on the Art of Painting by Twentieth-Century Poets*, ed. J. D. McClatchy [Berkeley, CA: University of California Press, 1988], 111–12.)

67 "looks at paintings . . ." Fairfield Porter, "Wyndham Lewis on Picasso: A Letter to the 'Kenyon Review'" (1941) reprinted in Porter, *Art in Its Own Terms: Selected Criticism 1935–1975*, ed. Rackstraw Downes, (1979; repr., Boston: MFA Publications, 2008), 239. Porter also wrote the first essay on Willem de Kooning, though the *Partisan Review* declined to publish his article about the then-unknown painter.

From "professional" to "more general way." Edwin Denby, "Dancers, Buildings and People in the Streets" in *Dance Writings*, ed. Robert Cornfield and William MacKay (Gainesville, FL: University of Florida, 1986), 552.

"sensitive, unbiased and articulate observers of art." John Ashbery to Clark Holzmann, 1985, Ashbery Papers, Houghton Library, Harvard University.

Note 13: The routine of writing short reviews (as well as long articles) was an act of compression akin to writing a poem. Schuyler sometimes wrote his reviews for *ARTnews* in verse, then removed the line breaks. (Carl Little, "An Interview with James Schuyler," *Agni* 37 [1993]: 152–82.) Writing these reviews also encouraged a work ethic that resisted the idea of writer's block. Ashbery later commented about the work ethic of writing art criticism in this way: "When I was writing at the *Herald Tribune*, I had to produce an article every week, rain or shine, exhibitions or no exhibitions, and the mere fact of having to sit down at the typewriter once a week and grind out several pages of copy possibly helped in the sense that it eventually dawned on me that I could sit down the same way with a poem and type if I wanted to." (Janet Bloom and Robert Losada, "Craft Interview with John Ashbery," *New York Quarterly* 9 [1972]: 13, 30.)

"De Kooning's landscapey . . ." Koch, "A Time Zone," 130–31.

"We inspired each other . . ." Kenneth Koch, "An Interview with Jordan Davis," *The Art of Poetry, Poems, Parodies, Interviews, Essays, and Other Words* (Ann Arbor, MI: University of Michigan Press, 1996), 213.

Note 14: Of course, during the 1940s and '50s, other poets and writers were meeting each other in New York: namely, Allen Ginsberg, Jack Kerouac, William S. Burroughs, and Gregory Corso, (though it wasn't until after Ginsberg moved to California in the 1950s that the name "Beat" was widely affixed to their poetry). There were also poets reading in New York like Charles Olson, Robert Creeley,

and Robert Duncan coming out of Black Mountain College. These poets had been publishing small-press books since the early 1940s, but the sense that these poets "belonged" to distinct groups was not as distinct then as it is now. And though they were being published in journals like *Evergreen Review*, the New York School poets had not even been named as such at this point; they were more a group of friends who had a particular taste in French and Russian poetry and who had close ties to the art world in New York.

III. Go on Your Nerve

95 "It's my lunch hour . . ." Frank O'Hara, "A Step Away from Them," *Collected Poems*, 258.

"everything honks" Ibid.

[Cage was, as Morton Feldman later noted . . .] See, for instance, Feldman's essay "Sound, Noise, Varèse, Boulez" in his book *Give My Regards to Eighth Street: Collected Writings of Morton Feldman*, Ed. B.H. Friedman (Cambridge MA: Exact Change, 2000) 1–2.

"I consider laughter preferable to tears." John Cage, *I've Got A Secret*, January 1960. TV SHOW TK.

[During this stint . . .] Clark Coolidge, interview with author, June 26, 2013.

98 *Note 1*: By 1959, "Beat" had become a familiar shorthand for bohemianism, drug taking, and liberal sexual relations and had been popularized to the extent that that year, *Playboy* magazine published Kerouac's 1958 address to students at Brandeis University on the origins of the Beat generation. In these years, the *Village Voice* photographer Fred McDarrah, who had photographed many members of the New York School, posted an ad in the *Voice* that offered to rent Beatniks out for parties, "Badly Groomed But Brilliant (male and female)." The ease with which Koch parodied the notion of jazz accompanying poetry at the Five Spot indicates how much the Beats influenced the performance of poetry in New York. As Ashbery later noted, "The 'Beat Revolution' happened to take place . . . [living in Paris] and when I got back [in 1965] —although I wasn't aware of it—everyone was giving poetry readings everywhere. I was astonished at being asked to give one, until I realized I was one of about a hundred poets one could have heard that night in New York." (Ashbery, quoted in Kane, *All Poets Welcome*, xvii.)

"Man . . . your poetry is weird." Lehman, *The Last Avant-Garde*, 198. As told to Lehman by Kenneth Koch and Larry Rivers.

From "more intellectual and cerebral . . ." to "Edwin was like my graduate school." In Alex Katz, "Edwin Denby Remembered—Part II," ed. William Dunas, *Ballet Review* 1, no. 2 (1984): 22, 25. Katz's

memories of meeting Denby are also described in Katz, *Invented Symbols* (Germany: Cantz Verlag, 1997), 54–55.

"lots of favorable comment . . ." Frank O'Hara to Vincent Warren, 15 February 1962, Allen Collection of Frank O'Hara Letters, Thomas J. Dodd Research Center, University of Connecticut Libraries. Of this exhibition of Katz's cut-outs, O'Hara also observed, "And everyone went around behind Maxine [Groffksy]'s to see if she had a bathing suit on in the rear, and were rewarded by her not."

"Blue air, fresh air . . ." Kenneth Koch, "Fresh Air," *The Collected Poems of Kenneth Koch* (New York: Knopf, 2005), 125–6.

"The louder the better . . ." John Ashbery, quoted in Lehman, *The Last Avant-Garde*, 211.

From "Don't just paint . . ." to "If you are interested in schools . . ." Frank O'Hara and Larry Rivers, "How to Proceed in the Arts" (1961), in O'Hara, *Art Chronicles 1954–1966* (New York: George Braziller, 1990), 92–95.

"in our own discursive way . . ." Frank O'Hara to Larry Rivers, 27 June 1953, Allen Collection of Frank O'Hara Letters, Thomas J. Dodd Research Center, University of Connecticut Libraries.

101 "on your nerve." O'Hara, "Personism: A Manifesto," *Collected Poems*, 498.

"Youth wants to burn the museums . . ." "How to Proceed in the Arts," reprinted page 120.

"life is beginning [to] resemble a game of Monopoly . . ." John Ashbery to Harry Mathews, 12 April 1961, Harry Mathews Papers, Van Pelt Library, University of Pennsylvania.

"more / more drives to Bear Mountain . . ." Frank O'Hara, "Poem Read at Joan Mitchell's," *Collected Poems*, 266.

"This poem goes on . . ." Ibid.

102 *Note 2*: There is a concordance (or perhaps a congruence), between the series of O'Hara's friends' deaths—Bunny Lang's, Jackson Pollock's, and John LaTouche's, in the summer of 1956—and the type of poems O'Hara began to write that summer, which he later described as his "I do this I do that" poems. For instance, it was only a week after Pollock's death that O'Hara wrote "A Step Away from Them." In celebrating the moment, the poem is intensely alive, but such instantaneity also anticipates the moment ending. The penultimate stanza refers to his friends' deaths, and by name. O'Hara was well aware that some readers would recognize Pollock's name, but few would recognize the others'. Yet "knowing" was not exactly the point. It was more a recognition of the tone that a set of "minute particulars" (as he put it in "Personism") could establish, the undercurrent of emotion that

could be suggested by simply naming another. In his statement for Donald Allen's anthology *The New American Poetry*, O'Hara commented on this feature of his poetry: "It may be that poetry makes life's nebulous events tangible to me and restores their detail; or conversely, that poetry brings forth the intangible quality of incidents which are all too concrete and circumstantial." (O'Hara, "Statement for *The New American Poetry*," *Collected Poems*, 500). Incidentally, O'Hara wrote "Personism" as statement of poetics for Allen's anthology, but Allen thought it too frivolous and turned it down. LeRoi Jones promptly published "Personism" alongside "Personal Poem" in *Yugen*.)

From "bathe in the everyday" to "*to write for them about them personally*." Paul Goodman, "Advance-Guard Writing, 1900–1950," *The Kenyon Review* 13, no. 3 (Summer 1951): 375–76.

"It is really lucid . . ." Frank O'Hara to Jane Freilicher, 1 August 1951, Allen Collection of Frank O'Hara Letters, Thomas J. Dodd Research Center, University of Connecticut Libraries.

From "at the risk of sounding like . . ." to "one of its minimal aspects . . ." Frank O'Hara in "Personism: A Manifesto," *Collected Poems*, 498–99.

"The poem is at last . . ." Ibid., 499.

Note 3: We tend to think that a work of art should stand alone, capable of a meaning quite separate from the conditions of its creation. Yet when we look at a collaboration like *Stones*, we sense the depth of Rivers and O'Hara's friendship because the relationship between image and text is *so* elliptical. Ironically, the fragmentary nature of this work guards against our own sentimentality, our desire to gain the inside track on a friendship, rather than consider *Stones* as a work of art in its own right. We cannot reconstruct O'Hara and Rivers's friendship from this text, but what we can reconstruct is Paul Goodman's sense of the occasion.

104 "This Siberian lady . . ." Rivers, "Life Among the Stones," *Location Magazine*, 92.

[Consider, for instance, his date book . . .] The details of Frank O'Hara's datebook are described in Lehman, *The Last Avant-Garde*, 197. Lehman was lent the datebook by Kenneth Koch in 1995.

"homage." *ARTnews* (December 1959), quoted in Gooch, *City Poet*, 342.

"make an analogy . . ." Bill Berkson, "A New York Beginner," *The Sweet Singer of Modernism and Other Art Writings 1985–2003* (Jamestown, RI: Qua Books, 2003), 257.

107 "keeping New York time." Ibid., 255.

"Going to see a new French movie . . ." Ibid., 260.

"An exchange between the various arts . . ." B. H. Friedman, *School of New York: Some Younger Artists* (New York: Grove Press; London: Evergreen Books, 1959), 11.

Note 4: The phrase "School of New York" was turning out to be strikingly malleable. According to B. H. Friedman in his introduction to *School of New York: Some Younger Artists*, the title also referred to the generation of artists who had flocked to New York City in the 1940s and '50s. Any sense of the "double-joke" (as Denby had put it) in the phrase had now been lost; Friedman, in his introduction, hoped the book would "give the label 'School of New York' a meaning as significant as 'School of Paris' was in the twenties" (11). Friedman's propensity to take the phrase literally is perhaps not so surprising; by 1959, it was clear that over the course of a decade, these younger artists *had* schooled themselves: under Hans Hofmann, at the Club, and as reviewers for *ARTnews*. These artists' common philosophical position, Friedman noted, was an "improved existentialism" (7). Of the eleven artists Friedman selected, five were represented by the Tibor de Nagy Gallery (Frankenthaler, Goodnough, Hartigan, Leslie, and Rivers), and Porter was commissioned to write a text (along with Schuyler, O'Hara, and Guest). (B. H Friedman, *School of New York: Some Younger Artists*.)

Note 5: B. H. Friedman's book is also revealing in the sense that it looks so definitively backward; namely, he included both Jasper Johns and Robert Rauschenberg in the book. The recognition of Pop art as an ascendant zeitgeist was at least two years away, and at this time, Johns and Rauschenberg were both understood within the context of a painterly action and a commitment to process.

"Joan: We'll open with a question . . ." Frank O'Hara, Elaine de Kooning, Norman Bluhm, Michael Goldberg, and Joan Mitchell in "5 Participants in a Hearsay Panel," *It Is*, no. 3 (Winter / Spring 1959); p59–62; reprinted in O'Hara, *Art Chronicles*, 149–50.

109 "very political, and very much . . ." Gooch, *City Poet*, 338.

"That's more than you ever did for it." Frank O'Hara to John Ashbery, 16 March 1959, Allen Collection of Frank O'Hara Letters, Thomas J. Dodd Research Center, University of Connecticut Libraries, reprinted page 129.

Note 6: Allen's anthology *The New American Poetry* was a self-conscious counter to *New Poets of England and America*, edited by Donald Hall, Robert Pack, and Louis Simpson, and published in 1957. The two

anthologies had not one poet in common. As Allen noted in his introduction, the poetry included in his book had "appeared only in a few little magazines, as broadsheets, pamphlets, and limited editions, or circulated in manuscript; a larger amount of it has reached its growing audience through poetry readings." (Allen, *The New American Poetry*, xi.) With the exception of the fifth section of the book, Allen broadly grouped the poets according to geographical locale. He noted that this form of organization was "arbitrary and for the most part more historical and actual," but the almost feudal sense of various poetic kingdoms operating across the United States was a particularly fetching idea. (Allen, *The New American Poetry*, xiii) It was also clear from the statements by various poets about their poetry (which were included at the end of the book) that one of the key distinguishing characteristics of the New York poets was an interest in visual art. Schuyler noted, "Of course, the father of poetry is poetry, and everybody goes to concerts when there are any: but if you try to derive a strictly literary ancestry for New York poetry, the main connection gets missed." (Schuyler in Allen, *The New American Poetry*, 419.)

Note 7: O'Hara had gotten to know Corso while he was in Cambridge, Massachusetts, in 1956, on a six-month writing fellowship; both O'Hara and Corso acted in Ashbery's play *The Compromise* (1956), which was directed by Bunny Lang. O'Hara and Lang were very close friends, and Corso was Lang's protégée (she had met him when he was homeless in New York, and brought him back to Boston). At the same time in Cambridge, O'Hara was introduced to Ginsberg by the poets Jack Spicer and Robin Blaser. O'Hara wrote to Koch (on receiving a copy of *Howl* in 1957) that he "liked" Ginsberg "enormously. Beat that. I think he's gotten *very good*...I feel very enthusiastic about him" (Gooch, *A City Poet*, 318). But the poets' characterizations of each other could be more biting—as is clearly evident from O'Hara's letter to Ashbery about his reading with Corso at the Living Theatre two years later, reprinted pages 129–131. Most of the poets could vacillate in their assessment of each other; for instance, Ginsberg's later slightly backhanded praise of O'Hara for even *liking* Corso's and poet John Wieners's work, who were, he later said in 1989, "certainly not part of the New York art scene money scene sophistication." (Ginsberg, quoted in Gooch, *City Poet*, 319.) Pieces of writing like "A Hearsay Panel" did nothing to allay this kind of skepticism.

From "much in common . . ." to "passionate about the New York City Ballet . . ." Myers, "In Regards to this Selection of Verse, or Every Painter Should Have His Poet," *Nomad* 10–11

(Autumn 1962), 30. All other quotes in this paragraph are from the same page.

"I have been doing research . . ." Kenneth Koch to Harry Mathews, c. 1960–61, Mathews Papers, Van Pelt Library, University of Pennsylvania.

112 "Collaboration gives objective form . . ." Kenneth Koch, "A Note on This Issue," *Locus Solus* II (1961): 193.

Note 8: Editorial selections for the other issues of *Locus Solus* also help demarcate the New York School's sociability (as did Ashbery's editorial selections for the later journal *Art and Literature*): *Locus Solus* also included Michael Benedikt, LeRoi Jones, Bill Berkson, Larry Rivers, Diane di Prima, Musa McKim (Philip Guston's wife), Daisy Aldan, Gerard Malanga, James Merrill, John Perreault, Anselm Hollo, Harold Rosenberg, Chester Kallman, Ted Berrigan, and John Wieners. Schuyler considered *Locus Solus* a "riposte" to Donald Allen's anthology. To Chester Kallman, for instance, Schuyler wrote, "part of its unstated objective is a riposte at THE NEW AMERICAN POETRY, which has so thoroughly misrepresented so many of us—not completely, but the implications of context are rather overwhelming" [*sic*]. (Schuyler, *Just the Thing*, 129). Schuyler's objection to context had to do with Allen's placement of Charles Olson's essay "Projective Verse" at the beginning of poets' prose statements at the back of the book. You could also put this placement down to be Olson being born before anyone else was in the book, but to Schuyler, it seemed clear that if one didn't want to be read by the light of Olson, one had to construct other sources of illumination—like *Locus Solus*.

Note 9: The Tiber Press was founded in 1953 by Daisy Aldan, Floriano Vecchi, and Richard Miller. Together they published *Folder* magazine and a number of prints by downtown artists (including Stuart Davis and Georgia O'Keefe) before turning to produce *The Poems*, *Permanently*, *Odes*, and *Salute*.

[books] "are the first [book-form] American example . . ." to "Poets and Painters in Collaboration" (1961), in Porter, *Art in Its Own Terms*, 220. Other quotes by Porter in this paragraph: "a more organic collaboration." Ibid, 225; "The artists have more in common than the poets . . ." Ibid, 221; "He tends towards . . ." Ibid, 223.

Note 10: It is worth describing the process of *Mediterranean Cities* in slightly more detail. Burckhardt and Denby had each traveled to Europe in the previous decade (for instance, Denby, with the support of a Guggenheim Fellowship, from 1948 to 1952) each man respectively photographing and writing sonnets about the cities and places they visited. They

did not always travel with each other. Denby's sonnets do not "describe" Burckhardt's pictures, but it's clear that he was just as interested as Burckhardt in capturing light and how it moves through different mediums. Both poetry and image are focused on generating an atmosphere. And Denby's sonnets often feel addressed to Burckhardt, as if continuing or extending a conversation about what they are seeing. For instance, "Mycenae" ends with the following lines: "We turn away to the parched plain, the desert light / To our friendship; under Greek oleanders / Blooming white in the brightness downward we wander." (Edwin Denby [sonnets] with Rudolph Burckhardt [photographs] *Mediterranean Cities*, [New York: George Wittenborn, 1956], 29.)

"the nubbly, handwoven texture . . ." John Ashbery to James Schuyler, 31 August [year unknown; document c. 1960–69], Schuyler Papers, Mandeville Collection, University of California, San Diego.

"'Well,' Victor said, 'you see . . .'" Ashbery and Schuyler, *A Nest of Ninnies*, 83.

113 "very *Nest*." Schuyler: "I hope Aline Porter (wife of Eliot, the painter who "shows" at Betty Parson's) is still here when you come. She's very *Nest*." James Schuyler to John Ashbery, *Just the Thing*, 191. Ashbery: "Of course, Jimmy and I have been doing a little 'Ninnying.'" John Ashbery to Harry Mathews, 2 June 1965/66, Mathews Papers, Van Pelt Library, University of Pennsylvania.

"Maxine almost mailed it . . ." Harry Mathews to John Ashbery, 1 March 1968, Ashbery Papers, Houghton Library, Harvard University.

"the door burst open . . ." John Ashbery and James Schuyler, *A Nest of Ninnies*, 92.

"I feel I have sat for quite a few life studies in it . . ." Jane Freilicher to James Schuyler, 19 July 1968, James Schuyler Papers, Mandeville Collection, University of California, San Diego.

"style at its highest ebb . . ." Frank O'Hara, Elaine de Kooning, Norman Bluhm, Michael Goldberg, and Joan Mitchell in "5 Participants in a Hearsay Panel" (1959), reprinted in *Elaine de Kooning: The Spirit of Abstract Expressionism: Selected Writings* (New York: George Braziller, 1994), 177.

IV. Depth and Surface

153 "with their presence . . ." Ron Padgett, *Ted: A Personal Memoir of Ted Berrigan* (Great Barrington, MA: The Figures, 1993), 1–2.

"*soi-disant* Tulsa School." John Ashbery, quoted in Ron Padgett and David Shapiro, preface to *An Anthology of New York Poets*, ed. Padgett and Shapiro

(New York: Random House, 1968).

"Our cellar is a good home . . ." Ted Berrigan, "Journals," *Shiny Magazine* 9/10 (1999): 15.

"There was tremendous camaraderie . . ." Padgett, *Ted*, 49–50.

155 From "poised and assured . . ." to "Nijinsky as Groucho Marx." Berrigan, "Journals," 9, 16.

"He, Koch, and Ashbery . . ." Ibid., 19.

"I had a marvelous dinner . . ." Ted Berrigan to Sandy Alper Berrigan, August 1963, Ted Berrigan Papers, Rare Book and Manuscript Library, Columbia University, New York.

156 "Not only was the magazine wonderful . . ." Ron Padgett, interviewed by Daniel Kane, "Teachers and Writers Collaborative, New York, March 3 1998, quoted in Kane, *All Poets Welcome: The Lower East Side Poetry Scene in the 1960s* (Berkeley, CA: University of California Press, 2003), 162.

"Yesterday Joe & I . . ." Berrigan, "Journals," 24.

"pieces of cardstock . . ." Padgett, *Joe*, 61.

"While the 'girls' . . ." Padgett, *Ted*, 77–78.

"as Ted himself . . ." Padgett, "On The Sonnets," in *Nice to See You: Homage to Ted Berrigan*, ed. Anne Waldman (Minneapolis, MN: Coffee House Press, 1991), 10.

160 "Humor is one of Joe Brainard's . . ." John Ashbery, "Joe Brainard (Untitled)," *Joe Brainard: Selections from the Butts Collection at UCSD, February 19–March 22 1987* (San Diego, CA: Mandeville, University of California San Diego, 1987), n.p.

"radical power of perception . . ." to "the familiar could not be exhausted." Ann Lauterbach, "Remembering Joe Brainard," *The Night Sky: Writings on the Poetics of Experience* (New York: Viking, 2005), 224.

"painterly excess and its claims . . ." Carter Ratcliff, "The Art of Alex Katz," in *Alex Katz* (London: Phaidon, 2005), 64.

167 *NOTE 1*: Warhol's rise was concomitant with the arrival in New York in 1962 of "Pop" as an art movement, largely announced by the exhibition *New Realism* at the Sidney Janis Gallery (which both O'Hara and Ashbery wrote about). In protest of the new art, a number of Abstract Expressionist painters resigned from the Sidney Janis Gallery (including Mark Rothko, Adolph Gottlieb, Robert Motherwell, and William Baziotes). It was (and is) very easy to play up these differences as indicators of a kind of epochal divide. Within the New York School, if there was a divide, or a sense

of "them" and "us," it could also be phrased as a growing distrust of the careerism and the burgeoning appetites of the art world.

NOTE 2: Reva Wolf discusses this controversy at length in her book *Andy Warhol, Poetry, and Gossip in the 1960s* (Chicago: University of Chicago Press, 1997).

"Zzzzzzzzzzz . . ." Ron Padgett, "Sonnet for Andy Warhol," in *Bean Spasms* (New York: Kulchur Press, 1967).

NOTE 3: Lita Hornick's importance as the publisher of *Bean Spasms* and *Kulchur* should be noted here. *Kulchur* went from being a magazine of mostly first-generation New York School poets to one featuring second-generation poets; in other words, along with her legendary parties, Hornick's magazine grouped these poets together in a way that few publications did.

NOTE 4: As Berrigan noted in his diary, "Joe [Brainard] told me that Kenneth [Elmslie] told him that John Cage called up John Ashbery and asked him who I was, and if I was putting him down or what in the interview? John told him no, that I actually admired him very much!" (Berrigan, "Journals," 31.)

NOTE 5: The "mimeo revolution" was a misnomer of sorts; many of the magazines and books produced by small presses throughout the 1960s were published using a range of other technologies, including mimeograph machine, letterpress, and inexpensive offset printing. We tend to associate the mimeo revolution with downtown New York and the rough hastiness of stencils and mimeograph printing, but there was also, for instance, the impeccably designed journal *Art and Literature*, which was published in Switzerland and Ashbery edited while living in France (from 1964 to 1967). The painters Anne Dunn and Rodrigo Moynihan provided the financial backing for the magazine as well as an extensive set of connections with the British art world. Further, a number of extremely influential anthologies were also published at this time, including Alfred Leslie's ambitious and wide-ranging one-shot magazine of others' writing, *The Hasty Papers* (1966). In addition to this range in publishing, it's also the case that Black Mountain and Beat poets had been publishing small magazines and running small presses well before the 1960s—as had, of course, many avant-garde movements in Europe in the early twentieth century, including the Russian Constructivists, Expressionists, Futurists, Surrealists, and Dadaists. In other words, the phrase "mimeo-revolution" simply reminded a broader audience of the well-established tradition of an avant-garde press under the command of poets and founders of literary movements.

168 "was a kind of free-flowing record . . ." Ron Padgett quoted in Kane, *All Poets Welcome*, 43.

"The world . . ." Diane di Prima, *Recollections of My Life as a Woman: The New York Years* (New York: Viking, 2001), 186–87.

173 *NOTE 6*: It's worth describing Ed Sanders's own recollections of the footage of *Amphetamine Head*, if only because it gives a great indication of the kinds of experimentation going on in the East Village at the time. Sanders found an apartment for rent at 28 Allen Street in the Lower East Side, purchased four ounces of amphetamine, and let it be known that anyone could come shoot up as long as they would allow Sanders to film the ensuing events. "Within minutes," he wrote, "the A-heads began to flock." Sanders filmed for two days, focusing, for instance, on a young woman (about sixteen years old) sitting cross-legged, with eyelashes drawn above and below her lips, "so that her mouth babbling torrentially had the look of a convulsing Cyclops." After drawing on other parts of her body, she set to work with a razor blade, shaving her stomach hair and occasionally cutting herself. Then she started to scrape the skin off of her lips: "When little edges of lip skin were hooked up, she would pick the skin with pinching fingers and tear it off. Soon long blood-pink strips had been peeled from her lips." Several days later, Sanders returned to the apartment to film the pad's "final state," which was bombed-out chaos. (Ed Sanders, *Fug You: An Informal History of the Peace Eye Bookstore, the Fuck You Press, the Fugs, and Counterculture in the Lower East Side* (Philadelphia, PA: Da Capo Press, 2011), 56–57.)

"seemed to require . . ." Diane di Prima, *Recollections of My Life as a Woman*, 376.

176 "My own line of descent . . ." Ted Berrigan, quoted in Bob Holman, "History of the Poetry Project," 1978 Poetry Project Archives, St. Mark's Church, New York, 9, and quoted in Kane, *All Poets Welcome*, 42.

"nearer Keystone . . ." Denby, backmatter, *Films by Rudy Burckhardt*, Microcinema (DVD), 2012.

177 "What I mean by an amateur . . ." Alex Katz, "Rudolph Burckhardt: Multiple Fugitive," *ARTnews* 62, no. 8 (December 1963): 38.

"wasn't something that was institutionalized . . ." It's worth providing Katz's complete sentences here: "The poets were more interesting to me in the 1960s than the painters; they were dealing with their life as they were living it. It's marvelous to see something fresh that belongs to the time you live in. And I felt empathy with the poets regarding the idea of an art form. It wasn't something that was institutionalized." ("Robert

Storr in Conversation with Alex Katz," *Alex Katz* [London: Phaidon, 2005], 34, 39.)

"If I ever get as fat as Eunice, shoot me . . ." Frank O'Hara and Alfred Leslie, *The Last Clean Shirt*, 1964.

179 "depth and surface at the same time." Berrigan, quoted in *Nice to See You*, 109.

NOTE 7: Before 1965, Baraka had been part of Umbra, a collective of black writers based in the Lower East Side (begun in 1962), which included Lorenzo Thomas and Ishmael Reed, but with time, the group felt insufficient to Baraka because it was, in part, premised on engagement with the (white) arts scene directly surrounding it. In *The Autobiography of LeRoi Jones*, Baraka describes a series of events throughout the mid-1960s that politicized him, but the moment most remembered by those in the New York School is an evening forum for the arts at the Village Vanguard in 1965. Earlier that evening Frank O'Hara had hosted a party in his loft that Baraka and Rivers had both attended, and nothing had seemed amiss. But at the Village Vanguard, when the jazz saxophonist Archie Shepp referred to the twelve million Congolese killed by the slave trade and Belgian colonialism, and Rivers "began to make an allusion to the Holocaust," Shepp interrupted, shouting, "There you go again, always bringing up the fucking Jews." An audience member asked Shepp and Baraka what they thought of the two (white and Jewish) civil rights workers, Andrew Goodman and Michael Schwerner, who were killed in Mississippi in 1964 along with James Chaney (who was African American). Baraka replied, "I can't worry about the two Jewish boys. I have my own to bury." (Rivers, *What Did I Do?* 431–32). Baraka remembers the evening similarly in his autobiography; though the dialogue differs, the sentiment is much the same, which Baraka characterized as a "viciousness," "the absolute distance raised, not only between Larry and ourselves but whole bunches of folks tied to him, who likewise had thought there was some intellectual and emotional connection between us" (279). In this "snarling," Baraka commented, "I was struggling to be born, to break out from the shell I could instinctively sense surrounded my own dash for freedom. I guess I was in a frenzy, trying to get my feet solidly on the ground of reality" (286). Rivers and Baraka didn't see each other for twenty years. (Baraka, *The Autobiography of LeRoi Jones* [1984; repr., Chicago: Lawrence Hill Books, 1997.])

"the only truth is face to face . . ." O'Hara, "Ode: Salute to the French Negro Poets," *Collected Poems*, 305.

ELIZABETHAN & NOVA SCOTIAN MUSIC

Charles North

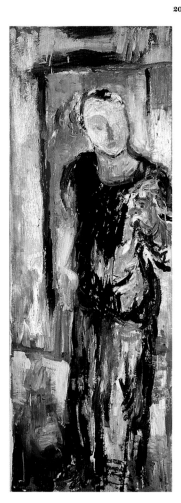

"rigid perspective . . ." Denby, "The Thirties," reprinted page 45.

"Do you think we both . . ." Kenneth Koch and John Ashbery, *A Conversation* (Tucson, AZ: Interview Press, 1965), 1. Reprinted page 190.

"moral image . . ." Denby, "The Thirties," reprinted page 45.

"free at last . . ." Ashbery, "Soonest Mended," *Ashbery: Collected Poems*, 184–85.

V. Continuing the conversation

203 "Frank O'Hara was my best friend . . ." Larry Rivers, "Speech Read at Springs," *Homage to Frank O'Hara*, 138.

"He was our Apollinaire." Philip Guston, as reported by LeSueur, quoted in Gooch, *City Poet*, 11.

204 NOTE 1: As Reva Wolf has pointed out in her book *Andy Warhol, Poetry, and Gossip in the 1960s*, the *Art in America* feature was also interesting because of who it didn't include: Francine du Plessix Gray did not pick, for instance, Andy Warhol, or any Pop or Minimalist artist, preferring to go with artists who exhibited an evident painterliness (e.g., Robert Motherwell, Grace Hartigan, Philip Guston, Jim Dine, and Robert Goodnough). The collaborations were very much in the style of the French *livre d'artiste*, as du Plessix Gray acknowledged in her introduction to the portfolio of work. Only in Jasper Johns's collaboration (with O'Hara) was the text incorporated *inside* the visual field. All in all, the feature was a conservative answer to the question of how painters "read" contemporary poetry.

NOTE 2: In the 1960s, Reverend Michael Allen agreed to participate in a grant from the federal Department of Health, Education and Welfare, which was administered through the New School. This grant funded the Poetry Project, which was described by Paul Blackburn and Allen as a program to combat juvenile delinquency in the surrounding East Village projects by offering an alternative venue for creative forms of expression. It should be noted that the project's mandate was not its actual focus—which of course, served a community who had moved into the area rather than growing up there. This funding lasted for two years and after that, other forms of funding became available. See Kane, *All Poets Welcome*, for an account of the Project's beginnings.

209 "having so much free time . . ." Fagin, "How Poets Collaborate: A Dialog," Padgett and Fagin, published page 298.

"the more unrelated the better . . ." Linda O'Brien, "Poet's Home Companion Handy Poem Writing Guide (For Authentic New York School Poems)," *Poet's Home Companion* (1968), reprinted pages 224–225.

Note 3: By the late 1960s, approximately forty poets had been referred to as second-generation New York School poets. In hindsight, as North has noted twenty-five "seems a more meaningful number"; poets dropped in and out of the Project and New York City and more importantly, found more pressing models of influence. North's list, in order of their arrival to the Project, is valuable: Bill Berkson, Tony Towle, Frank Lima, Joseph Ceravolo, David Shapiro, John Perreault, Jim Brodey, Ted Berrigan, Ron Padgett, Dick Gallup, Aram Saroyan, Clark Coolidge, Peter Schjeldahl, Michael Brownstein, Ted Greenwald, Bernadette Mayer, Tom Clark, John Giorno, Maureen Owen, Carter Ratcliff, Larry Fagin, Anne Waldman, Lewis Warsh, Charles North, Alice Notley, Paul Violi, and John Godfrey. Cases can also be made for Allan Kaplan, Ed Sanders, Lewis MacAdams, Michael Benedikt, Tom Veitch, Lorenzo Thomas, and John Koethe, among others. (North adds, "this account . . . omits [poets] who, despite being close in age to the second generation, have had ties to one particular first-generation poet rather than to the New York School in general." It should also be noted that not all of these poets collaborated with visual artists, though nearly all of them had book covers, flyers, and posters designed by artists. (Charles North, "School Ties," unpublished manuscript, 2009.)

"The first generation had . . ." Charles North, "School Ties," n.p.

Note 4: A number of other differences between first- and second-generation New York School poets have also been described. See Daniel Kane in his book *All Poets Welcome* for an overview. For instance, among second-generation poets, the practice of borrowing—that is, literally appropriating lines—became much more aggressively practiced. Lines (and tonal approaches) from Frank O'Hara's poems were literally reused dozens of times in other poets' works. Having met O'Hara also became a marker of sorts—at one point, to distinguish within the second generation, or to suggest a dividing line between the second generation and a third. Of course, there can be no "hard and fast rule." Even the word "generation" is misleading: for instance, Berrigan was eight years older than Waldman, and seven years younger than Ashbery.

211 "it's a remarkably dreary day out here . . ." James Schuyler to Gerard Malanga, 28 November 1971, Gerard Malanga Archive, Harry Ransom Center, University of Texas, Austin.

212 "one that values the everyday . . ." Schuyler, "An Aspect of Fairfield Porter's Paintings," *ARTnews* (May 1967), reprinted in *Selected Art Writings: James*

Schuyler, ed. Simon Pettet (Santa Rosa, CA: Black Sparrow Press, 1998), 16.

"I have to feel comfortable where I am . . ." Freilicher quoted in "The Views from Her Windows Are Enough," Dinita Smith, *The New York Times*, April 19, 1998.

"she [Freilicher] / and John [Ashbery] bought / crude blue Persian plates . . ." Schuyler, "June 30 1974," *James Schuyler: Collected Poems*, ed. Tom Carey and Raymond Foye (New York: Farrar Straus Giroux, 1993), 229, 230.

217 "a sympathetic vibration, a natural syntax . . ." Freilicher quoted in Gerrit Henry, "Jane Freilicher and the Real Thing." *ARTnews* (January 1985): 83.

"lacked that authoritarian look . . ." Schuyler, "The Painting of Jane Freilicher" (1966), reprinted in Schuyler, *Selected Art Writings*, 30.

Note 5: Though Freilicher designed sets for plays, book covers, and contributed images to books of poetry, her images all have an accommodatory feel, as if she were making room for the poet, helping to stage their words rather than creating any kind of third mind. For instance, her sketch of marigolds on the cover of *Hearing* (1966–76) (music by Ned Rorem and poems by Koch) is calm and light. The landscape drawings she did for Charles North's poetry collection *Elizabethan & Nova Scotian Music* (1974) are similarly modest. The house she drew for *What's For Dinner?* (1978), Schuyler's third novel, seems simply designed to express the comforts of a well-appointed home. In this collaborative work, she is setting the tone, but not the subject.

"Some nights in the late 1960s . . ." Berkson, "Working with Joe," *Modern Painters* (Autumn 2001); repr. *Jacket Magazine* 26 (March 2002), http://jacketmagazine.com/16/br-berk.html.

"the first real family of artists . . ." Lewis MacAdams, "Painter Among the Poets," *Painter Among Poets: The Collaborative Art of George Schneeman*, ed. Ron Padgett (New York City: Granary Books, 2004), 67.

"Made by George . . ." Steven Katz, "Made by George," *Painter Among Poets*, 110.

"Most . . . collaborations invent a sort of utopia . . ." Schneeman quoted in Notley, "An Interview with George Schneeman," 56.

220 "about things I don't know much about . . ." Brainard, "Bolinas Journal," *The Collected Writings of Joe Brainard*, 290.

"periods of unison . . ." Tom Clark to Clark Coolidge, quoted in "A Literary History of the San Andreas Fault: Bolinas Section," by Kevin Opstedal, *Jack Magazine* 1, no. 3 (Winter

2001), http://www.jackmagazine.com/issue3/index.html.

221 "Art bothers me . . ." Joe Brainard to Lewis Warsh, 23 November 1969, Warsh's personal papers.

"Continue the conversation . . ." Berkson, "Divine Conversation: Art, Poetry & the Death of the Addressee," *For the Ordinary Artist: Short Reviews, Occasional Pieces & More* (Buffalo NY: BlazeVOX [books], 2011), 11.

"Everything good happens among friends . . ." Berkson, "Divine Conversation," 13.

"It's so hard . . ." Joe Brainard to Lewis Warsh, 23 November 1969, Warsh's personal papers.

VI. Not Together, But Some Place

261 "resistance." Bernadette Mayer, quoted in interview with Lisa Jarnot, *The Poetry Project Newsletter*, Feb/March 1998, Issue 168, n.p.

Note 1: Bernadette Mayer was an important figure in the New York poetry world in the 1960s and '70s, and her workshops at the Poetry Project at St. Mark's Church in-the-Bowery were particularly influential for younger poets. In addition to *Unnatural Acts* (1972–73), and *O to 9* (1967–69), she also launched *United Artists* (1977–83) with Lewis Warsh and acted as director at the Poetry Project between 1980 and 1984. The poet Eileen Myles succeeded her in 1984, and held the position until 1986. Myles is another figure who was extremely important to the Poetry Project and who offered, in her magazine *dodgems* (1977–78), a different constellation of poetic inheritance in the New York poetry world. Myles was quite willing to reshuffle the deck of relationships, putting, for instance, John Ashbery and Charles Bernstein directly next to each other in an issue. Yet another key organizer (and director) in the Poetry Project in the 1970s and '80s was Maureen Owen, who arrived in New York in 1968 and began her own magazine, *Telephone*. All three women were extremely influential as organizers and editors. They created a climate in which others could work—which is, of course, a form of collaboration. Yet they are not as distinctly represented in this book. This is partly because the book's bias is toward collaborations between writers and artists, as well as collaborations that announce themselves as such; yes, other editors' (like Ted Berrigan, Kenneth Koch, Ron Padgett) selections are represented, but that is also because they extensively collaborated with artists. Yet it also seems significant that Myers, Owen, and Myles are women, and that women are, in general, underrepresented in this book. Asked why she began *Telephone*, Owen replied, "I was meeting a lot of terrific writers, a lot of them women who . . .

weren't really getting published anywhere." This observation begs many questions about the selections for this book, which was written, edited, and designed by three women, but whose advisory editors were two men, and whose framing forewords were also written by men. I look forward to discussing these issues at length in other publications; they deserve more than just a note. ("Notes on Publishing," interview with Marcella Durand, February 1999, *Jacket* 11 [April 2000], quoted in Terrency Diggory, *Encyclopedia of the New York School Poets* [New York: Facts on File, 2009], 365.)

"between two persons . . ." Frank O'Hara, "Personism: A Manifesto," *Collected Poems*, 498.

264 *Note 2*: Though John Bernard Myers had originally named Barbara Guest as one of the New York School poets, publishing her work in a Tibor de Nagy Gallery imprint, and though Guest had worked as an art writer for *ARTNews* and continued to collaborate with artists, she felt she was not welcome in the same social circles, particularly after O'Hara's death. Regardless of the supposed reason—which differed according to whom you spoke, and which might have been her gender, a personality clash, or her poetry itself. The exclusion felt palpable. Guest's exclusion is one instance of the complications, unspoken and ambiguously felt, that are inevitable to some degree in friendships and social circles over a long period of time. But even if Guest's absence resists articulation, its effects were clearly discernible. Guest remains the least-known, least-discussed first-generation New York School poet. Some of the poets who knew her and who, as teachers in colleges across the country, could have introduced her work to their students, did not.

"The frequency with which attributes . . ." Phillip Lopate, *Rudy Burckhardt*, 39.

267 "lacking the qualities of the high art . . ." Padgett, *Joe*, 253–4.

"very amusing and endlessly fascinating . . ." Hilton Kramer, quoted in Padgett, *Joe*, 254.

"People want to buy . . ." Brainard, "The Joe Brainard Interview," Tim Dlugos, *Little Caesar* 10 (1980): 31.

"the longing for relaxation and relief." Clement Greenberg, "William Dobell Memorial Lecture, Australia, 1979," *Arts* 54, no. 6 (February 1980): n.p.

Note 3: Today, collaboration tends to be considered by academics and art critics as more creative by-product than principal event. Alex Katz, for instance, has become one of the more widely known American painters of the late twentieth century; his portraits and landscapes have an instantly recognizable glamour,

a cool sense of restraint. But he is not often named as a New York School collaborator—even though, in addition to his cutouts of poets, he has consistently sought out collaborative projects over the years, most notably the books *Face of the Poet* (1978) (in which he paired his portraits of poets with a poem by that poet); *Fragment* (1969) with John Ashbery; *Selected Declarations of Dependence* (1977) with Harry Mathews; the marvelously simple and ingenious *Interlocking Lives* (1970) with Kenneth Koch; *Give Me Tomorrow* (1985) with Vincent Katz; *Light As Air* (1989) with Ron Padgett; *Gloria* (2005) with Bill Berkson; and *Give Me Tomorrow* (1985) with Carter Ratcliff. Along with his wife, Ada Katz, he was also involved with Eye and Ear Theater in the 1980s, which restaged a number of New York School plays, including Ashbery's *The Heroes*. He also worked extensively with Paul Taylor as a set and costume designer with from 1960 to 1986. These projects—and what they indicate of Katz's inventiveness beyond his painting—are not frequently afforded considerable critical attention.

Note 4: Trevor Winkfield edited *Juillard* in part because he was suffering from a case of painter's block. He also began to write descriptions of the images he couldn't create, which resulted in a series of surreal, vignette-like short stories. That a painter would consider such a shift in medium seems entirely in keeping with the literary and visual intertwining of the New York School, and his return to painting was similarly literary; he drew a picture of Robinson Crusoe's bedroom to accompany a short story of his for Larry Fagin's magazine *Adventures in Poetry*, and encouraged by the response from friends and readers, he began to draw again, also designing covers and flyers for poets associated with the New York School. Winkfield's creative process and instinctive translation between media is another clear indicator of a continuing New York School sensibility.

268 *Note 5*: For example: image and text often "push" against each other, delighting in undermining any assumption of creative affinity. In *A Way Home*, Winkfield's images do not describe objects in Mathews's text, though they were drawn in response. For instance, Mathews writes, "Imagination moves by angles, along a black line inscribed on a white ground that is itself bordered by blackness. The mind rests when it comes to identifiable objects athwart or alongside this line: chewable wood pellets, for instance, or a woman catching minnows." The facing image includes the figure of a woman—but she is raking earth. Our imagination might move by angles, but these angles are obtuse when it comes any correspondence here.

271 "A kind of haphazard theatricality . . ." Berkson, "The New Gustons," *ARTnews* 69, no. 6 (October 1970): 46–47, quoted in Debra Balkan, "Philip Guston's Poem-Pictures," *Philip Guston's Poem Pictures* (Seattle and London: University of Washington Press, 1994), 20–21.

"friendly antagonism . . ." Clark Coolidge to Bill Berkson, 18 August 1968, quoted in Debra Balkan, *Philip Guston's Poem Pictures*, 27.

"It is a strange form for me . . ." Philip Guston to Bill Berkson, 28 December 1975, Allen Collection of Frank O'Hara Letters, Thomas J. Dodd Research Center, University of Connecticut Libraries, quoted in Balkan, *Philip Guston's Poem Pictures*, 16.

"the new poem of the twentieth century. . ." Koch, "Fresh Air," *The Collected Poems of Kenneth Koch* (New York: Knopf), 123.

274 *Note 6*: Kenneth Koch continued to collaborate with visual artists during this time, in particular with Larry Rivers and Red Grooms. In the mid-1980s, Grooms and Koch made a series of maps, which included "Practicing Philosophers in Ancient Greece," "The Wine Regions of France," and "Speaking France." (Other maps that were planned but never completed included a map of shepherds and shepherdesses in Elizabethan England, an ice-cream map of Italy, and places where passages of Walt Whitman's poetry were read aloud by soldiers during stop for rest on the Long March.) It's no surprise that the natural authority of a map—its

promise to represent the world—was entirely in keeping with Koch's interest in pedagogical frameworks.

"Why is there a sense..." Charles North, "The NY Poetry Scene," reprinted page 292.

Note 7: Of course, some of Charles North's sense of lost energy could be put down to the inevitability of age. Larry Rivers offered his own spin on such inevitabilities in his autobiography, *What Did I Do?*, which is worth quoting at length, if only for the irony that his tone is still so energized: "Years ago friends who visited couldn't escape a studio tour. Nowadays I don't suggest they look at what I'm working on. Neither do they. We no longer talk about sex—nobody's 'into' it; no one asks for another drink—no one drinks; no more talk about acquiring property—it's more about deacquiring, putting it in your will. Health is of some interest, blood pressure, fractures that won't heal, how to distinguish a memory lapse from the onset of Alzheimer's, and the ever-popular discussion of how old so-and-so is getting to look. These conversations take place in a mirrorless room. Then food appears on the table, which sends the conversation careening toward diet as the low-salt, fat-free fare is wolfed down by guests glad not be hosts." (Rivers, *What Did I Do?*, 219.)

275 "Peter Schjeldahl, Carter Ratcliff, and John Perreault . . ." Charles North, "School Ties," n.p.

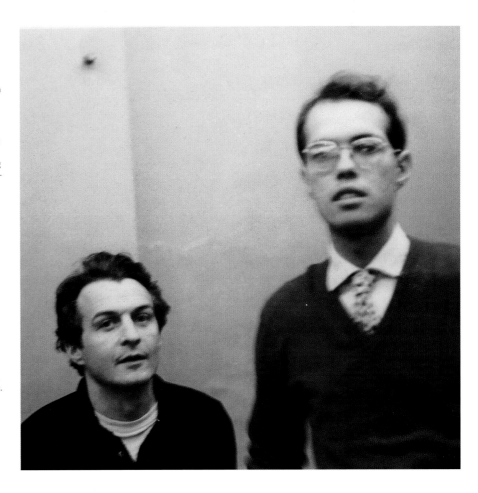

CREDITS

Frontispiece: Rudy Burckhardt, *A View from Brooklyn I*, 1953: © 2014 Estate of Rudy Burckhardt / Artists Rights Society (ARS), New York. **4**: Clockwise from top left: Courtesy Larry Fagin; Courtesy the Flow Chart Foundation; Photo by John Jonas Gruen; © 2014 The Willem de Kooning Foundation / Artists Rights Society (ARS), New York; Courtesy the Flow Chart Foundation; From Ron Padgett Personal Archive. **6**: © Estate of Joan Mitchell. **9**: Art © Alex Katz/Licensed by VAGA, New York, NY. **10**: Courtesy Bill Berkson. **11**: © Jane Freilicher / Courtesy Tibor de Nagy Gallery. **12–13**: Photo by John Jonas Gruen / Courtesy Larry Rivers Archive & Fales Library and Special Collections, New York University. **15**: By permission of Katie Schneeman. **17**: Art © Alex Katz/Licensed by VAGA, New York, NY. **18**: By permission of Katie Schneeman. **19**: Clockwise from top left: By permission of Katie Schneeman; Courtesy Bill Berkson; Courtesy Lewis Warsh; By permission of Katie Schneeman; Courtesy the Flow Chart Foundation; By permission of Katie Schneeman; Courtesy Bill Berkson. **20–24**: © 2014 Estate of Rudy Burckhardt / Artists Rights Society (ARS), New York. 25: Nell Blaine, between 1942 and 1943 / Robert Bass, photographer. Nell Blaine papers, Archives of American Art, Smithsonian Institution. **26–27**: © 2014 Estate of Rudy Burckhardt / Artists Rights Society (ARS), New York. **28**: Photo by Clemens Kalischer / Black Mountain College, State Art Museum of North Carolina Research Project (top); Federal Theatre Project Collection, Music Division, Library of Congress (center); Work Projects Administration Poster Collection, Library of Congress (bottom). **29**: © 2014 The Willem de Kooning Foundation / Artists Rights Society (ARS), New York / Photo courtesy Allan Stone Collection, Allan Stone Projects, New York. **30**: © 2014 The Willem de Kooning Foundation / Artists Rights Society (ARS), New York (top); Ellen Auerbach, Elaine and Bill de Kooning, 1940 © The Estate of Ellen Auerbach / Courtesy Robert Mann Gallery, New York (bottom). **31**: Photo by Beaumont Newhall / © 1948 Beaumont Newhall, © 2005, the Estate of Beaumont Newhall and Nancy Newhall / Courtesy Scheinbaum and Russek Ltd., Santa Fe, N.M. **32**: © 2014 The Willem de Kooning Foundation / Artists Rights Society (ARS), New York / Hirshhorn Museum and Sculpture Garden, Smithsonian Institution, Gift of the artist through the Joseph H. Hirshhorn Foundation, 1972 / Photo by Lee Stalsworth. **33**: © 2014 The Willem de Kooning Foundation / Artists Rights Society (ARS), New York. **34**: Robert Motherwell teaching at Black Mountain Rock, ca. 1945 /

unidentified photographer. Joseph Cornell papers, Archives of American Art, Smithsonian Institution. **35**: Art © 2014 Estate of Fernand Léger / Artists Rights Society (ARS), New York / ADAGP, Paris (right); Art © 2014 Estate of Marcel Duchamp / Artists Rights Society (ARS), New York / ADAGP, Paris (left). **36**: Photos by Max Yavno / Courtesy Center for Creative Photography, University of Arizona © Max Yavno Estate. **37**: Hirshhorn Museum and Sculpture Garden, Smithsonian Institution, The Joseph H. Hirshhorn Bequest, 1981 / photo by Cathy Carver. **38**: © 2014 Estate of Rudy Burckhardt / Artists Rights Society (ARS), New York. **39**: © 2014 The Willem de Kooning Foundation / Artists Rights Society (ARS), New York. **40**: © 2014 Estate of Rudy Burckhardt / Artists Rights Society (ARS), New York. **41**: © 2014 The Willem de Kooning Foundation / Artists Rights Society (ARS), New York / Courtesy Frederick R. Weisman Art Foundation, Los Angeles. **42–47**: © 2014 Estate of Rudy Burckhardt / Artists Rights Society (ARS), New York. **48**: Photo by Walter Silver / Grace Hartigan Papers, Special Collections Research Center, Syracuse University Libraries. **50**: Courtesy Tibor de Nagy Gallery (top); Courtesy the Flow Chart Foundation (bottom). **51–52**: © 2014 Estate of Rudy Burckhardt / Artists Rights Society (ARS), New York. **53**: Fred W. McDarrah / Getty Images (left); © 2014 Estate of Rudy Burckhardt / Artists Rights Society (ARS), New York (right). **54**: Photo by Jerry Cooke, © JCA, Inc. 2014. **55**: Courtesy Tibor de Nagy Gallery. **56**: Clockwise from top left: Fred W. McDarrah / Getty Images; Courtesy Living Theatre Archives; Joan Mitchell and Michael Goldberg, ca. 1950 / Unidentified photographer / Michael Goldberg papers, Archives of American Art, Smithsonian Institution; Weegee (Arthur Fellig) / International Center of Photography / Getty Images; Grace Hartigan Papers, Special Collections Research Center, Syracuse University Libraries. **57**: Philip Pavia and Natalie Edgar's Archive of Abstract Expressionist Art, Emory University. **58**: Art © Fairfield Porter Estate / Image courtesy Hirschl & Adler Modern, New York & Anderson Galleries / Howard Sutherland Collection. **59**: James Schuyler Papers, MSS 78, Archive for New Poetry, Special Collections & Archives, UC San Diego Library (left); Courtesy Tibor de Nagy Gallery (top right). **60**: James Schuyler Papers, MSS 78, Archive for New Poetry, Special Collections & Archives, UC San Diego Library / By permission of the Flow Chart foundation (left); Courtesy Tibor de Nagy Gallery (right). **61**: © 2014 The Willem de Kooning Foundation / Artists Rights Society (ARS), New York. **62**: Grace Hartigan Papers, Special Collections Research Center, Syracuse University Libraries. **63**: Art © the Estate of Grace Hartigan / Courtesy Grace Hartigan Papers, Special Collections Research Center, Syracuse University Libraries. **64**: Grace Hartigan Papers, Special Collections Research Center, Syracuse University Libraries. **66**: Fred W. McDarrah / Getty Images.

67: Jane Freilicher / Courtesy the Flow Chart Foundation. **68**: Photos by Walter Silver. **69**: Art © Estate of Grace Hartigan / Grace Hartigan Papers, Special Collections Research Center, Syracuse University Libraries. **70**: Art © Estate of Grace Hartigan / Collection Mr. and Mrs. Richard P. Doerer / Photo by Anne Diggory / By permission of the Estates of Frank O'Hara and Grace Hartigan. **71**: Clockwise from top left: Art © Estate of Grace Hartigan / Gallery K, Washington, D.C / By permission of the Estates of Frank O'Hara and Grace Hartigan; Art © Estate of Grace Hartigan / Collection Mrs. Robert B. Mayer / By permission of the Estates of Frank O'Hara and Grace Hartigan; Art © Estate of Grace Hartigan / Collection Emily Dennis Harvey / By permission of the Estates of Frank O'Hara and Grace Hartigan / Art © Estate of Grace Hartigan / Marie-Helene and Guy Weill Family Collection / Photo by Anne Diggory. **72**: Clockwise from top left: Art © Estate of Grace Hartigan / State University of New York at Buffalo (David and Becky Anderson Collection) / Photo by Anne Diggory / By permission of the Estates of Frank O'Hara and Grace Hartigan; Art © Estate of Grace Hartigan / Collection Mr. and Mrs. Leonard Kasle / Photo by Anne Diggory / By permission of the Estates of Frank O'Hara and Grace Hartigan; Art © Estate of Grace Hartigan / Gallery K, Washington, D.C / By permission of the Estates of Frank O'Hara and Grace Hartigan; Art © Estate of Grace Hartigan / Marie-Helene and Guy Weill Family Collection / Photo by Anne Diggory / By permission of the Estates of Frank O'Hara and Grace Hartigan. **73**: Art © Estate of Grace Hartigan / Collection Maureen Granville-Smith / photo by Robert Baldridge / By permission of the Estates of Frank O'Hara and Grace Hartigan. **74**: Digital Image © Smithsonian American Art Museum, Washington, DC / Art Resource, NY Goldberg, Michael (1924–2007). **76–77**: Photo by David Davidson Rieff. **78**: Art © Estate of Larry Rivers/Licensed by VAGA, New York, NY / Photo by Chris Felver. **79–81**: Art © Estate of Larry Rivers/Licensed by VAGA, New York, NY. **82**: Photo by Walter Silver / Courtesy Tibor de Nagy Gallery. **87**: © Jane Freilicher / Courtesy the Flow Chart Foundation & Tibor de Nagy Gallery. **88–89**: © Jane Freilicher / Courtesy Tibor de Nagy Gallery. **90**: © 2014 Estate of Rudy Burckhardt / Artists Rights Society (ARS), New York. **91**: © Jane Freilicher / Collection Elizabeth Hazan / Courtesy Tibor de Nagy Gallery. **92**: Photo by Hans Namuth / Courtesy Center for Creative Photography, University of Arizona © 1991 Hans Namuth Estate. **94**: Photo by Burt Glinn / Magnum Photos. **95**: Courtesy the Kenneth Koch Literary Estate. **96–97**: The Joseph and Robert Cornell Memorial Foundation/Licensed by VAGA, New York, New York (left); © 2014 Estate of Rudy Burckhardt / Artists Rights Society (ARS), New York (right). **98**: Art © Estate of Larry Rivers/ Licensed by VAGA, New York, NY / Digital Image © The Museum of Modern Art / Licensed by SCALA / Art Resource, NY Rivers, Larry (1923–2002). **99**: © 2014 Estate of Rudy Burckhardt / Artists Rights Society (ARS), New York / Courtesy

Alex Katz Studio. **100**: Art © Estate of Larry Rivers / Licensed by VAGA, New York, NY / Courtesy Larry Rivers Foundation. **101**: Photo by Walter Silver. **103**: © The Estate of Philip Guston / Courtesy McKee Gallery & Bill Berkson. 104: Digital Image © The Museum of Modern Art / Licensed by SCALA / Art Resource, NY / Kline, Franz (1910-1962) © ARS, NY / Poem © Estate of Frank O'Hara. **105**: Photo by John Button / Courtesy Bill Berkson. **106**: Photo by John Jonas Gruen (top); Photo by William T. Wood / Courtesy Bill Berkson (bottom). **108**: By permission of Harry Mathews. **109**: Courtesy the Flow Chart Foundation. **110**: Art © the Estate of Grace Hartigan. **111**: Private collection. **112**: By permission of Yvonne Jacquette. **114**: Fales Library and Special Collections, New York University (top); Fred W. McDarrah / Getty Images (bottom). **115**: Photo by John Jonas Gruen (top); Courtesy Tibor de Nagy Gallery (bottom). **116–117**: Grey Art Gallery New York University Art Collection Gift of Norma Bluhm, 1960 / Photos by Grey Art Gallery, New York University Art Collection / © Estates of Norman Bluhm & Frank O'Hara. **118–119**: © 2014 Estate of Rudy Burckhardt / Artists Rights Society (ARS), New York. **120–121**: Art © Estate of Larry Rivers/Licensed by VAGA, New York, NY / Text © Estate of Frank O'Hara. **124–125**: Alvin Novak. **128–129**: Fred W. McDarrah / Getty Images. **131**: Courtesy Living Theatre Archives. **132**: Art © Jasper Johns/Licensed by Vaga, New York, NY. **135–136**: Fred W. McDarrah / Getty Images. **139**: © 2014 Estate of Rudy Burckhardt / Artists Rights Society (ARS), New York. **140–141**: Art © Alex Katz/Licensed by VAGA, New York, NY. **142**: Photo by Hans Namuth / Courtesy Center for Creative Photography, University of Arizona © 1991 Hans Namuth Estate. **143–149**: Art © Estate of Larry Rivers/ Licensed by VAGA, New York, NY / Text © Estate of Frank O'Hara. **150**: From Ron Padgett Personal Archive. **152**: Photo by Pat Padgett / From Ron Padgett Personal Archive (top); Photo by Lorenz Gude / From Ron Padgett Personal Archive (bottom). **153**: © the Estate of Joe Brainard / From Ron Padgett Personal Archive. **154**: All from Ron Padgett Personal Archive: Photo by Lorenz Gude (top right); Photos by Ron Padgett (center left, center right, & bottom right). **155**: Courtesy Tony Towle (top); From Ron Padgett Personal Archive (bottom). **157**: © Ron Padgett & the Estate of Joe Brainard. **158**: Art © the Estate of Joe Brainard / Text © the Estate of Frank O'Hara. **159**: © the Estate of Joe Brainard (left); Photo by Lorenz Gude / From Ron Padgett Personal Archive (right, top & bottom). **162**: Art © the Estate of Joe Brainard / Text © Peter Schjeldahl. **163**: Art © the Estate of Joe Brainard / Text © Frank Lima. **164**: Art © the Estate of Joe Brainard / Text © Bill Berkson. **165**: Art © the Estate of Joe Brainard / Text © Kenward Elmslie. **166**: © 2014 The Andy Warhol Foundation / Artists Rights Society (ARS), New York (top); Fred W. McDarrah / Getty Images (bottom). **167**: © the Estate of Joe Brainard / Courtesy Granary Books. **168–169**: Art © the Estate of Joe Brainard / Text © the Estate of Ted Berrigan. **170**: © the Estate of Joe Brainard / Joe Brainard Archive,

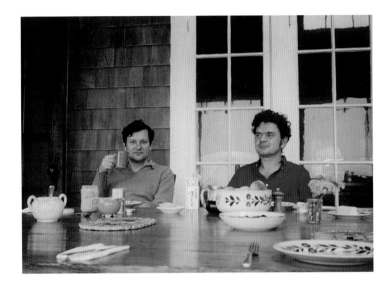

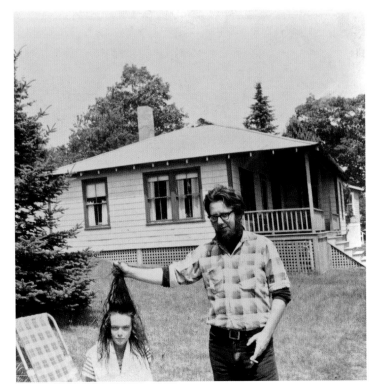

ACKNOWLEDGEMENTS

A very large number of people gave their time, energy and support to this book, and without them, *New York School: Neon in Daylight* wouldn't have been possible. I am hugely grateful to them, and hope that I can one day repay the favor.

I'd like to thank the following individuals and the institutions for which they do very fine work: Rob Melton at the Mandeville Special Collections at UC San Diego; Anne Garner and Isaac Gerwitz at the Berg Collection at the New York Public Library; Marvin J. Taylor and Nicholas Martin at the Fales Library, NYU; Lynn Gumpert at the Grey Gallery, NYU; all of the staff at the Houghton Library, Harvard University; Natalia Sciarini at the Beinecke Rare Book and Manuscript Library at Yale University; Melissa Watterworth Batt at the Thomas J. Dodd Research Center at the University of Connecticut; Laura Morris at the Joan Mitchell Foundation; David Joel at the Larry Rivers Foundation; Timothy O'Connor at the Flow Chart Foundation; Robert Polito, Don Share, Fred Sasaki and the staff at the Poetry Foundation; and Stacy Szymaszek, Will Edminston, and Nicole Wallace at the Poetry Project. I'd like also like to thank my students at the New School and NYU for helping me see much of the art and poetry gathered here in new ways.

There were people who patiently answered my (many) queries or put me in touch with others who could, who met me for coffee, showed me their work, or welcomed me into their homes: John Ashbery, Olivier Brossard, Michael Brownstein, Jacob Burckhardt, Steve Clay, Clark & Susan Coolidge, Terence Diggory, Jane Freilicher, John Gruen, H.R. Hegnauer, Yvonne Jacquette, Vincent Kane, Vincent Katz, David Kermani, Nathan Kernan, Karen Koch, David Lehman, Al Leslie, Constance Lewellan, Harry Mathews, Lewis MacAdams, Leslie Miller, Maureen O'Hara, Charles and Paula North, Robert Polito, Archie Rand, Karin Roffman, Dan Saxon, Katie and Paul Schneeman, Kyle Schlesinger, Mark Silverberg, Justin Spring, Tony Towle, Anne Waldman, Lewis Warsh, Tom Walker, and Trevor Winkfield.

In terms of the book's production: I'd like to thank Beverly Joel, who designed this book, Alan Wiener for photographing some of George Schneeman's work, and the staff at Rizzoli, including Kayleigh Jankowski who, many times, took the devil out of the details, Colin Hough-Trapp and Rebecca Ambrose in the production department, and Elizabeth Smith and Susan Homer who copyedited and proofread the text. Carter Ratcliff and Bill Berkson wrote terrific forewords, and Larry Fagin and Ron Padgett wrote a similarly terrific "dialog," and I'm honored to have these men's words open and close this book.

Then there are people who I don't think I could ever repay. Ron Padgett was the patron saint of this book. I'm sure he'd wince at the thought, but it's true; if no one else knew, Ron did. He was the repository of email addresses, permissions, photos, books, prints, and information, and could always be relied on for his decisiveness and good taste. Every time, he steered me in the right direction. And Eric Brown at the Tibor de Nagy Gallery is a prince among men. Along with his colleagues, Andrea Wells and Andrew Arnot, Eric fielded umpteen requests for information and art, always with good humor and efficiency.

Finally, there is Allison Power, who edited this book, and Bill Berkson and Larry Fagin, who were the book's advisory editors. The four of us have worked on this book for almost four years. Words can't really express. It's been a labor of love, and I love them for it.

Grateful acknowledgement is made to the publishers and individuals for their permission to reprint the following:

Excerpt from "Lotsaroots," by Rudy Burckhardt: From *Mobile Homes*, ed. Kenward Elmslie (Calais, VT: Z Press, 1979), 24. By permission of Yvonne Jacquette.

Excerpt from "de Kooning Memories," by Elaine de Kooning: First appeared in *Vogue*, December 1983. Reprinted in *Elaine de Kooning: The Spirit of Abstract Expressionism: Selected Writings* (New York: George Braziller, 1994), 213–14. Courtesy Vogue. © 1983 Condé Nast Publications, Inc.

"The Silence at Night (The designs on the sidewalk Bill pointed out)" by Edwin Denby: From *Edwin Denby: The Complete Poems*, ed. Ron Padgett (New York: Random House, 1986), 10. By permission of Yvonne Jacquette.

"The Thirties" by Edwin Denby: From *Dancers, Buildings, and People in the Streets* (New York: Horizon Press, 1965). By permission of Yvonne Jacquette.

Excerpt from letter by Kenneth Koch to Frank O'Hara, March 22, 1956. By permission of The Kenneth Koch Literary Estate & The Henry W. and Albert A. Berg Collection of English and American Literature / The New York Public Library / Astor, Lenox and Tilden Foundations &. No other rights are granted or implied.

Excerpts from *The Journals of Grace Hartigan, 1951–1955* (Syracuse, N.Y.: Syracuse University Press and the Special Collections Research Center of Syracuse University Libraries, 2009) edited by William T. La Moy and Joseph P. McCaffrey. By permission of the Estate of Grace Hartigan.

"Why I am Not a Painter" by Frank O'Hara: From *The Collected Poems of Frank O'Hara*, New York, 1971, Alfred A. Knopf, Inc. © 2014 Maureen Granville-Smith. By permission of Alfred A. Knopf, Inc. & the Estate of Frank O'Hara.

"Larry Rivers: A Memoir" by Frank O'Hara: From *Art Chronicles, 1954–1966*, by Frank O'Hara (New York: Braziller, 1990). © 2014 Maureen Granville-Smith. By permission of George Braziller Inc. & the Estate of Frank O'Hara.

"Jane Freilicher" by John Ashbery: From *Reported Sightings, Art Chronicles 1957–1987*. © 1989 by John Ashbery. By permission of Georges Borchardt, Inc., on behalf of the author.

Excerpt from "Dancers, Buildings and People in the Streets" by Edwin Denby: From *Dance Writings*, ed. Robert Cornfield and William MacKay (Gainesville, FL: University of Florida, 1986), 552. By permission of Yvonne Jacquette.

Excerpt from "Alex Katz's Cutouts" by Carter Ratcliff: From *Alex Katz: Cutouts* (Deutschland, Germany: Hatje Cantz Publishers, 2003). By permission of Carter Ratcliff.

"Song Heard Around St. Bridget's" by Bill Berkson & Frank O'Hara: From *Hymns of St. Bridget & Other Writings* (The Owl Press, 2001). © 1975, 2001 by Bill Berkson & the Estate of Frank O'Hara. Reprinted by permission of Bill Berkson.

"The Car" by Jane Freilicher & Kenneth Koch: By permission of Jane Freilicher & The Kenneth Koch Literary Estate. No other rights are granted or implied.

Excerpt from "A New York Beginner" by Bill Berkson: From *The Sweet Singer of Modernism and Other Art Writings, 1985–2003*, by Bill Berkson (Jamestown, RI: Qua Books, 2003). By permission of Bill Berkson.

Excerpt from "Twenty-Six Things At Once: An Interview with Norman Bluhm" by John Yau and Jonathan Gams (1996–97). By permission of John Yau.

Excerpt from "Life Among the Stones" by Larry Rivers: From "Life Among the Stones," *Location* 1, no. 1 (Spring 1963), 98. By permission of the Larry Rivers Foundation.

"How to Proceed in the Arts" by Frank O'Hara & Larry Rivers: From *Art Chronicles, 1954–1966*, by Frank O'Hara (New York: Braziller, 1990). By permission of George Braziller Inc. & the Estate of Frank O'Hara.

Letter by Fairfield Porter to James Schuyler, ca. 1961. James Schuyler Papers, MSS 78, Archive for New Poetry, Special Collections & Archives, UC San Diego Library. By permission of the Estate of James Schuyler.

"Crone Rhapsody" by John Ashbery & Kenneth Koch: By permission of the Flow Chart Foundation & The Kenneth Koch Literary Estate. No other rights are granted or implied.

Letter by Frank O'Hara to John Ashbery and Pierre Martory, March 16, 1959. Allen Collection of Frank O'Hara Letters, Archives & Special Collections at the Thomas J. Dodd Research Center. © 2014 Maureen Granville-Smith. By permission of the Estate of Frank O'Hara.

Letter by Frank O'Hara to Jasper Johns, July 15, 1959. Allen Collection of Frank O'Hara Letters, Archives & Special Collections at the Thomas J. Dodd Research Center. © 2014 Maureen Granville-Smith. By permission of the Estate of Frank O'Hara.

Memo by Frank O'Hara to James Schuyler, December 23, 1959. Allen Collection of Frank O'Hara Letters, Archives & Special Collections at the Thomas J. Dodd Research Center. By permission of the Estate of Frank O'Hara.

"Alex Katz Paints a Picture" by James Schuyler: Appeared in *ARTnews*, February 1962. From *Selected Art Writings*, edited by Simon Pettet (Santa Rosa, Calif: Black Sparrow, 1998), 36–44. By permission of the Estate of James Schuyler.

Excerpt from "Life Among the Stones" by Larry Rivers: From "Life Among the Stones," *Location* 1, no. 1 (Spring 1963), 93–94. By permission of the Larry Rivers Foundation.

Excerpt from *Joe: A Memoir of Joe Brainard*, by Ron Padgett: From *Joe: A Memoir of Joe Brainard* (Minneapolis, MN: Coffee House Press, 2004), 141. By permission of Ron Padgett & Coffee House Press.

Excerpt from "A Personal Memoir" by Aram Saroyan: From *Nice to See You: Homage to Ted Berrigan*, edited by Anne Waldman (Minneapolis, MN: Coffee House Press, 1991). By permission of Aram Saroyan.

Excerpt from "Poetry and Publishing in the Sixties (1962-65)" by Dan Saxon: From *The Rutherford Red Wheelbarrow*, Number 6, 2013. By permission of Dan Saxon.

Excerpt from the subtitles to the film *The Last Clean Shirt* by Frank O'Hara: From *The Last Clean Shirt* by Alfred Leslie, 1964. © 2014 Maureen Granville-Smith. By permission of the Estate of Frank O'Hara.

"XV" & "LIX" by Ted Berrigan: From *The Sonnets* by Ted Berrigan (New York: Penguin, 2000). By permission of the Estate of Ted Berrigan & Viking Penguin, a division of Penguin Group (USA), Inc.

"Back in Tulsa Again" by Joe Brainard: From *Collected Writings of Joe Brainard*, edited by Ron Padgett, with an introduction by Paul Auster (The Library of America, 2012). Reprinted by permission. All rights reserved.

Excerpt from *Perpetual Motion: Michael Goldberg* by Bill Berkson: From *Perpetual Motion: Michael Goldberg* by David Anfam, Bill Berkson, and Elizabeth Anne Hanson (Long Beach: University Art Museum, California State University, 2010). By permission of Bill Berkson.

Excerpt from "A Conversation with Kenneth Koch": © 1965 by John Ashbery and Kenneth Koch. Reprinted by permission of Georges Borchardt, Inc., on behalf of John Ashbery & The Kenneth Koch Literary Estate. No other rights are granted or implied.

"An Interview with John Cage" by Ted Berrigan: From *Bean Spasms* by Ted Berrigan & Ron Padgett (New York: Kulchur Press, 1967). Reprinted in Bean Spasms (New York: Granary Books, 2012), 62–67. By permission of the Estate of Ted Berrigan.

Excerpt from "An Aspect of Fairfield Porter's Paintings" by James Schuyler: Appeared in *ARTnews*, May 1967. From *Selected Art Writings*, edited by Simon Pettet (Santa Rosa, Calif: Black Sparrow, 1998), 14. By permission of the Estate of James Schuyler.

"The Secret of Jane Bowles", "The Infinity of Always", & "Waves of Particles": From *The World of Leon* by Bill Berkson, Michael Brownstein, Larry Fagin, Ron Padgett, & others (Bolinas: Big Sky, 1976). Reprinted by permission of Bill Berkson, Michael Brownstein, Larry Fagin, & Ron Padgett.

"Poet's Home Companion Handy Poem Writing Guide (For Authentic New York School Poems" by Linda O'Brien: From *Poet's Home Companion*, 1968. © Linda O'Brien.

Excerpts from Joe Brainard's diaries, May 9, 1969 & July 29, 1969: From *Collected Writings of Joe Brainard*, edited by Ron Padgett, with an introduction by Paul Auster (The Library of America, 2012). Reprinted by permission. All rights reserved.

Excerpt from "Working with Joe" by Bill Berkson: From *Modern Painters: A Quarterly Journal of the Fine Arts*, Autumn 2001. By permission of Bill Berkson.

Letter by Ted Berrigan to Joe Brainard. By permission of the Estate of Ted Berrigan.

What is Money? by Joe Brainard. From *Collected Writings of Joe Brainard*, edited by Ron Padgett, with an introduction by Paul Auster (The Library of America, 2012). Reprinted by permission. All rights reserved.

"The Invisible Avant-Garde" by John Ashbery: From *Reported Sightings, Art Chronicles 1957–1987*. © 1989 by John Ashbery. By permission of Georges Borchardt, Inc., on behalf of the author.

"New York Diary 1967*" by Lewis Warsh: Reprinted by permission of Lewis Warsh.

Excerpts from "Oo La La" by Ron Padgett: Reprinted by permission of Ron Padgett.

Excerpt from "Memorial Day" by Ted Berrigan & Anne Waldman: Reprinted by permission of Anne Waldman and the Estate of Ted Berrigan.

Excerpt from "School Ties" (unpublished essay, 2009) by Charles North: By permission of Charles North.

Quotation by Trevor Winkfield: From email to the Author, October 21, 2011. By permission of Trevor Winkfield.

Excerpt from letter by Philip Guston to Bill Berkson, November 6, 1973 (handwritten manuscript), Box 4, Bill Berkson Papers, Archives and Special Collections at the Thomas J. Dodd Research Center, University of Connecticut Libraries. By permission of The Estate of Philip Guston.

Clark Coolidge on working with Philip Guston: Quoted in "Combined Aesthetics: Philip Guston & Clark Coolidge," by Debra Bricker Balken in *Art New England*, vo. 11, no. 3, March, 1990. By permission of Clark Coolidge.

"I Got Easy" by Eileen Myles & Alice Notley: Reprinted by permission of Eileen Myles & Alice Notley.

"Arrivederci Modernismo" by Carter Ratcliff: © 2014 Carter Ratcliff.

"April Dream" by Anne Waldman: From *Homage to Frank O'Hara*, edited by Bill Berkson & Joe LeSueur (Bolinas: Big Sky, 1988), 10. By permission of Anne Waldman.

Excerpt from *Yo–Yo's With Money* by Ted Berrigan & Harris Schiff: From *Yo–Yo's With Money* (United Artists, 1979). By permission of Harris Schiff and the Estate of Ted Berrigan.

Excerpt from *The Basketball Article* by Bernadette Mayer & Anne Waldman: From *The Basketball Article* (Angel Hair Books, 1975). By permission of Anne Waldman.

Excerpts from *What's Your Idea of a Good Time?* by Bill Berkson & Bernadette Mayer: From *What's Your Idea of a Good Time?* (Tuumba Press, 2006). © Bill Berkson & Bernadette Mayer, 2006. By permission of Bill Berkson.

Excerpt from "The Ballad of Popeye and William Blake" by Kenneth Koch & Allen Ginsberg: From *Making It Up: Poetry Composed at St. Mark's Church on May 9, 1979* by Allen Ginsberg, Kenneth Koch, & Ron Padgett (Catchword Papers, New York, 1994). By permission of The Kenneth Koch Literary Estate. No other rights are granted or implied.

Excerpt from "Land's End," by Charles North & Tony Towle: From *Gemini*, Swollen Magpie Press. © 1981 by Charles North and Tony Towle.

"The N.Y. Poetry Scene/Short Form" by Charles North: From *No Other Way* by Charles North (Hanging Loose Press, 1998). By permission of Charles North & Hanging Loose Press.

"Honeymooners" by Ron Padgett & Larry Fagin: From *The World of Leon* by Bill Berkson, Michael Brownstein, Larry Fagin, Ron Padgett, & others (Bolinas: Big Sky, 1976). Reprinted by permission of Larry Fagin & Ron Padgett.

First published in the United States of America in 2014 by
Rizzoli International Publications, Inc.
300 Park Avenue South
New York, NY 10010
www.rizzoliusa.com

2014 2015 2016 2017 / 10 9 8 7 6 5 4 3 2 1

Printed in China

ISBN: 978-0-8478-3786–1

Library of Congress Catalog Control Number: 2014942920

Editor: Allison Power
Design: Beverly Joel, pulp, ink.
Design Coordinator: Kayleigh Jankowski

... of dreaming. his dream visions were passing and wandering. he went through Barrytown and through ... ation. he was named thirteen. one by one he lost ... staff fell at Antibes. his pony trailed off at ... Tierra de Fuego a beggar stole his cloak. he noticed all of ... from far away. something called him to the temple. there he ... of doves and drank sacramental incense. it was sweeter than honey. but it must have contained knock-out drops he woke on a ship bound for Shanghai. they told him he'd ... for thirteen years. he laughed and began to batten down the hatches. he was praised for his efforts. no one noticed him the boat sank somewhere. he wasn't on it. a tailor in Brooklyn had hired him to sew. sew what? and he did. Easter came and filled but he was gone I never seen a flower. not yet. somehow he was in school made the gymnastics squad. he beat William Saroyan in ... the commodemonic telegraph company of North America ... he discovered then that learning was a trap. Henry Mil... left. Hipolite, old and doddering, was guarding the place. No sex was allowed. in mild became he controls himself. birds sang. angels swooped and dove around him. water lily grew between his thighs to replace his lost ... But it was no good. he couldn't piss. urine ... up in him, filled his veins, and turned to burst, sinister, and gold. he died. death was Texas, then ... his stomach grew lean and hard. he gave them more of all he had, a flower. they gave him back ... learning was marvelous. his prick grew out ... he raced to shore and pole vaulted down the barge. he ... the idea of order at key west. it was his thirteenth birthday. he celebrated by breaking his mother ... as they did his laundry in the broom. angels ...